garden*lust*

garden*lust*

A BOTANICAL TOUR *of the* WORLD'S BEST NEW GARDENS

CHRISTOPHER WOODS

TIMBER PRESS
PORTLAND, OREGON

For Mary.
I could not have done this without you.

And for the gardeners of the world.
You with the crazy eyes and rough hands.
You who are so much in love with growing things.
You artists and scientists, poets and painters, protectors and advocates.
You who fall in love again and again.

CONTENTS

INTRODUCTION

I FELL IN LOVE WITH PLANTS when I was very young. Every autumn, my father and I would travel from our home in London to a small village in Northamptonshire. We would walk for miles, he picking mushrooms in the morning and blackberries in the afternoon, and I eating them. Britain had not yet fully recovered from the Second World War. Farms were small and wheat fields were full of poppies. Thousand-year-old hedgerows contained a garden of hawthorns and dog roses, and skylarks sang so high in the sky they were all but invisible.

Much later, like so many of my generation, I considered moving away from the city to live an idealized life in the country. I took a small step first and became a gardener at the Royal Botanic Gardens, Kew. I planned on working there for just a few months, but on the first day, I was hooked. It takes hold quickly, this plant addiction.

I then went on to work in a succession of gardens: Portmeirion in Wales, where I discovered the wonders of Himalayan rhododendrons; Bateman's in Sussex, and Cliveden in Berkshire, where I learned about the history of gardens and the bureaucracy of management. All the while, I was falling deeper and deeper in love with growing things.

I am a restless man at heart, though, so eventually, feeling confined by Britain, I moved to the United States. A whole new world of plants and gardens was mine to explore. There was even sunshine. I spent twenty years working in a garden in the suburbs of Philadelphia, Chanticleer, before finally giving in to my desire to have a long-term affair with California. I initially moved to a two-room shack on the edge of Los Padres National Forest. My Zen credibility was high. I learned many things in the West, from how to remove rattlesnakes from my kitchen to which California lilac turned the mountains from white to pale blue, then to deep blue and back to white again. I never learned to surf.

At this point in my life, I have more or less replaced constant resettlement with near-constant travel. I continue to fall in love with this extraordinary world and its botanical marvels. Blue poppies in the Himalayas. Aloes in the desert. Banksia in the Blue Mountains of Australia. Orchids in Laos. I am a romantic fool. It's a curse and a blessing. It probably makes me look at things from a somewhat naïve perspective, but the perspective is mine.

I want everyone else to fall in love with our world too, and with gardening's potential for adding beauty to the world. Hence this book. After a life spent in public horticulture, I began traveling the world in search of gardens that intrigued me by offering a particularly modern take on using inherently interesting plants, fresh approaches to how to place them that result in the creation of something new or at least unconstrained by the weight of tradition, and faraway places where I could touch, feel, and breathe in mass gatherings of the plants I had too often only experienced as lonely "specimens" in the old-fashioned and ecologically clinical settings favored by too many Western botanical gardens. I moved from conformity to chaos, only to find out it wasn't chaotic at all.

I set myself a criterion of visiting only gardens created in the past two decades—I was in search of true twenty-first century gardens. So in short, this is a book about contemporary gardens and landscapes, but with every word, it is a love letter to the planet and to the people who have dared to create beauty, who have devoted their lives to helping others learn to see that beauty.

This book therefore naturally projects a quite personal opinion of what constitutes good innovation in garden design. I ask the reader to trust that my qualifications permit me to share my opinions. Brazen modifications of iconic historic gardens, such as Alnwick in the U.K., are always good. Imagining an entire forest smack in the middle of a crowded Tokyo business district, also good. Turning the bark of scribbly gum trees into inspiration for fanciful pathways, such as at the Royal Botanic Gardens, Cranbourne, in Australia—great. Gardens that envelop you in moody botanical opulence, such as the gardens of Juan Grimm in South America—fantastic.

Fifty designers' work is presented here. Many fine gardens are undoubtedly not included. Even I, with my enthusiasm for travel, am aware of my limits. I have chosen from among botanical gardens, public parks, private residential gardens, and corporate landscapes to illustrate the diverse range of thinking and expression that permeates contemporary design. I have asked myself what forms gardens can take now, what needs they must fulfill, and what the indicators are of how garden design will progress as the century advances. Each selection answers one or more of these questions in a significant way. Many new and important gardens have been created in the past eighteen years, but which successfully illustrate possibility?

Our view, our interest, and our understanding of what gardens and landscapes can accomplish have changed radically in the past few years. What makes modern landscape design different from most other forms of contemporary art is our growing understanding of the effects of deforestation and climate change, the lessons to be learned by studying ethnobotany, the importance of an urban forest, and the impulse to use what we hope are ecologically appropriate or native plants. Several themes run through the stories that follow, threads that make an interwoven pattern. No garden touches on just one—most have all of them.

BEAUTY The desire for beauty, often expressed as a deep need to embrace nature in our daily lives, has become more important than ever. It's technology backlash.

We continue to visit the grand palace gardens of the eighteenth and nineteenth centuries but the modern palaces are now global corporate and government centers. A question rarely asked is how beautiful should they be?

The country garden has become a postmodern collection of clean lines and smooth surfaces, geometric shapes and repeating patterns, in an attempt to create a garden that has a controlled and organized appearance. Conversely, it has become a tiny prairie, a meadow, a memory of wildness and a metaphysical murmur.

Often, people grow quiet when they enter a garden. In the face of so much beauty, there is often not much to say. In the Garden of Five Senses in India, even the young lovers are quiet, and the meditators, sitting in the shade of a tree, come to a place of beauty to sit in peace.

In the Naples Botanical Garden in Florida, visitors write down the name of plants and marvel at the color of bromeliads. They go out on a boardwalk overlooking the wetlands and their posture changes, backs straighten, mouths open, as they absorb the sun on the grasses and the flash of a heron taking flight.

In a small residential garden in the Netherlands, a mother says, "This is my house, this is my garden, this is my life. I want it all to be beautiful."

A fern, growing in a crease of rusted metal in a former steel plant in the Ruhr Valley, is the most beautiful thing I have ever seen. Until the next beautiful thing.

NATURE Gardeners now take the long view, and openly recognize that they must contribute in a large or small way to preserving plant diversity. Estimates vary of what percentage of the world's assessed plants are in danger of extinction. Of the approximately 300,000 species we know, the Center for Biological Diversity estimates that about 68 percent are currently threatened with extinction.

Botanical gardens and public and private gardens are taking urgent steps to care for the rare. Collecting plants suddenly seems like less of an eccentric hobby than an imperative for survival. Garden designers are getting very clever at bringing awareness of just how many fascinating species are out there, and continue to find refreshing ways of educating the public by bringing plants to them in unexpected ways. Take the Crossrail Station in London as an example, where commuters who want to make their way to their train have to first make their way through a slice of the tropics. The Ark of Conservation sails through choppy waters, but it does sail on.

Private gardens have also responded to the possibilities of new construction technology, bio art, and change of use. Garden rooms, once described for distinct gardens such as rose gardens, white gardens, or herb gardens, have become outdoor living and entertainment spaces, often with simple yet visually dynamic plant architecture.

Studies in brain-mapping, semiotics, learning processes, childhood development, physics and mathematics, and especially evolutionary biology keep pointing out what should be obvious: we're designed to be outside. The age of information and its constant availability brings greater knowledge, and with it a desire to escape the screaming narcissism of electronica by being outside in what we call "nature."

Our big brains have worked against us by producing a delusion of separateness. A delusion that serves us ill. It is preposterous stupidity to continue to think we are "us" and every other living thing on the planet is "them." Gardens remind us—gently—to stop the falsity of our dominance and to embrace the nature in us and around us. Gardens are to our hands what language is to our social structure: a constructed, artificial mechanism we've devised so we can explain things we see around us to ourselves. That may be why so many gardeners mutter as they work alone.

It is often said that we should have a relationship with nature, as if we could pick nature up in a bar or via an online dating service. We can't have a relationship with it; we *are* it. We are bags of salty water with a slosh of six elements and a lot of bacteria. We share 98.8 per cent of our DNA with chimpanzees—and approximately 60 percent with bananas. We do not stand alone; we are everything.

PLANTS AND PEOPLE Globalization has radically altered our view of the world—and has expanded it, usually for the better. A garden creator from Vietnam can now decide what's needed for a new landscape in Paris. An American woman designs gardens in Holland and an Italian working in London designs a garden in Morocco for a family from New Zealand.

Underlying every story in this book is the universal and enduring human connection with plants, with using plants as a means of expression. We have worked the land for over 15,000 years, our curious minds and busy hands selecting the grass seeds, berries, and nuts that were most nutritious and tasty. One somewhat surprising by-product of all our jet-setting is a new recognition that people who were historically stuck in one place for a long time got to know it really, really well and maybe learned a useful thing or two about the nearby plants while they were at it. Ethnobotany, the study of the relationships between humans and plants, is experiencing a sort of renewal of respect. Gardeners express this by increasingly including plants proven by ethnobotany to have useful properties in modern gardens. With a larger worldview comes a greater interest in the beliefs, stories, myths, instructions, songs, art forms, rituals, recipes, and practices of other cultures. With a larger worldview comes the certainty that gardeners had better hurry up and educate the current populations of particularly botanically diverse regions about their own cultural and horticultural wealth before economic constraints compel them or their governments to chop everything down.

Modern gardeners can also learn an immense amount from traditional practices. One of my most memorable experiences with this came while touring Oman, on the Arabian Peninsula. I met Abdulrahman Al Hinai, an ethnobotanist who has been gathering plants and their stories for the Oman Botanic Garden—stories that are being lost as the old wisdom, held in the minds of old men and women, fades under the onslaught of time and modern culture. He invited me to accompany him to the mountains, the Western Hajar, and to one village in particular, Wakan. He was being lured by a rare variety of lentil.

It had rained torrentially the night before the excursion. Abdulrahman told me that some of the mountain passes had been washed out and he wasn't sure if we could reach Wakan. But that lentil. With boyish enthusiasm, we decided to try for it anyway.

On the way, we stopped to look at the rushing water in a wadi. Around us, locals were taking photographs of the stream. In the desert, water is an event. Along the banks, *Saccharum kajkaiense*, a relative of Ravenna grass, giant cane (*Arundo donax*), and a rush (*Juncus rigidus*) shone in bright and relieved shades of green.

We continued on, passing through gravel desert and dark hills and cliffs of ophiolite, an igneous rock thrust up from the oceanic crust. Oman is a geologist's dream. Wakan is 2,000 meters (6,562 feet) above sea level, a small village winding on top of a crest of rock and looking down to Wadi Mistal below. It exists because year-round mountain springs provide drinking water and irrigation for many small terraces of subsistence crops. Like many places in Oman, you see the green clusters of date palms (*Phoenix dactylifera*) before you see the houses.

The terraces are small and defined by raised soil walls. Each has a rock that serves as a gate. It's simply removed to direct water that comes from a central water channel—*falaj* in Arabic. We walked past terraces of garlic, wheat, a kind of fava bean, and spring leaf crops. Abdulrahman and I climbed 700 steps through the village, talking about ancient techniques of subsistence farming, varieties of crops that are drought tolerant, and the need to preserve and protect botanical knowledge as a cultural necessity. The steps were shaded by fig, pomegranate, apricot, almond, and peach trees. A few flowering herbaceous plants grew in the terraces. We found *Gladiolus italicus* and the rare orchid, *Epipactis veratrifolia*, growing at the base of a wall.

We came upon three elderly men sitting in the shade. One of the elders was carrying a bag of male date palm pollen. Hand pollination of female date palms is one of the oldest agricultural techniques in the world. It was time for the palms of Wakan to be pollinated. A fast and loud conversation took place between the elderly men and Abdulrahman. We all shook hands. Such soft and respectful handshakes. We were invited to enter the village men's meeting room, the *majilis* (مجلس), where we sat on cushions and conversed.

Bowls of dates were brought and sweet oranges quartered and offered. Thanks to an ancient cell phone, we were connected with a farmer in possession of the mysterious lentil. That day, he happened to be herding goats halfway up the mountain and was not near his farm. He offered to show the ethnobotanist the lentil next time. This caused great excitement amongst my hosts.

The convergence of time struck me. Visitors arriving in a modern four-wheel-drive car at an ancient village came to see farming techniques that are at least 2,000 years old and discuss lentils on a seemingly stone-age mobile phone so that the lentil can be grown at a modern botanic garden.

It was a perfect day.

———

NATIVITY One of the strongest trends in modern gardens is using or reintroducing plants native to the garden's specific region. Large-scale drought and environmental depredation, the desire to control invasive plants, and a growing appreciation for the beauty of native flora all add momentum to the movement. Many garden designers have already chosen camps: some design with native plants exclusively, while others mingle natives and exotics.

You'll see many expressions of this impetus in these pages. A garden in New Zealand consisting exclusively of natives, Paripuma, adapts them to create a formal garden that, unlike most, accentuates wildness of the surrounding landscape. A garden in New Jersey, Federal Twist, commingles a golden gorgeosity of U.S., European, and Asian plants into a secret retreat, its diversity creating a greater moment, a greater garden. And a nursery in South Africa takes desert aloes and breeds them to produce nine months of bloom so they'll be more appealing to use in home gardens.

URBANIZATION The majority of us live in urban areas. With human population expected to increase to 9 billion in a few years, and while we increase by about 220,000 per day, this trend will only continue. Great work is being undertaken to make cities more livable. Urban forests are being created around the world. I wax lyrical about the garden city of Singapore. Cities in China, with their concomitant problems of air pollution, are planting millions of trees, to clean the air and lower temperatures. Living walls and roof gardens are now common. We are beginning to expect and to demand greening efforts in cities, both on the street and in the backyard.

————

Gardeners are nothing if not philosophical. Carrie Preston in the Netherlands describes her garden: "What I like about my garden is it is so comfortable, fitting like a favorite sweater. Not the fancy one you wear for special occasions, but the one you put on when you are alone and want to feel that you are in a place you can trust, a place that is yours."

And Rik Gadella, Director of Pha Tad Ke Botanical Garden in Laos PDR writes, "Even in poetry and art does nature have its place, do flowers blossom in unexpected places and do trees reach up to the sky. Not everything is pure science and what would garden design be without a palette of color, a sense of composition and structure, a playful line between nature and culture."

The life of the world is a joy and a treasure if you have eyes to see it. There are fifty worlds in this book. Fifty stories with hundreds, if not thousands, of streams of thought, work, and passion.

Please enjoy this book, then go outside and play in the beautiful cultivated and uncultivated places of the world.

north america

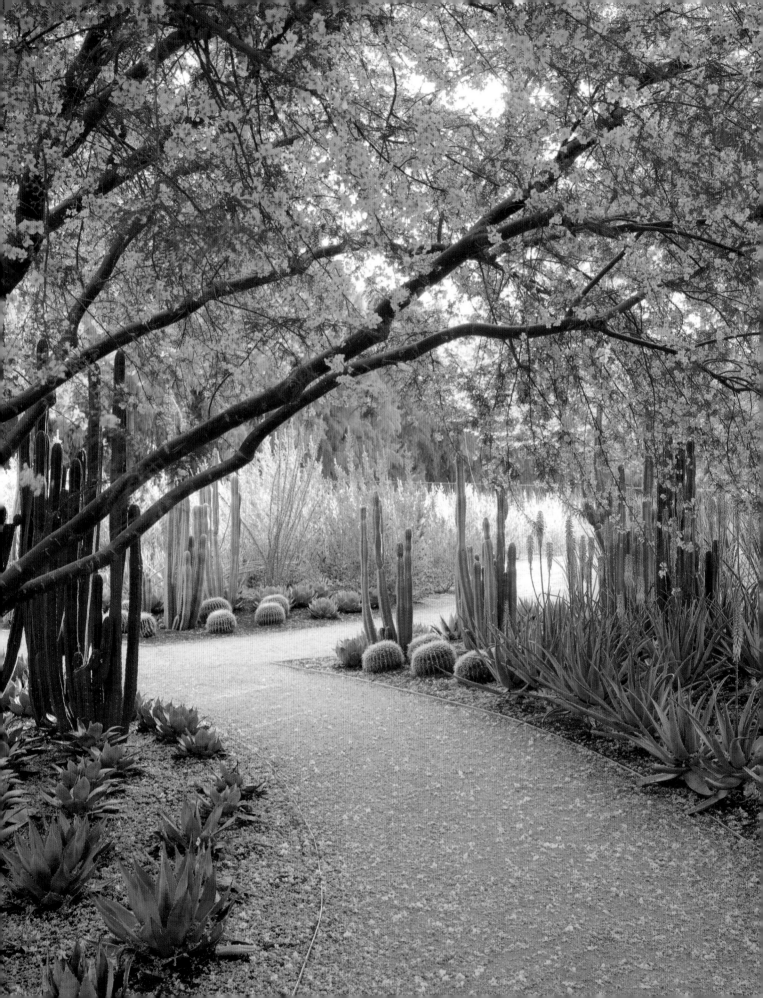

Sunnylands Center and Gardens

RANCHO MIRAGE, CALIFORNIA

James Burnett · 15 acres (6 hectares) · 2011

FORMAL AND ORDERED PLANTINGS make Sunnylands a refreshing addition to the canon of contemporary gardens. It moves in the opposite direction of garden design so fashionable at the moment—green spaces that attempt to evoke a cultivated wildness. The immediate impression is of elegant simplicity. Polished geometry comes through in the globes of cactuses, triangular spikes of aloes and agaves, and ellipses of ebony sage.

Binding these diverse shapes together are avenues of one of the most beautiful desert trees, palo verde (*Parkinsonia* sp.), Spanish for "green sticks." A hybrid, 'Desert Museum,' a cross between the Mexican and foothill varieties, is grown in boulevards and curving lines. The butter-yellow flowers bloom twice, in spring and in summer. In the intervening period, the flowers fall to the ground, creating a decorative ground cover like blonde confetti, which in the hot desert wind becomes sweeping, swirling, romantic.

Landscape architect James Burnett designed the garden, using Vincent van Gogh's paintings *The Olive Trees* for loose inspiration. The rustic quality in the original artworks was interpreted into a smoothed pastoralism appropriate for a public event space in stylized Palm Springs. Burnett's work is beautifully simple, and the other trees included in the design, like mesquite (*Prosopis* sp.), with its multistemmed wildness, and the spreading canopy of sweet acacia (*Acacia farnesiana*) provide an arboreal framework for what grows beneath.

Orderly rows of golden barrel cactus (*Echinocactus grussonii*), Moroccan mound (*Euphorbia resinifera*), and artichoke agave (*Agave parryi* var. *truncata*) guard populations of pink hesperaloe (*Hesperaloe funifera* hybrid) and white offerings of Our Lord's candle (*Hesperoyucca whipplei*) like an army. The undiluted, decadent use of specific plants en masse creates a strong rhythm and liveliness. With fifty species and 53,000 individual plants, the

Parkinsonia 'Desert Museum', one of the most ornamental trees for arid climates, casts its sunny flowers on the garden path.

Ranks of light-blue artichoke agave (*Agave parryi* var. *truncata*) are laid out in concentric arcs.

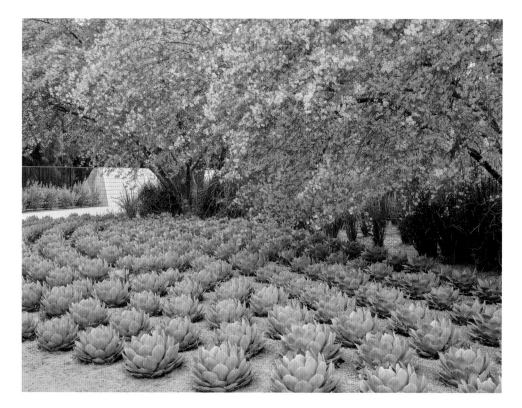

arid landscape is unexpectedly rich with sweeping color and a rare fecundity. A less formal natural planting nearby, complete with Southwestern native plants, invites the local fauna, and is home to Gambel's quail, the greater roadrunner, and many other species of birds.

Sunnylands was the winter estate of philanthropists Walter and Leonore Annenberg, a 200-acre (80-hectare) desert retreat with twenty-two guest bedrooms that, now a nonprofit meeting center, has hosted royalty, presidents, and film stars. Frank Sinatra wore his fedora for it, and Bob Hope sang "Thanks for the Memory" to it. The property is, incidentally, at the intersection of Frank Sinatra and Bob Hope Drives.

The modernist house, designed by Californian A. Quincy Jones in 1963, is available for public tours—except, that is, when a president is in residence. In 2006, the Annenberg Foundation commissioned Burnett to design a series of arid gardens around the new interpretive center, and the garden opened in 2011.

Sustainability is top of mind at the garden, and the staff is serious about using the most advanced desert growing systems possible. The project has received LEED (Leadership in Energy and Environmental Design) Gold Certification—not an easy accomplishment in such a dry climate. They use only 20 percent of their allotted water supply and have systems in place to reclaim and use wastewater.

The garden is located in the Sonoran Desert, at the foot of the San Jacinto Mountains, where the desert light and air bring an element of magic to the environment. The sunrises and sunsets bathe the grids of cactuses and agaves in warm, orange light and cast ethereal shadows from the sculptural meanders of ocotillo, mesquite, and palo verde.

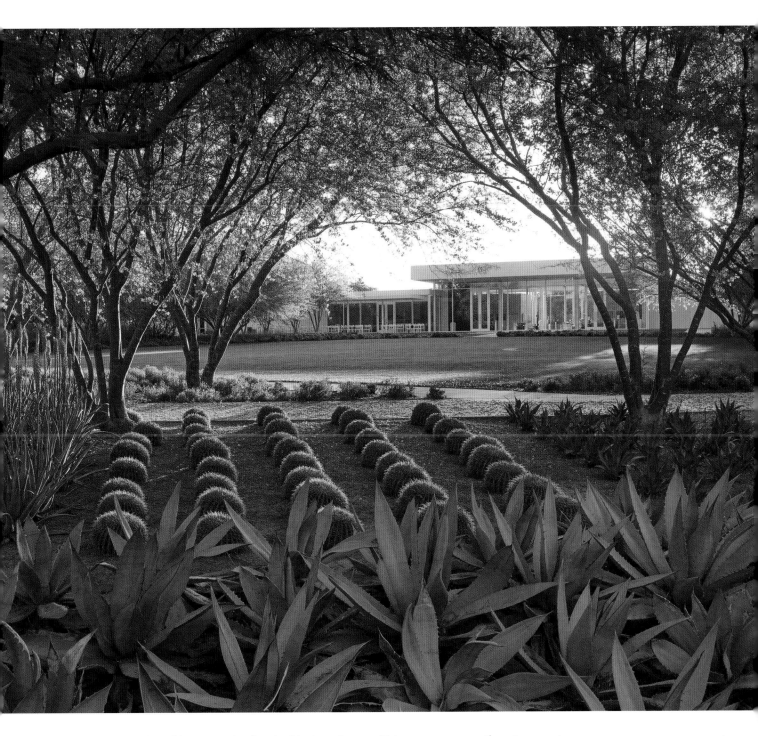

Blue agave (*Agave tequilana*) and golden barrel cactus (*Echinocactus grussonii*) are just two shapes and two colors, but together they make one dramatic planting.

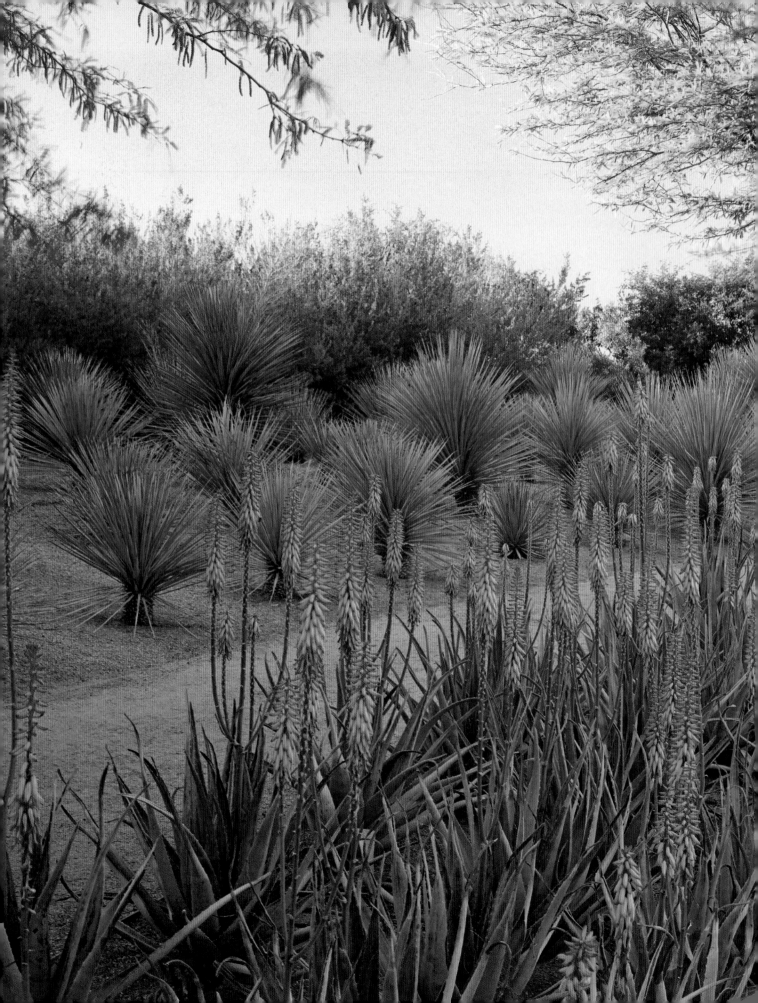

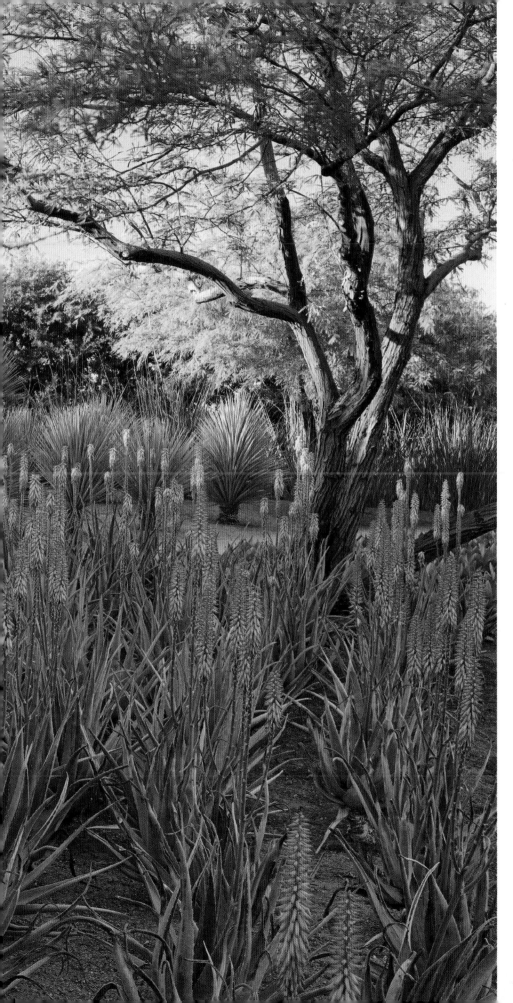

The morning sun changes the blue tint of the yucca to green and brightens the soft purple of the aloe foliage while turning the flowers to gold.

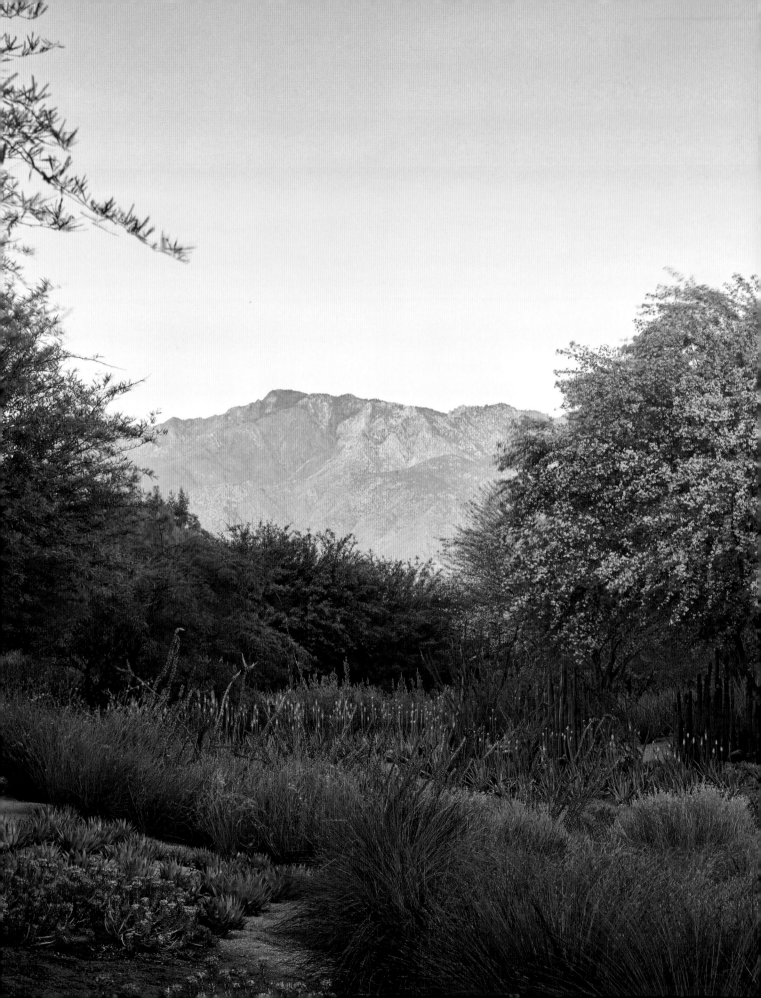

Red yucca, *Hesperaloe parviflora*, is highly attractive to humming-birds. The tubular flowers are borne on stalks up to 5 feet (1.5 meters) tall.

← Palo verde trees are underplanted with swaths of aloe, agave, and hesperaloe, with the San Jacinto Mountains in the distance.

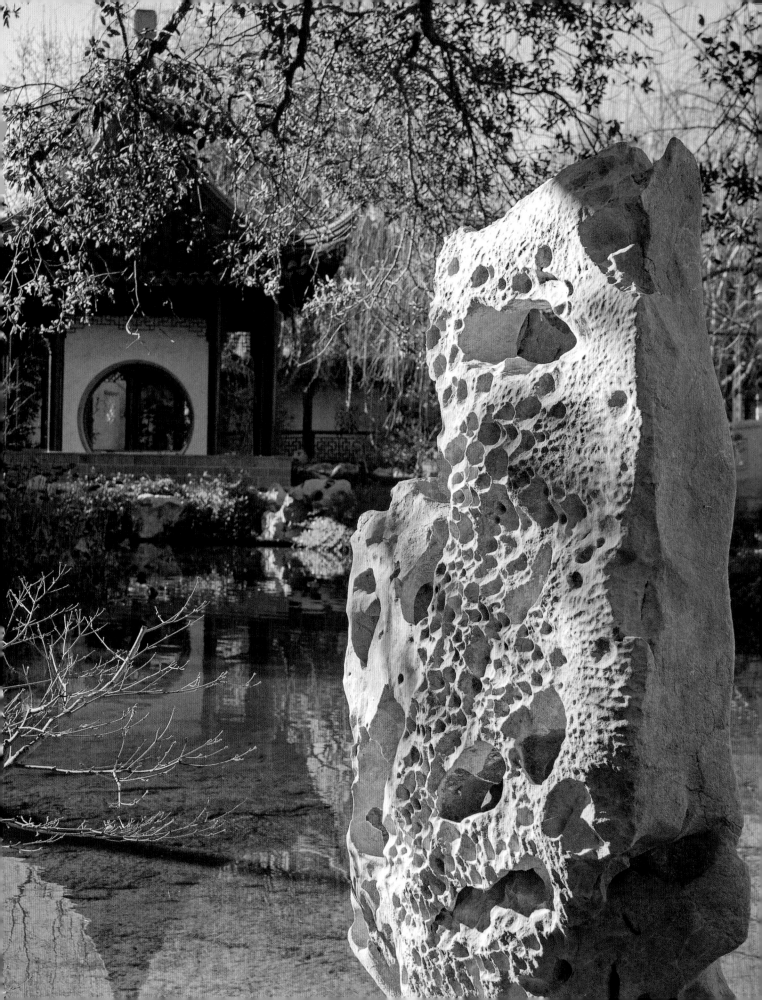

The Garden of Flowing Fragrance, Huntington Botanical Garden

SAN MARINO, LOS ANGELES COUNTY, CALIFORNIA

Jin Chen, Jim Folsom · 12 acres (4.9 hectares) · 2008

"You ask me why I dwell in the green mountain;
I smile and make no reply for my heart is free of care.
As the peach-blossom flows downstream and is gone into the unknown,
I have a world apart that is not among men."

—LI BAI, CHINESE POET, TANG DYNASTY

TO CREATE A PLACE of poetry, painting, and philosophy; a place of reflection and study; a place both for solitude and for sharing with friends. To distill nature to its essence by using the elements of rock, water, plants, and architecture as a means of expressing the ideal harmony between man and nature. To understand and appreciate the symbolism in Chinese tradition. These are the goals of classical Chinese gardens, often referred to as scholars' gardens, which have evolved over 3,000 years.

It is fitting, then, that a twenty-first-century interpretation of a Chinese scholar's garden should be located at the Huntington Botanical Gardens and Library, home of an extensive collection of Asian art and literature and a collection of Asian plants. Fitting, too, for an urban area, where, according to the 2012 U.S. Census, almost 600,000 inhabitants are from mainland China, Taiwan, Hong Kong, and Macau. Chinese American influence on the cultural life of Los Angeles has been profound, yet until recently there was no example of one of its highest forms of art: the garden.

Prized scholars' rocks from Lake Tai, near Suzhou, China, dot the garden. The observer is meant to see a variety of geological, animal, or plant forms in their abstract shapes.

In the mid-1990s, the staff at the Huntington began planning the Garden of Flowing Fragrance, or *Liu Fang Yuan* (流芳園). In 2003, Chinese American landscape architect Jin Chen completed the master plan. The skills of Chinese and American architects and landscape architects, builders, artisans, and gardeners were used to create the garden, and it opened to the public in February 2008.

Even though some of the elements of the garden were constructed in China, it is not simply an imported garden but rather a translated one. The Garden of Flowing Fragrance is a modern interpretation of a classical Chinese garden, adjusted for the parameters of the present era and its Southern California location. This means, among other things, that it has a teahouse and restaurant where a study might otherwise have been. Construction is also more solid than it would have been in eighteenth-century China, to anticipate inevitable earthquakes.

A tablet inscribed with four large Chinese characters meaning "another world lies beyond" graces the entrance and, as with every classical Chinese garden, the visitor must step into it over a low threshold and, in doing so, symbolically move into a different place, a different frame of mind.

The Lake of Reflected Fragrance lies at its center—the calm, nurturing *yin*, the heart of the garden. Surrounding it are scholars' rocks—fanciful, eroded limestone boulders from China's Lake Tai, implying mountains, or the virtue and stability, the *yang*, of the garden. The Chinese term for landscape is *shan shui*, mountains and water, and here the two complement and complete each other.

The many pavilions and other structures in the garden have been given poetic names, each with a literary and/or horticultural allusion. The Pavilion of Three Friends, for example, situated on a corner of the lake, looks out over the Isle for Welcoming Cranes and the Bridge of the Joy of Fish. The "three friends" alluded to are pine, bamboo, and plum trees. These grow in the coldest parts of China as well as in the heat of Southern California, and they symbolize fortitude, integrity, and resilience.

It is apt that the Love for the Lotus Pavilion sits above a portion of the lake named the Pond of Reflected Greenery, which contains a large planting of the sacred lotus (*Nelumbo nucifera*), a plant that grows in the mud, produces round leaves that reach for the light, ultimately floating on the surface of the water, with its pink and white flowers on tall stems waving above the water. The eight petals of the lotus blossoms are revered in Chinese Buddhism for representing the Noble Eightfold Path. The Pavilion for Washing Away Thoughts is at the bottom of a recirculating rivulet that runs from the lake. Outside the Hall of the Jade Camellia, the Terrace that Invites the Mountain bids the visitor to look over to the Jade Ribbon Bridge and beyond, to the San Gabriel Mountains in the north, using the principle of "borrowed scenery," or *jiejing*.

When moving among the various architectural elements in the garden, visitors experience a series of carefully composed scenes based on a traditional design principle that highlights the importance of concealment and surprise. As the Chinese proverb says, "By detours,

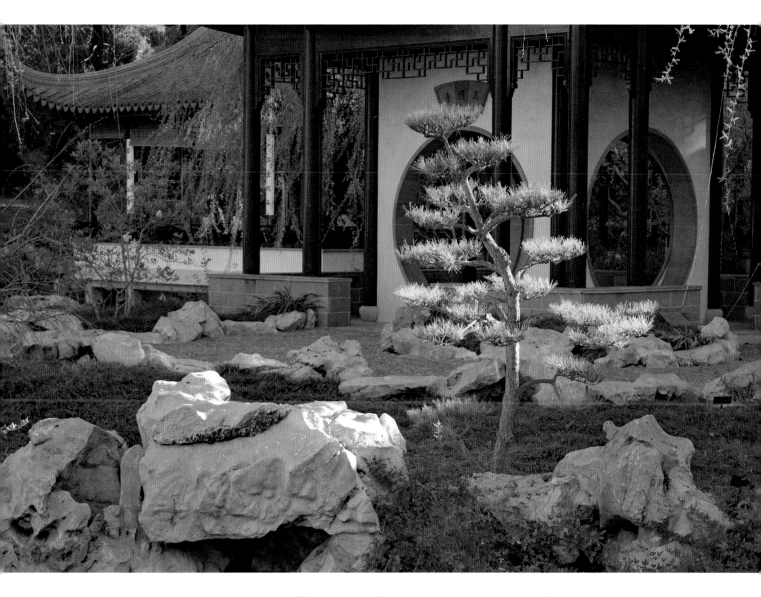

A tightly pruned Japanese black pine (*Pinus thunbergii*) sits amid carefully placed rocks. Pines are greatly treasured in Northern China, being, along with *Prunus mume* and bamboo, one of the "three friends" of the cold season.

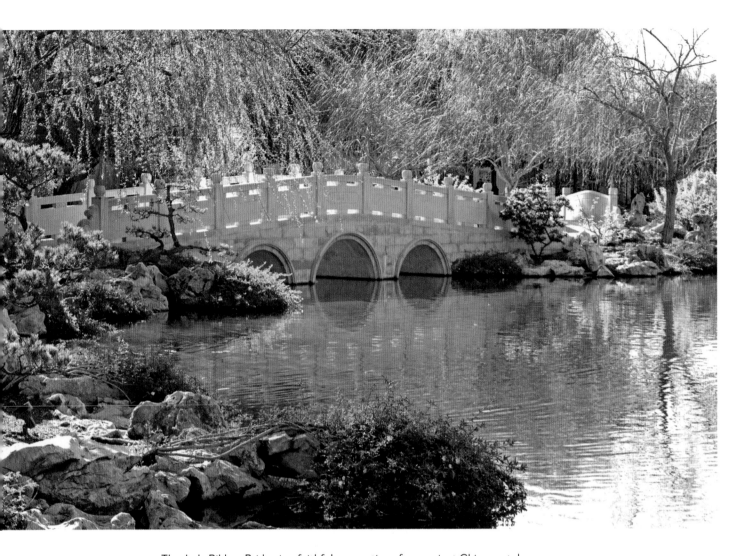

The Jade Ribbon Bridge is a faithful re-creation of an ancient Chinese style.

access to secrets." As in traditional Chinese gardens, the Garden of Flowing Fragrance is meant to evoke the feeling of being out in the larger natural world. Rocks suggest mountain ranges, trees represent forests, and ponds imply oceans. The microcosm of beauty becomes a macrocosm of our delight.

Plants add an important layer of symbolic meaning in Chinese gardens. With more than 31,000 species of beautiful ornamental plants growing in China, how did the designers choose? The climate of Los Angeles County restricted what could be grown, and, although similar to the climate of Suzhou, site of UNESCO World Heritage classical Chinese gardens, the dry climate is not kind to stalwarts such as maples. Because the garden sits in a large topographic bowl and is just one part of the greater Huntington gardens, plants from the original collections have a presence in the Chinese Gardens, either directly or as part of the borrowed landscape. Borrowed are large California live oaks (*Quercus agrifolia*) and California incense cedar (*Calocedrus decurrens*), with its red bark and bright green foliage, growing

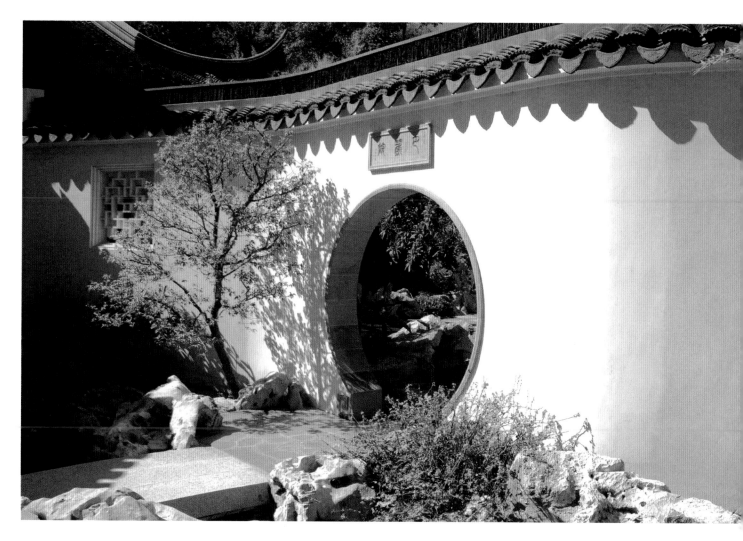

The moon gate leading to the Terrace of the Jade Mirror symbolically leads the visitor into a new realm.

← Undulating, tile-capped white walls enclose the garden, adding to the sense of privacy and peace a traditional scholar would have felt upon entering his sanctuary, removed from the activity of the surrounding city.

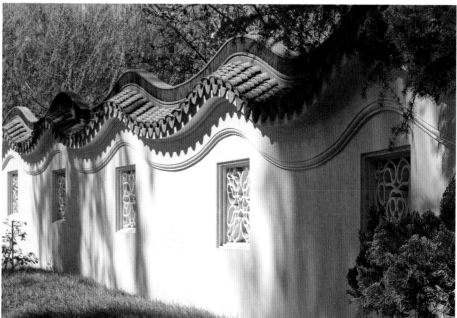

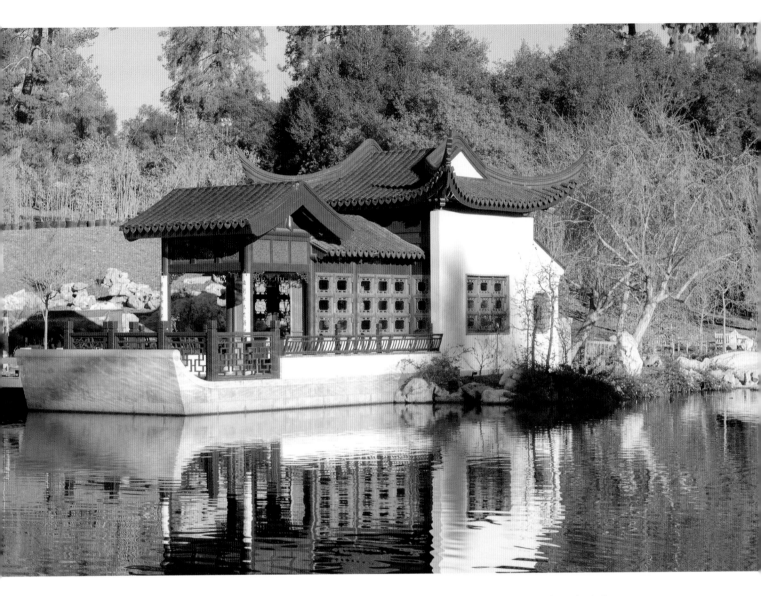

Crossing the Bridge of Strolling in the Moonlight, you come to a pavilion overlooking the Lake of Reflected Fragrance. Traditionally, Chinese pavilions were used as focal points and to provide places for contemplation.

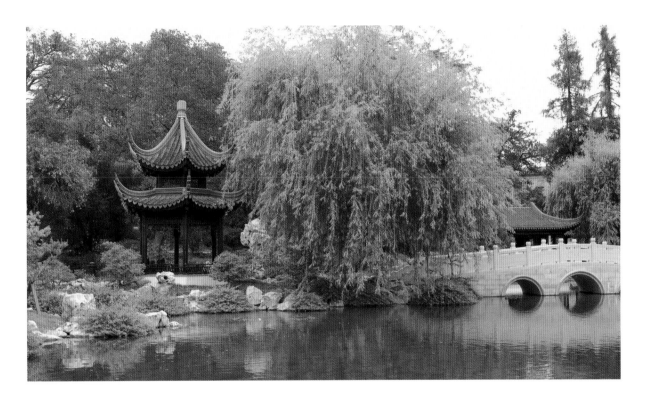

A Peking willow (*Salix babylonica*), flanked by the Pavilion of Three Friends and the Jade Ribbon Bridge, dips elegiac branches into the Lake of Reflected Fragrance.

naturally in the San Gabriel Mountains just a few miles away. Pots of sago palm (*Cycas revoluta*) are placed on various terraces, a decorative feature that is customary in many gardens in China. In late winter, the golden-yellow blossoms of forsythia (*Forsythia viridissima*) bloom along the Flower Washing Brook. Unknown in the West until the early nineteenth century, this shrub, now ubiquitous in U.S. suburbia, here is left to grow long and open, its flowering stems trailing in the water. The Yulan magnolia (*Magnolia denudata*) blooms in January here, drawing attention to its snow-white flowers that are a symbol of purity. The deciduous conifer, dawn redwood (*Metasequoia glyptostroboides*), native to China and once thought lost in its native habitat but now rescued and prolific in many parts of the world, grows close to its relative, the Californian coast redwood (*Sequoia sempervirens*).

There is even more to come for the Garden of Flowing Fragrance. Plans are under way to build a studio, the Flower Brush Studio, the Garden of Falling Petals, and a new courtyard, the Court of Assembled Worthies. A large public garden such as the Huntington attracts a multicultural audience, making this beautiful site a bastion of Chinese tradition, symbolism, and legend, for those of Chinese ancestry and anyone else who is struck by the beauty of nature.

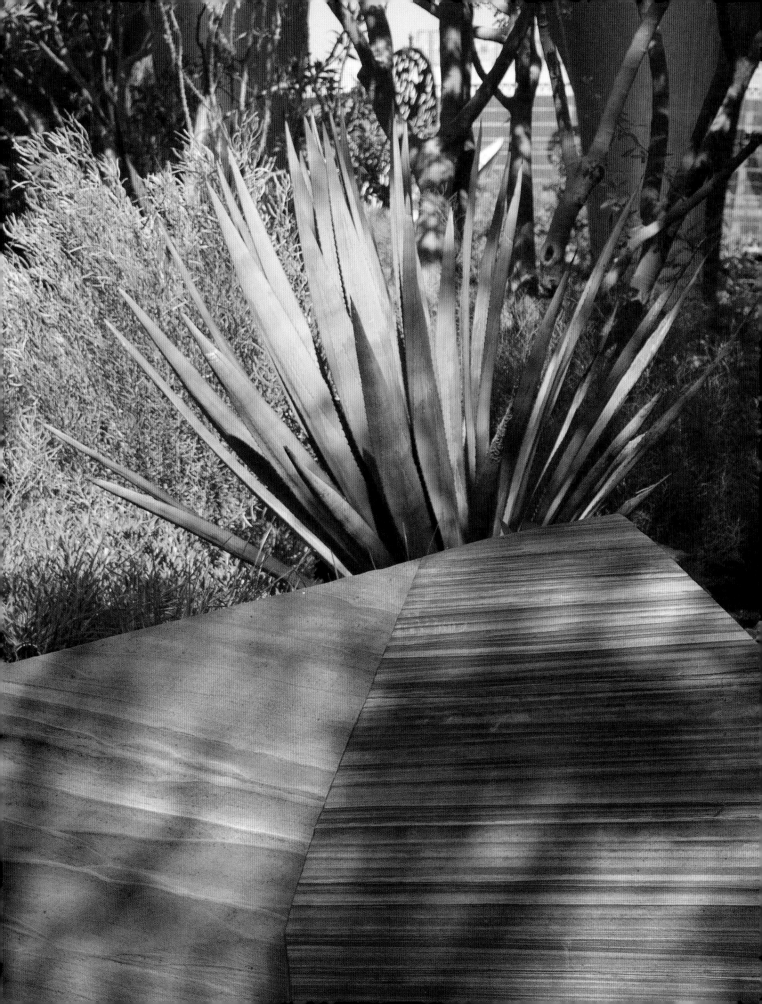

The Park

LAS VEGAS, NEVADA

!melk Landscape Architecture · 6 acres (2.4 hectares) · 2016

TODAY'S LAS VEGAS SITS where there once was a shallow sea. That was about 400 million years ago. The land rose, the sea drained, and a desert was formed. Roughly 180 million years ago, 3,000-foot (914-meter) cliffs of bright orange-red Aztec sandstone rose to the west and northeast, creating what we now know as Red Rock Canyon Conservation Area and Valley of Fire State Park. Most people, some forty-two million visitors a year, come to Las Vegas to see spectacles of different and less natural kinds.

Las Vegas is a microcosm of the global metropolis. The Park, by !melk, was destined to become one of the most visited green spaces in the world—and its design needed to anticipate the ensuing logistics in a thoughtful way. It is a snaking boulevard that runs from the Strip to a large indoor concert and sports arena. It is surrounded by tall buildings, the brightest lights in every color, and lots of noise. In the early morning—a time most visitors sleep through—you can hear birds chirping and the breeze rustling through trees. This is a pleasant place, and that's no weak descriptor in a city famous for its over-the-top artificial attractions, flashing neon, and electronic billboards—especially one, unintentionally ironic, warning people to be aware of the signs of attention deficit hyperactivity disorder.

The Park, a moment of sanity in a surreal circus, is an urban woodland of acacia and rock oak (*Quercus buckleyi*), Texas live oak (*Quercus fusiformis*), and cathedral live oak (*Quercus virginiana* 'Cathedral'), providing a necessary shade canopy from the fierce sun and heat of the Nevada desert. The fast-growing evergreen ash (*Fraxinus uhdei*), native to Central America, will become a large tree, changing the feel and look of The Park in a short time.

Pink meta-quartzite stone, quarried in Jean, Nevada, makes for beautiful striated retaining walls and places to sit. It evokes nearby Red Rock Canyon, and the desert plantings behind it, including a gray-blue *Agave weberi*, offer a naturally appealing color palette.

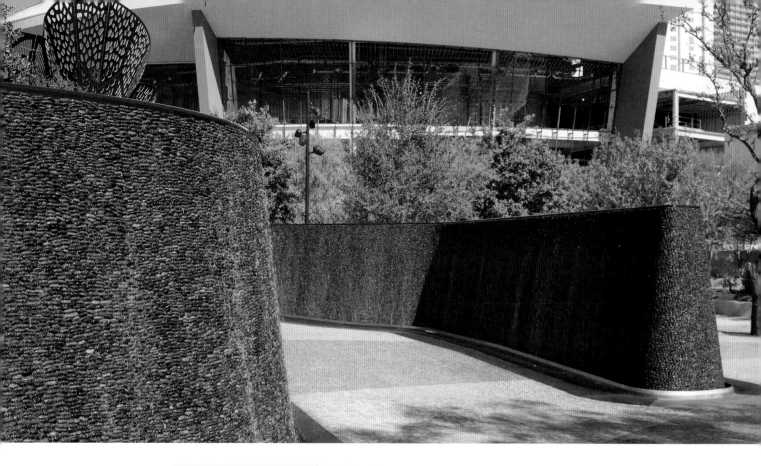

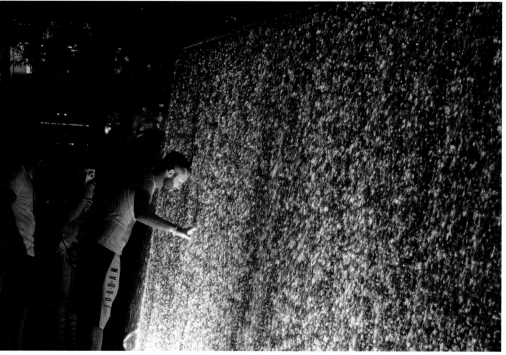

A wall of water that tumbles over millions of tiny pebbles is designed to evoke desert springs. It makes nighttime, especially, so often a time when parks are avoided, just the right time to visit The Park; the wall is uplit, creating a jackpot of sparkling diamonds.

Soft, pale pink, foxglove-like blooms come in with ×*Chitalpa tashkentensis*, a hybrid of the cigar tree (*Catalpa bignonoides*) and the desert willow (*Chilopsis linearis*).

In addition to the trees, three sculptural elements add drama, dynamism, and artistic sensibility to the site. Marco Cochrane's sculpture *Bliss Dance*, a 40-foot-tall (12-meter-tall) dancing woman, made from steel tubing and stainless steel mesh and lit by nearly 3,000 LED lights at night, is the centerpiece. A modern interpretation of the classical nude, it is a refreshing take on titillation in this silicone-enhanced city. Her bliss is her own; she's beholden to no one.

Clusters of filigree-cut steel flowers sprout from the pavement nearby like giant metal cactus flowers. These provide both shade and visual excitement; each bloom features its own pattern, and they fan outward to the sky, casting changing, intricate shadows on the paving below. At night, they vibrate with shifting colors appropriate to the setting, flooding the trees around them with soft mood.

Any water feature in Las Vegas is bound to attract attention from the parched, dehydrated masses. Here, two 100-foot-long (30-meter-long), 8-foot-high (2.4-meter-high) side-winding walls pour sheets of water down over a surface of small, horizontally embedded pebbles. Since nighttime lighting is de rigueur here, white lights projected up from the base create an effective illusion where the pebbles become tiny diamonds.

Two other hardscape elements complete the site. Numerous sitting areas made from concrete and wood, as well as red-painted metal chairs give The Park the air of a plaza, a place to sit and pause, a place of repose to take a break from the frenzy of the Strip.

Walls of pink meta-quartzite stone—full of silica and stronger than granite—retain the planting beds where, along with trees, there are several dry-loving agaves, including the Weber agave (*Agave weberi*) with gray-green leaves up to 5 feet (1.5 meters) tall and the octopus agave (*Agave vilmoriniana*) with twisting, arching leaves up to 4 feet (1.2 meters) long. The beds are full of plants, most of them drought-resistant.

The careful and conscious planting is aesthetically pleasing, and for anyone sober enough to pay attention, identifying plaques name the many intriguing plants that can be grown in arid zones. Is The Park an oasis in the desert, as it is often described? It is a waterwise garden that features 250 trees and 7,000 individual native and adapted desert plants. It's a well-designed garden that is also a place to rest weary feet. And, it is a cultural spot, with its sculptures and plazas, its space and its plants. So yes, it is an oasis, and there is much to be enjoyed.

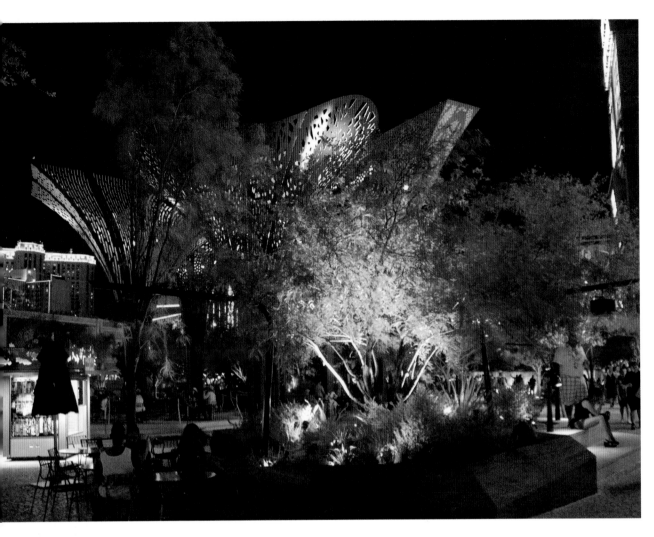

Sixteen artistic metal shade structures, some 75 feet (23 meters) high, provide shade by day while their individual filigree flowers cast patterns on the ground below. At night, colors orchestrated by world-famous lighting designer Leni Schwendinger help them keep up with the surrounding neon blitz.

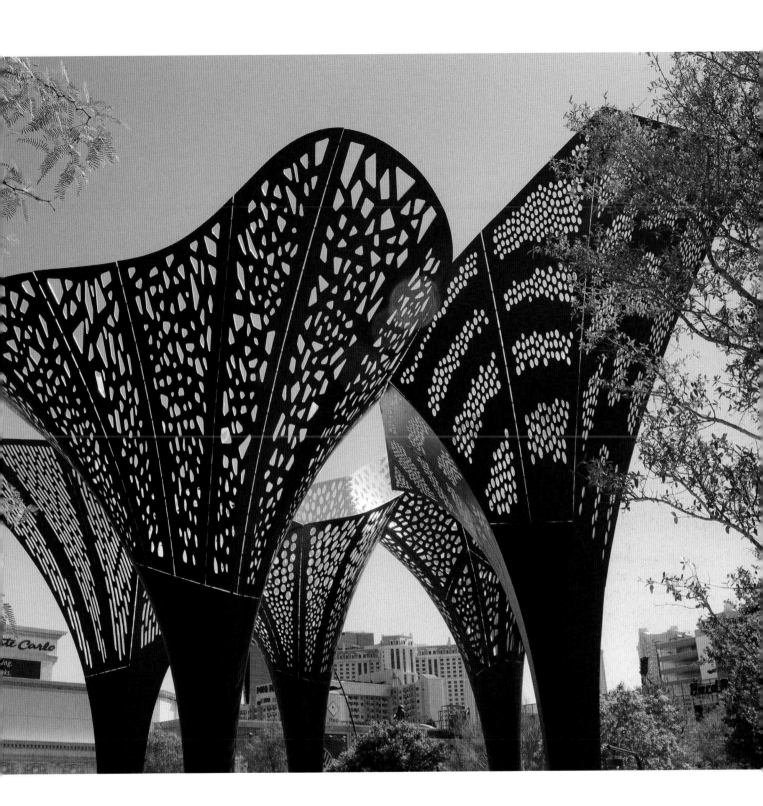

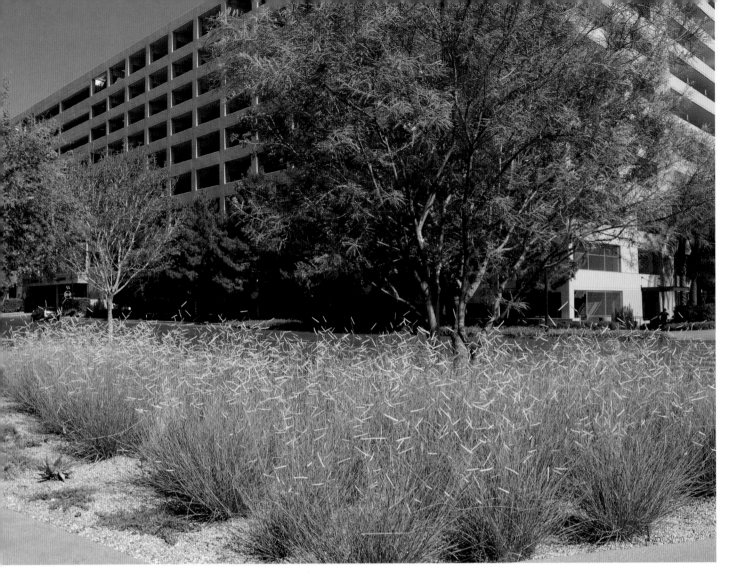

Large plantings of mosquito grass (*Bouteloua gracilis*), whose flowers look like clouds of insects, have nothing to do with mosquitos. Here the regular rhythm of its seed heads creates a texture that works well against the backdrop of parking garage decks.

→ The Park's display of dry-adapted plants provides an apparent oasis in the middle of the city—an oasis from the surrounding visual overstimulation, that is.

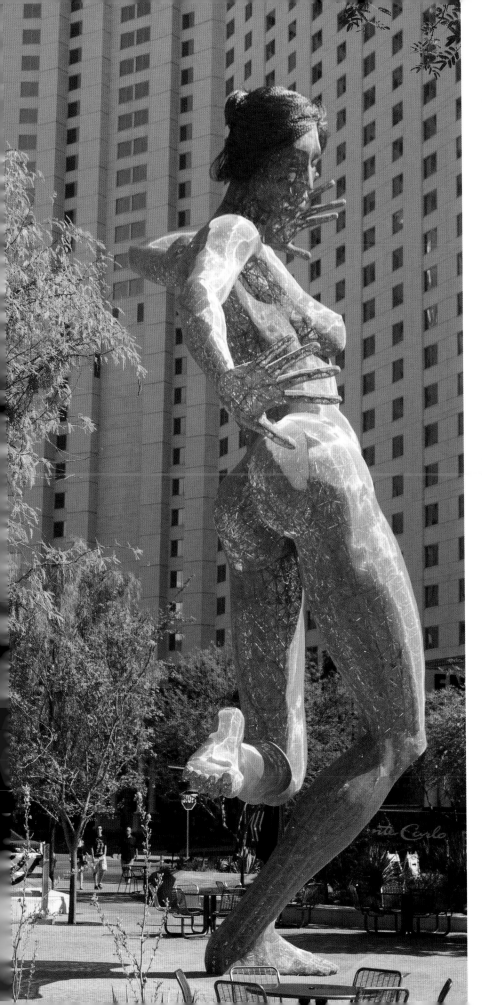

Marco Cochrane's *Bliss Dance* adds a remarkably sensitive artistic element to a city better known for its often-crude visual cacophony. When lit at night, she dominates one end of the garden.

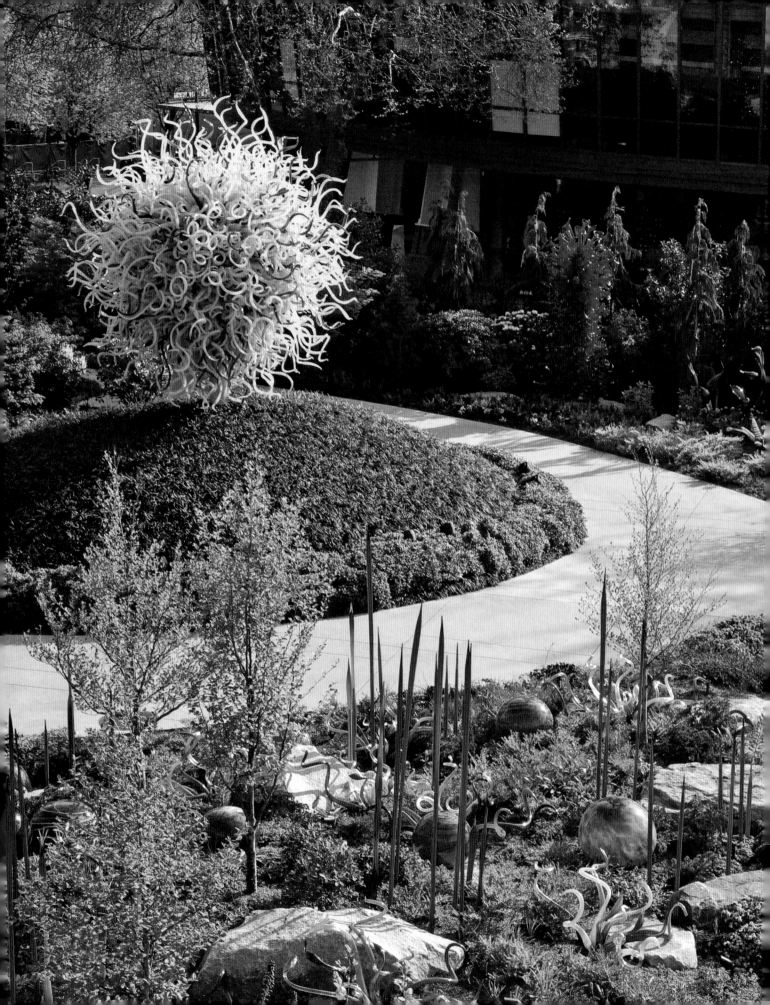

Chihuly Garden and Glass

SEATTLE, WASHINGTON

Dale Chihuly, Richard Hartlage of Land Morphology
1.5 acres (0.6 hectare) · 2012

ART HAS BEEN USED to embellish gardens for centuries, and many gardens have likewise been designed specifically to hold collections of sculpture. Chihuly Garden and Glass, however, situated at the base of the Space Needle in the Seattle Center, manages to achieve a symbiosis of multicolored blown glass sculptures and an astute use of plants that sets a new standard for the term "sculpture garden."

Dale Chihuly is the best-known contemporary artist working with glass sculpture, and is world-renowned for his dramatic and colorful pieces. Anyone who has attended a special exhibition of his work in a museum, botanical garden, or park knows exactly how popular his craft is with the public. His Museum of Glass in Tacoma, Washington, gets thousands of visitors a year, hosts a visiting artist residency program, and has a "hot shop" where visitors can see live glass-blowing demonstrations.

Richard Hartlage, designer of the garden, disavows the notion that he himself is an artist. He would prefer to be regarded as a craftsman. If that is true, the combination of glass artist and garden designer has produced a unique space where the garden can hardly be considered just a supportive backdrop for Chihuly's works.

It has been argued that a garden is not a work of art, but that the act of conceptualizing a garden is. In which case this is a masterpiece. Looking beyond the spectacular, glinting sculptures, an observant mind will quickly grasp that the subtle interplay between sculpture and plant makes more of both than either medium could achieve on its own. The multilayered and complex horticulture, ever-changing throughout the seasons, alternates pleasantly with the sculptures to compete for the viewer's attention.

Chihuly's *Pacific Sun* gleams on a mound planted with the short tufts of almost black mondo grass, *Ophiopogon planiscapus* 'Nigrescens'.

This is the first time a permanent exhibition of Chihuly's work has been placed in a garden setting. Visitors begin their experience by moving through eight interior galleries that document the artist's significant series, and then into the 40-foot-tall (12-meter-tall) Glasshouse, with a 100-foot-long (30-meter-long) suspended sculpture of red, yellow, and orange glass pieces. Chihuly has a fondness for the glass greenhouses and conservatories of the eighteenth and nineteenth centuries, and there is more than a little sense of Victorian madness in this space—but if it is mad, it is intoxicatingly so.

The galleries lead outdoors to the bright garden, and while it is small on a 1.5-acre (0.6-hectare) site, its opulence and intense color make it feel much larger. The flowing paths are wide, creating the requisite space for large crowds but also supplying breathing room. Four tall sculptures and many smaller ones immediately draw the eye for how they catch light in a completely different way than any of the backlit or spotlighted pieces in the interior spaces ever could. The sculptures come from Chihuly's close observations of nature in the Pacific Northwest, his lifelong home. The forms he re-creates are stylized and romantic, and, as such, are perfect for gardens, which achieve so much by addition of a little fantasy.

Huge flowers with a preternatural number of petals are an oversize celebration of blooms. Reeds in alluringly bright colors stand in a phalanx, the bulbs of bull kelp pull it up into the air, and the vespine stings of hornets, turned into glass ferns, become a golden green cluster of spiraled glass. Native American baskets and blankets, as well as fishing and nautical objects like glass floats originally used by Japanese fishermen are some of Chihuly's many inspirations, and glass artworks informed by these objects are placed among the plants.

An impressive example of the ingenuity of the all-season design is a section containing a large cluster of intensely blue glass rods, colored with neodymium, a soft metal that turns glass blue and violet, which look like otherworldly reeds. In early spring, *Tulipa sylvestris*, a woodland tulip with soft yellow flowers, and the delicate white flowers of *Anemone nemerosa* 'Vestal' form a complementary carpet surrounding the reeds. Later, as deciduous lady fern (*Athyrium filix-femina*) and alpine water fern (*Blechnum penna-marina* 'Nana') unfurl and provide a flat green base, the brilliant scarlet-orange flowers of 'Holland's Glory' tulips contribute maximum contrast and vibrancy to the scene.

Deeper into spring, the plants-and-glass combination evolves again, in an even more enthralling way. A mass of *Camassia leichtlinii* subsp. *suksdorfii* Caerulea Group, a native bulb with star-shaped, deep purple-blue flowers, grows strong and upright and reaches to half the height of the glass reeds. The camassia and the reeds seem to hum as if electrified, matching each other pigment for pigment—an unusual feat. In the summer, when the camassia foliage has passed its peak, the blue-green foliage of Japanese mahonia (*Mahonia japonica*) and its berries, and the soft blue and lacy flowers of *Hydrangea macrophylla* subsp. *serrata* 'Bluebird', support and temper the scene. Then, the blue reeds seem to be stepping up and out of a woodland to grab the attention of passersby. The seasonal drama ranges from the pretty to the stunning and then to the understated. It is a provocative piece of artful gardening, and one repeated in each and every bed.

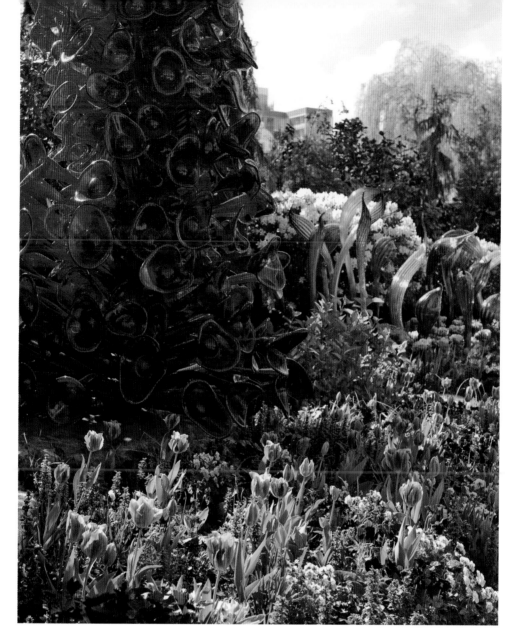

Fiery red glass trumpets on Chihuly's *Viola Crystal Tower* are complemented by the blue flowers of *Ajuga reptans* 'Catlin's Giant'. The red and the blue combine to create a violet tone to the eye.

The centerpiece of the garden, the undisputed crowning glory, is a large sculpture of red and yellow flames named *Pacific Sun*. Set on a mound planted with black mondo grass (*Ophiopogon planiscapus* 'Nigrescens'), it is a brilliant eruption of color. As Chihuly says, "If you take a thousand hand-blown pieces of a color, put them together, and then shoot light through them, it's going to be something to look at."

The garden is subject to the Northwest temperate climate, and so expects visitors year-round. Those not able to visit in the full rush of summer can still expect visual treats. For example, serpents of red glass surrounded by vibrant-stemmed *Cornus sanguinea* 'Midwinter Fire' and the coral bark maple (*Acer palmatum* 'Sango-kaku') create a winter border

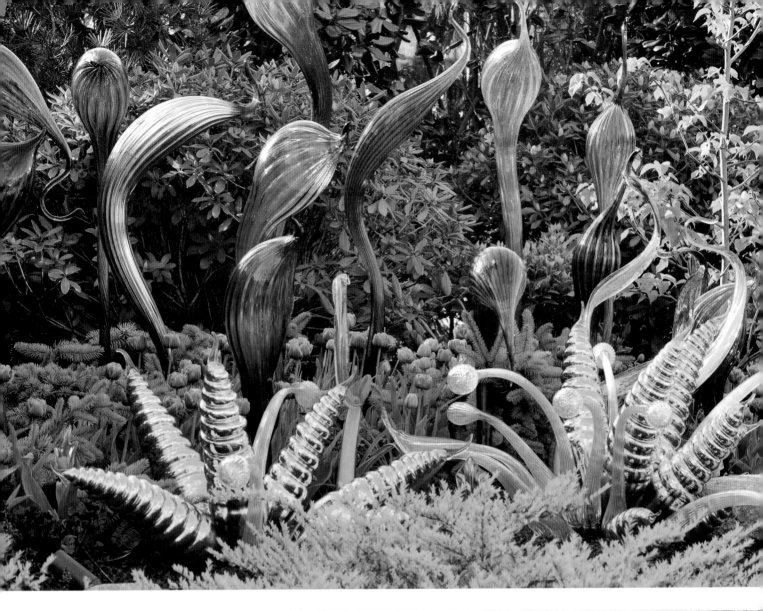

What is plant, and what is glass? The colors of the art pieces dance with the soft orange of the tulips and the blue foliage of the dwarf conifer.

→ The blown blue glass reeds colored with neodymium do a perfect dance with the North American bulb *Camassia leichtlinii* subsp. *suksdorfii* Caerulea Group.

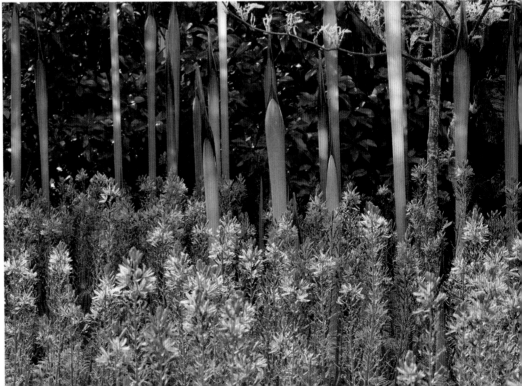

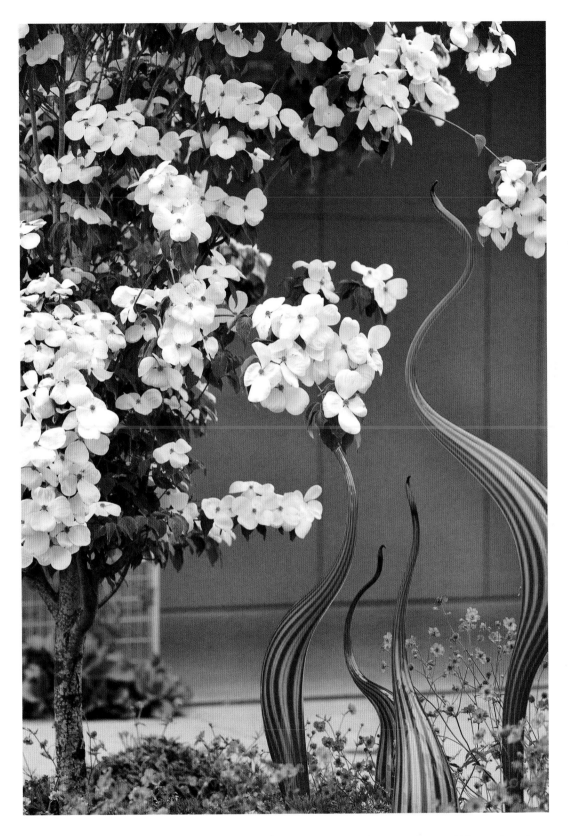

Celestial dogwood (*Cornus ×rutgersensis* 'Celestial'), a hybrid between Japanese dogwood (*Cornus kousa*) and flowering dogwood (*Cornus florida*) known for its large white flowers, grows above *Geum* 'Totally Tangerine', a stunning combination to set off waving orange glass forms.

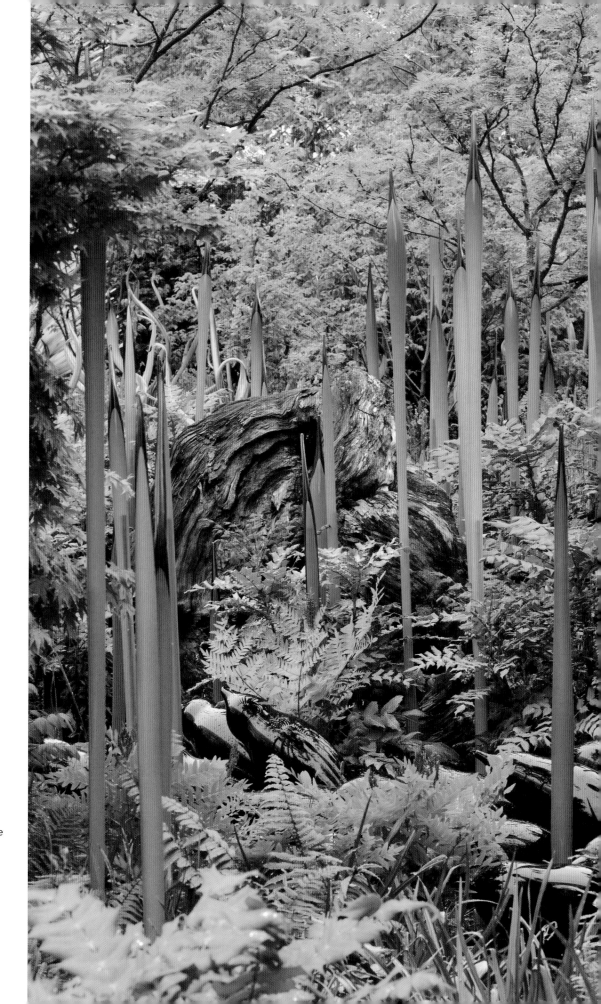

The many textures
of ferns, shrubs, and
forest wood set off the
intensity of smooth
blue glass rods and
black pods.

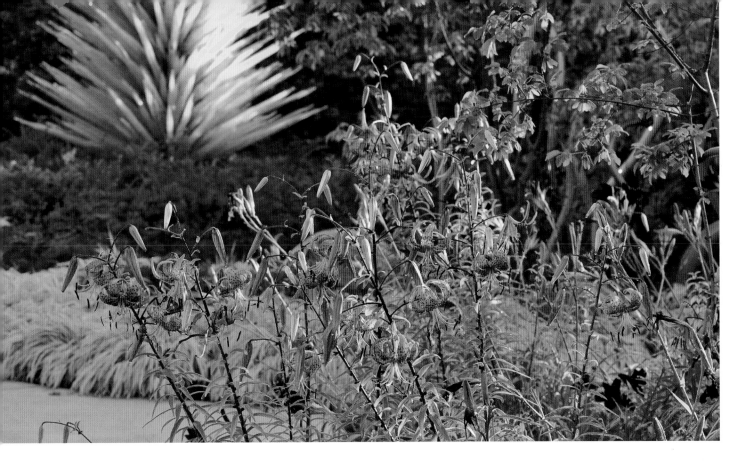

The color of *Lilium lancifolium* 'Splendens', a fancifully shaped tiger lily, is a perfect complement to the bright yellow-green of Chihuly's *Citron Icicle Tower* in the background. The lily is a showy, prolific, and easily grown bulb that flowers at a height of 3 to 4 feet (0.9 to 1.2 meters).

that provides a fascinating foil for the sanguineous, dancing glass. While the sculptures may be static, the plants and their changes throughout the seasons provide movement. In summer, the border becomes soft and modest as a band of Japanese forest grass (*Hakonechloa macra*) adds a light green wave to contrast with the rubicund glass.

The garden will continue to evolve and change as the trees and shrubs grow over the years. The lovely dove tree (*Davidia involucrata* 'Sonoma') and the magnificent white-flowering dogwood (*Cornus* ×*rutgersensis* 'Celestial') will grow to at least 18 feet (5.5 meters), as will the multistemmed Japanese stewartia (*Stewartia pseudocamellia*), with its white, blousy flowers. Dense hedges of *Magnolia grandiflora* 'Southern Charm' and western red cedar (*Thuja plicata* 'Atrovirens') will form increasingly dense perimeter walls that provide a neutral backdrop for the luminosity of the glass compositions. The whole area will eventually be more shaded, in turn changing the dynamic colors of the garden into something else—something as yet unknown. Working with living things is always an exploration. Underplantings will be modified as needed and desired by Hartlage. Perhaps even a sculpture or two will be moved or replaced to maintain Chihuly's desire: "I want people to be overwhelmed with light and color in a way they have never experienced."

Twisting glass shafts and gazing globes of blue glass are well matched by violets and the soft white flowers of *Geranium ×cantabrigiense* 'St. Ola'.

Mordecai Children's Garden, Denver Botanic Gardens

DENVER, COLORADO

Denver Botanic Gardens, Terra Design Studios, Mundus Bishop

3 acres (1.2 hectares) · 2011

THE MAGICAL CONNECTION between a child and a flower, a butterfly, or a soft summer breeze has become increasingly rare in the twenty-first century. Today's children spend an average of seven and a half hours a day in front of electronic screens of one sort or another. This equates to 114 days year. Not surprisingly, they are spending less time outdoors than any generation in history.

Richard Louv, author of *The Nature Principle* (2011), calls children's disconnection with the outdoors a "nature deficit disorder." This worrisome trend is regarded as a contributing factor to the worldwide epidemic of childhood obesity and the increasing use of pharmaceuticals to combat juvenile attention deficit disorder. The U.S. Centers for Disease Control, alarmed by these statistics, recommends that a child spend at least two days a week outdoors, if possible.

Many of our most formative memories are of playing outside. In the past, children were both allowed and expected to play outdoors and encouraged to create their own adventures. In modern times and for many reasons, some logical and some not, a child's environment is often controlled for them.

It was with these disturbing trends in mind that the Denver Botanic Gardens set out to create a space that would appeal to twenty-first century children. The Mordecai Children's Garden's goals include creating a safe place for children to play, providing an environment to educate children about the wonders of biodiversity in Colorado, and encouraging a balance between plants and electronic media in a child's life.

The rock garden teaches children about the beauty of their state's geology as well as about Colorado alpine plants.

A fallen tree trunk becomes sculpture, and is surrounded by Rocky Mountain plants, including blue and red penstemons.

Colorado is well known for its spectacular mountains, wildlife, and native plants. Rocky Mountain National Park welcomes 3.5 million visitors a year, on average, and Denver residents tend to be more outdoorsy than the average citizen. But children in Denver are the same as everywhere. Despite being surrounded by natural beauty, many are subject to over-programmed, restrictive schedules based on indoor activities.

At first glance, it's not obvious where in the garden children are supposed to romp freely. The horticulture is highly sophisticated, and the architectural elements do not immediately present the features commonly associated with children's spaces. For many years, public gardens designed for the young were little more than playgrounds with plants—often including giant inflated vegetables, swing sets, and fiberglass butterflies. This is changing for the better as information from research on child development and place-based education begins to alter the way children are taught. Intuitive learning that allows each child to discover at his or her own pace has become a widespread technique and shows desirable outcomes.

Cindy Tyler, principal at Terra Design Studios in Pittsburgh, Pennsylvania, was hired to create the master plan for the garden. She says, "You have to reach the parents. Stimulating the curious parent with a dense and diverse plant palette can only lead to a child being curious

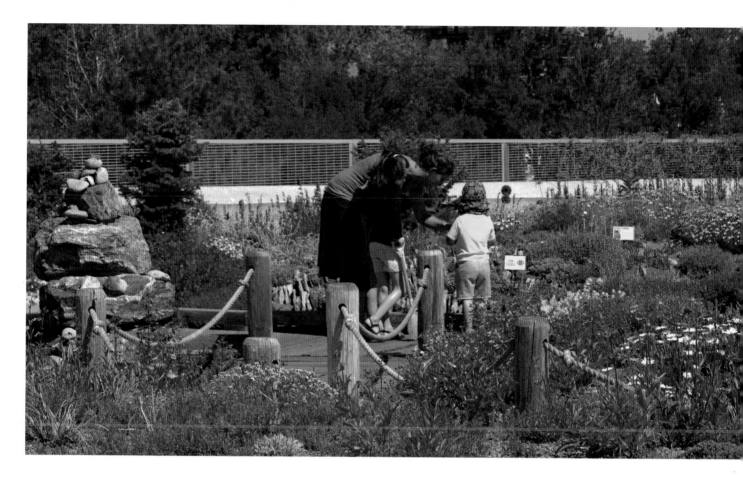

Teach the parents, and they will teach the children.

about the plants that delight its parents." Perhaps "children's garden" is a misnomer then, for this is a garden for children accompanied by adults—parents, grandparents, caregivers. By participating with the children, the adults have interactive opportunities to share information, enthusiasm, and wonder as the children play and learn. "Family garden" might even be a better name. Regardless, it's popular—thousands of parents and children have flocked to the garden since it opened, with attendance growing each year.

Tina Bishop of Mundus Bishop, a landscape architecture company in Denver, designed the garden based on the master plan of a series of individually themed spaces. Bishop explained, "We created a journey, an experience. We created plant communities to reflect the biodiversity of Colorado's natural landscape. What you see in the garden is a condensed version of what you see in nature. And that's the point. Children will remember the garden and have some idea of stone, plant, and animal communities. They will take the memories and, when they are out in the wild, they'll recollect and be able to more easily understand the natural world around them."

Julie Casault, the garden's horticulturist, articulates the mission in a personal way: "We know that children explore visually at first. Kids see something, and they walk straight up

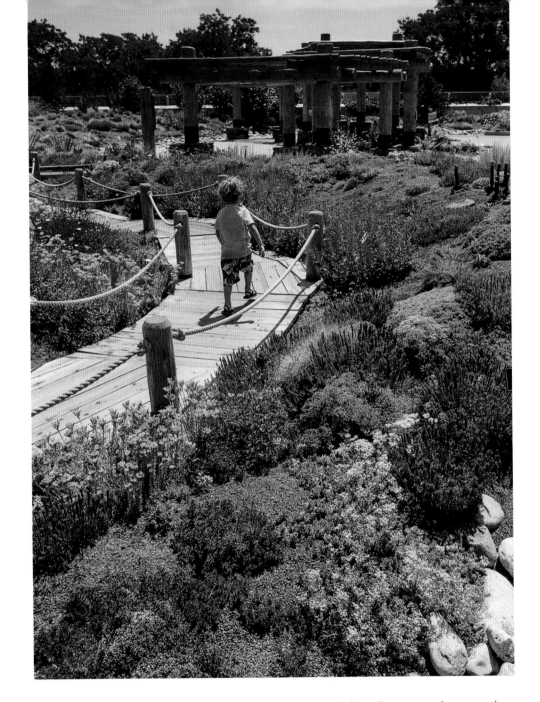

The sophisticated and intelligent garden does not talk down to children, but entices them to explore by presenting alluring plants, textures, and directionals.

to it and grab it. They do this without fear. They are at an age when they have no fear. And because they have no fear, they have no limits to their curiosity. With their parent's guidance, children create their own space, and watching the children do this is what is really lovely about the garden. There is nothing more satisfying than watching a child chase a cricket, float pine cones in the stream, or dig in the dirt. I don't even mind if they step on a plant or break off a flower. I'd rather they didn't, but I'm growing a lot, too."

Two things stand out in the garden—one you don't see, and another you do. What isn't immediately apparent is that the garden is really an elaborate green roof that tops a large parking garage. Substantial feats of engineering and clever design disguise this from the visitor. What you do see are large native trees, healthy and growing well. The shallow soils of their native habitat are replicated with a geofoam underlay and composite soil. Rocky Mountain bristlecone pine (*Pinus aristata*), Douglas fir (*Pseudotsuga menziesii*), Colorado blue spruce (*Picea pungens*), and Colorado white fir (*Abies concolor*) represent the evergreens, interspersed with deciduous quaking aspen (*Populus tremuloides*), notable for its soft green-white bark and heart-shaped, tinkling leaves. Along with stumps and trunks of trees from Mount Goliath, one of Denver Botanic Garden's outlying properties, these elements form the central architectural and botanical backbone.

Alpine plants, which represent flora found on the highest peaks in Colorado, grow in great, sparkling profusion on hummocks throughout the most botanical of the garden rooms. Serious gardeners will consider this one the "prettiest." Edged with granite cobbles, the curvaceous beds are filled with the white flowers of moss phlox (*Phlox hoodii* subsp. *muscoides*), clumps of scarlet bugler (*Penstemon barbatus*), dots of golden columbine (*Aquilegia chrysantha*), drifts of orange sunset agastache (*Agastache rupestris*), and the state flower, the Colorado blue columbine (*Aquilegia caerulea*).

Past the alpines and Marmot Mountain, the highest point of the garden and one from which you can see downtown Denver and the Rockies, there are places to play actively. Young sculptors can try their hand at assembling and disassembling tall cairns of rocks. Under a swinging rope bridge, a stream bubbles, kids splash, and there's a place to dig in the soil, shaded by trembling aspens. An abandoned mine building, reminiscent of those around the mountain town of Leadville, brings in a little of the area's human history. Beyond the mine, a grassland captures the feel of the state's Eastern Plains. This sunny area, with crisscrossing paths, attracts butterflies and bees, darting hummingbirds, and zipping kids.

Down the slope is Pipsqueak Pond, a catch basin for winter's melting snows and summer's thunderstorms. It's a home for dragonflies, mayflies, frogs, and cattails (*Typha latifolia*). Surrounded by peach-leaved willows (*Salix amygdaloides*), mountain alders (*Alnus incana* subsp. *tenuifolia*), and water birches (*Betula occidentalis*), it is a quiet place for parents to rest, children to giggle, and rufous hummingbirds to nest. As if there weren't already enough to explore, there is a Discovery Center and vegetable garden, where children learn hands-on gardening techniques and natural history comes alive.

The Mordecai Children's Garden is an intentional classroom. It uses creative temptations to invite curious play and interactive experiences with aspects of nature. The creators of the garden believe in the potential of the visitors, young and old, to be perceptive. Raising children has never been easy, but it is particularly difficult in this age of anxiety. If the Mordecai Children's Garden is successful, it will help both children and adults to comfortably explore the natural world outside the garden. The hope is that children will move beyond the garden and create adventures in nature of their own.

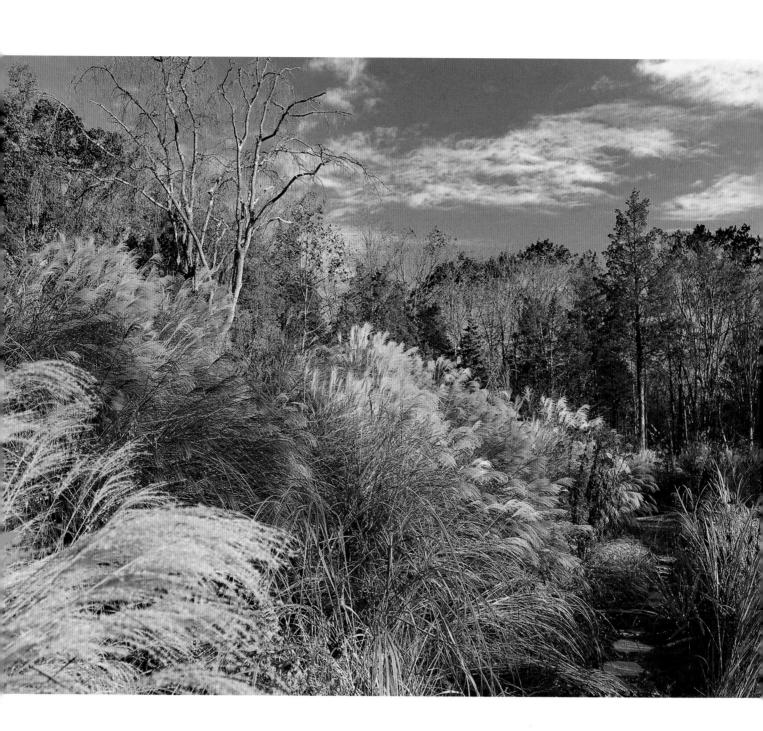

Federal Twist

STOCKTON, NEW JERSEY

James Golden · 10 acres (4 hectares) · 2004

GARDENS ARE PERSONAL things both to make and to experience.

James Golden grew up in rural Mississippi. Timid and shy, he was happiest in places of seclusion and protection. He spent much of his time hiding in an old cemetery near his home amid its tall grass, tilted gravestones, and trees dripping with Spanish moss—all tangled up in the languorous, heavy heat of the South. It was quiet, melancholy, and safe.

In 2004, Golden and his husband, Phillip, bought a house north of the Delaware River in New Jersey and named it after the main road, Federal Twist. When first purchased, the land was a solid mass of juniper, the only plant that was happy in the foul, anaerobic clay soil. It wasn't a good place to garden. The junipers were removed, as were eighty other scrubby trees, opening the area to the sun and to the horticultural experiment that was to follow. Being a man of contemplation, he set about creating his garden with a sense of longing. He sought the solitude he had enjoyed as a child, and he felt, rather than knew, how to articulate the kind of garden he wanted. He was attracted to the wild, the untamed, and to land and plants that spoke to his Romantic nature: "I see my garden as very much a unified thing, groups of communities and processes of growth and life and death. I sometimes think it's an organism, an organism that's a part of me . . . perhaps I really mean a bodily connection. A oneness."

Although a self-taught gardener, he was influenced greatly by the work of Wolfgang Oehme, who, along with James van Sweden, created a loose, naturalistic style reliant on native perennial and prairie species. Midwestern landscape architect Jens Jensen, a Danish

The wildness of grasses *Miscanthus* spp. and *Spartina pectinata* 'Aureomarginata' glory against a crisp autumn sky.

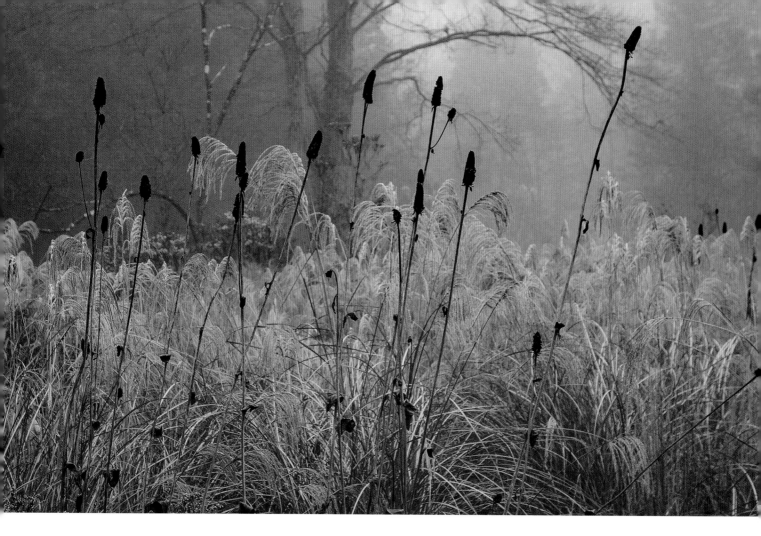

Late-season rudbeckia seed heads against a background of *Miscanthus* suit the melancholy fog.

→ From an elevated terrace you can see across the garden to woods beyond. Most of the foreground is *Miscanthus* of different kinds, heavy with mood.

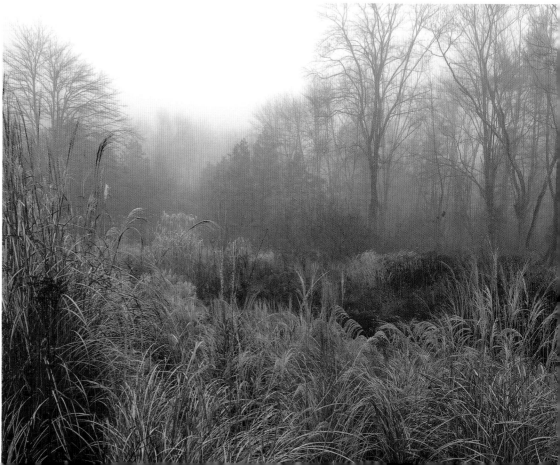

immigrant and a revolutionary in his time (1860–1951), paved the way for them in some respects. This "New Perennial" movement, as expressed today—which favors "accidental-looking" plants that self-sow and are, or seem to be, left to their own devices—owes a debt of gratitude to Continental Europeans for reintroducing American gardeners to their own backyards. History, like falling leaves, brings fertility to a garden. While wholly distinct from the formal and mannered style of the English estate and cottage garden traditions that had for so long dominated American garden aesthetics, it is still artifice, a conscious husbandry. It is a relaxed interpretation of nature, seeking not to overpower but to cohabit. In this sense, it is entirely modern—a new movement in garden design that incorporates ecological sensitivity and an almost abstract quality to its informal formality.

Golden has become a disciple, an apprentice, of this style—the naturalistic mix of native and non-native plants—and he has successfully interpreted it with selections that bring visual poetry and grand emotion to his personal sanctuary. "I see all gardens as very much about life, about death, about memory, and about meaning. I am interested in the emotional and the romantic. I don't like the term habitat garden, but in a sense, that's what I set out to do, create my own habitat," he explains. Golden has achieved an intimate prairie, if such a thing can exist, on a site where there had never been a prairie. In creative conflict with his introverted self, he was drawn to the sinuous and sweeping, the big and the bold.

The creation of a "wild garden" generally requires great confidence. Perhaps Golden succeeded because he, ironically, had the advantage of not knowing what to do first. While invited visitors accustomed to touring rigidly axial schemes may feel a subconscious discomfort with the garden's apparently loose design, it quickly becomes evident that Golden expresses a self-assurance with the relaxed environment.

More than magic was needed to garden on this challenging site; alchemy, or turning a leaden site golden, was what he accomplished. He began with a tall, tough grass, giant miscanthus (*Miscanthus* ×*giganteus*), a sterile hybrid of *M. sinensis* and *M. sacchariflorus*. With each plant reaching 12 feet high (3.6 meters) and almost 10 feet (3 meters) across, it was simply the biggest grass he could find. While woodland wraps the garden tight, this robust perennial provides the equivalent of hedging, creating the necessary visual divisions to make the garden feel at once secluded and larger, by virtue of creating distinct views. Other grasses, *many* other grasses, grow at Federal Twist as well. *Miscanthus sinensis* 'Silber-feder' is a favorite with, as the name describes, silver feather flowers in late summer and fall. *Chasmanthium latifolium*, northern sea oats, has many benefits: it is one of the few grasses that grows in shade, its green leaves turn copper in late summer, and the seed heads turn bronze then straw colored by early winter, when they are cracked by finches.

Horsetail and elecampane are tough plants. *Equisetum arvense* is not something for the timorous gardener, but Golden takes it at a gallop. Its feathery, whorled foliage and appealing geometric structure distract us from remembering its aggressive nature—its roots can go down as much as 6 feet (1.8 meters). It is a perfect foil for plants with more generous proportions such as butterbur (*Petasites japonicus*) with big rhubarb-like leaves, and ostrich

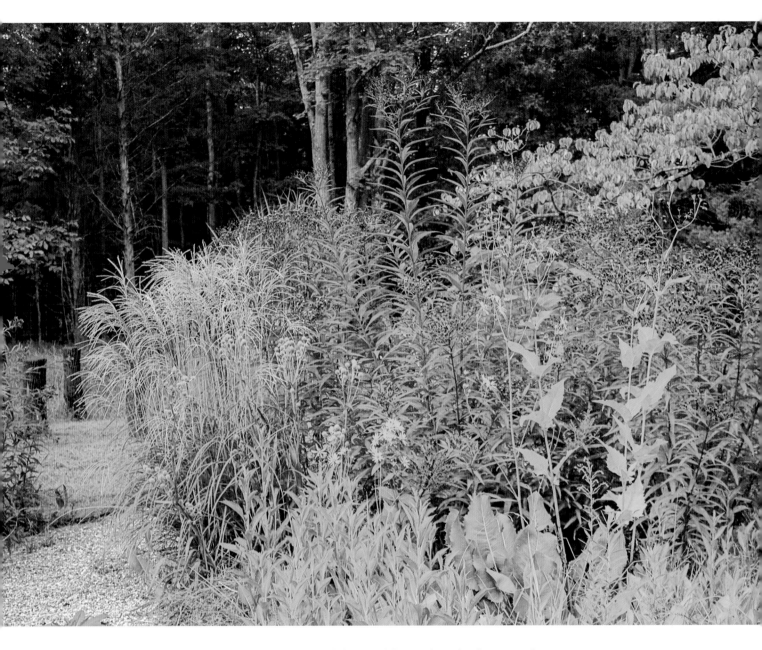

Miscanthus, various self-seeded vernonias, *Silphium perfoliatum*, *S. terebinthinaceum*, *Aster tartari-cus* 'Jindai', and *Eryngium yuccifolium* are on display in full summer glory.

fern (*Matteuccia struthiopteris*) with its three-foot-tall fans. Golden jokes that gardening with weeds should perhaps be considered a truly contemporary art form.

Plants with fleshy roots cope well in heavy soils, and a particular variety of elecampane, *Inula racemosa* 'Sonnenspeer', seemingly ignores the clay—it soars in spires 7 feet high and provides generous clusters of yellow flowers. The long, hairy leaves can exceed 3 feet (2.1 meters) in length and 12 inches (30.5 centimeters) in width. Leaves and flowers persist until the first frost, when they curl and dry in a structurally intriguing sort of gray morbidity.

Leaves, berries, and faded flowers are the gift of the garden in autumn, and the drooping branches of American beautyberry (*Callicarpa americana*) are heavy with purple fruits, while the horizontal branches of possumhaw (*Ilex decidua*) hold their red berries into winter, providing food for songbird, opossum, and raccoon. Golden does not forget hydrangeas—the woodland ones, not the Victorian mopheads. *Hydrangea paniculata*, *H. arborescens*, and *H. quercifolia*, all puffy with flowers fading to burgundy, metallic purple, and then to tan in the autumn sun. He leaves the lacy flowers until spring, as he does with many other plants, offering a decorative wildness to the winter.

Large-leaved plants call into sharp relief the contrasting forms of several grasses' subtle foliage. Giant coneflower (*Rudbeckia maxima*) is yet another huge plant with big, powder blue leaves and rockets of deep golden flowers. Autumn brings goldfinches to feed on the rich seeds. Golden planted a lot of this because he likes its fat leaves and tower of flowers, and now it shines throughout the garden, as does short-toothed mountain mint (*Pycnanthemum muticum*), a densely leaved plant with dark green leaves, a spearmint fragrance, and silvery flowers—though these are really bracts that appear to be dusted with powdered sugar. There are large areas of it at Federal Twist, providing a sugar treat for birds and butterflies. Whether by accident or design, the naturalistic garden provides a lively ecosystem for birds and beasts.

Federal Twist is a garden of great complexity. In late fall and winter, perhaps like its creator, the garden comes into its best. "The still point of the turning world," as T. S. Eliot puts it. It is a time when the tall grasses and forbs are lit by the low sun, a time to enjoy the way the textures of so many different seed heads display the crystalline pleasures of the first frost, then the first snow, bending and breaking stems into sculpture that stands through the winter sadness—here, a time when a garden can be nurtured by an icy moon.

If melancholy is Golden's preferred mood, this is his time. As he says, "One of the few disadvantages of a prairie-style garden is the mostly vacant stare it gives you until June. Then, in summer, you have the sheer mass, the atmosphere, the magic of a big garden. In summer, my gardening process is a series of interventions to control mess, to refine and sculpt mass from mess. My pleasantest time in the garden certainly is autumn. I'm not sure why autumn evokes such powerful feelings of nostalgia, but it does for me, and I think for most people. The harvest season, when the world turns from green to warm reds, oranges, yellows, feels, for some reason, like coming home. It certainly evokes thoughts of ends, of death, too, but a death followed by the magical transformations of winter. Though I don't grow any food plants, the autumn atmosphere is perfumed with smells of fermentation and a fragrant rot that are reminders of life, the life that comes from ripeness and death."

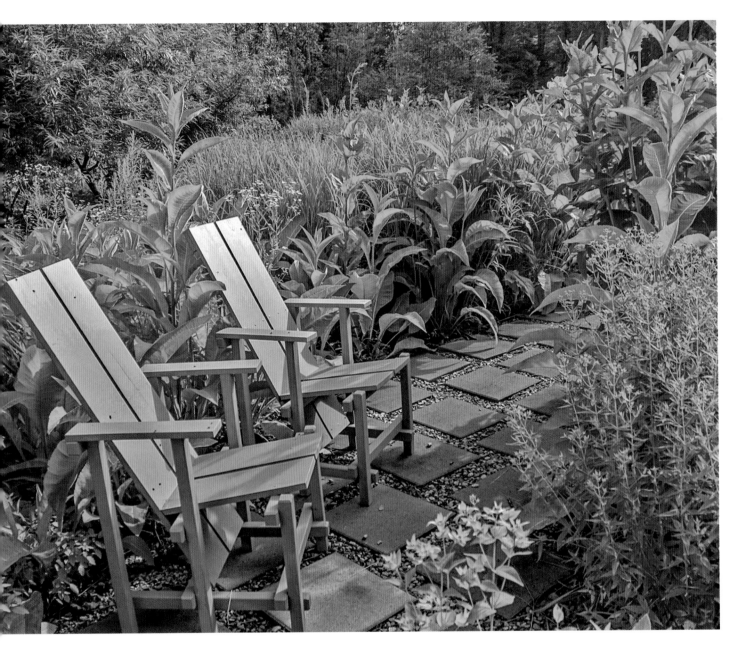

Pale-blue chairs made by Chanticleer gardener Dan Benarcik are placed in a secluded seating area, surrounded by *Inula racemosa* 'Sonnenspeer', *Pycnanthemum muticum*, *Miscanthus* 'Purpurascens', *Silphium perfoliatum*, and *Salix udensis* 'Sekka'.

A prairie simulacrum of *Silphium laciniatum, Liatris spicata, Hemerocallis altissima, H.* 'Pardon Me', *S. terebinthinaceum, Astilbe chinensis* 'Purple Lance', *Rudbeckia maxima,* and *Calamagrostis ×acuti-flora* 'Karl Foerster' surrounds a bronze sculpture by Marc Rosenquist.

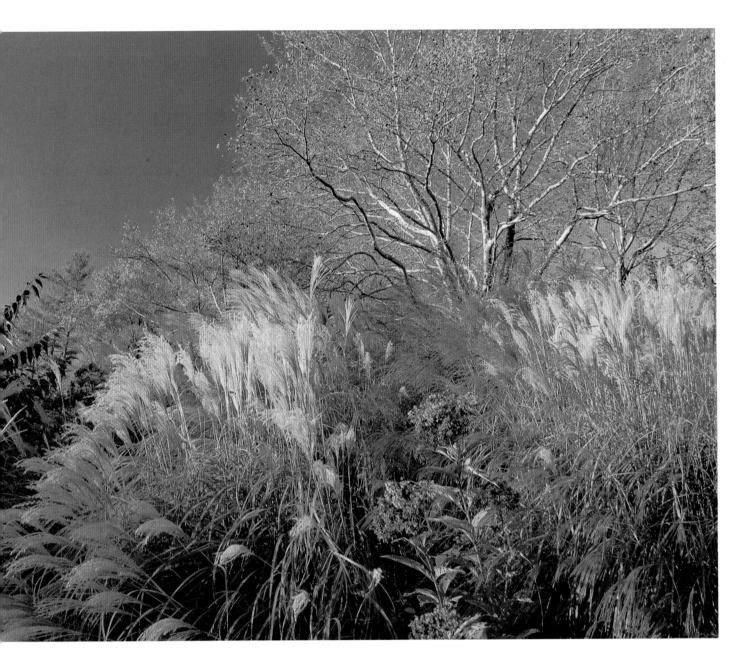

A bank full of miscanthus rises up to three sycamores on an elevated terrace just outside the house. The seed heads of *Eupatorium* and the red leaves of *Viburnum plicatum* f. *tomentosum* 'Mariesii' complete the sun-bright fall scene.

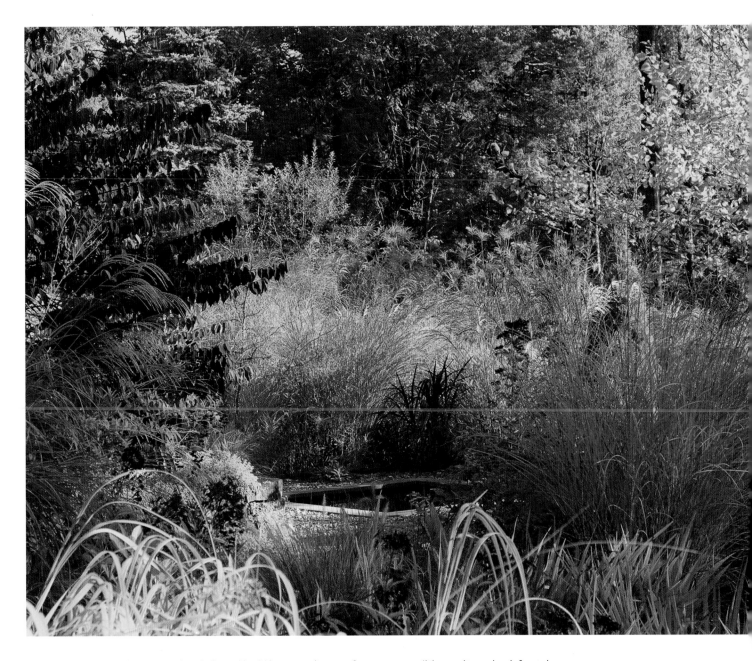

A reflecting pool is sheltered by *Viburnum plicatum* f. *tomentosum* 'Mariesii' in red at left, and the elegantly limpid leaves of *Spartina pectinata* 'Aureomarginata' in the foreground.

Junto Farm

HUDSON VALLEY, NEW YORK

Thomas Phifer and Partners; SE Group; Oehme, van Sweden
40 acres (16.2 hectares) · 2004

THE VISUAL TENSION BETWEEN this highly geometric "farmhouse" in upstate New York, which is open to the public on occasion for charity, and the plantings that flow around and beneath it is palpable and exciting. The architects, Thomas Phifer and Partners, placed a pure, rectangular main house wrapped in double-height glass on the crest of a hill and set four individual bedroom bunkers down and to the side, tucking them into the slope itself.

On the approach up the entry drive, Oehme, van Sweden orchestrates a welcome that surrounds visitors with prolific waves of massed grasses and flowers that frame glimpses of the modernist house. Upon reaching the top of the property, the plantings dissipate in intensity, opening up the view, letting the house's clean lines and the view be appreciated in their own right, and inviting new arrivals to take a big breath of fresh country air. A short allée of London plane (*Platanus ×acerifolia*) trees underplanted with low, seasonal ephemerals matches the width of the main house, leading the eye on a direct procession toward the architecture while, to the west, a second allée of little-leaf linden trees (*Tilia cordata*) create a shady, formal bosque visible from the main living spaces inside. A plateau of uninterrupted lawn both highlights the distinctness of the volumes of the main house and bedroom areas and connects them. American modernist landscape architect Dan Kiley would surely have approved.

A sweep of ornamental grasses and other herbaceous plants create a welcoming flow that builds anticipation by contrasting in texture and color with the restrained palette of the architecture materials.

Glass-fronted suites look outward, giving guests a view of the sweeping valley below the cultivated gardens.

Oehme, van Sweden built its reputation partly on designing with ornamental grasses and prairie plants, and was among the first landscape architects to reintroduce the now-ubiquitous *Sedum* 'Autumn Joy', which also appears on this property, and the robust black-eyed Susan, *Rudbeckia fulgida* var. *sullivantii* 'Goldsturm'.

The vigorous and fast-growing perennial *Aconogonon* ×*fennicum* 'Johanniswolke', a member of the knotweed family Polygonaceae, holds its own here. It grows up to 6 feet (1.8 meters) high and has creamy-white flowers. It is a strong plant and is of particular value when planted with red switch grass (*Panicum virgatum* 'Haense Herms') and short-toothed mountain mint (*Pycnanthemum muticum*).

Another robust plant, *Sambucus ebulus*, an herbaceous elderberry, features prominently. Robust is a kind word, because this plant spreads with enthusiasm. It has white flowers and pinnate leaves. The smell of the foliage is an acquired taste. Oehme liked it. It has now naturalized in New York State, and is not loved by advocates of native planting.

This planting works because it complements the clean, strong geometry of the architecture without diluting it. It is possible to garden too much, muddling an original vision. The success of this garden comes from balancing an appealing but controlled exuberance with highly disciplined design.

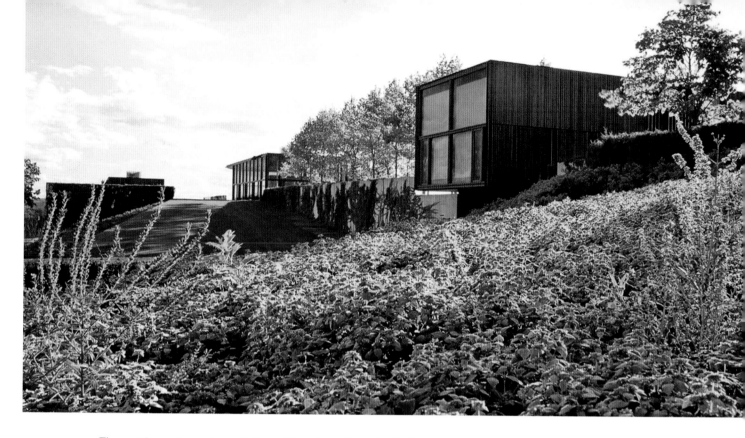

The cantilevered guesthouse is framed by a slope planted with short-toothed mountain mint (*Pycnanthemum muticum*).

A broad expanse of lawn accentuates the house's reddish polished mahogany and corten steel features while creating a dramatic approach for taking in the Duchess County view.

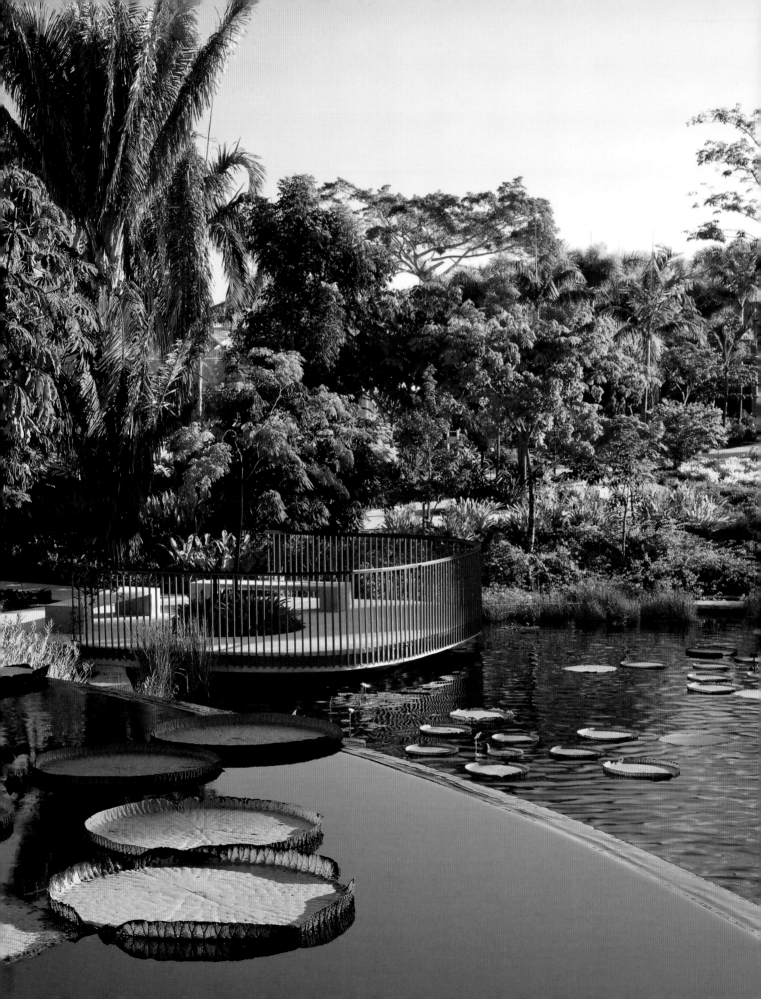

Naples Botanical Garden

NAPLES, FLORIDA

Ellin Goetz, Ted Flato, Raymond Jungles, Herb Schaal, Bob Truskowski, Made Wijaya, Brian Holley
170 acres (68.8 hectares) · 2008

HORTICULTURE CAN BE AN undisciplined craft—the lack of set rules sometimes gives rise to brilliance, sometimes not. Those with unbridled enthusiasm for plants tend to chafe under the restraint of design while designers often complain that gardeners are messing things up. Fortunately, horticulture and design partnered to make the Naples Botanical Garden garden a true joy. The designers were a remarkably talented group who worked collaboratively with each other and with the staff. What could easily have turned into a vanity fair became instead an organized and thoughtful process that created a center for horticulture, art, design, and ecology in South Florida.

It all started in 1993 with a cadre of people wanting to reclaim the site of an old shopping complex and garbage dump. Philanthropist Harvey Kapnick Jr. purchased the site in 2000, and they were off. Brian Holley, the founding executive director, remembers when he got the call: "He said, 'I have a hundred and seventy acres of Florida swamp and want to build a botanical garden.' Probably the wackiest proposition I ever heard. Even crazier, we did build it, and it is beautiful! Just ask the thousands of people who visited last year!" They unpaved the lot and put in a paradise. By 2014, the theme gardens were completed, two lakes were dug, and the excavated soil was used to create elevation. Plantings were in. Now, over a quarter of a million visitors a year come to enjoy the impressive demonstrations of the flora of the tropics.

It is a garden based on latitude—26° north and 26° south, to be precise. This includes the tropics and a few degrees of subtropics, to account for Naples itself. Every plant found in this

Victoria 'Longwood Hybrid' mimics the flat, round shapes of pool and promontory.

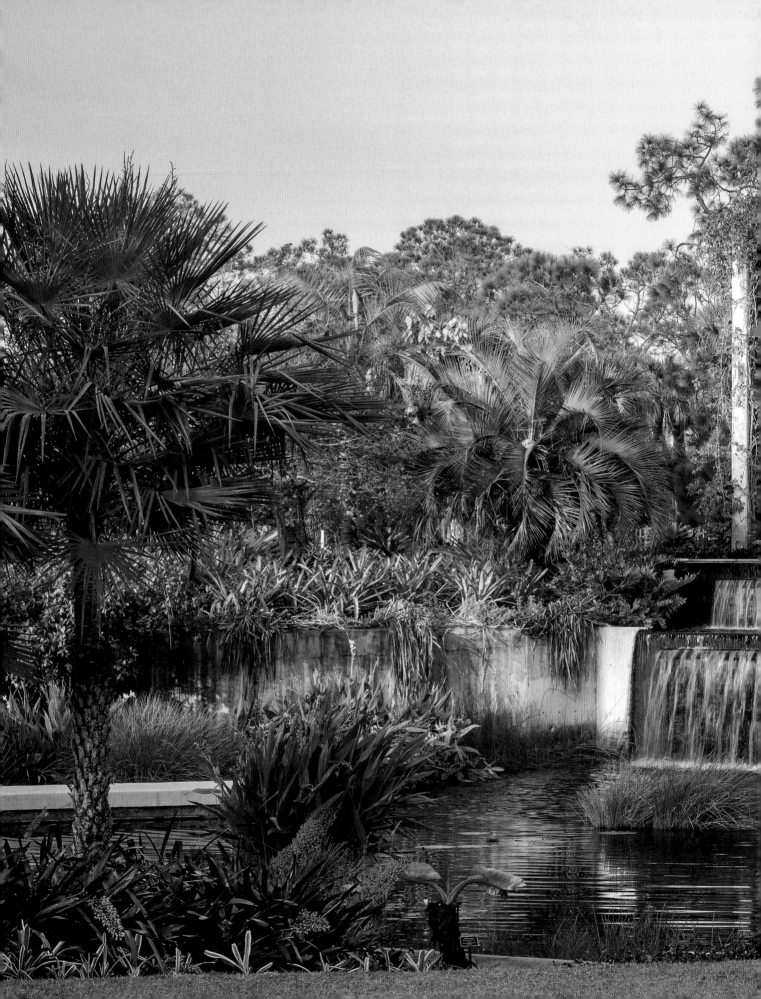

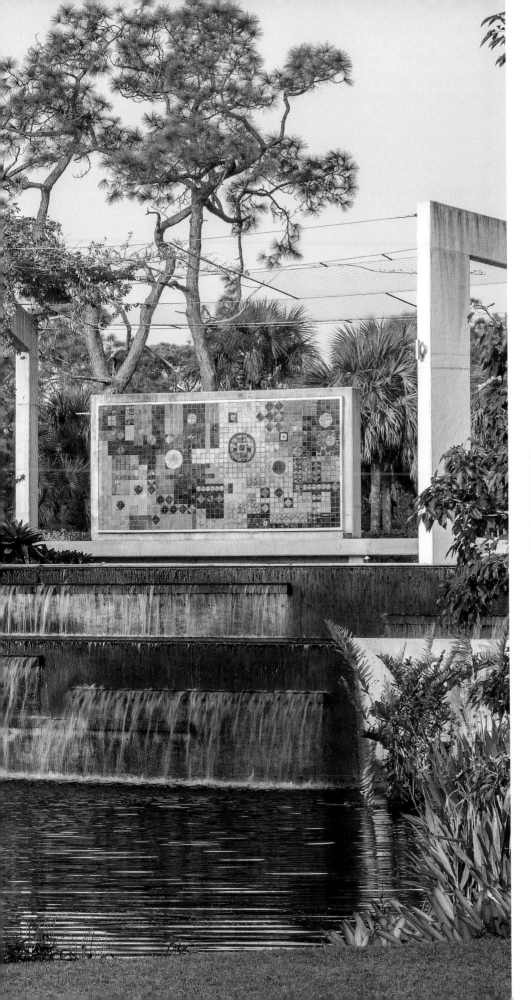

Raymond Jungles, designer of the Brazilian Garden and protégé of landscape architect Roberto Burle Marx, donated the late master's ceramic mural and made it the centerpiece of the garden.

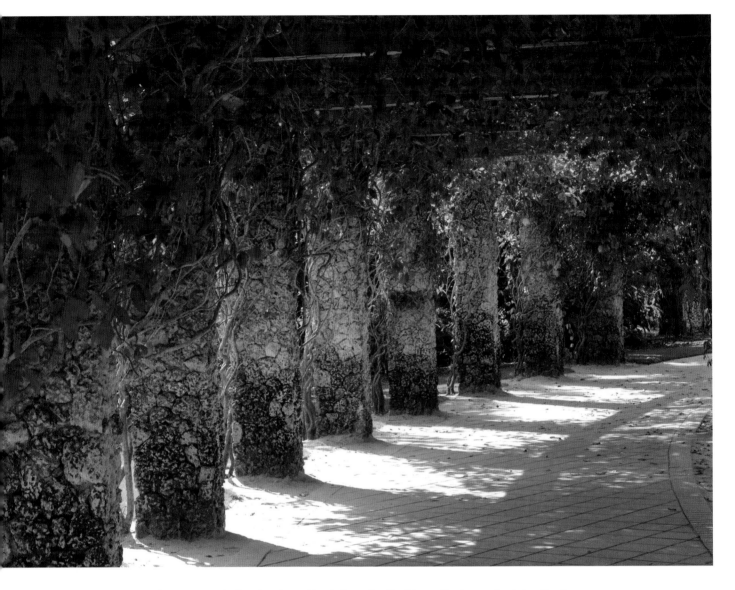

A stone pergola faced with coral leads from the Caribbean Garden to the Asian Garden.

garden lives within that equatorial band in one or another of the world's many tropical and subtropical ecosystems, and four of the main gardens here—Asian, Brazilian, Caribbean, and Florida—underscore the geography. Creating a series of theme gardens always runs the risk of turning a good idea into a petting zoo for plants, but, in this case, commissioning five garden designers with different styles and personalities proved to be fruitful. The different gardens have distinct personalities, but blend and connect to create a remarkably harmonious whole.

Florida is a land defined by water. The Florida Garden captures this in a series of hummocks, a Southern term for naturally occurring elevated mounds, habitat islands rising out of

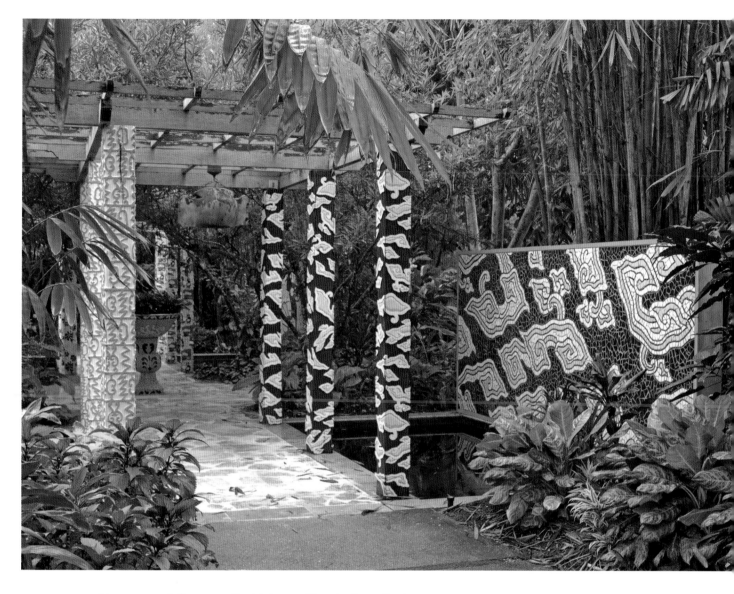

Abstract murals feature stylized Asian motifs in the Asian Garden.

the marsh, that tend to be circular in shape. This enclosure is surrounded by the area's characteristic grasses and representative native palms, such as the sabal palm (*Sabal palmetto*), the Everglades palm (*Acoelorrhaphe wrightii*), and the graceful royal palm (*Roystonea regia*). The enclosure of palms and the slight rise of land directs the eye around and up, up to the sunny sky. A delightfully sinuous river of grasses and sedges, sawgrass (*Cladium jamaicense*), Gulf Coast spikerush (*Eleocharis celluosa*), sand cordgrass (*Spartina bakeri*), and spiky Fakahatchee grass (*Tripsacum dactyloides*) weaves around and through the circles and down to the water where the duck potato (*Sagittaria lancifolia*) grows.

Successful landscape architecture is a bridge between the natural and the man-made. The Florida garden is a success because it translates the native environment for those who do not know it and are unlikely to venture into the wild. It is a civilized approach to what lies beyond: The Preserve is a 90-acre (36-hectare) refuge of the greatest importance in terms of natural habitat, conservation, and ecology. It is home to 300 species of native plants and a rich profusion of wildlife. White pelicans bob on the water, the magnificent frigatebird soars on long wings, and purple gallinules search for frogs in the marshes. There are red mangrove (*Rhizophora mangle*) swamps, flatwoods of slash pine (*Pinus elliottii var. densa*) and coastal plain staggerbush (*Lyonia fruticosa*), and coastal scrub made up of scrub palmetto (*Sabal etonia*), Florida rosemary (*Ceratiola ericoides*), and wiregrass (*Aristida beyrichiana*).

Beyond the garden walls, these habitats are threatened by a general disregard for the natural environment, unrelenting greed, and the ever-expanding subdivisions, country clubs, and shopping malls. It is astonishing to think that large areas of the 4,000-square-mile (10,360-square-kilometer) Everglades were drained for agriculture and building development and planted with the thirsty and invasive Australian punk tree (*Melaleuca quinquenervia*). One of the most important wetlands in the world is now contaminated with fertilizer and receives a third of the amount of water it once did. If the garden did nothing but protect these ninety acres, it would be a place beyond value. "Naples Botanical Garden sits at the epicenter of a looming conservation crisis. There are over 2.8 million acres (1.1 million hectares) of public lands within a hundred miles of the garden that are threatened by increasing numbers of invasive exotic plants and animals, introduced diseases, climate change, and the ever-growing pressures of urbanization. The garden's current conservation programs protect several species of native plants that are directly threatened with localized extinction," explains Chad Washburn, its deputy director.

There is more richness. The Caribbean Garden includes many cultivars, varieties, and species of plumeria, also known as frangipani. Tough plants with flowers that have an almost overwhelmingly sweet perfume, the common name is thought to come from a sixteenth-century Italian nobleman, Marquis Frangipani, who scented his gloves. When the flower was discovered by Europeans, its perfume reminded them of the scent, and so the flower was named after him. This may not be entirely true, but it is an agreeable story.

Robert Truskowski, internationally acclaimed landscape architect, designed the Caribbean Garden with ethnobotany—the study of how people use indigenous plants—in mind. There is a human scale to this area, in that it appears to be less of a display garden and more of a space that interconnects the fruits, flowers, and trees of the Caribbean with its peoples: calabash trees (*Crescentia cujete*), the national tree of St. Lucia; the so-called wild poinsettia of Trinidad and Tobago (*Warszewiczia coccinea*); and the Pride of Barbados (*Caesalpinia pulcherrima*) with ever-blooming, fiery red flowers. A Caribbean garden would be incomplete without coconuts, and *Cocos nucifera* 'Maypan', a cultivar bred in Jamaica for its resistance to lethal yellowing disease, grows tall in the heat and sun of Florida. The garden is as relaxed as the region it represents.

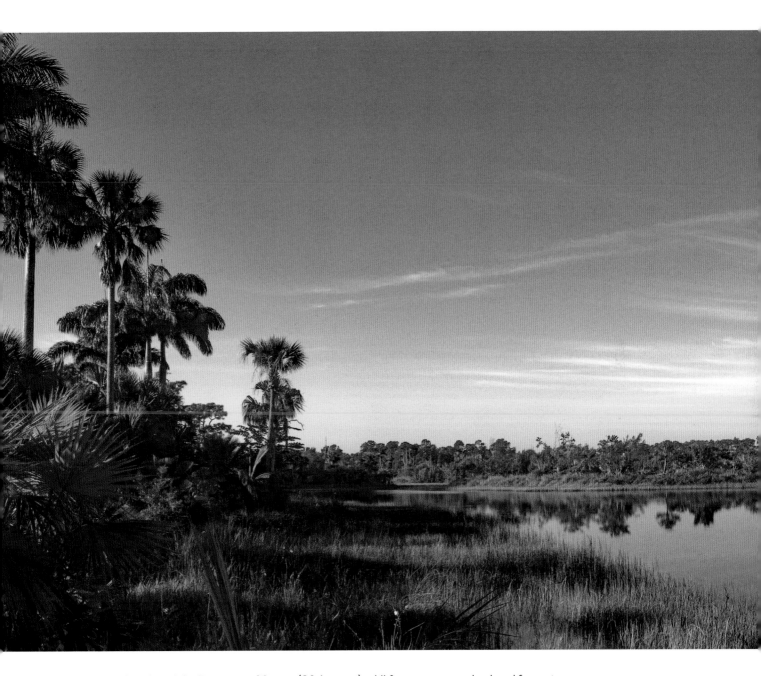

The edge of the Preserve, a 90-acre (36-hectare) wildlife sanctuary, wetland, and forest, is a part of the Naples Botanical Garden.

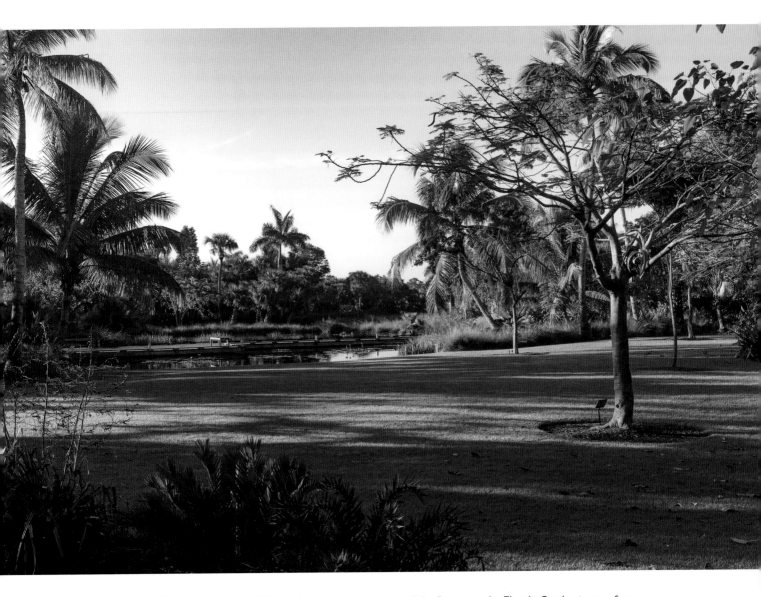

From cultivated to wildly cultivated to the wonders of the Preserve, the Florida Garden is a perfect place to see native plants for use in the garden.

The Brazilian Garden is a living tribute to one of the greatest nature artists of the twentieth century, Roberto Burle Marx. Called by the American Institute of Architects "the real creator of the modern garden," it's difficult to overstate his influence. His friend and protégé Raymond Jungles designed the garden with a tropical vibrancy and artful passion, and included a colorful ceramic mural by the master himself. The piece presides over all on a platform high above a two-tiered waterfall that pours into a large, black-bottomed pool where enormous pads of the Amazon water lily (*Victoria* 'Longwood Hybrid') grow up to 5 feet (1.5 meters) across. It is also framed by kapok trees, *árvore sumaúma* (*Ceiba pentandra*), South American palms, cattleya orchids, and mass plantings of bromeliads. *Alcantarea imperialis*, a Brazilian giant, lives up to its royal name with a mass of foliage that can grow to 4 feet (1.2 meters) high and red flowers reaching up to 6 feet (1.8 meters). It is planted in large groups with colorful varieties of *Neoregelia* and *Aechmea*, and the aptly named, red-stalked, lavender and green flowers of *Portea* 'Jungles' imported from Burle Marx's own garden. The garden feels effectively like a contained wildness with a just a trace of jungle fever.

The Asian Garden, designed by Made Wijaya, an Australian who lived in Bali from 1974 up to his death in 2016, bursts with a complex encapsulation of Southeast Asian plants and culture. It is sometimes frenzied, fantastic, and flamboyant. Much like the man himself.

A Thai Pavilion surrounded by water marks the garden's center. The red flowers of 'Holy Fire' and the pale gold of 'Soaring Golden Phoenix' lotus (*Nelumbo nucifera*) rise up out of the still water. The pale blue stems of tropical blue bamboo (*Bambusa chungii*) arch overhead. The black-tinged green leaves and black stems of a banana, *Musa* 'Thai Black', add darkness to the lush green of this mass of tropical foliage. A stepping-stone path leads to a Balinese shrine, the shrine of Dewi Sri, the goddess of rice and fertility. Snake fruit (*Salacca zalacca*), a small palm that gives clusters of red-skinned fruit, encloses the area, while a path leads to a walled area of abstract mosaics featuring stylized Asian motifs. A Javanese ruined temple and limestone plaza is complete with statues made by Balinese craftsmen.

Naples Botanical also features other gardens, including an orchid garden, a garden of the most "charismatic" or bizarre plants from the region, a garden meant to evoke the paintings of Henri Rousseau, and a Children's Garden designed by Herb Schaal. The remarkable thing about the Naples Botanical Garden is that it looks and feels as if it has been in existence for decades rather than just a few years. It is this way because of the lusty nature of tropical plants, the skill of the staff, and the landscape architects' intelligent designs.

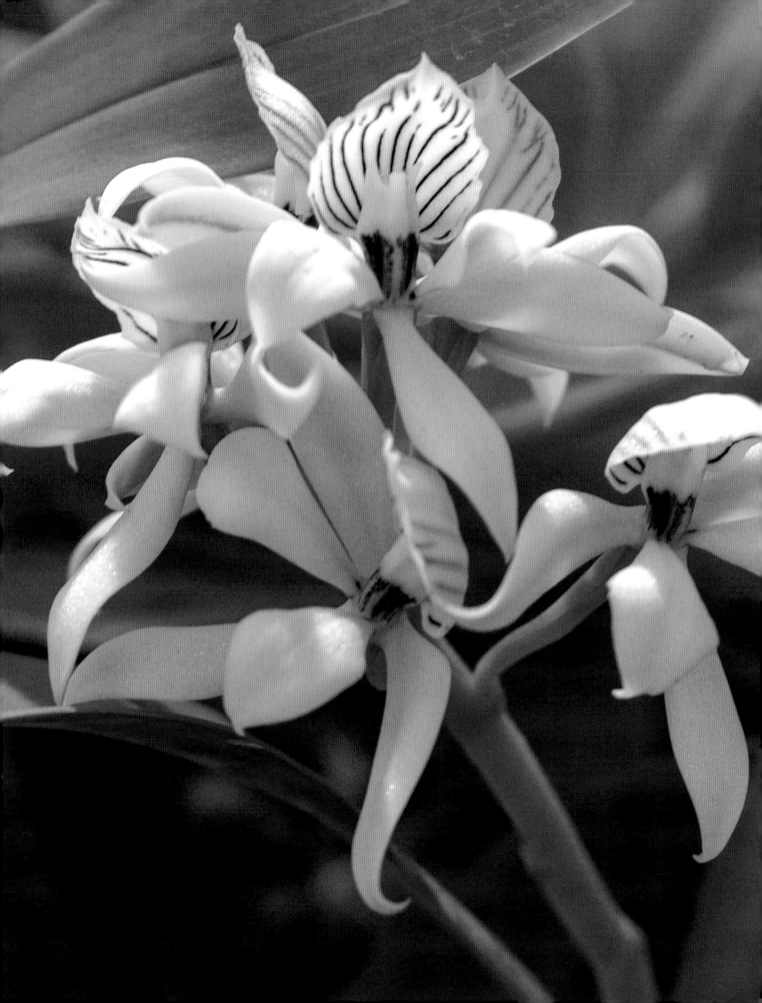

Vallarta Botanical Garden

PUERTO VALLARTA, MEXICO

Robert Price · 19 acres (7.7 hectares) · 2005

CURRENTLY, MEXICO IS RECOGNIZED as the fifth-richest country in plant and animal species, but expanding human population and legal and illegal logging are taking their toll. Less than one-fifth of the country remains forested. Species are disappearing at an alarming rate, with 815,000 acres (330,000 hectares) of forest cut each year.

According to a government report published in 2016, Mexico now has the second-fastest rate of forest depletion in the world, second only to Brazil. Many important plants are disappearing, lost forever. The country has about 1,150 identified species of orchids. All are under threat. A concerted effort is being undertaken by staff at the Vallarta Botanic Garden to conserve as many orchids as possible, and these efforts are central to their overall mission. If it is true that we are facing another great planetary extinction of biodiversity, then even modest efforts in conservation become enormously important.

There is something both comfortable and radical about the Vallarta Botanical Garden. The warm, domestic-feeling buildings, with their welcoming furniture and shelves of books, belie an underlying seriousness of directive.

Located on the Pacific Ocean's Bahía de Banderas, the Vallarta Botanical Garden is 14 miles (23 kilometers) south of the resort city of Puerto Vallarta, in a tropical dry forest. It sits on the side of a hill above the Río Horcones. Robert Price, its creator, founder, and visionary, describes himself as an accidental tourist. He had always visited botanical gardens in his travels around the world, and, when visiting Puerto Vallarta, asked himself, "Why isn't there a botanical garden here?" His question was followed with the eureka moment when he realized he could start one himself. He and his mother, Betty, had been successful restaurant

Prosthechea fragrans is one of the most fragrant of Mexican orchids. Despite its diminutive size, just one plant will fill a room with sweet perfume.

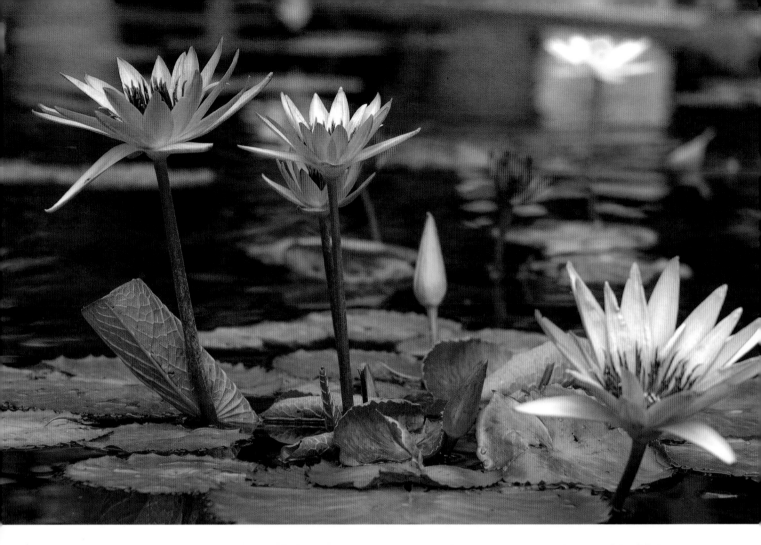

Day-blooming water lilies open as the sun rises, then silently fold their flowers in the late afternoon.

→ *Thunbergia laurifolia*, a native of India and a gorgeous addition to the tropical vine collection, flowers almost continuously, its 3-inch-wide (7.6 centimeter-wide) blue flowers covering the entire plant.

owners in Florida before exploring and then moving to Mexico. On their early trips, they became fascinated with Mexican orchids and began to collect them. Together, they decided to build a botanical garden to display plants, educate locals and the thousands of tourists who come for the beaches, and explain regional ecological systems such as the dry forest, the river valley, and orchid habitats.

Price purchased a piece of sloping, partly forested land in 2004 and began gardening in earnest in January 2005. He hasn't stopped since. Now, the garden is well on its way to becoming one of the most important, interesting, and beautiful in Mexico. It is a place for plants as well as a place that celebrates the richness of Mexican culture. Mexican crafts are on display and are for sale. Herbs, both culinary and medicinal, are also available. Significant moments in Mexican culture are celebrated, such as the Day of the Dead, an important time for Mexicans to reflect on their families and their ancestry. The weaving of biodiversity and cultural diversity creates a contemporary and vibrant story.

In December 2014, the Orchid Conservatory opened to the public. The rare and endangered *Govenia jouyana* is grown here, protected from the depredations of logging. Mexican vanilla (*Vanilla planifolia*), itself an orchid, is beginning to climb to the roof. Its soft yellow, tubular flowers will turn to dark brown vanilla bean pods. Only two of the 100 *Vanilla* species produce commercial vanilla, and they both grow in the conservatory. Another offers a second culinary scent: honey. A small orchid, just 12 inches (30.5 cm) high, *Prosthechea fragrans* has flowers so sweet-smelling their fragrance fills the large, cathedral-like space.

The newly discovered *Magnolia vallartensis* is already protected—a triumph of botanical exploration and plant conservation—and is on display here too with its other rare friends. To add texture to the displays, the spiny dwarf palm (*Cryosophila nana*) is dotted throughout the exhibit space. Overall, the conservatory is light and spacious, a palace of plants topped proudly with the Mexican flag.

The Dick and Dee Daneri Vireya Rhododendron House is a shade pavilion for vireya rhododendrons, species native to the Malay Peninsula, New Guinea, and Papua New Guinea—a gift to the garden from benefactors from the United States. It may seem incongruous that rhododendrons are grown here at all, but they are thriving and add an additional exotic. They are welcome because they are also highly endangered in the wild.

Wandering is encouraged and rewarded here. Side paths lead to a forest of large jaguey blanco trees (*Ficus trigonata*) dripping with orchids and ferns. The air plant (*Tillandsia jalisco-monticola*), an endemic bromeliad and a symbol of the garden, is plentiful as well. Another path, edged with gumbo limbos (*Bursera simaruba*), tall trees with cinnamon-colored, papery bark—also referred to as the "tourist tree" for its peeling red skin—leads down to a small beach and a swimming hole on the Rio Horcones. The river bottom is bright with skipper butterflies and raucous with the sound of the San Blas jay, a blue-and-black member of the crow family.

The Hacienda de Oro, architecturally reminiscent of an eighteenth-century plantation house, is the busy hub of the garden. The two-story building with open, shaded verandahs

contains a large restaurant, gift shop, meeting space, and offices. It feels convivial, more like a large home ready for a party than a business. Perhaps this is because of the sofas and comfy chairs that are scattered throughout the building, the colorful cut-out paper flags that hang from the ceiling, and the glass hearts decorating the glassless windows. It is a place to sit and take in the view of the river and the mountains, and enjoy the hummingbirds and the Inca doves looking for crumbs.

The Hacienda de Oro is draped with the ever-flowering bouganvillea, the coarse, thorny, scrambling shrub with beautiful flower-like bracts. The vines surround the building, billowing white among the green, white, and red bands of the Mexican flags that are hung every

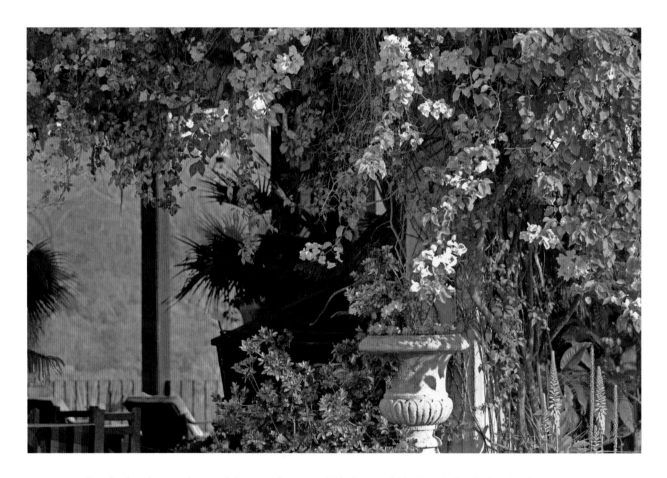

Prosthechea fragrans is one of the most fragrant of Mexican orchids. Despite its diminutive size, just one plant will fill a room with sweet perfume.

→ Jade vine (*Strongylodon macrobotrys*) can never fail to impress. With flowers 4.5 feet long (1.4 meters long) on a vine that can grow 40 feet (12 meters) tall, it is one of the plant kingdom's most amazing sights.

Opulent displays of bougainvillea and the Mexican flag express national pride in the garden.

Rhododendron 'Vireya', though from across the Pacific, is highly prized for its rarity and so keeps good company with other endangered plants at the garden.

few feet. At the entrance to the shop, a curtain of Indian clock vine (*Thunbergia mysorensis*), with brick-red and rich yellow flowers, is perfect against the burnt sienna of the walls.

Vines are favored here. Arguably the most beautiful is the jade vine (*Strongylodon macrobotrys*). Its competitor for the title may be the blue trumpet vine (*Thunbergia laurifolia*), with its pale blue, trumpet-shaped flowers. It, too, can grow long and large. In these conditions, it covers much of one building.

The central courtyard offers another place to sit, relax, and watch the bustle of birds, insects, and humans as they flit about the garden. An ornamental pool clad in Mexican tile is filled with serene blue and white tropical water lilies.

This garden continues to be created piece by piece. Recent additions of an international peace garden and a cactus house continue to strengthen the social/land/botanical mission of the garden. With Puerto Vallarta experiencing greater numbers of tourists as well as a burgeoning expat population, the garden will become a major destination, gathering momentum. It has a bright future.

central america
and the caribbean

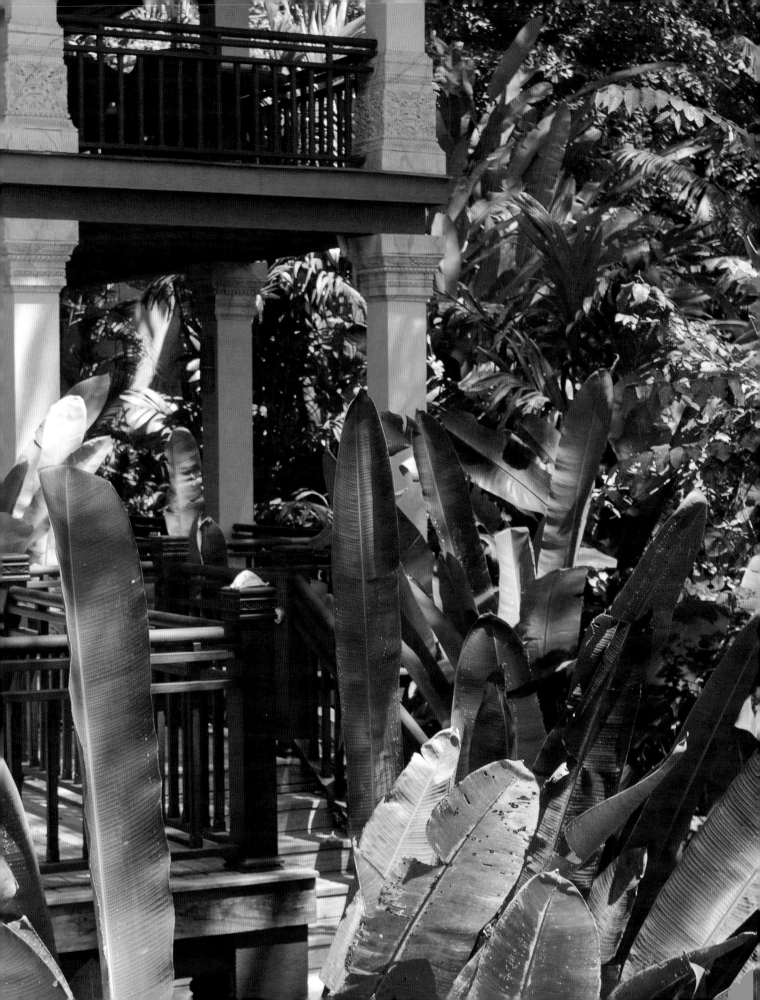

Los Elementos

DOMINICAL, COSTA RICA

Dennis Schrader · 7 acres (2.8 hectares) · 2012

RARE AND UNUSUAL PLANTS interwoven with second-growth Costa Rican trees and shrubs are reclaiming this patch of tropical forest, returning it to its rightful, lush state after it served for a long time as a cow pasture. The development of the Los Elementos, a private garden, began with the construction of the main house, Villa de Agua, on a hill above the sloping property. Designed by the owner, Ilene Vultaggio, with Dennis Schrader and Bill Smith, proprietors of Landcraft Environments, Ltd., in Mattituck, New York, the villa is a mixture of Balinese and Costa Rican architecture, with a few Italianate elements sprinkled in. The 12,000-square-foot (1,115-square-meter) house includes many open terraces and shaded sitting areas, as befits the climate. At the back of the house, a dense, dark forest of trees is home to white-faced capuchin monkeys that bounce from tree to tree and rainbow-billed toucans that feed on the fruit of the cecropia (*Cecropia pittieri*) tree. The front terraces look west to the Pacific Ocean and are exposed to the hot afternoon sun.

Schrader designed the garden, starting with a verandah leading to a bedroom. Its entrance is covered by a curtain of bluebird vine (*Petrea volubilis*), a distinctly beautiful twining plant with clusters of light-blue star-shaped flowers that turn gray as they age. Rare bromeliads and ferns peek out from behind, secured to a wall by decorated lath.

Away and up from the verandah, steps edged with bowls of pink, orange, and lavender bougainvillea beckon visitors to a Balinese stone temple. Near the temple is a rare plant from Thailand, the variegated fishtail palm (*Caryota mitis* 'Variegata'), its light green leaves striped with yellow.

The main house's back terrace looks out to a thick jungle of heliconia, palm, and ficus foliage.

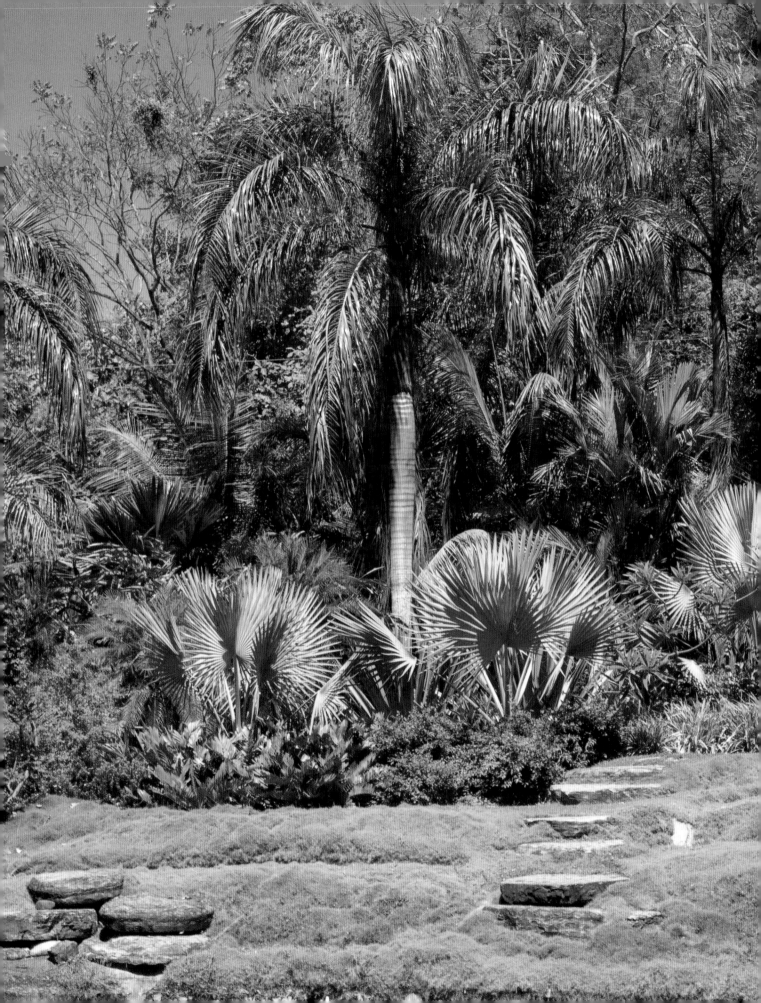

Bluebird vine (*Petrea volubilis*), with its generous sprays of light-blue flowers, is among the most beautiful of tropical vines.

→ *Mussaenda* 'Snow White' is a popular plant for tropical gardens because of its lovely and abundant large pure white blooms.

(opposite) Pots of assorted bougainvillea in different colors decorate steps leading from the pool up to a Balinese-style temple.

Balinese and Indian screens divide space inside the house, while a narrow corridor of ferns and rare orchids—including the Costa Rican national flower, Flor de San Sebastián (*Guarianthe skinneri*; syn. *Cattleya skinneri*)—defines the front garden. There is an ease between the inside and outside of the house that's impossible to create in colder climates. Both rely on each other to create a carefully nuanced harmony.

A guest house sits below, simpler than the main house but elegant with its ipe-wood flooring and moongate chairs, designed by Schrader and made from sustainably grown local teak. It holds a real treasure that's almost as much of a pleasure to say as to see: the hairy heliconia (*Heliconia vellerigera)*. It is a rare flower, though there are between 200 and 250 species of *Heliconia* overall, as well as a number of hybrids and cultivars. This specimen has pendulous, orange-red bracts covered with a fur that is as soft as the hair on a baby's head. The large leaves seem to give birth spontaneously to this most wonderful flower hanging in clusters of hirsute wonder. The pink heliconia (*Heliconia chartacea*) grows next to it, unusual also in that the bracts of the species are usually restricted to reds and oranges. This cultivar is 'Sexy Pink', an unnecessarily silly name for a plant that already drips with lasciviousness.

A wooden pagoda carved in ornate Balinese style forms a focal point beyond the water lily ponds and terracing. Around it, the garden opens up from the shade of the surrounding forest into an oval open space in broad, scorching sun. A cluster of silver Bismarck palms (*Bismarckia nobilis*), native to Madagascar and widely grown in the tropics, dominate visually. After the intimacy of the terraces and verandahs, the public space feels exposing for a moment. Two small artificial lakes abound with rare and not so rare plants. The national tree, elephant ear (*Enterolobium cyclopcarpum*), stands high above coconut palms, near the red-leaved, green-flecked, and rare Siam banana (*Musa* 'Siam Ruby'). The now widely grown white mussaenda (*Mussaenda* 'Snow White') is combined with a strong pink plumeria. It's a dazzling garden.

Costa Rica is one of the most biologically rich countries in the world, partly because of its geography as a land bridge between North and South America. Los Elementos brings native and nonnative plants together in an atmosphere of horticultural affluence. There is no doubt that human affluence is involved too, but the houses and gardens reflect the unofficial Costa Rican motto of *pura vida*—the wish for a peaceful, simple, uncluttered life with a deep appreciation for nature.

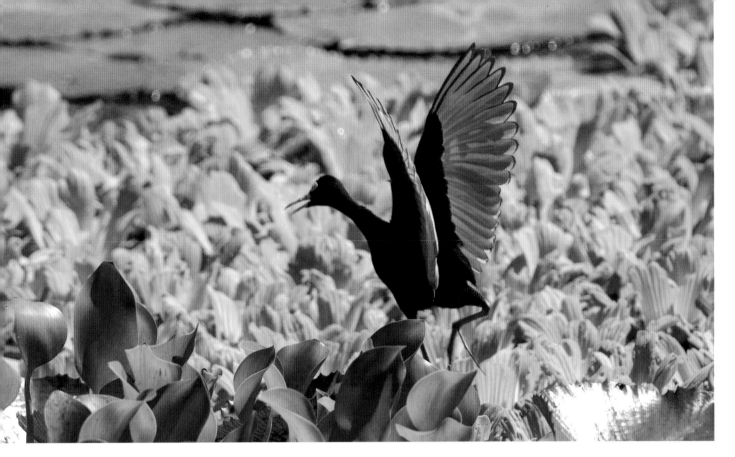

A northern jacana (*Jacana spinosa*) steps light-footed over the leaves of water hyacinth (*Eichhornia crassipes*) in one of the property's ponds.

→ Siam banana (*Musa* 'Siam Ruby') and the stems of false bird of paradise (*Heliconia* sp.) create a rich play of textures.

The world might be a better place if everyone could grow a hairy heliconia (*Heliconia vellerigera*).

← Silver-gray Bismarck palms (*Bismarckia nobilis*) add light to a dense backdrop of tropical foliage.

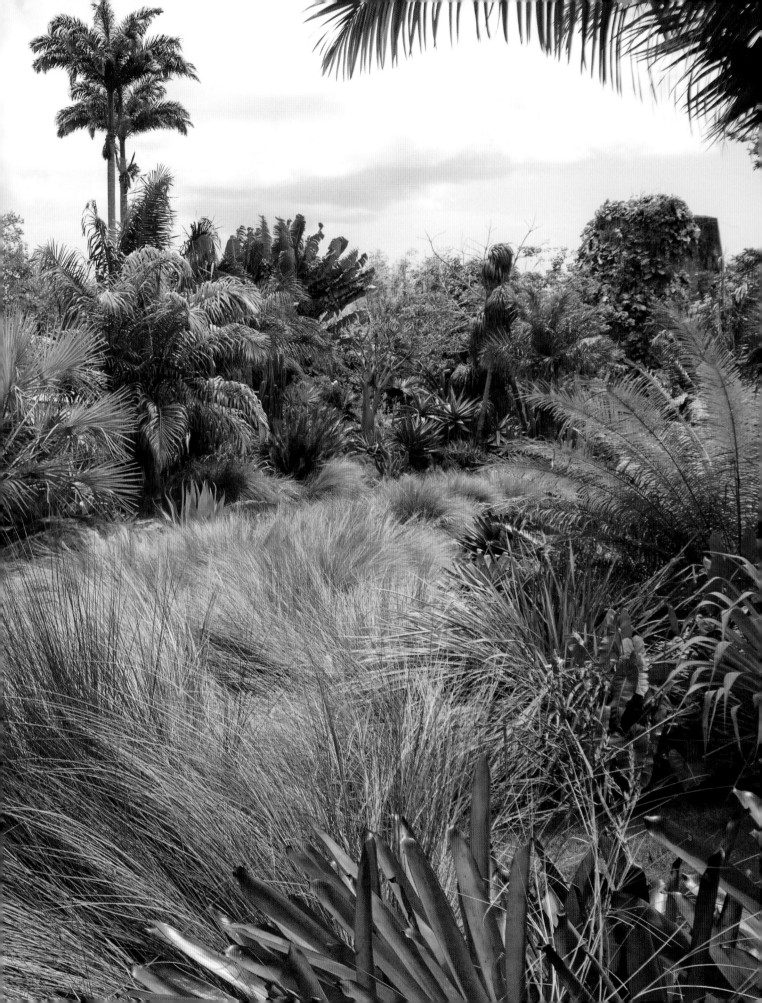

Golden Rock Inn

NEVIS, WEST INDIES

Brice and Helen Marden, Raymond Jungles · 25 acres (10 hectares) · 2010

WHEN TWO WORLD-FAMOUS artists decide to turn their creative energies to sculpting an entire landscape, only amazement can result. Helen and Brice Marden decided to buy the Golden Rock Inn, a veritable piece of paradise on the Caribbean island of Nevis, and looked at the work of half a dozen of the world's most prominent garden designers to help them realize their lush vision. They easily decided to call in landscape architect Raymond Jungles, who specializes in subtropical and tropical landscapes, to help translate color from the abstract canvas of a paper plan to a fully three-dimensional, sensual reality.

Helen says she and her husband are each naturally attracted to different aspects of the undertaking: "Brice concentrates on the rocks, and is meticulous with their placement. Raymond and I look at the plants. I focus on color, Raymond adds to that, and then applies his great knowledge of design and horticulture."

To mesh the needs of guests with the ruins of historic sugar mill buildings on the site, they added architect Edward Tuttle to their charrette. He designed a series of rectangular pools, the restaurant, a number of outbuildings, and a rill—a narrow waterway that leads away from the formal terraces to a garden below.

Situated on the slopes of Nevis Peak, the garden surrounds the small hotel's eleven guest rooms. It may be one of the most botanically enthusiastic small hotels in the world. Designed in three phases—the owners are coy about adding a fourth—it feels appropriately like wild tropical abandon, but with deeper observation it becomes clear that it's more of a highly stylized wildness.

Within a veritable arboretum of palms and clustered with bromeliads, the relief of sand cordgrass (*Spartina bakeri*) gives the eye a soft landing place for a moment.

The flying buttress roots of a 200-foot (60-meter) kapok tree (*Ceiba pentandra*) provide a home for seedling palm trees and a tropical *Justicia* species.

Jungles's signature of having spent lots of time at the site is the large and sweeping gatherings of bromeliads that swirl down the slopes. His deep knowledge of the family allows him to choose plants with uncommonly bright colors and fat leaves; as they tumble through and around each other, they create rhythmic patterns that both propel and pull the garden together. If there is one dominant plant among considerable competition, it is the sun-loving, orange-leaved bromeliad *Aechmea blanchetiana* 'Orangeade'. With a height of 4 feet (1.2 meters) and a spread of 3 to 4 feet (0.91 to 1.2 meters), even one plant would stand out. He takes it a bold step farther and plants in groups of twenty or thirty, making each swath a gloriously rubicund tidal wave. When their tall flower spikes of brilliant red rise from the central rosette and last for many months, the effect is simply staggering. The orange foliage is a unifying color among the many other shades of green, always bright as fast-moving clouds, pushed by the trade winds, are constantly changing the light. Orange works with blue and red, and the bromeliad is planted next to the blue leaves of *Agave americana* and

White-fleshed vining cactus pithaya, or dragon fruit (*Hylocereus undatus*), adds drama to the property's partially restored sugar mill. The red on the shutters was chosen by Helen Marden.

the blood red bracts of *Bougainvillea* 'Flame'. It seems a simple combination, but of course the simplest and bravest choice is often the strongest.

Other bromeliads are also planted en masse. Hundreds of them. The huge rosettes of *Alcantarea imperialis*, with waxy, blue-green leaves tipped in purple, can reach up to 5 feet (1.5 meters) across. The silver fountain foliage of *Alcantarea odorata* plays against the deep copper-purple leaves of *Aechmea* 'Marcelino' and the burgundy of *Alcantarea vinicolor*.

And then there are the palms. Lots of palms. The Montgomery palm (*Veitchia montgomeryana*) grows tall from the flat terraces of the ornamental pools. The ruffled fan palm (*Licuala grandis*), with such elegant leaves, is planted throughout the grounds, while the zombie palm (*Zombia antillarum*) from Hispaniola, with its trunk wrapped in 4-inch spines, is wisely planted back from the paths.

As well as being particular about rocks, Brice is particular about bamboo. This interest reflects his knowledge of Japanese and Chinese art and minimalism. Near his studio, there

If there was just one bromeliad to grow . . . fortunately there isn't. *Aechmea blanchetiana* 'Orangeade' pours down a hillside in rivers of tangy color.

→ *Aechmea* 'Marcelino' features brooding, dark copper-purple leaves covered in the powdery silver found on many species. Here, several are gathered in front of the relics of a sugar mill.

Alcantarea imperialis, a true king, produces a 6-foot (1.8-meter) flower spike of small, fragrant white flowers.

← Covered in irridescent silver powder that makes this species almost glow in the shade, *Alcantarea odorata* features bright yellow flowers that are strongly fragrant.

The geometric elements of pools, terraces, and a domed dining area are offset by the tall fronds of Montgomery palm (*Veitchia montgomeryana*).

Agave americana waves languidly at guests as they move up the entry drive.

↓ Brice Marden's studio and a guest cottage frame clumps of various bamboo underplanted with flowering tropical vines and ground covers.

← Is there such a thing as an orderly jungle? By definition, no, but at Golden Rock, winding paths are discernible through elegant palms and cycads.

At the entrance to one of the cottages, a fat blue *Agave americana*, orange cosmos, and an edging of speckled bromeliads create a visceral welcome.

↓ Water in a rill designed by architect Edward Tuttle tumbles down a hillside as smoothly as the foliage of philodendrons and bromeliads.

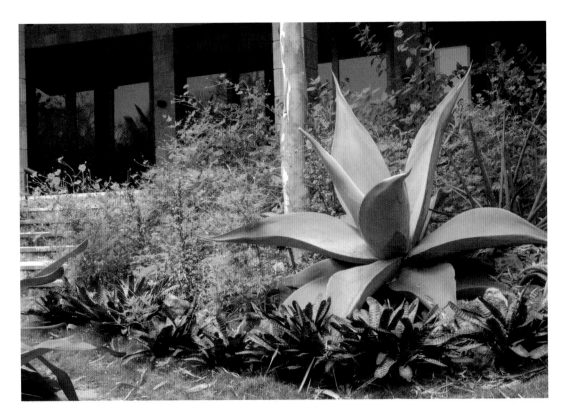

When the cool blue of *Agave americana* and the blood red of *Bougainvillea* 'Flame' meet, they make a combination that is at once subtle and turbulent.

are clusters of Timor black bamboo (*Bambusa lako*), shiny and dark, and *Dendrocalamus latiflorus* 'Parker Giant', or dragon bamboo, a fast-growing variety that can reach a height of 115 feet (35 meters). The clacking of their stems in the wind provides percussion for the *whoo-whoo* melody of ground doves and the night-fluting of tree frogs. In the afternoon, a troop of vervet monkeys, seeking fruit, may pass from tree to tree. And on a walk through the garden, if you stop to sniff the sweet perfume of a frangipani, you might be lucky enough to see a 6-inch-long (15-centimeter-long) black-and-yellow caterpillar, the larva of the gray sphinx moth, nibbling at the base of a flower.

All this abundance is set against a mixture of eighteenth-century Caribbean colonial plantation architecture, romantic ruins, mid-century furniture, and brightly colored cottages. It is a hospitable jungle, ineffably sublime, loud with color and then, just when you think you've had enough, you notice one more ingenious combination, like the delicate finery of tiger grass (*Thysolanaea maxima*) and its fuzzy flowers planted against the huge, dark-green leaves and smoky stems of *Alocasia macrorrhizos* 'Black Stem' Or you come upon a soft swarm of sand cordgrass (*Spartina bakeri*) or the simplicity of a dragon fruit (*Hylocereus undatus*) climbing between two red window shutters, and you stop, slow down, and breathe in the garden all over again.

south america

Jardín de Salvias

MAR DEL PLATA, ARGENTINA

Rolando Uría, Francisco Javier Lozano · Display garden 538 square yards (450 square meters), research garden 358 square yards (299 square meters) · 2015

ROLANDO URÍA HAS A love for salvias and hummingbirds. Formerly a professor of agronomy at the University of Buenos Aires, he moved to a new home in Mar del Plata on the Atlantic Coast so he could follow his passion for both. Two species of hummingbirds (*picaflores* in Spanish) are resident, the white-throated (*Leucochloris albicollis*), which stays year-round, and the green (*Chlorostilbon lucidus*), which is a spring and summer visitor. He noticed that they particularly enjoyed feeding on the different *Salvia* species he had growing, and this observation led him to study the genus and start collecting species, hybrids, and cultivars. He got a little carried away.

He is now known for discovering the excellent ornamental *Salvia* 'Amistad', a bushy hybrid between *Salvia guaranitica* and/or *Salvia mexicana* and *Salvia gesneriiflora*. He named it after the Spanish word for friendship and, in that spirit, he has since distributed it to many nurseries around the world. It is a big plant, for frost-free areas, reaching 4 feet (1.2 meters) high and 3 feet (0.9 meter) wide, with intense violet-purple flowers that bloom for nine months of the year.

With the help of his partner, Francisco, he has now created both an ornamental garden and a garden for research and breeding. When asked to list five of his favorite salvias, he looked puzzled. "Five? Just five?" he said. When pressed, he first listed 'Amistad' and went on to talk excitedly about the morphology of the plant. "*Salvia guaranitica*, one of the parents, is an octoploid containing eight sets of unpaired chromosomes. There are many morphoptypes, a group of different individuals within the same species. It's a beautiful plant.

Uría discovered, named, and widely distributed the friendship salvia, *Salvia* 'Amistad'.

The display garden is full of salvias, though he has condescended to let a few other plants squeeze in, such as California poppy (*Eschscholzia californica*) and the wonderful Argentine purslane (*Portulaca echinosperma*).

What's amazing about salvias is their promiscuity. They hybridize naturally. I am discovering that those plants we once thought were species are, in fact, hybrids." Rolando's scientific background has clearly complemented his forays into gardening. He finally listed his four remaining favorites: *Salvia pallida* 'Iberá', *S. calolophos*, *S. foveolata*, and *S. cuatrecasana*.

Salvia pallida 'Iberá' originates in the wetland of the same name in northern Argentina, the world's second largest. It grows up to 5.5 feet (1.7 meters) tall and has deep blue flowers in long, crowded clusters. It blooms from midsummer to late fall; without frost it will continue blooming into winter.

High-altitude salvias are rare—and they are difficult to grow in lowland gardens. Rolando is particularly fond of *Salvia calolophos,* a native of northern Argentina. It is a mounding plant, 2 feet (0.6 meter) high and 2 feet (0.6 meter) across, with deep blue flowers with a white throat. In its native habitat it grows in dry, rocky soils and as a cultivated plant can quickly meet its end when overwatered.

Salvia foveolata, a species from Haiti, is decidedly tropical but it grows well in Rolando's garden. It can reach a height of 12 feet (3.6 meters) and has large yellow, tubular flowers with basal bracts that are dark red. It is a cloud forest species that thrives in humid environments. It is not dissimilar to *Salvia aspera*, a Mexican species with yellow flowers. A new cultivar, 'Early Sunshine', has yellow flowers with prominent purple-red calyces.

Salvia cuatrecasana is a rare and endangered sage from high-altitude Colombia. Rolando obtained his first seeds of the plant from the Bogotá Botanical Garden. It is a tropical shrub, growing up to 5 feet (1.5 meters) and has hairy stems and fuchsia-colored flowers with a white dot. In the garden, it grows in part shade and flowers in the fall.

Rolando has expanded his plant-breeding operation to make a living. He searches for rare and endangered salvias to protect and preserve them, citing "conservation through cultivation" as his mantra. In much of South America, mining is destroying habitats at an alarming rate. The reality of climate change is already causing havoc, with many *Salvia* species succumbing to weather conditions beyond their natural range. They are dying of increased heat and drought. They are disappearing.

The history of horticulture is full of stories of plant hunters and the plants they have introduced—we think of Ernest Henry "Chinese" Wilson, George Forrest, David Douglas, Tom Hart Dyke, and Dan Hinkley. These adventurers have brought back treasures for our gardens and saved plants from extinction. Rolando Uría may not be as famous yet but he is certainly worthy of being counted among them.

The green hummingbird (*Chlorostilbon lucidus*) feeds on the nectar of salvias in the Argentine spring and summer.

This large salvia, *Salvia foveolata*, grows up to 12 feet (3.6 meters) and offers yellow flowers—something to talk about.

→ Try a *Salvia cuatrecasana* at home if you can get it. This tropical shrub is rare, intriguing, and desirable.

Salvia calolophos grows well in dry, rocky soil and thrives on what most gardeners would consider neglect.

← Intensely blue flowers and a height of over 5 feet (1.5 meters) make *Salvia pallida* 'Iberá' a noteworthy choice for the garden.

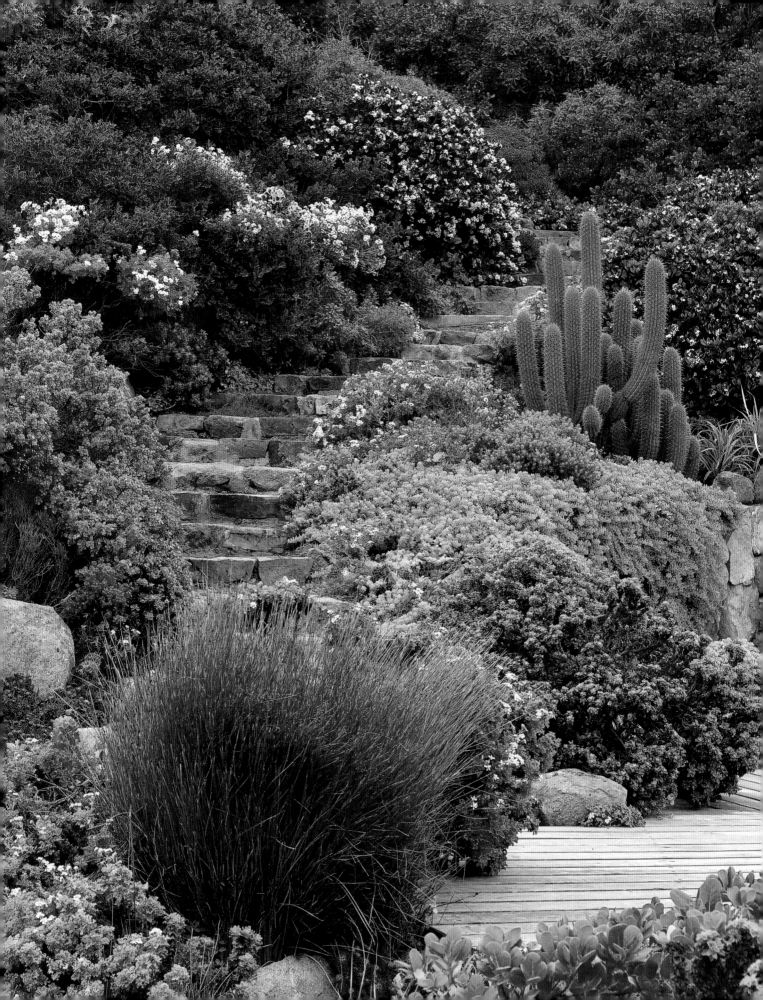

Juan Grimm Gardens

CHILE, URUGUAY, AND ARGENTINA

ONE OF THE MOST storied careers in contemporary garden design started with wet towels. When Juan Grimm was a boy, his family would go to the beach to escape the heat of the city. His brothers would play soccer on the sand. Juan, uninterested in ball games, would take the wet beach towels, fold them, and make shapes with them. Shapes of dreamed houses and gardens. The child imagines. With luck, the adult becomes that imagining. Grimm became an architect. But he began to move outward. Into the wild. He began to design gardens. Over a thirty-five-year career, he has designed over 600 parks and gardens worldwide. As an architect, he learned to build spaces, then applied those skills to providing a framework for outdoor spaces, all the while recognizing that there is a diffraction, a bending of the light and a change of mood that can take place only outdoors, in nature.

BAHIA AZUL GARDEN, COAST OF CHILE

Many years later, Grimm's dreams manifested as a real house and garden cantilevered over a cliff and overlooking the deep sea: Bahia Azul. It is where he lives. It is not where he works. It is too beautiful for work.

The architecture relies on planes as confident and prominent as the ocean's horizon, softened and eased by plump native shrubs and even the unpredictable undulations of the massive boulder outcropping on which the house rests. Decorative plants—alstroemerias, fuchsias, and spiky puya—are speckled between the round shrubs to add perfectly orchestrated moments of light and levity in a garden whose intensity might otherwise make it at risk of taking itself slightly too seriously. The garden doesn't end at the edge of the nearby cliff, but bravely cascades down to a circular swimming pool, then over jagged rocks to the ultimate infinity pool, the Pacific Ocean.

Shrubs in an intriguingly moody arrangement of deep colors and varied textures tumble down a hillside at Bahia Azul, Juan Grimm's home on the Chilean coast.

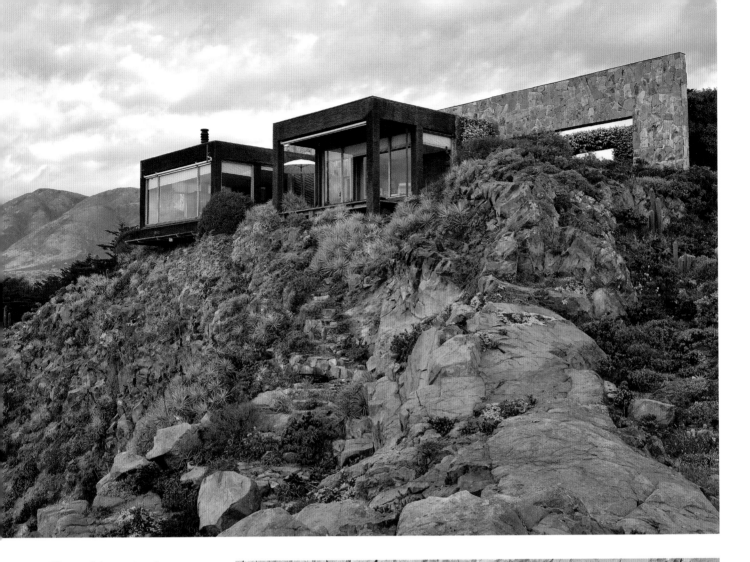

Plants of distinctive shapes—globe cacti, tight hedges, wandering shrubs—form as much a part of the architecture of Grimm's landscape as the house's walls.

→ Plants in a surprising array of hues thrive in sharp crevices on the imposing outcrop of rock where the house is perched.

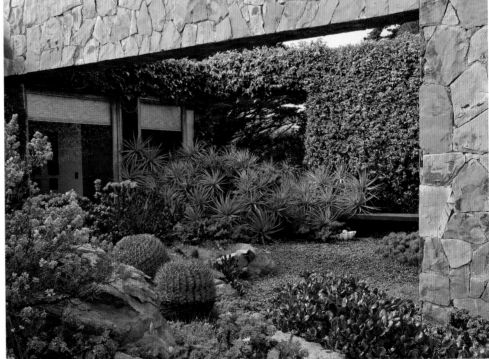

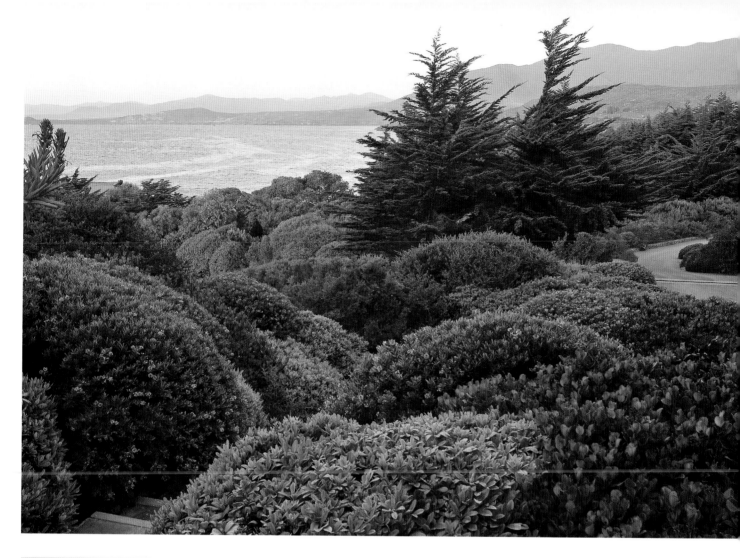

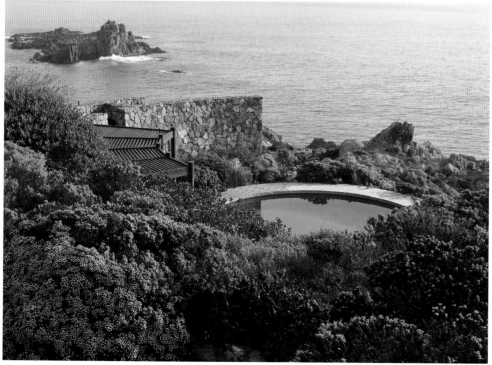

A path between rounded shrubs invites visitors down to the circular pool, which lies below the level of the main house. The soft lines of both the shrubs and the pool contrast pleasantly with the jagged rocks, sharpness of the mountains, and the horizontal line of the ocean.

LOS LAGOS PARK, MONTEVIDEO, URUGUAY

In the public sphere, Grimm has designed a park close to Montevideo. It is a place for nature, albeit designed nature. Most of Uruguay is prairie. Clusters of trees grow close to water, and Australian eucalyptus and the Californian Monterey pine (*Pinus radiata*) are now widely planted. Humboldt's willow (*Salix humboldtiana*), native to the region, also grows close to the watercourses.

Los Lagos, created on a former landfill, has three man-made lagoons and plenty of woodland. In this hot and humid city, it is a place to escape, a good place for bird watching. Southern lapwings wade in the water while the occasional imperial shag dries its wings, perched on the rocks. Grimm inserts his design as gently as possible, bending nature, not imposing it in his design, to accommodate human visitors. It is deceptively simple, yet it is seductive.

The planting is scattered with endemic palms, like the jelly palm (*Butia capitata*), and "exotic" trees such as the American bald cypress (*Taxodium distichum*) and the Asian camphor tree (*Cinnamomum camphora*). Large blocks of pale gray quarried granite along the side and in the lagoons are a remarkable and unusual inclusion, both a commotion and a congruent addition. They disturb precisely because they are obviously man-made and man-placed. They fracture the green outline of the water and puncture the congruity of the vegetation. But this was never a pristine natural area, at least not in living memory, so the stone blocks act as contrapuntal sculptures, solid waypoints for the eye to rest within the torrent of willows and water. Grimm describes the park as having two feelings: of a Japanese garden, and of an English park. He admits that he prefers the Japanese style, describing English gardens as "often far too pretty."

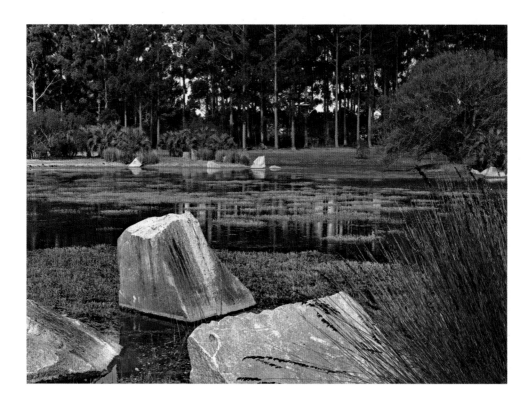

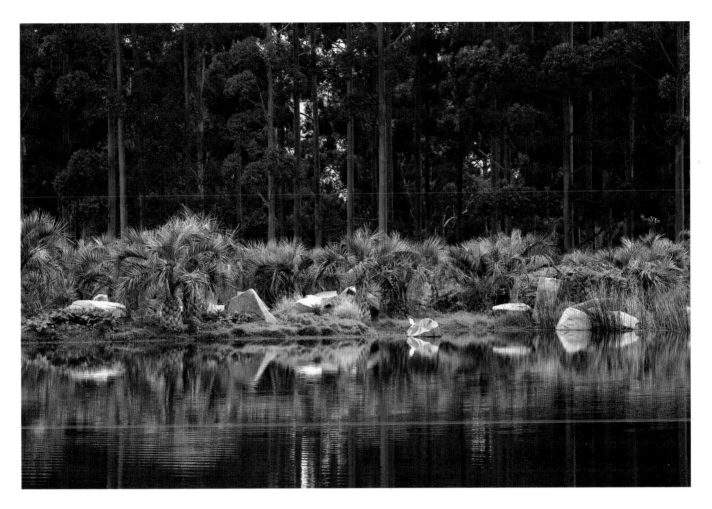

A simple planting of palms against a background of eucalyptus makes the most of the pond's reflective quality, bringing the unique combination's color scheme out far onto the water.

← Jelly palm (*Butia capitata*) and a Bismarck palm (*Bismarckia nobilis*) frame a view of one of the lakes.

(opposite) Precise placement of roughly shaped rocks at Los Lagos creates an appealing visual tension between water and land, furthering the designer's play on the roles of manicured areas and wilder elements that occurs throughout the park.

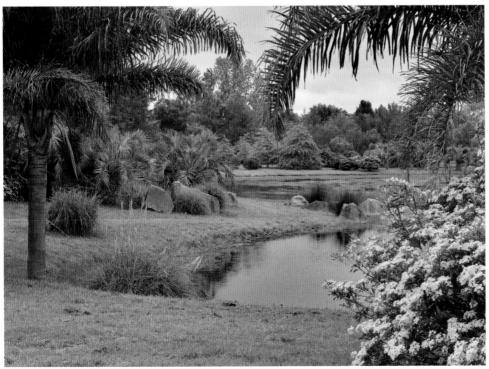

In a large private property in San Martín de los Andes, Argentina, Grimm has created a garden of abundant trees and shrubs on a property that borders slopes of a volcano, a fast-flowing river, and the shores of a lake.

Close to Parque Nacional Lanín, a 1,000-acre (405-hectare) preserve, the garden slopes gently down from the main house. Using the endemic flora and balancing the potential wildness with gracefully sweeping lawn, he has created a garden whose elegance derives from its balance with the surrounding magnificence. Wisely determining that competition with a forest and a volcano was futile, he has grouped native species of trees, the southern beeches (*Nothofagus obliqua*, *N. pumilio*, *N. dombeyi*), interspersed them with the endemic monkey puzzle tree (*Araucaria araucana*), and added shrubs to literally round it off.

The beeches, the dominant trees of the region, are generally small-leaved evergreen deciduous trees. They have a light and airy look and grow to a great age. The monkey puzzle trees, placed as absurd novelties in small Victorian gardens, finally feel proper here—to a Western eye. They grow sparsely and add a deep green, coniferous steadiness to the seasonally fickle beech forest. "When you work with nature, you don't know what is going to happen. A great idea is an event of nature. That is the magic of landscape architecture," Grimm says. Anyone, however, viewing the harmony of color this garden provides in autumn, when the beeches turn gold and red, dense with color but soft with light, might suspect he has studied nature closely enough to know precisely what will happen at his hand. Clipped shrubs lead a tumbling view through trees and down to the river, and the sun shines on the whole through the mountains. The garden is perfect.

The house at San Martin de los Andes is surrounded by cultivated conifers and nothofagus in front, while the untamed slopes of a volcano serve as its enviable backyard.

← Seen here in midsummer, the garden reveals how Grimm uses plants as sculpture to create shaped spaces and a mood of controlled wildness.

Parque Explorador Quilapilún

COLINA, CHILE

Consuelo Bravos · 11 acres (4.5 hectares) · 2014

THE NEWEST BOTANICAL GARDEN in Chile, Parque Explorador Quilapilún, is part of a 939-acre (380-hectare) conservation project, and was designed by Harvard-educated landscape architect Consuelo Bravo. Its three highlights are plant collections, hardscape design, and environmental remediation.

The remediation is a project funded by AngloAmerican, a multinational mining company, to repair the land near one of its containment dams that was found to contain poisonous copper waste from its mines in the Andes. The funding also supported the park's design, construction, and environmental and other educational programs.

The valley in which the park lies is part of the intermediate depression that separates the Andes from the Coastal Range. At an altitude of about 2,000 feet (610 meters) above sea level and with a Mediterranean climate, it gets blisteringly hot and dry in the summer. Without a hat and water, the visitor can suffer from heat-induced intermediate depression quite quickly. The entrance to the garden is marked with a demi-colonnade of Chilean wine palms (*Jubaea chilensis*), a palm with the thickest trunk of the family and so named because their sap can be used to make a fermented drink. While the sap is intoxicating for humans, the tree is killed in the harvesting process, and it is consequently now relatively rare in the wild.

The garden's concrete paths are wide, long, and angled—the term hardscape is particularly apt to describe them. Geometrically distinct beds are cut by their acute lines. A local rufous stone is used as mulch, the volcanic ferocity with which it was formed and indeed placed in the garden seems an appropriate accompaniment to the spiky sclerophyllous trees growing out of it.

Echinopsis chiloensis, one of the most prominent and recognizable cacti in Chile, can reach a height of 25 feet (8 meters). Its white flowers bloom at night.

A striking combination of *Verbena bonariensis* blooms, and feather-like seed heads of *Aristida pallens* remind us that to caress the living world is to be alive.

→ *Puya chilensis* is a relative of the pineapple. Springtime flower spikes can reach up to 12 feet (3.7 meters) while the plant can be 6 feet (1.8 meters) wide.

Drought is dominant, of course, and the thorny forest contains tough trees. *Acacia caven* is a small, flat-topped tree with yellow flowers and large brown seedpods. The wood is used for fence posts by humans, while the flowers are an important food source for bees. Chilean mesquite (*Prosopis chilensis*) is a large, spiny tree common in the arid region. It is a staple food for cattle, as well as a source of firewood for the local population.

The farthest reaches of the garden contain the taller trees of the hard-leaf forest. Boldo (*Peumus boldus*) is the prevailing tree, its camphor-like aromatic flowers and leaves perfuming the area, particularly as the sun goes down. It is widely used in alternative medicine, where it is used for dyspepsia, and in cooking, where it is used in a way similar to bay leaves. No Chilean landscape would be complete without the injection of some striking cacti silhouettes, and here *Echinopsis chiloensis*, a proper tree cactus, belongs in the forest too, thanks to its radial stems that can reach up to 25 feet (8 meters) in height.

Lest the garden give visitors the impression that all in the surrounding mountains is hard and spiny, scrabbling to survive by projecting thorns at innumerable angles, the garden is also populated with sweeps of local grasses, soft green in spring and early summer, gold in late summer to winter. *Aristida pallens*, a fine-textured grass, is planted with the native *Verbena bonariensis*, widely planted as an annual in faraway temperate gardens. *Amelichloa caudata* is a grass that forms tussocks, while the golden spikelets of Cola de Zorro (*Cortaderia rudiuscula*), a form of pampas grass, tower loftily above the rest of the garden's foliage as they float almost 10 feet (3 meters) above the parched ground.

The glory of the garden, indeed the glory of all Chile, is *Puya chilensis*. This bromeliad grows wild in the rocky slopes of the Andes, forming large rosettes of gray-green leaves edged with hook-shaped spines. When it flowers, it puts even the most zealous landscape architecture to shame by comparison. Spikes of bright chartreuse yellow flowers up to 6 feet high (1.8 meters) thrust out of the round base in spring and early summer, trumpet within trumpet, reaching for the sky.

The park is a gift for the people of Chile and for those adventurous enough to travel outside the tourist spots of Santiago—what a pity it would be to miss the puya for lack of inquiring what else might be nearby. This garden, with its magnificent native plants, tells us that the real wealth of Chile is its natural environment, and reminds us that the marvels of the world are out there, waiting patiently for us to pay attention to them for their inherent beauty.

Volcanic rock is used here as a site-appropriate mulch between acacia and other dry-tolerant tree species.

→ *Acacia caven*, a tough tree suited to arid zones, bears prominent seedpods.

(opposite) *Lobelia tupa* is called the devil's tobacco, a less than flattering name for a fine plant. It grows to a height of 6 feet (1.8 meters) and its red flowers appear in late summer and autumn.

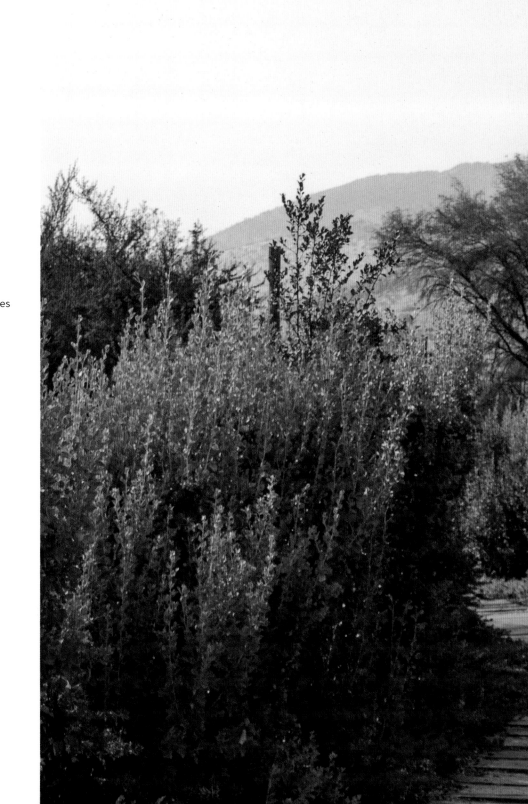

The Parque Explorador Quilapilún lies in the dry foothills of the Andes.

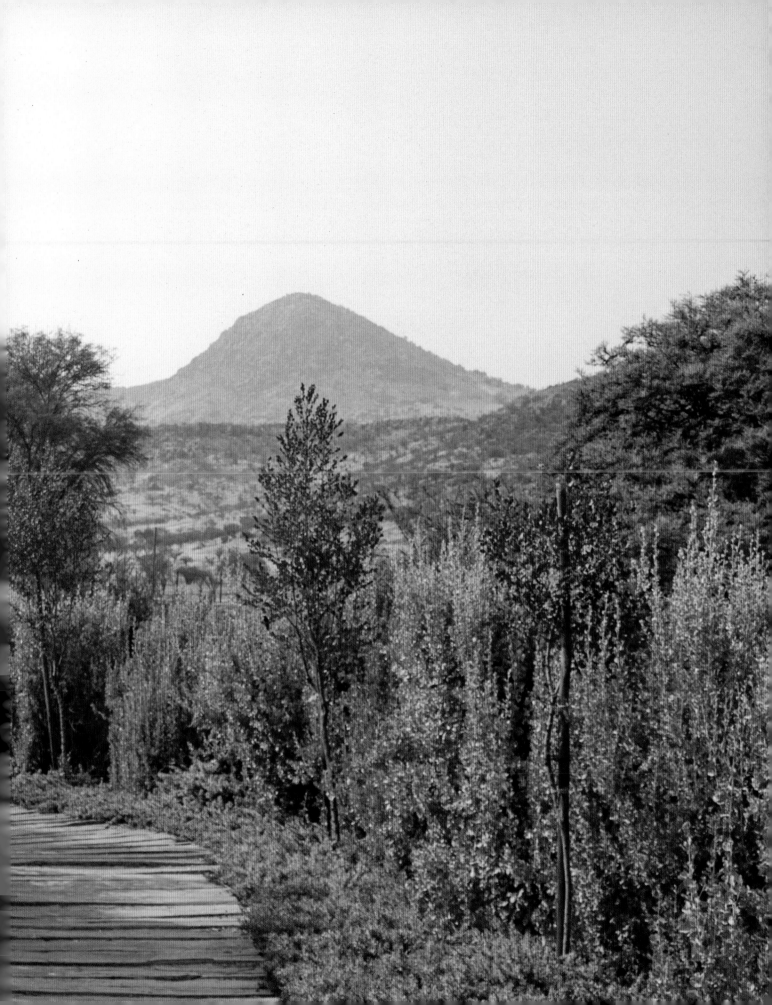

europe

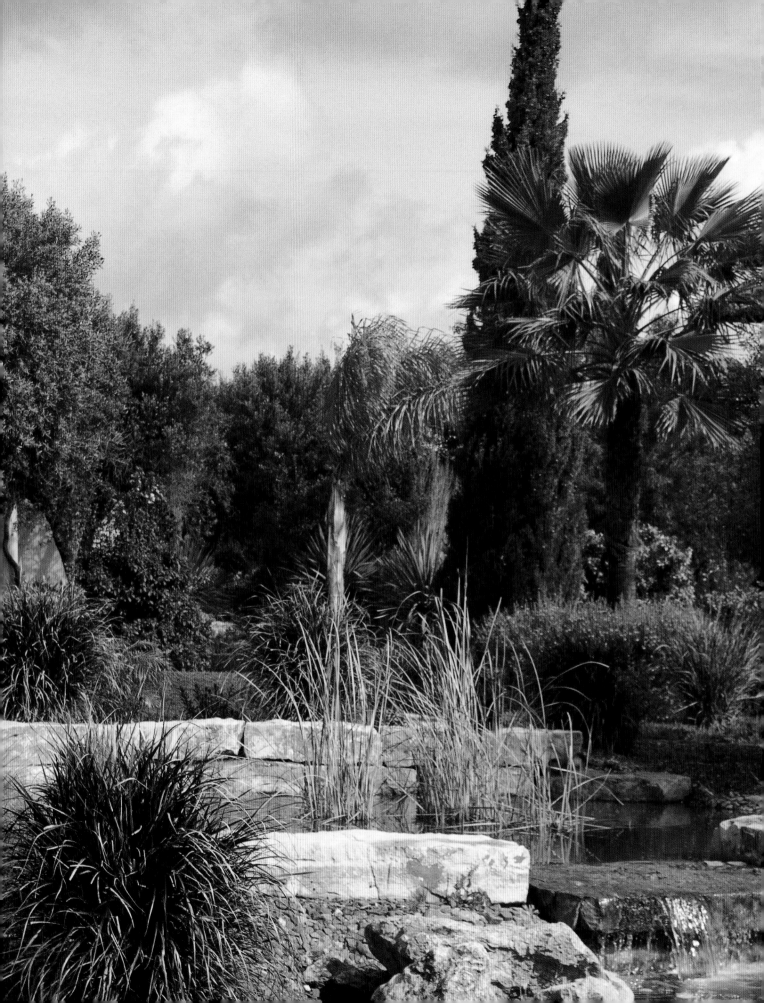

Iúri Chagas Gardens

THE ALGARVE, PORTUGAL

IÚRI CHAGAS WAS BORN and raised in the Algarve, in southern Portugal. It was a world of small farms, cork oaks, carob, oranges, and figs. He fished for sardines with his grandfather, helped repair the red-stone walls around his farm, and searched for wild orchids in the hay fields.

He became a landscape architect—one who actually knows about plants. Although just now in his early thirties, Chagas has designed a number of residential gardens in the region. He brings a design sensibility that is intrinsically Portuguese, with an innate awareness of the Algarvean climate and soil.

The Muslim influence and climate in the Algarve has resulted in many houses being painted in simple white and decorated with two things to give them individuality: ornate chimneys reminiscent of mini minarets, and intricately patterned tiles, often blue and white, called *azulejos*. Recently, many Northern Europeans have moved to the Algarve, building contemporary houses, some of which attempt to retain elements of Moorish influence. New houses need new gardens, so Chagas has likewise been busy trying to honor the region's Moorish history while creating gardens that feel satisfactorily modern.

PRIVATE GARDEN
1 to 3 acres (0.4 to 1.2 hectares) · 2014 to 2015

In 2015, Chagas completed a 1,076-square-yard (900-square-meter) back garden with a pond feeding into a small lake. In such a dry summer climate, the sight and sound of water comes as a great physical and psychological relief. It's a benefit for wildlife too—the endangered Mediterranean chameleon likes to sit in the almond trees close to the water.

Olives, palms, and Italian cypress combine with a grassy understory to provide elements expected of a quintessential Mediterranean garden, while Chagas's forward-looking design brings them into the modern day.

A rock with a lot of character and rosemary (*Rosmarinus officinalis*) are two simple ingredients that combine to create an intriguing vignette.

A mixture of native and drought-adapted plants give the garden an open and light feel even while it is in fact planted intensively. A native carob tree (*Ceratonia siliqua*), a large evergreen that bears pods of sweet seed, anchors the side of a large pergola. The pond and the lake are edged with fawn-colored stone from Cerro de São Miguel and river stone from the Ribeira da Asseca in Tavira. Limestone outcroppings, once buried deep, are colored with red and orange minerals, and are placed around the garden. Close to the water is the small Mediterranean fan palm, *Chamaerops humilis*, and with it, clumps of red fountain grass (*Pennisetum ×advena* 'Rubrum'), and tufts of green Mexican feather grass (*Nasella tenuissima*), which turns blond in summer. Pygmy date palms (*Phoenix roebelenii*) and Queen palms (*Syagrus romanzoffiana*) shoot their coarse, feather-like fronds high above the other plants. Cork oaks (*Quercus suber*), a native tree widely grown in Portugal, are placed throughout the garden, their thick, deep bark a rough counterpoint to the refinement of the graceful grasses. Another native, familiar to many, is rosemary. Here, the low-growing form, *Rosmarinus officinalis* 'Prostratus', acts as a fragranced ground cover. A particularly compact selection is used to edge the paths.

The garden flows away from the house into the pond and lake and then out to a former orchard filled with oranges (*Citrus* sp.), almonds (*Prunus dulcis*), and naturalized figs (*Ficus carica*). While the garden has a constructed formality, it is the apposition of garden and old orchard that gives the whole a deeply romantic atmosphere.

PRIVATE GARDEN

1 acre (0.4 hectare) · 2015

A much different garden by Iúri Chagas, near the coastal town of Albufeira in Portugal, is simpler and stronger in its landscape architecture. It too is a water garden but with large, round pads of white stepping-stones slithering through the water like a polka-dotted python. All shape and texture, it is a small private garden with a lot of impact. The shiny green unfurling of sago palm (*Cycas revoluta*), the blue-hazed fans of the Mexican blue palm (*Brahea armata*), and the hefty paddles of the giant white bird of paradise (*Strelitzia nicolai*) confirm that large plants in a small space, through a trick in perception, make that space appear much larger than it actually is.

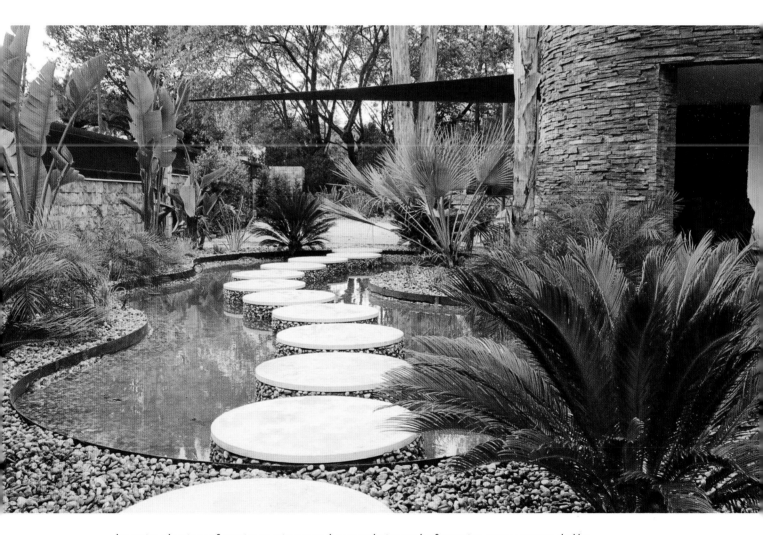

Intensive plantings of outsize specimens and a meandering path of stepping-stones surrounded by a narrow pool help make this small private garden seem large.

SERENOA
REPENS

Quinta da Granja

MIRANDA DO CORVO, PORTUGAL

Kevin G. Scales · 2.5 acres (1 hectare) · 2014

KEVIN SCALES MOVED FROM Norfolk, England, to Portugal for a very logical reason from a plant lover's point of view: so he could grow bananas. Not for the fruit, but for their colorful ornamental leaves. Scales is a rather colorful character, too.

Bananas, originating in Southeast Asia, were imported into Europe and the New World as early as the 1500s. It wasn't until the late 1800s, though, that the banana we know today became a popular fruit. Growing them for ornamental use alone is a more recent phenomenon still, once largely confined to tropical gardens or conservatories in the temperate world. In the late twentieth century and into this one, gardeners beleaguered by cold winters have been growing bananas outdoors and then moving them into protected areas during inhospitable months. Christopher Lloyd played with bananas at Great Dixter in England, and at Chanticleer, in Pennsylvania, ornamental bananas have been a key feature of a particularly sheltered courtyard garden for some years.

Kevin Scales became obsessed with tropical plants while growing up in chilly Norfolk. After a career in retail management, he made his obsession into a full-time occupation. In 2013, Scales created an exhibit at the Royal Horticultural Society's Hampton Court Show titled, "Don't be afraid of big leaves and monsters. Hats off to the plant explorers." He won a gold medal and, although there has been an explosion of interest in tropical plants in the United Kingdom, some traditionalists sniffed. He was not deterred. When asked if there was such a thing as a British style, he said, "Yes, too many people saying 'you can't do that!' I started my tropical garden and people told me it wouldn't work, but it did and it was wonderful. I knew I could do it—and I did."

Musa griersonii, a fast-growing banana native to northern India, confers happily with *Serenoa repens*, saw palmetto, from the southeastern United States. This musa can reach a height of 13 feet (4 meters), while the palmetto grows to 10 feet (3 meters).

Now living in Portugal with his partner, Steve Eldred, Scales gardens in a mild, subtropical climate and can more or less grow all the bananas he wants. Situated on a terraced slope and surrounded by 7.5 acres (3 hectares) of olives, cork oaks, and Australian eucalyptus, the garden faces south and gets hot in the summer but is perfect in the spring and fall. Winter is barely winter there, but the occasional sharp frost does happen—sharp enough to hurt the bananas and other tender plants. "I should have a garden in Hawaii," he noted with a slight grimace and a few expletives as he looked at a damaged plant.

Musa basjoo, the Japanese fiber banana, is the hardiest of all. It makes large clumps up to 15 feet (4.6 meters) tall and has flat green leaves. *Ensete ventricosum*, the Ethiopian banana, can grow to 20 feet (6 meters), but unlike *Musa*, does not produce offshoots. The cultivar 'Maurelii' has red midribs and a leaf color that ranges from red-brown to purple-red. 'Montbeliardii' has darker red tones and looks almost black in the red of sunset. It is one of Scales's favorites.

Lest he be typecast as a bananaphile, he's rather fond of palm trees too. With much excitement, he grows *Trachycarpus* 'Nova.' This fast-growing, cold-hardy cultivar may be a form of *T. princeps* or *T. fortuneii*. Whatever its parentage, everyone does seem able to agree on the attractiveness of its slender trunk and deeply cut, even leaves.

Bananas and palms "pull the sky down," as Scales says. "Our eyes follow the plants from the ground to the top of the leaves and then they seem to stop. We look up to the sky as if it were something separate. Using big and tall foliage makes us look up, but we see the sky as part of the drama of that foliage, and the drama of the garden. The sky then becomes an important feature of the garden." It is one of his design principles, although he would never use that phrase. He is a man without principles, in the garden. "I was never formally trained as a gardener or garden designer, and I think that's an advantage. I don't come with prejudice. I come with enthusiasm."

His natural artistic sensitivity is apparent in the garden surrounding his house and garden. On the south terrace, he has pruned an olive tree (*Olea europaea*) in a cloud bonsai way; without enough soil there to harbor its root ball, he was forced to place the tree in a container. Instead of just sticking a pot on the patio, though, he paved up and over the base of the tree with *calçada portuguesa*, Portuguese traditional tiles. It's a charmingly unexpected central feature.

Other intriguingly unorthodox surprises await. On one side of the house, a row of twelve identical stone pots are filled with twelve identical, bronze-hued succulents. An oil jar dating to 1679 sits humbly in a corner of a walkway. Underneath a porch, crowds of plants, protected from the cold and from the hot sun, sit like a gathering of friends waiting for a drink.

At nightfall, Scales often sits on the terrace, a glass of wine in hand, while Eldred plays Schumann on the piano in the living room. Dogs sleep at their feet. The impatient gardener becomes lost in reverie. "This is the garden of my wildest dreams," he says.

To the side of the house, a narrow bed contains a bevy of bananas and young *Alocasia macrorrhizos* 'Borneo Giant', a giant taro that will reach 10 feet (3 meters) tall and support leaves 5 feet (1.5 meters) wide.

The main terrace is kept spare to emphasize the view of oaks, olives, and eucalyptus. A large agave adds a counterpoint of green.

→ When grown in full sun, the normally yellow-green leaves of *Sedum adolphii* turn a soft orange-red.

(opposite) Scales uses traditional Portuguese tiles in place of a conventional pot to accommodate a uniquely pruned olive tree on the terrace.

Different textures of foliage form a lush backdrop for a showy pink canna.

Trachycarpus 'Nova', a cold-hardy, fast-growing palm, has aficionados in a tizzy.

Washingtonia robusta, the Mexican fan palm, at left, begins a chorus line that includes *Ensete ventricosum* 'Red Stripe', Ethiopian banana, and *Musa sikkimensis*, the Darjeeling banana.

(opposite) A weathered stone pot holds *Colocasia esculenta* 'Burgundy Stemmed', which has 6-foot (1.8-meter) stems and 3-foot (0.9-meter) leaves.

Camellia japonica (left) adds to the romance of the property's old water mill.

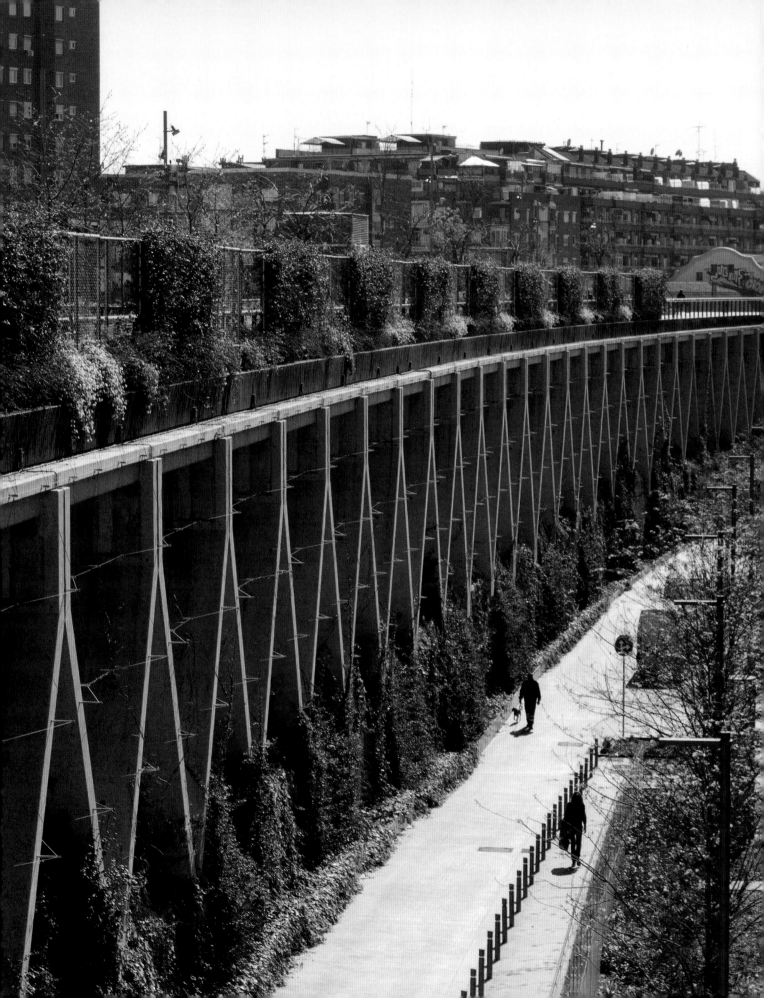

Jardins de la Rambla de Sants

BARCELONA, SPAIN

Sergi Godia, Ana Molino · 12 acres (4.9 hectares) · 2016

WHEN BARCELONA SET OUT to create an elevated park, Los Jardins de la Rambla de Sants (the Elevated Gardens of Sants), which has been called "the Spanish High Line" after the High Line in New York City, it did so with a unique, socially conscious, and egalitarian goal in mind: joining two working-class and ethnically diverse communities divided by a busy railroad line.

The New York High Line has garnered praise and acclaim—and rightly so. It is horti-culturally and artistically sophisticated and its popularity and consequent marketing has added new heights of architecture, wealth, and epicurean living to one of the last parts of Manhattan to be mostly devoid of those things.

Without the luxury of starting with an unused but charming rail line, as in New York, the Barcelona architects opted to build a support structure and new deck over active tracks and, in doing so, have created an entirely new recreational space where none existed before. It is not without controversy, but then few public works ever are. Locals are rightfully wary of green gentrification—the gift that keeps on taking.

To cover the rail lines, Godia and Molina designed a long, rectangular armature of pre-fabricated concrete diagonal beams. These give the impression that the park is resting on a series of triangles, which in turn create a pleasing rhythm when viewed into the distance. It makes the intervention feel like some sort of modern-day aqueduct bringing life deep into the center of the city. Glazing is used to fill open areas in the geometry, so trains can be seen but not heard. Vines, trained on wires, will gradually grow up these concrete cages, creating a veritable hanging garden.

Prefabricated concrete beams enclose the rail line running within, support the upper footpath, provide a structure on which vines will eventually grow high, and create a distinctive visual pattern for the whole garden.

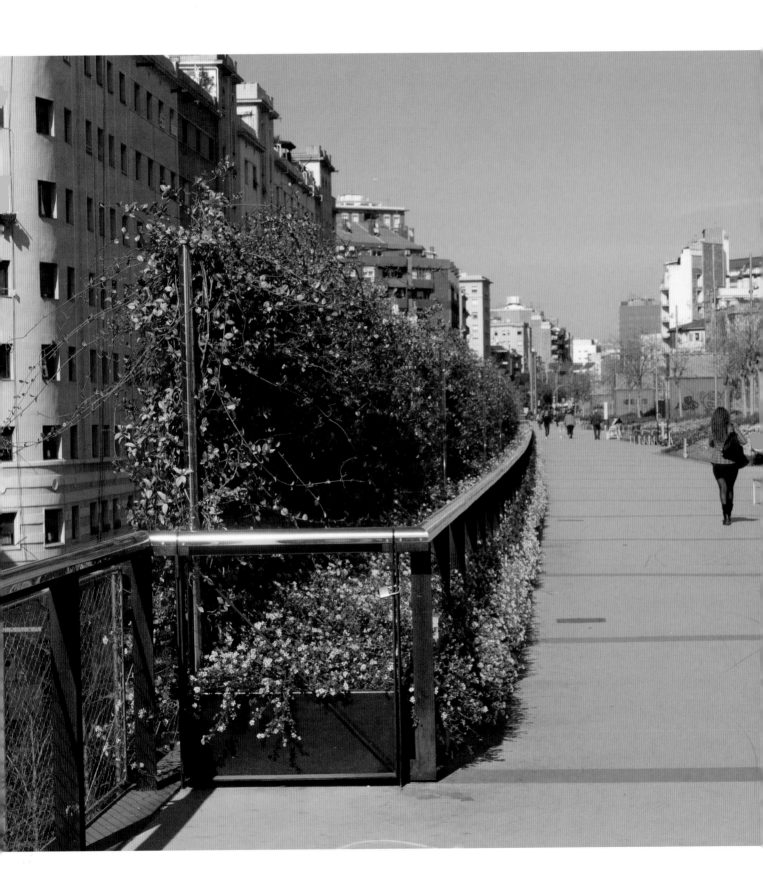

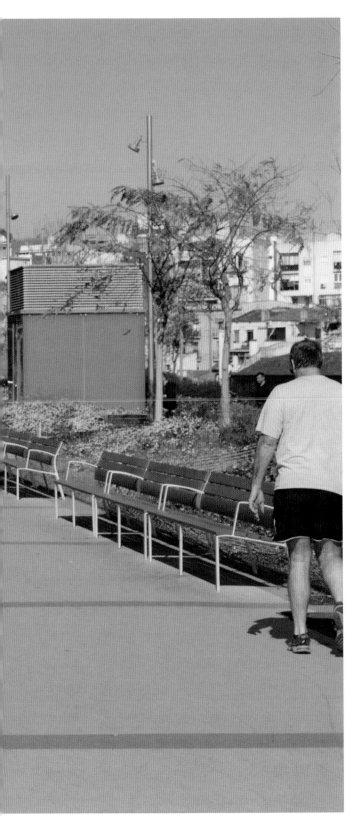

Salvia 'Royal Bumble' is a dramatic plant notable for its purple-black calyces and stems as well as its bright red flowers that last for a long period throughout the year in this Mediterranean climate.

← The pale turquoise color of the path creates a continuum of color with the acrylic panels. It is a cool color for the hot side of the garden.

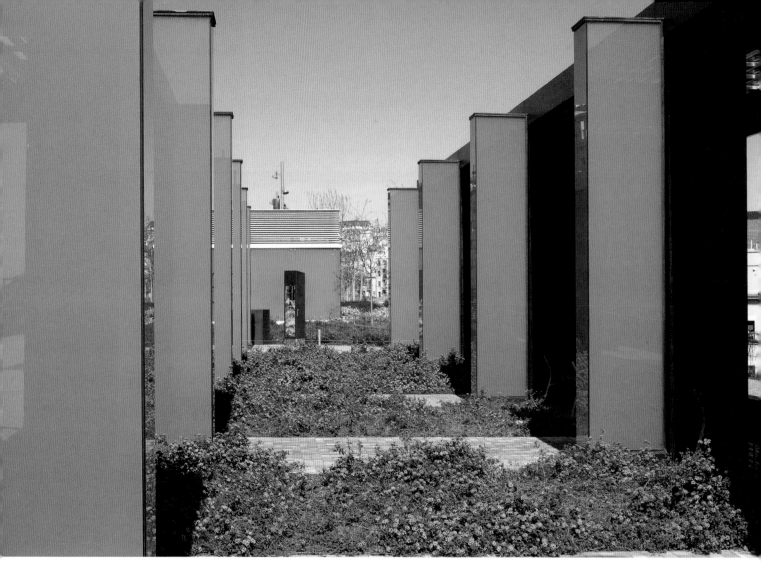

Decorative panels of turquoise acrylic disguise support columns on the back of pergolas by day and function as lanterns by night. In between lie large swaths of *Lantana montevidensis*, a wise choice for hard-to-reach areas since it needs little maintenance.

→ The silvery underside of waterwise, tough evergreen *Teucrium fruticans* 'Azureum' leaves catch sunlight, while the shrub's flowers add a deep blue to rival the color of the Catalonian sky.

The roof of the enclosure creates the footpath of the promenade, 40 feet (12 meters) high at its highest. A total of 875 linear feet (267 meters) of garden is separated by paths into a shaded area along the north side and a permanently sunny area along the south. Pergolas fitted with plenty of benches, roofed with photovoltaic panels, provide resting places. A gateway—or umbraculum, to be correct about it—forms the entrance from the Plaza de Sants.

To give the eye visual pauses along the length of the garden, the plantings are massed in rectangular and curving, rising and falling, beds that break up the rectilinear path. Flowering from late winter into late autumn, a bright red, bushy, evergreen sage, *Salvia* 'Royal Bumble', with almost black stems and calyxes, fills a good part of the sunny borders. It's a luscious thing, all velvety and soft, buzzing with bees.

A cooler color proliferates with *Teucrium fruticans* 'Azureum', a silvery shrub about 5 feet (1.5 meters) tall with deep blue flowers for most of the year except the dead of winter. It is native to Spain and Portugal and is often seen pruned into globes and other unfathomable topiaries. In this garden, it rests happily in a large mass, pruned but not absurdly.

Trees are a necessity anywhere people might want to gather in the hard Catalan sun, and here the apricot-colored flowers of tipuana (*Tipuana tipu*), a large tree native to South America, add beauty to the large canopy. The golden raintree, *Koelreuteria paniculata*, is also used because it's a good choice for hot sun and poor soil. As its common name suggests, yellow flowers in great profusion bloom from the tips of the branches, the spent blossoms covering the ground when the wind blows. In late spring, *Malus* 'Evereste', a crab apple with red flower buds opening to white flowers, marks the turning of the cool season to the hot Mediterranean summer.

Shrubs, such as *Cistus albidus*, native to Spain, with gray leaves and purple-pink flowers, the white-flowering tree heather *Erica arborea*, and *Lantana montevidensis* 'Alba', with trailing white flowers, complete the well-thought-out understory.

A crowded part of the city now has a place to see itself from a new vantage point, flowers to smell, and somewhere safe to walk. A garden.

Lantana montevidensis 'Alba' is a low-growing plant that gets about 2 feet (0.6 meter) tall and trails to 10 feet (3 meters). It is a tough ground cover for sunny, hot areas that blooms profusely and continuously.

The Garden of Stone

PERATALLADA, SPAIN

Mesura · 0.5 acre (0.2 hectare) · 2016

IN COASTAL SPAIN, where precipitation is scarce, especially in the dry summer months, people have been using stone to shield themselves from the sun in the way others use shade trees. The village of Peratallada, near Girona, has been doing this since the tenth century, when it began as a fortified settlement—its name translates to "carved stone." In the eleventh century a castle was built up, then three castellated towers, the Place de les Voltes, and a series of medieval arcades. It is one of the most beautiful villages in Spain. To rub a hand against the rough stone walls in the heat, to place your cheek against it, is to feel its long history.

Mesura, a company of architects based in Barcelona, was commissioned to reconfigure the now privately owned castle into a private and public space. The challenge was to help the medieval flow into the modern. They did this in three phases, the first being the creation of a terraced garden and a small vacation house, once a small farmhouse. The second phase is the creation of a luxury hotel, the third, a museum.

At first glance, it seems quite simple. The space is defined by the ancient stone walls. The garden is within a courtyard. A rectangular swimming pool with water lapping over one edge creates an 18-inch-high (46-centimeter-high) cascade that sits at right angles to the house. There are few plants—trees, some lavender, and a cycad—yet it is undeniably a garden.

When the builders dug into the thousand-year-old cistern to repair it and create a tank for the recycling water system, they found pieces of pottery. Archaeologists from the nearby university identified them as shards from the second century B.C.E., adding to the responsibility of creating a thoughtful intervention.

An acacia, gnarled and worn with time and heat, presides over the contemporary courtyard.

The smooth travertine pool terrace, roughened by olive and oak bark, lies just in front of the walls of the eleventh-century castle.

Ancient wood and stone provide all the texture the eye desires.

Unlike the masons who served as their inspiration, the architects had the benefit of digital tools to help them piece their stonework together. They selected Turkish white travertine marble, rescued from another site, and jigsawed together steps, pool, benches, and coping. Then, modern technology gave way to ancient handcraft. The pieces were tamped into the correct position using stonemason's mallets and punch hammers, tools that have been in use since the making of the pyramids.

The planting is profoundly simple. In this case, less is less, and less is better. Dominating the courtyard is a hundred-year-old acacia tree, its twisted, thorny presence choreographed with the ancient walls: it arches toward the pool; like a dancer it catches its reflection in the mirrored surface. Two hundred-year-old olives (*Olea europaea*) and a younger cork oak (*Quercus suber*) accompany the older tree, contributing venerably gnarled trunks and flickering evergreen leaves.

A museum is being designed for the same complex, where works by Catalan artists, including sculptor Xavier Corberó, painter Antoni Tàpies, and painter Joan Miró, will be on display. Modern art will grace ancient halls. But in the garden, the tower and the tree more than suffice. There is a pop of cork, the glug of wine being poured. Laughter, and the sun on shoulders. Centuries of chirping sparrows. The heavy scent of lavender. Quiet thoughts. Peace grows in this garden of stone.

Parc Clichy–Batignolles/ Martin Luther King

PARIS, FRANCE

Atelier Jacqueline Osty & Associates · 24.7 acres (10 hectares) · 2007

A STROLL THROUGH PARIS'S Martin Luther King Park is a lesson in multiculturism and multiplicity of uses. Hijab-wearing women walk arm in arm, joggers are everywhere, hipster mothers wheel their babies in futuristic-looking strollers, teenagers skateboard and sneak cigarettes, lovers tell each other sweet lies, and lawyers from the nearby courthouse have lunch and tell not-so-sweet lies.

Saved from becoming a potential site for the 2012 Olympics, and named in honor of the civil rights leader, this salubrious and wonderfully rustic park in northwestern Paris's 17th arrondissement, is a boon to the local residents as well as visitors. The entire area covers 111 acres (45 hectares), and the park, surrounded by new building development that includes public housing, as well as city government buildings, is the community's nucleus.

The area was formerly occupied by warehouses, stockyards, and freight yards for the French railway company SNCF; now a garden occupies the site of an earlier railway platform, transformed into a bridge that leads over the snarl of tracks heading to the Gare Saint-Lazare and then on to a series of sports fields, pétanque courts, and play areas.

New technology and sustainability planning feature prominently here. The park is highly valued as a part of the climate plan adopted by the city in 2007, which set a target of zero carbon dioxide emissions. Many buildings surrounding the park are heated using geothermal technology and are powered by solar energy. Some of the residential buildings are faced with green walls, lush vertical gardens providing insulation as well as beauty that is healthful.

Miscanthus 'Purpurascens', known as flame grass, introduces bold autumn color in the middle of a densely populated neighborhood.

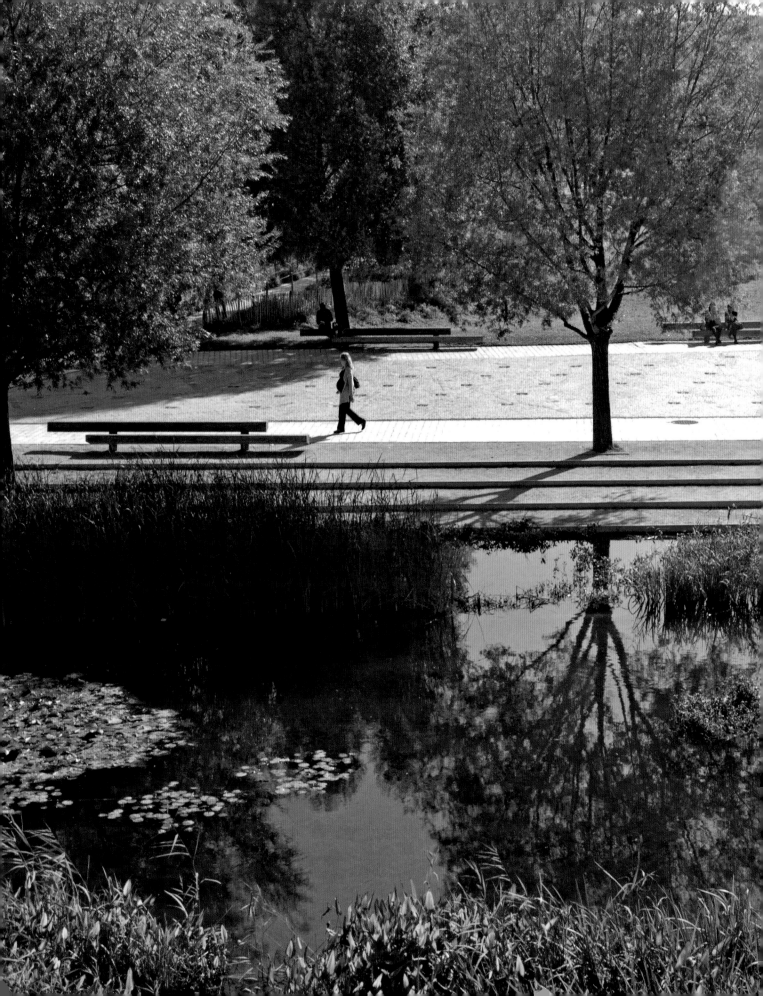

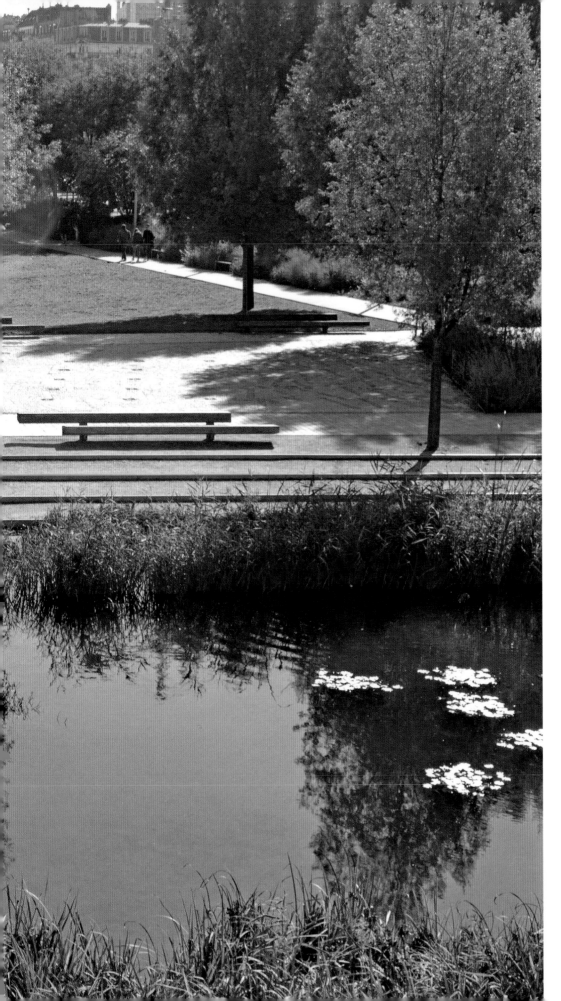

Large rectangular ponds provide a much-needed environment for water-loving flora and fauna in this crowded city.

What the designers dub a "natural prairie" is really highly controlled, but it nevertheless introduces a wilder type of planting that Parisians seldom get to see.

Irrigation comes from rainwater stored in ponds at one end of the garden. Power comes from a small windmill. The paths are made of reconstituted construction material.

A growing urban forest is not only pleasing to the eye but helps lower local temperatures in the summer. The park is thick with trees, in fact, with avenues of scarlet oak (*Quercus coccinea*), golden ash (*Fraxinus excelsior* 'Jaspidea'), and red horse chestnut (*Aesculus* ×*carnea*). There are many smaller spring-flowering trees, in particular the wedding cake dogwood (*Cornus controversa* 'Variegata'), with horizontal branches and pure white flowers; *Magnolia* 'Heaven Scent', with fragrant pink flowers; and Judas tree (*Cercis siliquastrum*), with deep pink flowers in spring. Thousands of snowdrops, daffodils, and blue camassia bloom in spring under the trees and in the lawns, making the park a densely planted garden of a park—an unusual feature in Paris.

One area off-center to the main avenue is sculpted into mounds, dips and hollows, planted with bands of drought-tolerant fountain grass (*Pennisetum alopecuroides*) and flame grass (*Miscanthus* 'Purpurascens'), the last turning orange-red in autumn. Grasses grown in a protected area form what here is called a "natural prairie," installed to provide a "natural evolution area," a place for insects, small mammals, and birds.

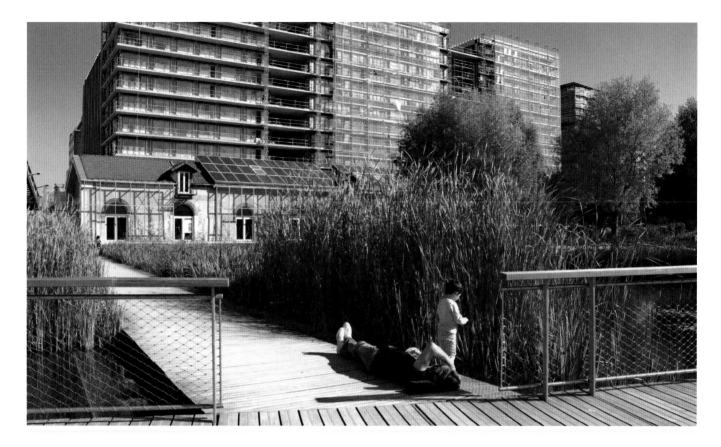

The park is an essential resource for those living and working nearby, and it gets constant use.

Water also is a major ecological and visual component here, and the red water lily (*Nymphaea* 'Attraction'), the narrow-leaved bulrush (*Typha angustifolia*), and arrowhead (*Sagittaria latifolia*) fill a series of rectangular ponds at one end of the park, which are a habitat for fish, frogs, and dragonflies.

The importance of small urban parks like this one cannot be overestimated, particularly for cities like Paris that are constrained by history and laid out with tightly designed geometry, unable to simply decide to develop new open space on a whim. The "casual" design of the park contrasts with the classically laid out parks of Paris—The Tuileries, Champ de Mars, Jardin du Luxembourg—places where visitors are constrained by formality. Small parks, such as this one in Clichy, provide significant local social and psychological benefits, enriching our lives with meaning. They offer nearby recreation opportunities for city dwellers who may otherwise have limited or no access to nature-based recreation.

Periods of time spent in nature appear to reduce anxiety and advance general well-being. City parks provide a place for neighbors to congregate, strengthening community ties, creating healthier communities, and building a social ecology. We know that even a short walk in a park improves mental health, and increases neighborhood vitality.

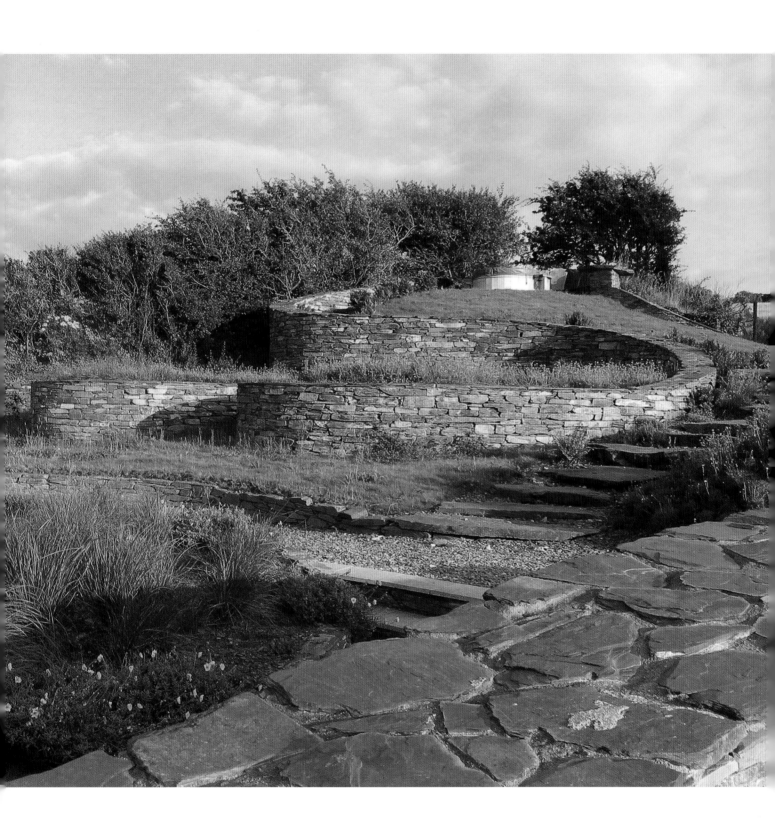

Camel Quarry House

CORNWALL, UNITED KINGDOM

Mary Reynolds, Totti Gifford · 1.2 acres (0.5 hectare) · 2010

"The world is full of magic things, patiently waiting for our senses to grow sharper." —W. B. YEATS

MARY REYNOLDS IS A land lover. To say that she cultivates an intimate and personal relationship with the land would be an understatement. Famous in gardening circles for becoming the youngest person to win a gold medal at the Chelsea Flower Show in 2002, she describes herself as a nature activist and reformed landscape designer. In her book, *The Garden Awakening* (Green Books, 2016), Reynolds writes, "We are losing what few wild places we have left; those places where the spirits of the earth are flowing freely, where harmony and balance still exist, and we feel accepted for the truth of who we are. We have strayed off course and need to find our way again."

Reynolds's feelings toward shaping land are complex and passionate, wildly Irish, poetic, frequently funny, and deeply honest. They are expressed in her gardens, in her writing, in everything about her. You could call her an ecofeminist and she wouldn't disagree.

Camel Quarry House is located near the River Camel on the North Cornwall coast of the Celtic Sea. It is a romantic and wild place full of swirling weather, the cry of curlews, and the silver shine of the crooked river. The house, a modernist glass-and-stone cube, and garden are on the site of a former slate quarry, and the remnants, the shades of gray slate, are the keystone. From these existing features, Reynolds crafted a garden of stone and earthen spirals, twists, and coils.

The undulations of the stone wall echo the folds of the rolling Cornish hills in the distance.

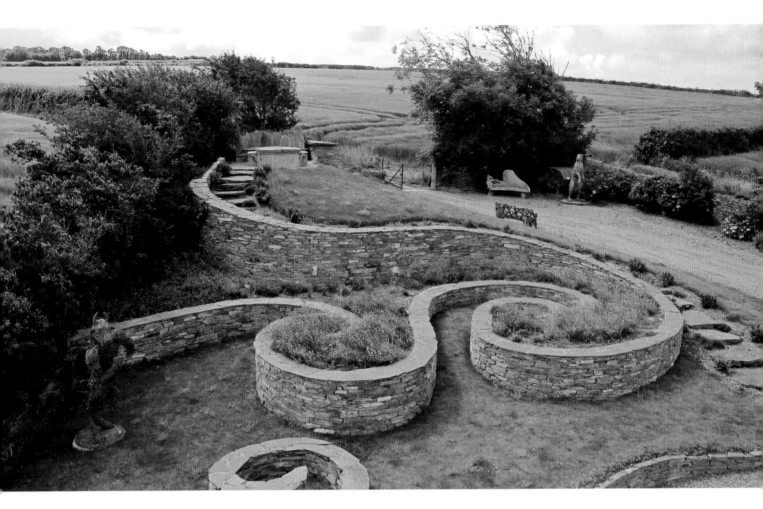

Spiraling walls enfolding the garden reinforce the area's strong Celtic heritage.

→ A slate bench built on a dry-laid wall stone promises a view to the river.

Spirals are a central part of much of Reynolds's work. These ancient symbols embedded in most of the great myths of humanity represent many things: the mythical pilgrimage to find a god or goddess, the womb and fertility, and the fiercely female protective force known as Mother Nature.

Reynolds uses native plants where possible here. The sea pink, or thrift, *Armeria maritima*, grows in the sandy soil and salt air. Wild thyme, *Thymus vulgaris*, and Cornish heath, *Erica vagans*, are planted between the rocks and in the paths. Hardy fuchsia, *Fuchsia magellanica*, native to southern South America, has naturalized in southern Ireland and Cornwall, and is used as a hedging plant, flowers dangling like dancing faeries.

Grasses mirror the waves of wind and sea and the ripples in the sand. The New Zealand wind grass, *Stipa arundinacea*, is planted in masses. It is aptly named, glowing with amber foliage, flouncing in the breeze.

Reynolds is almost happy with the completed garden. She fulfilled two of the three self-imposed pieces of the puzzle. She designed the garden in harmony with the river, the fields, and the weather; and she designed it with intention, a nuanced response to the needs of the client's family. What is missing, she says, is that when she designed it, she wasn't listening to the land. Her sensitivity and attention to what the land is telling her, the way she tries to absorb its needs rather than the needs of the human ego, turned her into an activist and reformed designer. With a strong feeling that humanity's abuse of the land is untenable, unsustainable, and poisonous, Reynolds is a strong advocate for permaculture, no-till organic regenerative farming, and agroforestry. She has moved away from artificially, heavy-handed, constructed gardens toward a more intuitive approach. She wants to be of service to the land rather than have it serve her.

As mother of two children, she likens her way of designing gardens to being a parent. How we treat our children, how we manage ourselves, she says, is how we should relate to our gardens and our larger world. As she says in her book, "An old pathway, overgrown and forgotten, is waiting patiently to lead us back home."

Crossrail Station Roof Garden

LONDON, UNITED KINGDOM

Gillespies LLP, Growth Industry, Foster + Partners · 1.3 acres (0.5 hectare) · 2015

THE ELIZABETH LINE, also known as Crossrail, is a 73-mile (118-kilometer) east-west commuter railroad line that crosses London and some of the surrounding counties, with a stop at Canary Wharf in London's East End. The Wharf is London's second-largest business center, particularly for banking. It is a place of gleaming glass-and-steel towers. Located on the Isle of Dogs, it was once one of the busiest shipping docks in the world. From the West came sugar, coffee, and tobacco; from the East, bananas, spices, tea, and opium. It seems fitting that a highly conceptual garden displaying many of the plants brought into commerce from foreign lands rests above it all now in the form of an exquisite roof garden. It is a botanically inclined place for city-dwellers to indulge in a little exotic recreation—just without the opium.

It is unusual for a public plaza to have such horticultural depth in combination with sophisticated and truly meaningful symbolic design, but Gillespies LLC has managed to meld an intelligent palette of plants within a dynamic vessel of world-class architecture by Foster + Partners. It is, in short, a ship full of plants. The structure is shaped like a conservatory with a wooden lattice roof, but in the twenty-first century we use cushions of polymer (ETFE) instead of glass panes. Part of the roof is open to let rain and air penetrate, but the insulating panels provide protection from the coldest of nights, allowing frost-tender plants to thrive. A sharp-angled, bluestone central path serves as ballast and directs the main flow of foot traffic. Meanders of soft paths on each side provide quiet spaces to sit among the greenery.

The garden is roughly organized by dividing East and West. Japanese and Chinese plants lie to the east, and American and Australasian plants to the west. There is geobotanical crisscrossing where it suits a larger design purpose. A number of towering New Zealand tree

The spruce-lattice roof of the Crossrail Station Garden fulfills its pragmatic purpose of protecting plants from inclement weather as any conservatory would, but also serves an aesthetic purpose by virtue of its futuristic design.

—

ferns, including *Dicksonia antartica*, the soft tree fern, *D. fibrosa*, the gold tree fern, and *D. squarrosa*, the brown tree fern, pop up like green-crowned chimneys throughout.

A hefty specimen of Japanese maple, *Acer palmatum* 'Osakazuki', turns crimson in autumn. *Magnolia kobus*, native to northern Japan, blooms with masses of white fragrant flowers in spring. The Persian silk tree, *Albizia julibrissin*, a spreading, broad-crowned tree with ferny leaves, boasts silky, silvery pink flowers throughout the summer.

Running along the southern side of the garden is a veritable artery of Japanese blood grass, *Imperata cylindrica* var. *rubra*, backed by a dwarf bamboo, *Indocalamus tessellate* syn. *Sasa tessellata*. The roof lattice casts effective diamond shadows on its oblong, large, and geometric leaves as the earth spins.

To represent the West, the designers chose a stalwart *Magnolia grandiflora*, native to the southern United States. It is a tree cultivated around the world, growing well in urban conditions, as does another American native, the sweet gum, *Liquidambar styraciflua*.

The lovely strawberry tree, *Arbutus unedo*, a member of the heather family and native to Ireland and the Mediterranean, is planted along with flowering dogwood, *Cornus florida*. It is an eclectic concoction.

What a joy it is to see an urban garden that is not dumbed down. A garden that expects intelligence and interest from the visitor. A garden that brings home a sampling of the world's plants for the public to enjoy, just as the British famously used to do.

↖ The Persian silk tree, *Albizia julibrissin*, is in bloom. Used in traditional medicine for depression, we can only wonder if the designers thought it might be useful post-Brexit.

← The garden's roomy paths edged with blue stone provide clear circulation patterns for the many visitors while containing the fecundity of the plantings in a visually unobtrusive way.

Queen Elizabeth Olympic Park

LONDON, UNITED KINGDOM

Sarah Price, Nigel Dunnett, James Hitchmough, Piet Oudolf · 568 acres (230 hectares) · 2012

ON SUNNY SUMMER DAYS in East London, Queen Elizabeth Olympic Park is filled with dazzling flowers and shiny, happy people. On the other 350 days of the year, not even the masses and masses of ornamental grasses can lift the spirit from the gray rain and cold wind blowing in from the Essex marshes and the Kentish heights. Add to that the present-day neo-Brutalist architecture of the Olympic buildings and surrounding apartment towers, and you find yourself in one of the most conflicted urban parks of the modern age.

The conflict begins with the structures and art installed here specifically for the games, which have drawn considerable ire from critics. The ArcelorMittal Orbit—a sculpture, observation tower, and slide—is a 377-foot-high (115-meter-high), £22 million, blood-red hunk of twisted metal. It is impossible to look at it without thinking immediately of intestines.

Can gardens redeem bombastic and fundamentally ugly architecture? Maybe, but only if they're given due prominence. The designers have created meadows and prairies and habitats for plants, birds, and insects, but it still appears that nature has entered the park by accident. The opposite is actually true—the more uncontrived and natural a garden looks, the more disciplined and artful the designer. Unfortunately the gardens, surely given a full staff during the games, have since descended into an untended mess of grasses punctuated by some very good plants. There is a fine line between benign neglect and laziness. In this particular space, even benign neglect has been neglected.

That is not to say that the gardens aren't clever. They could be beautiful if they were cared for. But not even the weaving, windblown grasses can completely offset the modern gulag, the dead hand of design around them. Naturalistic plantings are to the twenty-first

California poppies (*Eschscholzia californica*) brighten up a cloudy day and add help relieve anxiety produced when visitors are faced with Anish Kapoor and Cecil Balmond's Orbit tower.

century what topiary gardens were to the seventeenth—very fashionable, artful, and entertaining. But in a world full of environmental decay, we should be vigilant in applying critical thinking to how the introduction of nature in gardens will be interpreted. Perhaps it is the word "naturalistic" that smells faintly of green-washing and eco-conceit. These are meadow and prairie gardens where no prairie stood before. The herbaceous borders popular in the twentieth century have been transmuted into a looser aesthetic that favors complex plants, many of them native but not exclusively so. They are contrived and managed—barely, in this case—and, while there is nothing wrong with that, there should be no pretense that they aren't artificial. With nature on the run, we have developed a romanticized ideal of the fields, meadows, and prairies we have destroyed and will never see again. We want any relationship with nature, however dysfunctional. The dream of running free in a meadow with the wind in your hair can only last until you bang into a café or public toilet or trip over a rubbish bin. As large as the park's gardens are, they are still painfully, obviously captive within the metropolitan environment, which cannot help but make them seem like an afterthought even though a world-class planting team designed them.

Sarah Price, along with Nigel Dunnett and James Hitchmough, designed a series of gardens based on plant habitats from around the world. The plants are grown in large groupings that interact with each other and are food sources for birds and insects. The greenscape, however, has to find its way between a soccer stadium, an aquatics center, an "Olympicopolis" that now houses campuses for University College London and the University of the Arts, along with new spaces for the Victoria and Albert Museum. To be fair, the park was never intended to be a restoration of marshes past or woodlands long gone. It is a multifaceted, linear space built to accommodate the millions—yes millions—of people who come for events, as well as locals who just want to walk the dog.

The River Lea has had its industrial contamination cleansed and, now canalized, runs through the park. Although you wouldn't want to drink from it and it does have a bit of an odor on a warm day, it makes a perfectly nice silver corridor, and its engineered curves are echoed by flowing paths and arching bridges. The echo repeats in the promenades of oak, linden, and tulip trees, some planted in close formation to create shady groves and sculpted retreats. Some 4,300 trees make a woody framework for the specialized gardens that interlace the park.

There are lots and lots of ornamental grasses, such as moor grass (*Molinia* sp.) and tufted hair grass (*Deschampsia* sp.). In one area, the flamboyant grasses are restrained by a series of curving boxwood (*Buxus*) hedges, giving the border a curvilinear frame of reference that attempts, unsuccessfully, to rein them in.

The North American Garden, for example, features the wonderful big bluestem (*Andropogon gerardii*) grass native to the Great Plains and prairies, prairie smoke (*Geum triflorum*) with feathery seed heads, and clumps of showy goldenrod (*Solidago speciosa*) that flower in autumn.

A wall of switch grass (*Panicum virgatum*) turning to brown is rimmed by white Japanese anemone blooms (Anemone ×*hybrida* 'Honorine Jobert').

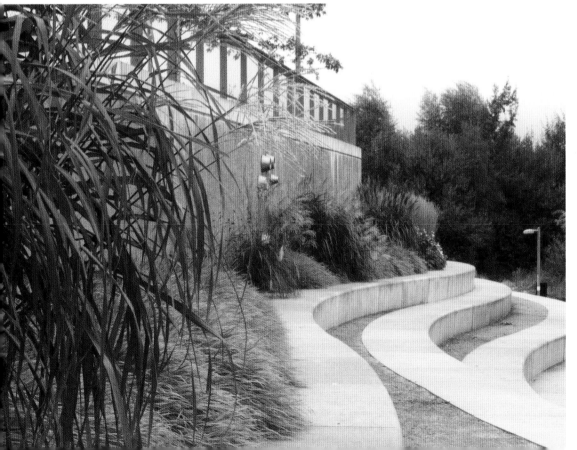

← Grasses dominate the planted areas and help to soften the architecture somewhat.

Sweet black-eyed Susan (*Rudbeckia subtomentosa* 'Henry Eilers'), an American native, is one of the perkiest plants in the garden. It grows from 3 to 6 feet (1 to 2 meters) tall and flowers throughout the summer and autumn.

In between, grown on banks angled toward the river, are multitudes of California poppy (*Eschscholzia californica*), their bright yellow-orange flowers showing well even when closed on a cloudy day. Bright white and yellow flowers of the common oxeye daisy (*Leucanthemum vulgare*) are grown in large and impressive quantities, adding a pleasingly rural element to the hardscape.

The Asian section includes large weaves of eulalia (*Miscanthus sinensis* 'Gracillimus'), a graceful and increasingly common grass that flowers late in the season, with red Japanese lily's (*Lilium speciosum* var. *rubrum*) tubular flowers struggling to be seen through it.

The most successful plantings belong to the Southern Hemisphere, partly because the plants poking through the copious orange clumps of New Zealand sedge (*Carex testacea*) and the stiff green stems of Cape rush (*Chondropetalum tectorum*) are so dominant. A good collection and large planting of red-hot poker (*Kniphofia* sp.), with tall spikes of red, orange, and yellow flowers, works particularly well in the arrangement.

Piet Oudolf, genius plantsman and designer, has created a subtle and intricate meadow of "wild" plants that snakes through a good portion of the park. There are more grasses, a favorite

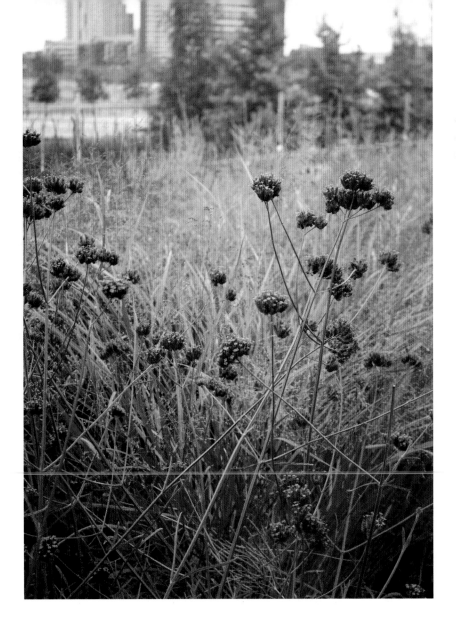

Verbena bonariensis, amid an ocean of grasses, adds a little color to the urban meadow.

of his, with cultivars of switch grass (*Panicum* sp.) dominating. Bright spots of white Japanese anemone (*Anemone ×hybrida* 'Honorine Jobert') and a particularly attractive cultivar of yellow rudbeckia (*Rudbeckia subtomentosa* 'Henry Eilers') help relieve the grassy monotony.

Gardens such as this need constant tending to keep their untended look an illusion, not a reality. Getting out of the way of nature doesn't mean ignoring it. This important park needs a big helping of tender loving care, and it's surprising that just a few years after a massive initial investment, the space has been marginalized where funding is concerned.

London's population is expected to reach over 10 million by 2029. The pressure on schools, housing, and recreational space is already tremendous. Olympic Park is well-placed to continue accommodating the needs of many Londoners. By that date, the trees will be tall and full, and the gardens may well have been rethought. People may even learn to love The Orbit as Parisians did the Eiffel Tower. The critics will have moved on, the birds will sing, and Londoners may well walk in the park with shiny, happy faces regardless of the weather.

Orpheus, at Boughton House

NORTHAMPTONSHIRE, UNITED KINGDOM

Kim Wilkie · 1 acre (0.4 hectare) · 2009

THIS IS A STORY of history, myth, and mathematics.

With 11,000 acres (4,047 hectares) of land, the palatial Boughton House is one of the grand estates of England, now the home—or, famously, just one of them—of the Duke of Buccleuch. Fortunately, the garden did not suffer the depredations of the later English landscape movements, including the modern ones, and remains one of the best kept and most elegant examples of seventeenth-century landscape design.

Dutch gardener Leonard van der Meulen, who worked at Boughton from 1685 until his death in 1717, created much of the original formal design for the park, and Charles Bridgeman (1690–1738), who worked at the garden from 1726 to 1731, specialized in geometric design and created a raised, 22-foot-high (6.7-meter-high) earthwork from excavated soil; a flat-topped mound of precise mathematics.

In 2004, landscape architect Kim Wilkie was invited to visit the restored landscape and to suggest augmenting the flat, fallow area adjacent to the angular feature. Interpreting the original earthwork as Mount Olympus, the home of Greek gods and muses, he proposed a counterpoint that would be a symbolic opposite to the mount of heaven: an inverted pyramid in the same proportions. He named this intervention *Orpheus*, after the Greek mythical figure who descended into Hades in an attempt to bring back Eurydice, his wife.

Wilkie had the aid of computers and laser-sights, and he succeeded in copying the exact proportions of the original mound. It is precisely 22 feet (6.7 meters) deep and 530 feet (49.2 meters) square, with a spring-fed pool at the bottom. Wide interior ramps let us navigate down, like Orpheus. The dark water at the bottom is a clever allusion to his fateful decision to catch one last glimpse of Eurydice in the underworld—it tempts us to peer in deeper, again, from different angles, irresistibly curious to see what lies behind the mirrored surface of hell.

Ramps tempt visitors down into *Orpheus* for a closer view of the mesmerizing reflecting pool.

Viewed from a distance, Wilkie's interventions are barely visible in the land; the original sculptured mound was recently restored, but has endured for almost 300 years.

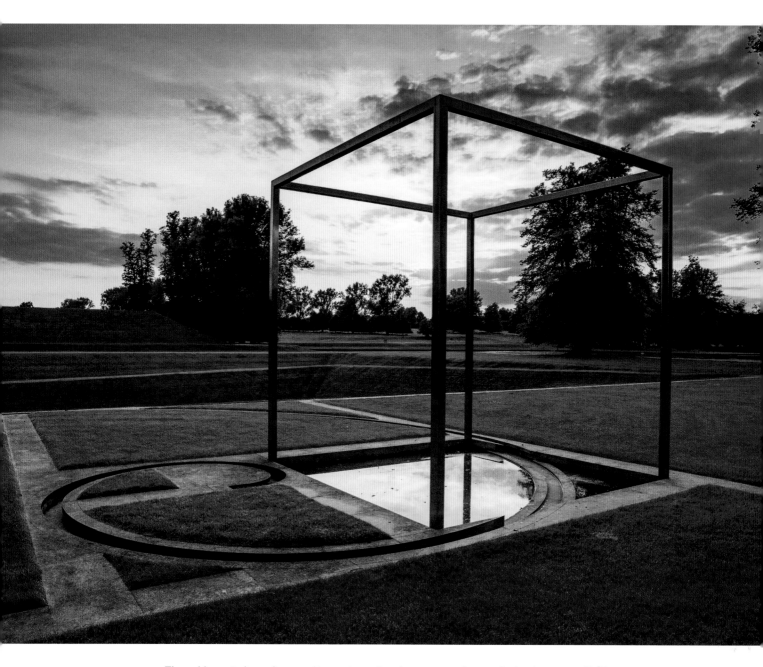

The golden spiral, so often used in art, is rendered as a piece of art in the landscape itself. (For scale, see figure at lower right corner of reflecting pool in photo opposite.)

To build on the Greek theme, Wilkie added a third feature. He created a golden spiral of similarly impressive dimensions immediately to the east. Flat stone was used as the outline of the perimeter rectangle, subsequent interior squares of diminishing proportions, and to render the famous arc itself, though a small stream sets this apart and emphasizes its graceful, mathematically perfect curve. At its hub, a stainless-steel, 13-foot (4-meter) cube sculpture with open sides invites visitors to step into a second intangible realm: infinity.

The spiral may well be arcane to many, but similar patterns occur throughout the natural world. The scales of a pine cone, for example, are arranged in a spiral of Fibonacci numbers, a sequence starting with 0 and continuing with 1, 1, 2, 3, 5, 8, 13, and so on, as are the position of the branches on a tree and the leaves on the branches, the seeds of a sunflower, and the spines on a cactus.

What Wilkie has created goes far beyond simply bending the land into a forced geometry simply because he could. It is a masterpiece that, by presenting some of our oldest knowledge in an entirely fresh and innovative way, creates a powerfully thoughtful and emotional environment. It pulsates with meaning but goes beyond the purely intellectual by providing an intense sense of harmony and a quite extraordinary feeling of peace.

The Alnwick Garden

NORTHUMBERLAND, UNITED KINGDOM

Jane Percy, Duchess of Northumberland; Wirtz International

12 acres (4.9 hectares) · 2000 to present

WHEN SOMEONE SETS OUT to make radical changes to a castle that has been a family seat for 700 years, the second-largest occupied castle in the United Kingdom, the first being Windsor—people notice. Alnwick Castle is one of England's most iconic. In 1309, Henry Percy, the first Baron Percy, purchased Alnwick, and it has been in the same family, belonging to the Dukes of Northumberland, ever since. Its dramatic recent garden overhaul comes from the vision and determination of someone who had every right to undertake it—Jane Percy, the twelfth duchess of Northumberland. Restlessly creative and with an irreverent spirit, she developed the idea to create a modern garden, a garden for entertainment, for spectacle, for education, and as a safe place to play. She wanted a grand public garden of classic symmetry and beauty, a garden for four seasons, day and night.

The community programs that are central to the mission of the garden as a registered charity is what makes it truly modern—even more so than its evolved position on landscape and horticulture. "The garden stimulates change through play, learning, the arts, healthy activity, addressing disability and the economic renaissance of a rural community," the duchess wrote to me. If it weren't for the programs, this new garden could be regarded as an exercise in sheer vanity. The fact that it isn't is a result of the very real economic impact of the garden and the duchess's profoundly conscious effort to improve people's lives.

Over the past ten years, Alnwick Garden has generated an extra £150 million for the region. It is a transformational cultural project delivering real benefits to an area suffering from high unemployment since the closure of heavy industry. In addition, Alnwick has specifically developed programs that benefit underserved people in the region, including Elderberries, an activity-based program for seniors in Northumberland, specifically

The Meniscus is one of seven water sculptures in the Serpent Garden created by William Pye.

The Grand Cascade, designed by Wirtz International, clearly builds on great estate garden tradition but updates it with clean lines that suggest ornamentation rather than slavishly including it.

targeting individuals who may be lonely due to geographical isolation; Blooming Well, which introduces therapeutic horticultural practices to promote feelings of well-being and happiness for those with early-stage dementia; Roots and Shoots, for children who have issues with obesity and bullying; and Forget-Me-Not, a program funded by the local council and designed specifically for children with significant physical disabilities or learning difficulties.

Even mixed martial arts (MMA) has a presence at Alnwick. The duchess writes, "We've hosted cage fights in the garden. The events were incredibly successful and the garden was filled with young people who would never have visited the garden otherwise. If we were only welcoming a certain type of visitor from a certain type of background, then I would have failed at what I set out to achieve."

To set the actual renovations in context, the garden at Alnwick Castle dates back to 1750. In the eighteenth and nineteenth centuries, it was renowned for its conservatories filled with exotic plants. The greater landscape—the rolling parkland surrounding the castle and echoing the meander of the River Aln—was designed by Lancelot "Capability" Brown, to add to the pedigree. A kitchen garden was created and, over the decades, expanded. The fourth duke, attracted to the culture of Renaissance Italy, created a formal, Italian-inspired garden complete with parterres and allées. The labor shortages created by the First and Second World Wars took a severe toll on the property, and, after the Second World War, the gates were locked and the garden became derelict. Through the centuries, there have been six grand gardens on the site. In 2000, work began on the latest, grandest, and the most controversial of the formal gardens.

The current duchess engaged the landscape architecture firm of Wirtz International, from Belgium, to design a cascade with surrounding formal gardens. It was controversial from the onset, soliciting substantial xenophobic criticism and scorn. In such an English garden, hiring a foreigner to redesign it created a lot of pursed lips. It has been called wild, wacky, and not quite right. Sir Tim Smit, creator of the Lost Gardens of Heligan, was an early enthusiast, however. In *The Making of the Alnwick Garden*, he wrote: "The British disease of worshiping the past and making restoration no more than history in aspic is a recipe for misery." He said to the duchess, "For this garden to work, you have to want to bring a woman here and make love to her in every single corner." Such exertion is not required of the everyday visitor.

The Grand Cascade is certainly grand, and it dominates the area, as it was designed to do, with its three-tiered water staircase made of honey–colored sandstone and blue limestone edges. The dramatic fountains spurt and splash at apparently unforeseen and balletic moments. It is bold and theatrical, but it is also a modern interpretation of palatial waterworks of the past—the Continental tradition of *giochi d'acqua*, or water features. The whole fountain is tradition with a twist, tempered by the strict green architecture of tunnels of clipped hornbeam (*Carpinus betulus*) and pruned hedges of beech (*Fagus sylvatica*). The densely packed green leaves of the hedges do much to balance the visual weight of the cascade, and the tunnels with cut-out windows and doors looking out to the water create a formal horticultural architecture.

Fountains, pools, and rills run on either side of the Grand Cascade.

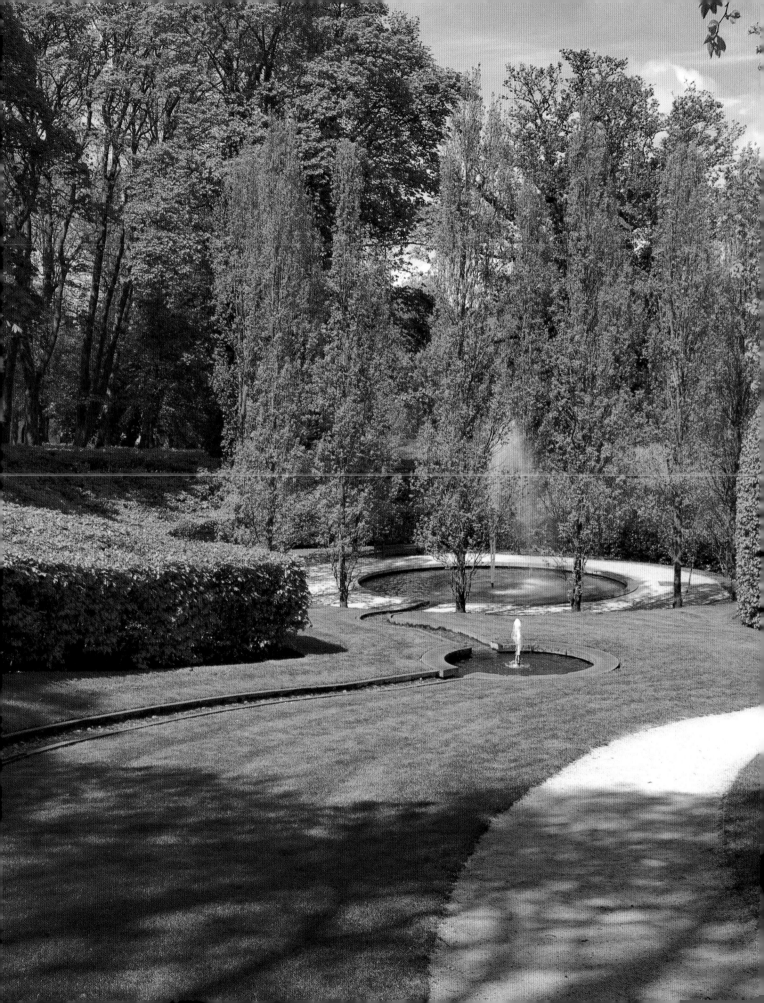

An ivy-covered tunnel creates an intriguingly ominous entranceway to the Poison Garden.

→ Unthinkable in so many public gardens, lovely, noisy, playful children are provided toy tractors and invited to dig up gravel.

Beyond the top of the cascade is a walled ornamental garden, a favorite of the duchess, which is a series of squares defined by hedges of crab apples (*Malus* 'Red Sentinel' and *M.* 'Evereste') planted with over 16,000 flowering plants, including irises, delphiniums, peonies, hydrangeas, and euphorbia. It is the most flowery, even cottage-like, of the gardens, but it is not the flowering plants that grab the eye. Rather, the geometrical arrangement of hedges as walls, their height and closeness pressing in upon the visitor, is what impresses. The somber gray of the central pond is in contrast to the prettiness of the flowers. Tall slate pots disturb the floral flow. The pond appears to feed the cascade, which is pure trompe l'oeil—an old trick but a good one.

A series of individual gardens unroll from the base of the cascade, notably the Rose Garden, the Bamboo Labyrinth, and the Serpent. The Serpent is a strange one, a maze-like arrangement of hedges and fountains. Designed by William Pye, seven water sculptures explore the behavior of water. *Torricelli*, named after the Italian scientist who created the first sustained vacuum, is a fountain of transparent tubes with ninety jets of spurting water. The *Meniscus* is a stainless-steel bowl full of liquid tension. A rose garden is, well, always a rose garden, and this one is filled with over 3,000 David Austin roses, notably *Rosa* 'The Alnwick Rose', a fruitily fragrant pink flower. To get to the Rose Garden, the visitor passes through the Bamboo Labyrinth, a maze made up of *Fargesia rufa*, a clumping bamboo from China that is cold hardy and noninvasive. There is a stone at the entrance to the labyrinth inscribed with the phrase, "Only dead fish swim with the stream," a riposte to the garden's detractors.

On the far other side of the cascade is a cherry orchard of over 300 *Prunus* 'Tai Haku', their big, white flowers glowing when the sun shines and sprinkling the ground like snow as the petals fall. Beneath the cherries are thousands of pink tulips and purple alliums.

To the left, at the base of the cascade, is a garden that has attracted a great deal of attention, the Poison Garden. Perhaps the duchess has a dark side, or perhaps this is more of her insistence that the garden be of social value. The gates are locked, and access can only be had in the company of a Poison Garden warden. Guests are asked to make a donation to help fulfill this garden's educational mission: The Garden Trust, a charitable body, brings local theater companies, reformed drug addicts, and scientists into the garden to educate local schoolchildren about the benefits and harm caused by drugs. Among the 100 plants grown in the Poison Garden, some are caged to protect the visitor, such as oleander, cannabis—an unhappy plant in the cool climate of Northumberland—and angel's trumpet (*Brugmansia suaveolens*), the latter being a strong hallucinogen producing powerful dreams before an often-fatal sleep. The opium poppy (*Papaver somniferum*), pretty in flower, produces two drugs that have benefited and devastated human life, morphine and heroin.

It is the mixture of aesthetic vision, grand garden making, and social programming that makes Alnwick an inherently intriguing and very modern garden. Despite intense criticism, Jane Northumberland and her team have created something new and vibrant out of something old and crumbling. It is a beautiful garden, but it goes beyond aesthetics to add meaning and value to human life. This is her powerful, rare vision: "If your values behind a project are solid then you'll always have the higher ground."

Carrie Preston's Gardens

THE NETHERLANDS

Carrie Preston · 0.3 to 0.5 acre (0.1 to 2.2 hectares) · 2007 to present

DUTCH GARDENERS HAVE HAD a profound influence on horticulture and garden design in the entire West. This is a result of their energetic nursery industry, and to the influence of gardeners whose fame and work has migrated beyond the country to the rest of Continental Europe, the United Kingdom, and North America, such as Mien Ruys, with her famous gardens in Dedemsvaart; Henk Gerritsen, designer with Anton Schlepers of Priona; Rob Leopold; Romke van der Kaa; and Piet Oudolf. In a small country, where room for residential gardens is often diminutive, the architectural and spatial relationships within a garden drive decisions while the selection of plants comes second.

The Netherlands is a flat country with, by and large, conservatively designed gardens. Flamboyance, in Dutch society as well as in gardens, is not a natural trait. This is not necessarily a bad thing: it creates a certain decency, as well as good bicycle paths and neat rows of tulips.

The standard home is a terraced house two stories high, with a small space for gardening. "One cannot imitate nature in a garden," wrote Mien Ruys. Especially not in a tiny one.

Small gardens are now Carrie Preston's specialty. Born in New Jersey, living in the Netherlands since 2000, and designing full-time since 2007, she is fast becoming well-known for her work with residential gardens.

The way she describes her own garden explains how she makes gardens in general: "What I like about my garden is it is so comfortable, fitting like a favorite sweater. Not the fancy one you wear for special occasions, but the one you put on when you are alone and want to feel that you are in a place you can trust, a place that is yours." She brings that same sense of comfort and trust to her clients.

In a small rectangular space, lowering the grade to create a sitting area then raising it to lead to a covered patio greatly increases the perception of space.

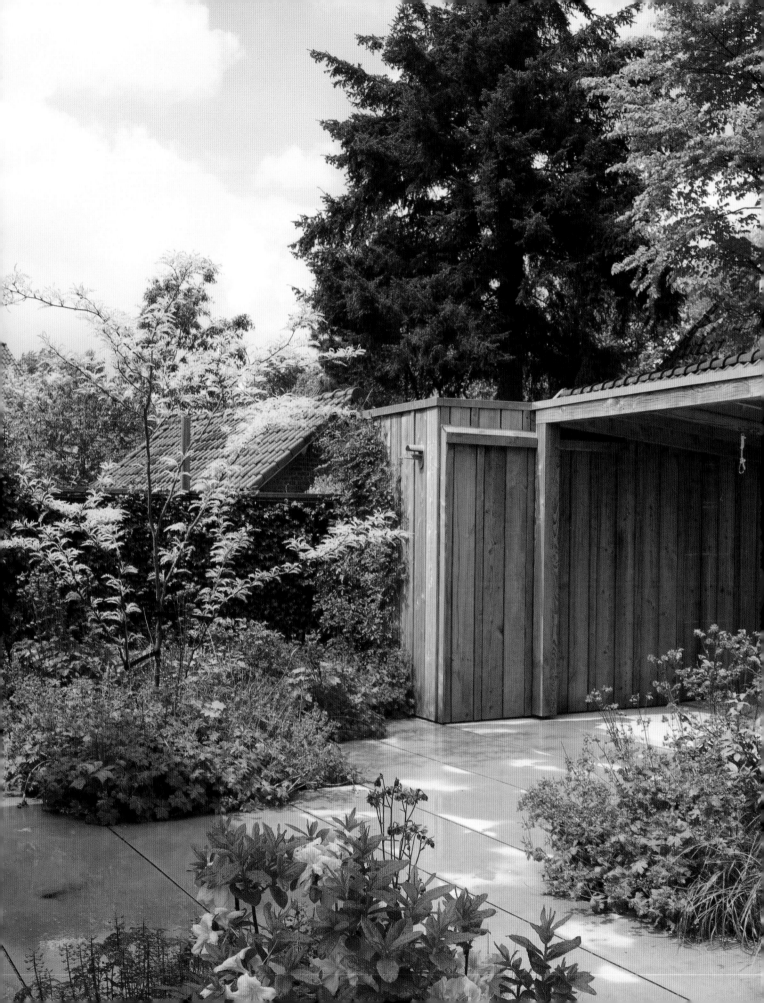

Dicentra spectabilis 'Alba', the white bleeding heart, with its tears of flowers, is a particularly good plant against the fresh foliage of unfurling ferns.

← A paved backyard and year-round covered sitting area are planted with deciduous azaleas, blue columbine, purple-pink geranium, and the golden locust *Robinia pseudoacacia* 'Frisia'.

As a woman in her thirties, Preston has grown up with feminism. Aware that there is a danger of generalization, she is cautious about ascribing gender identity to design, but she is also conscious of how it informs her gardens: "I work in a way that I would identify as female. I don't want control, I want to work with the client, the space, the topography, and the plants. I don't want to dominate the space, I want to dance with it." It is paradoxical that residential gardening is a hobby still mainly engaged in by women while show gardening is a profession principally held by men. That is changing.

In a flat landscape, subtle differences in elevation resonate. In one, in Amsterdam, Preston created a small patio where steps descended, then rose again to a steel and glass porch. In another, in Amersfoort, she lowered the entire grade, built pools, and then raised the grade by paving most of the garden with flagstones and building raised garden beds. The added dimension creates an appearance of a much larger garden. It is a skillful trick.

A Dutch garden wouldn't be right without bulbs, but Preston shies away from the big and blousy tulips and prefers delicate blooms such as *Narcissus* 'Thalia', a perennial daffodil with fragrant white flowers, or a mixture of snowdrops, anemone, scilla, and chionodoxa. It's not that she doesn't like the big tulips; she just likes them as cut flowers in a vase, particularly when they are beginning to fade: "That is the prettiest moment for tulips, just as they start to fall over in a sigh."

Given the wealth of plants available from local nurseries, she finds it difficult to pick just a few. Recently she became enamored of *Mahonia eurybracteata* subsp. *ganpinensis* 'Soft Caress', a compact shrub with foliage that looks almost like bamboo and bright yellow flowers in late summer and autumn. It is a good backdrop for bulbs and small herbaceous plants like the frilly wood sage, *Teucrium scorodonia* 'Crispum Marginatum', a tough ground cover with ruffled leaf edges, and the white bleeding heart *Dicentra spectabilis* 'Alba'.

In another garden, again in Amersfoort, she augmented the sense of space by installing a long, rectangular pool: its reflection makes the yard feel larger the way a mirror would in a small room. She also establishes a visual rhythm by repeating the same shapes—rectangles—throughout. They extend from the interior of the house and patio via a sofa, a long table, and a large painting above the fireplace, through the rectangles of the windowpanes, and into the garden.

After the bulbs come the summer perennials. *Baptisia* 'Carolina Moonlight' and *B*. 'Purple Smoke' are favorites, both beautiful on 3-foot (0.9-meter) stems with blue-green foliage. 'Carolina Moonlight' has butter-yellow flowers, while 'Purple Smoke' has gray stems and soft violet flowers. The giant fennel (*Ferula communis*) has smoky, fine foliage that she shows to advantage as a backdrop for many of the ornamental onions, particularly *Allium* 'Purple Sensation'.

This very tight back garden has nowhere to expand but down. Soil was excavated, pools made and paving raised, providing a dynamically kinetic space for a young family.

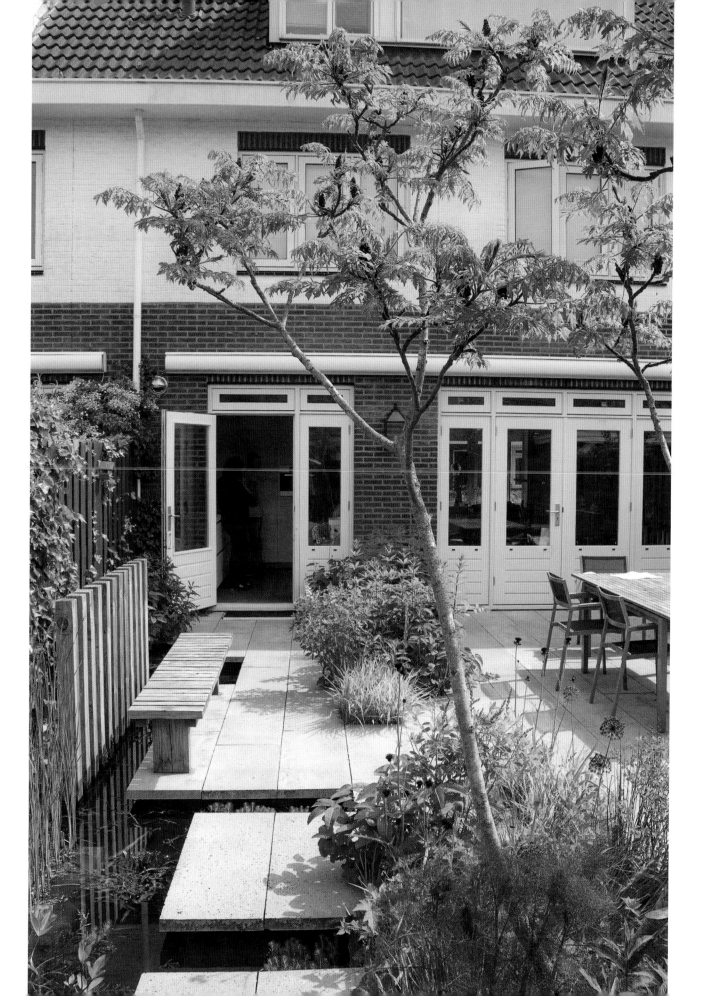

A series of rectangles elongates the garden away from the house, creating the perception of a much larger garden. Raised planters and a small lawn satisfy the owners' need for green space.

She uses *Baptisia* 'Carolina Moonlight' in many of her gardens but most effectively in one in particular, a border in a garden near Schalkwijk originally designed by Henk Gerritsen. The garden is dense with planting, but the flowing water of a canal provides space, breath. An old garden has been refreshed with new ideas, new plantings. The border is round and divided into quarters. Preston also managed to get hold of mixed *Baptisia* hybrids from the trial beds of a local nursery. Over fifty five-year-old plants in assorted shades of yellow, cream, brown, and smoky blues now fill much of the border, along with pale yellow columbine (*Aquilegia chrysantha* 'Yellow Queen'), the soft lavender spikes of *Veronicastrum virginicum* 'Lavendelturm', the low-growing, maple-leaved *Heuchera villosa*, the light yellow flowers of *Potentilla recta* var. *sulphurea*, and the Arkansas blue star (*Amsonia hubrichtii*), one of the most rewarding herbaceous plants, with fine foliage and light blue flowers. The leaves turn golden in the autumn.

Often, the beauty of gardens we see elsewhere feels unattainable without vast acreage and unlimited funds. We feel that we cannot have anything even approaching exquisite at home. That, somehow, the grand and famous gardens—the ones we visit, the ones in books—are too sophisticated, too complex for ordinary lives. But this is not true, and Carrie Preston's work proves it. "I am just a gardener, nothing more," she says with a challenging look in her eye.

↖ A young magnolia comes into leaf. Plants begin to flower in the raised beds. And this gravel garden, on the front corner of the property, becomes a place for neighbors to stop, admire, and chat.

← Canals and *sloots*—drainage ditches—are a major part of the landscape in the Netherlands. A garden near Schalkwijk is designed around the canals that surround the property and the *sloot* that penetrates the land.

The Tree Museum

RAPPERSWIL, SWITZERLAND

Enzo Enea, Oppenheim Architecture + Design · 2.5 acres (1 hectare) · 2010

"THE MOST IMPORTANT QUALITIES and functions of the garden: the calmness that prevails inside, as if the surrounding world had momentarily disappeared and fallen silent; the invigorating air, the light element par excellence, as if the entire garden itself were breathing, enticing the visitor to breathe as well; the lightness and fragility of the vegetation, the interplay of movement and motionlessness; the bounty of ageless nature as an everlasting gift."—Michael Jakob, *Enea Private Gardens*

Enzo Enea learned to garden from his grandfather, a fountain-maker and stonemason. Together, they "grew the best peaches imaginable." This family heritage from Cesena, Italy, helped form the child into a man with a strong sense of the magic tactility of things made by hand. Enea became a manufacturer, a maker, a famed garden engineer and industrial and landscape designer with an international portfolio.

He works in architecture and landscape, blurring the boundary between inside and out. He believes that buildings and gardens should be perceived as one, joined by a calmness of proportion, a stillness. While he respects the archaic, his designs are decidedly modern. While they are united by an apparent effortlessness, he is not a minimalist. He finds that noun inappropriate for a garden maker: "I am not looking for minimalism. I am Italian."

The Tree Museum is his own collection of rescued trees set against a backdrop of limestone columns. Museum is a misnomer, really—the garden is part theater and part temple. Enea is part playwright and part high priest. The garden is populated with discarded orphans saved by him from sites that were about to be bulldozed. It is also an exploration of space, or, more accurately, of the relationship of space to object. The trees are placed at decadently wide intervals throughout the garden. There is room to see them breathe.

Clipped shrubs, sculpted into sinuous and softly erotic forms balance the hard geometry of the blocks of limestone.

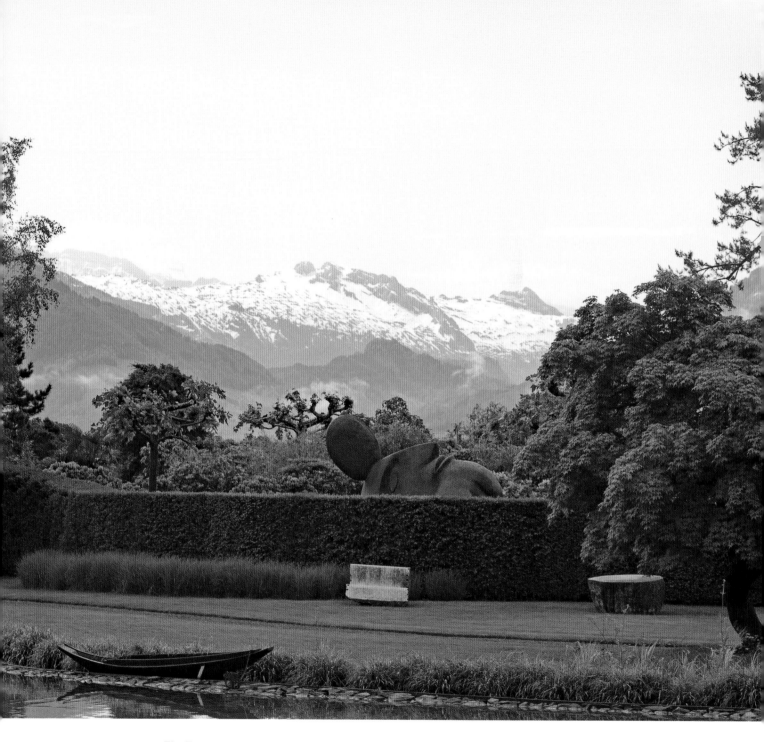

The Tree Museum's enviable location in the Swiss Alps adds to its appeal.

Enea is a collector of pots as well as trees. Both give him great joy.

The fifty trees each has, as intentioned, great presence. They are tightly pruned, like large bonsai. A single Japanese maple (*Acer palmatum* var. *dissectum* 'Garnet') flows over stone, its wriggling branches clothed in purple-red, feathery leaves. The delicacy of this foliage contrasts immediately and intriguingly with the weight of its mineral companion. A dwarf Hinoki cypress (*Chamaecyparis obtusa* 'Nana Gracilis') flings a branch out and above its container, an asymmetrical commotion against the order of white tablet behind it.

Two important complements to the geometry of the limestone slabs and the ripples of trees appear with regularity in the garden. First come pots. There are many: beautiful, rough, round, limestone, terra-cotta, granite. Each is plump with a huge orange azalea or a juniper or a maple. The second, planted within the grass lawns are shapes made of boxwood, pruned like Henry Moore sculptures, reclining vegetal female forms adding a soft eroticism.

A line of pleached London plane trees (*Platanus ×acerifolia*)—a tightly trained back-drop—encloses the garden. And just beyond it, one of the most elegant uses of trees possible, a straight and lengthy allée of bald cypress (*Taxodium distichum*), a pyramidal tree of light grace, with soft green needles in the spring and fiery foliage in the autumn. Such beauty.

"Gardens are very special places; they are, in effect, magical spots on the earth's surface. Inside them the highly modern and the archaic overlap, the civilizing always bordering on the anti-civilizing."—MICHAEL JAKOB, in *Enea: Private Gardens*

Bald cypress (*Taxodium distichum*) makes a particularly elegant allée. With its orderly and triangular demeanor and its light green leaves flat upon its branches, it is a tree of fine geometry, making it perfect for a promenade.

→ A deciduous fragrant azalea in full flower is strikingly displayed in a crumbling limestone pot with an intriguingly uneven rim and a sought-after patina of moss.

Landschaftspark

DUISBURG-NORD, GERMANY

Latz + Partner · 568 acres (230 hectares) · 1991–2002

"A generation without history is a generation that not only loses a nation's memory but loses a sense of what it's like to be inside a human skin."
—SIMON SCHAMA

LANDSCHAFTSPARK GROWS WITH fragmented abundance out of the ruins of a former iron smelting plant in the Ruhr Valley. The most industrial of landscapes is gradually yielding to a series of designed gardens, a concert and events hall, a sports arena, and a postindustrial theme park. These all make good and worthy use of reclaimed land and hit the appropriate contemporary notes about urban renewal, but the complex's most important purpose, one whose meaning needs no explanatory signage for transmission, is to serve as a repository of cultural memory.

From forest to farmland to center of German industry, the history of the region and of the area now occupied by the park is extensive. Founded by industrialist August Thyssen, the plant's five blast furnaces started operation in 1912. The Second World War created profit and loss. German manufacturers were keen to profit from Nazi rearmament and aggression, Thyssen not least among them. Slave labor was used openly. In October 1944, Allied bombing stopped its production of iron completely. Postwar, as part of the Marshall Plan, new furnaces were constructed and production continued until the European Union decided steel was being overproduced. The plant closed for good in April 1985.

The complex of ruined furnaces is a work of art in its own right—it has all the magnificence of a forsaken biomechanical cathedral, as if H. R. Giger, Richard Serra, and Anselm Keifer had been called in as consultants. Quietly and slowly, trees, ferns, and moss are taking over. Rust

Places where men and women once slaved have become places for children to play.

The park is a mixture of industry and arcadia, where visitors can walk among the trees and the metal skeletons of the ironworks.

The tension between the new, fresh woodland and the rusting, cold mechanical systems is palpable.

never ceases to spread; neither do seeds and roots. The park's managers would hope visitors see outdated industry becoming Arcadia, a pastoral wilderness forcing its way through the metal skeletons of blast furnaces and Cowper stoves, storage bunkers and pump houses.

Parks, gardens, landscapes: their definition changes with every generation. We are a culture with an uneasy relationship to history. If we look at historic landscapes at all, we tend to direct our attention to the surface-level beauty in evidence at classical gardens of the aristocracy and bourgeoisie. We look to the famous gardens of England and the Continent, with their manicured lawns and topiaries—as if the fictional Downton Abbey and the brutal class system that kept it whole were something to idolize. We are attracted to sanitized

stories of the past, semiconsciously deciding that fields watered with blood, sweat, and tears are not great options for days out and picnicking.

It is to the planners' credit, in particular Peter Latz, that the furnaces and other buildings are left intact for time, the great healer, to erode cathartically before our eyes. Also that we can simultaneously watch the landscapes grow up, in and around the buildings, forging a remarkable alchemy and deeply symbolic partnership between mankind and nature, ugliness and new life. Atonement for the people who made the furnaces, who died working them, is public—in the ferocity of the curving metal and the leaden cobbles as well as the bucolic gentleness of avenues of trees and the moorhens nesting in the reeds of the canal.

The Sinterplatz, where powdered metal was formed into material for smelting, now has walkways so that visitors can look down upon its bunkers. Today, they contain designed gardens and play areas for children. Seedling birches and hawthorns are taking possession in areas that are untended. Many of the bunkers feel sinister and some are repositories of sequestered toxic soil; some are dark and flooded with "weeds" while others have become sectioned woodlands, enclosed by weeping concrete and twisted metal, decay and growth combined in a manufactured *danse macabre*.

Landschaftspark joins other postindustrial sites that have been turned into gardens and have transformed their surrounding areas. James Corner Field Operations and Piet Oudolf's High Line in New York, Richard Haag's Gas Works Park in Seattle, and Latz's Harbour Island in Saarbrücken are successful examples of defunct industry and manipulated nature married. This park has likewise been designed to accommodate large numbers of visitors with diverse needs. The Piazza Metallica can accommodate 50,000 people for festivals. The old wastewater canal, an open sewer when the plant was in operation, has been restored to health and is lined with trees and shrubs.

Healing the wounds of history does not mean the expurgation of the past. Landschaftspark is a place where people come to play, to dance, to read time, and to learn to remember at once. They come to see sculpture and light, roses blooming against the rust, butterflies amongst the ruins. To embrace life.

In some areas of the park, nature is left to run its course; in others, like this, a designed carpet of plants is set deep in one of the storage bunkers to create a specific view from elevated walkways.

Peter Korn's Garden

ESKILSBY, SWEDEN

Peter Korn · 12 acres (4.9 hectares) · 2002 to present

"I have never listened too much to the experiences of others, as I prefer to try things myself before listening to other people." —PETER KORN

PETER KORN IS A man in love. He is in love with earth, rocks, mountains, rivers, and plants. Like most of us, he didn't choose when to fall in love; it happened when he least expected it. Since then, his singular purpose has been to garden. His first infatuation was with dahlias; fortunately this was a short-lived teenage tryst and he quickly moved on to more mature relationships. He is a plantsman of vigor, enthusiasm, and passion. He joins the far-too-small group of people around the world who have absolute devotion to plants. If Swedish horticulture were a religion, he would be its whirling dervish. "My greatest source of inspiration is nature. If I can only re-create the conditions that are there, then the problems are solved. I start from the assumption that there aren't any plants that are hard to grow, only environments hard to create," he says.

When asked, "What is your favorite plant?" he replied, "On what day, what hour, what minute? At the moment, this exact moment, it is the Japanese wood poppy, *Glaucidium palmatum*. It is blooming now, on a cold day in May, and it is the most beautiful thing in my garden." This plant is indeed a great treasure, growing up to 3 feet (91 centimeters) and just as wide, with 4-inch (10-centimeter) lavender-pink to white flowers. It is a rarity, but grows happily in Sweden. "But tomorrow is another day. And when I come back from plant hunting in Kyrgyzstan this summer, a whole new world of plants will enthrall me."

Korn enjoys taking on the particular challenges that come with creating a garden in a Nordic climate, on a rocky hillside, with poor soil.

Dicentra 'Burning Hearts' probably boasts the most saturated flower hue of any fern-leaf bleeding heart, and it adds some of the brightest, most surprising color to Korn's garden.

← A plant-filled escarpment filled with low-growing specimens leads to Korn's house.

He disproves the myth that Scandinavian garden design must equate to plainness. His designs are in demand, not least because he moves beyond the limited plant palette people assume is available in Sweden and incorporates the rare and unusual. His knowledge of environments and what plants need makes him a specialist. "For over fifteen years, I have been laying out beds primarily for wild species. I am not particularly orthodox and mix plants from all over the world, as long as they come from similar environments and require the same cultural conditions. That makes the garden very easy to care for."

Peter's personal garden is large and filled with many plants, many of which would be categorized as rock garden plants. "I am not a plant snob. I like everything, even the tiny white plants that you can barely see. I don't need to grow all of them anymore, though. I just need to grow everything else."

He starts with soil. The conditions he works in are not ideal. The soil is acidic and at some spots the pH is so low that it releases aluminum, which is poisonous to many plants. Below the minimal topsoil, the ground moraine turns to mud in the wet season and to brick in the dry season. Not even weeds grow in it voluntarily. So he doesn't weed, because he doesn't have to. In a delightfully Swedish statement, he says, "In nature it is mostly wild boars and other wild animals that churn up the soil, creating a perfect environment for weeds. In the garden, many gardeners often act like a herd of wild boars." All of his cultivated areas are elevated by at least 8 to 16 inches (20 to 41 centimeters) of sand or peat, horse manure, and sand. "I just put the cultivation beds on top of the original soil, which makes the job easier. Then I don't need to ponder what is underneath." He gardens up, and he also gardens down, sometimes digging up to 10 feet (3 meters) of soil away to expose the beautiful rocks beneath. He likes to move big rocks around. He makes it sound easy, but it's just him, a pickax, a wheelbarrow, and a shovel.

Korn's love of woodland plants tempers his deep attraction to exposing rough and barren sections of the earth's crust. Even in his heavily sand-amended soil, plants thrive of the *Gentiana sino-ornata* group, *Corydalis flexuosa* types, and, surprisingly, *Meconopsis* sp.

Fortunately for Sweden—and for the rest of us—Korn's personal garden is open to visitors and his work can be seen in an increasing number of public and private gardens. He is a self-effacing genius who sums up his work with characteristic modesty: "It's interesting what you can do with a shovel."

(top, left) Pasque flower (*Pulsatilla vulgaris*) bears seed heads that are as attractive as the flowers. The plant grows without difficulty in Korn's garden, which may be why he keeps so few of them.

(top, right) Japanese wood poppy (*Glaucidium palmatum*) is one of the most prized plants in Korn's collection.

(bottom) *Lewisia cotyledon*, also known as cliff maids, is native to the Siskiyou Mountains of southern Oregon and Northern California in the United States. It forms a compact rosette of dark green leaves with 4- to 12-inch (10- to 30-centimeter) stems and a mass of pink to yellow flowers.

africa and the arabian peninsula

A Garden of Shape and Light

MARRAKECH, MOROCCO

Luciano Giubbilei · 2.3 acres (0.9 hectare) · 2008

IN THE FLATLANDS OUTSIDE Marrakech, before the land rises to the Atlas Mountains, an Italian designer based in London has created a garden for a New Zealand family that also lives part-time in London. Such a confluence of internationalism, reflected in the Islamic and Italianate garden and decorated with Moroccan pottery and French sculpture, is not uncommon in this age.

Moroccan domestic architecture is usually simple, with facades facing the street, in what Western observers might be tempted to describe as minimalist. Houses are private, life happens inside. Unadorned red-clay houses with small windows and doors disguise elaborate decoration within. Morocco's famous multilevel houses with rooms arranged to surround a planted interior courtyard, or *riyad*, are frequently ornamented with colorful *zellij* tilework and balanced by the focus of a round or octagonal marble fountain. These basic features are symbols of Islamic paradise.

This house features all of these, as well as a courtyard full of orange trees and bougainvillea weaving through an arabesque screen. The sitting rooms and bedrooms are open and rectangular. Kilim rugs and Berber carpets fill the tile floors and adorn the walls like pictures. The house is full of light and air. So is the garden.

Luciano Giubbilei, born in Siena, Italy, and educated at the Inchbald School of Design in London, has taken the simplicity of the house and designed a garden that reflects it. His design is formal—Moroccan and Italianate, at once—a combination of two cultures that share a love of geometry. And yet, despite the straightforward axial plan and rigid individual ele-

Over 14,000 fountain grass plants (*Pennisetum alopecuroides*) are set in linear squares between olive trees. Morning and evening light turns the grasses to a mesmerizing silvery pink. Seen from above, the strict geometry of the fountain grass beds becomes clear. While the lines may be severe, the planting is silky soft, and therefore succeeds in creating what Giubbilei calls a "modern parterre."

An intimate courtyard fountain bordered with tile is surrounded by orange trees.

A traditional Moorish entryway leads into a formal courtyard garden.

The large, abstract *toupies* (or tops) sculptures were created by French artists Serge Bottagisio and Agnes Decoux.

The soft texture of the fountain grass contrasts with harder edged blue agave and the dark green clouds of olive leaves above. The hues of the three combined create a decidedly unique and appealing color scheme for this dry location deep in the Atlas Mountains.

ments, the overall garden is softly erotic and mysteriously seductive. Old, gnarled olive trees (*Olea europaea*) grow in straight lines on a grid pattern, ghosts of a former plantation. The olives create a dark counterpoint to squares of fountain grass (*Pennisetum alopecuroides*). Over 14,000 of them are planted in precisely framed squares centered exactly between trees, availing themselves of the grid and indeed bombastically exploiting it as an organizational concept in a way only the most confident of garden designers would ever dare. There are a few blocks of roses, planted at the back and sides of the garden, seemingly relegated to an undignified post until you experience the way their perfume fills the hot evening air.

Close to a small swimming pool and poolhouse, a sculpture of two spinning tops, 6 feet (1.8 meters) high and 8 feet (2.4 meters) across, created by French artists Serge Bottagisio and Agnès Decoux, tilt the formality with grace and humor. The wide grass paths and blocks of grasses make orderly space a visual and physical conservation of energy. The geometry does not challenge; the garden is not a mystery. It is not meant to be.

It is the light that is the primary element. The dark olives absorb, seeming to pull the light into them, bringing it down from the desert sky while the play of sunlight on the grasses is nothing short of choreographed. At dawn and sunset the grasses burn red. With a little cloud cover, soft light brings the slight pink in the grasses upward and outward. When the clouds roll away and the light becomes harder, the silver of the grasses rises up: 14,000 fountains of sparkling light in the desert. An earthly paradise.

The Aloe Farm

HARTBEESPOORT, SOUTH AFRICA

Andy De Wet · 210 acres (85 hectares) · 2005

DEPENDING ON WHO YOU talk to or what taxonomists tell you, there are 300 or 400 or more than 500 species of aloes. Most are native to South Africa, with a few species scattered throughout the Arabian Peninsula and Madagascar. Many species and cultivars are widely grown in gardens in the dry subtropical and tropical regions of the world. Hybrids and cultivars, improvements on the species, are easy to grow, requiring considerable sunlight, very little water, minimal fertilizer, sandy or gravelly soil with a bit of compost, and predominantly frost-free conditions. They are beautiful, robust plants that flower in the cool season. For those who wish to garden in a sustainable manner, they are fast becoming one of the most widely grown plants for Mediterranean climate and xeric gardens.

South African flora is one of the most diverse and spectacular in the world. Many fine garden plants have been produced from the native species of the region, including *Protea*, *Pelargonium*, *Plumbago*, and *Kniphofia*, and there are many more.

Andy De Wet has spent over forty years selecting and breeding horticulturally superior aloes, agapanthus, and other varieties for the landscape and retail industry. He does so with great diligence and passion and has taken South African plants to new heights of horticultural development. His nursery near Hartbeesport is a botanic garden of his plant selections, highlighting two of the most emblematic genera of the country.

Hartbeespoort is about an hour northwest of Johannesburg, on the slopes of the Magaliesber Mountains. Many species of aloes grow in the mountains; *Aloe peglerae*, a stemless plant with red flowers and purplish stamens, and *A. davyana* (syn. *A. greatheadii* var. *davyana*), with white-spotted leaves and pale pink flowers, can be seen dotting the dry

Aloe's tubular flowers open from the bottom, often changing hue as they do. Planting different aloes together creates a spectacular display of varied colors.

Aloe 'Peri Peri' is an excellent long- and profuse-flowering aloe of a compact form.

→ Sunbirds, with their long, curved bills, are one of the only organisms capable of pollinating aloes. They feed on the nectar produced in the tubular flowers.

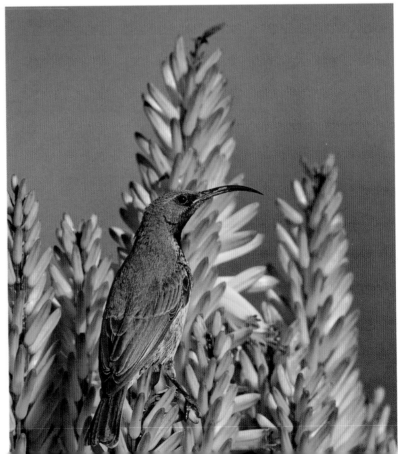

slopes. *Aloe peglerae* is endangered in the wild, mostly from overcollecting. *Aloe davyana* is not under threat. Yet.

De Wet started breeding aloes in 1973, and in 2005 he bought a 210-acre (85-hectare) farm on which he selects, grows, and sells South African native plants. He has devoted a large portion of the farm, which sits on the side of the mountain, as a conservation area—something he is also passionate about.

In recent years, he has produced a slew of aloe cultivars. To produce a good and sale-worthy plant, he selects the seed parents, then hand pollenates with a carefully selected parent. The cross-fertilized flowers get marked and recorded.

He has produced many fine aloes. 'Peri Peri' is one of his most successful. It has a long flowering season, from early autumn through winter. The flowers are red-orange on a small plant 8 by 8 inches (20 by 20 centimeters). It grows well in part shade and is an excellent plant when grown in a mass, where its profusion of flowers and expanding clumps of foliage quickly fill a tough area. It is now being used as a street planting in some cities in South Africa.

'Hedgehog' is the product of *Aloe humilis* and three other parents. It grows rapidly and is good for massing or as a container plant since it only reaches a height of 8 inches (20 centimeters). The vibrant coral-red flowers bloom throughout the winter, and the spiked leaves grow upright and curved inward in a ball.

'Bafana' is a big succulent shrub, growing up to 6 feet (1.8 meters) high and 5 feet (1.5 meters) wide. Its large, tubular yellow flowers bloom in winter. It was named after the nickname for the South African soccer team.

Agapanthus is a summer-flowering perennial with evergreen, strap-shaped leaves and big balls of flowers. All of the six or so species are native to Southern Africa, so De Wet has decided to try his hand at breeding these as a sideline. When not grown in the ground, they make excellent container plants. His selections include the stunning 'Blue Ice', with pale blue flowers with a darker blue base. Its name describes it. 'Bingo Blue' is a short plant with multitudes of bright blue flowers on 11-inch (30- centimeter) stems, and 'Great White' has large white floral balls with yellow stamens.

To flesh out the display gardens at the nursery, a garden that seems always to be in bloom, De Wet also showcases *Plectranthus*, a genus in the mint family, and *Tecoma*, of the trumpet vine family. He also likes other South African natives and is fond of the Natal lily (*Clivia*), a member of the amaryllis family, and *Lachenalia*, the Cape cowslip.

"Plant breeding has great possibilities, but it is much harder, more expensive, and slower than most people realize, and I believe one should be very patient and passionately dedicated to get the results that are acceptable to the horticultural industry. We often work on a genus for several years and then walk away from it and discard all material as we realize that we cannot achieve the goals we thought were possible. That's plant breeding for you. It's hard work but a lot of fun," he says. De Wet continues to breed plants for the betterment of ornamental horticulture. In doing so he is expanding our knowledge of and appreciation for some of the world's most beautiful plants. His work is deeply South African, yet he and others are spreading the word of the value and wonderful beauty of South African plants around the world.

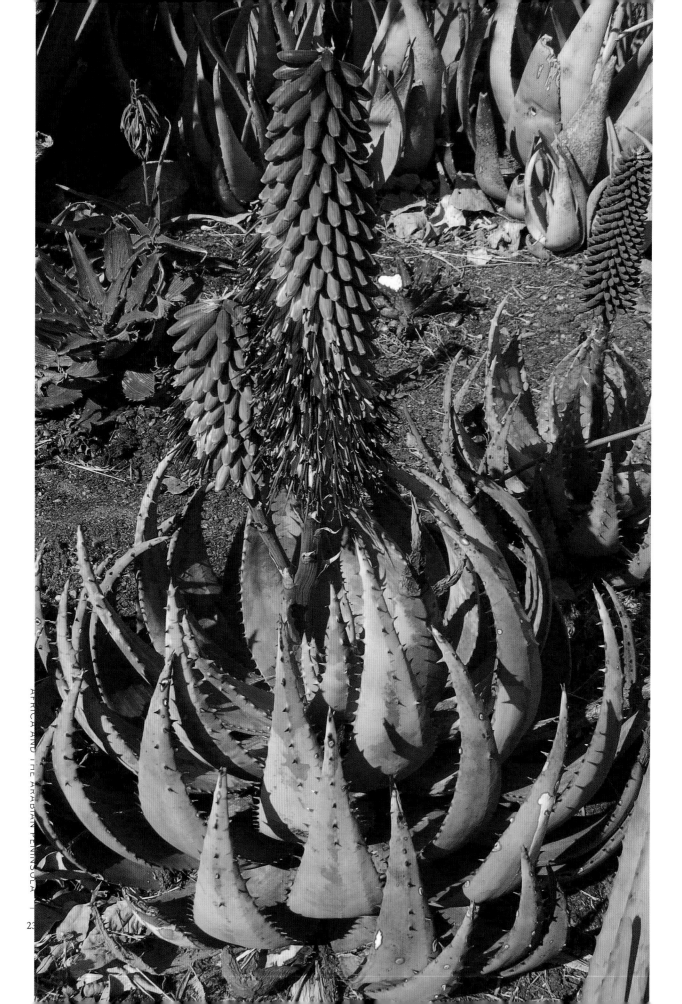

The Aloe Farm is a display garden, nursery, and botanical garden in one.

← With stout, gray-green leaves that curl in on themselves when the weather is dry, *Aloe peglerae* is stemless and often produces only a single flower stalk. The flowers are brick red with purple stamens. It is listed by the International Union for Conservation of Nature as being in danger of extinction.

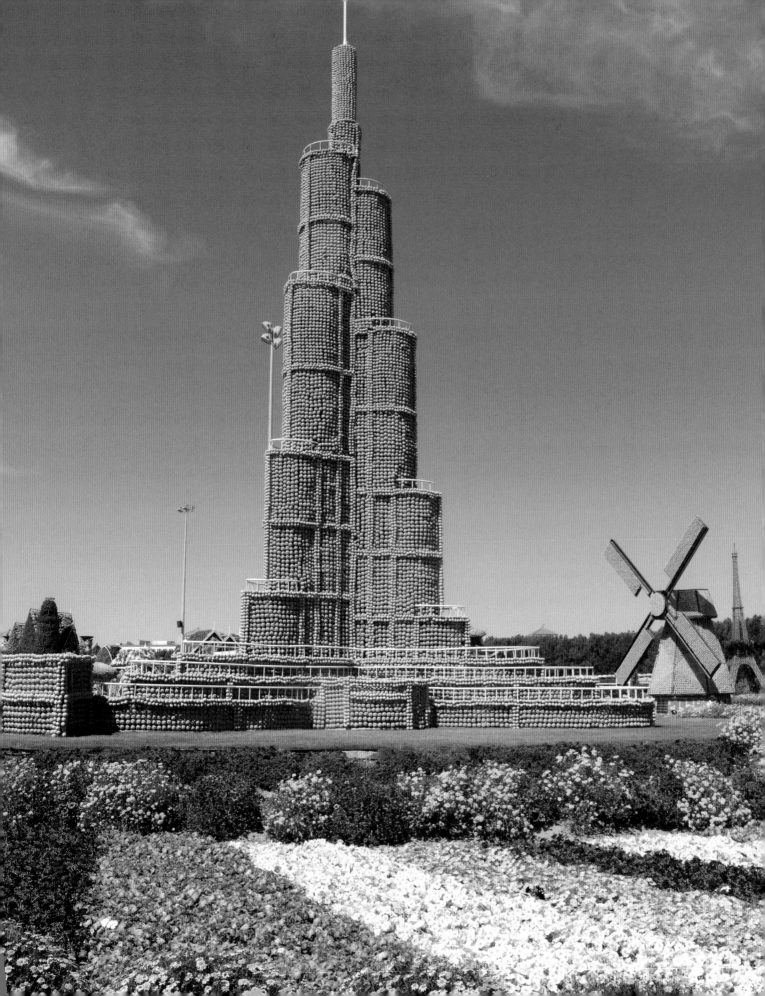

The Miracle Garden

DUBAI, UNITED ARAB EMIRATES

Akar Landscaping Services · 18 acres (7.3 hectares) · 2014

FORTY-FIVE MILLION PETUNIAS and geraniums in the desert. A mirage, a madness, a Garden of Eden, a paradise?

Dubai is a modern desert city, seemingly always under construction with one glorious or inglorious thing after another. The weather is wonderful in the autumn, winter, and spring and appallingly hot in the summer. The temperatures relate directly to the population's available avenues of recreation. In the cooler seasons, many flock to see the Miracle Garden.

There is a British slang word that may adequately describe a person's reaction to the Miracle Garden: "gobsmacked." There is no doubt that entering through the petunia-laden gates is a jaw-dropping experience. The visitor from afar would do well at this point to remind himself or herself that color is cultural. In the West, white is the color of brides, weddings, and peace. In the East, it is symbolic of sadness, death, and mourning. It is very evident here that the bright colors of millions of annual plants is a cultural phenomenon that sits uncomfortably in Western culture but delights, in general, those from an Eastern culture. And if all you normally see is desert—dry and dusty—all these flowers and yes, even petunias, might seem luxurious, a feast for the senses.

Approximately 70 percent of the UAE's highly international population is Indian, Pakistani, Bangladeshi, and Filipino. And this demographic fits the average visitor to the garden. With that demographic comes a range of cultural biases that generally favor displays of bright colors. So here, they get their money's worth. Seemingly endless archways of petunias lead to crossing hearts writ with geraniums. Igloos, too, and pyramids, domes, and a village of flower-strewn cottages. Let us not forget pink flamingos, and let us pay attention to a somewhat alarming fountain of an upside-down automobile penetrated by a thick column

When life gives you lemons, make a windmill and a replica of the Burj Khalifa in Dubai.

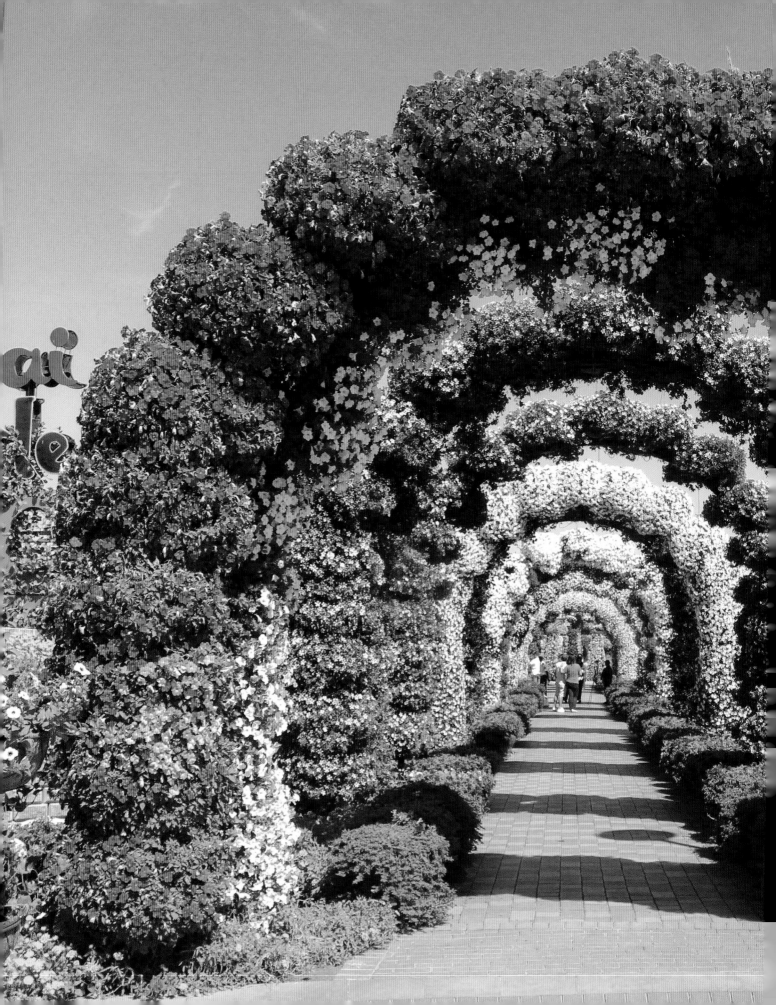

Archways of petunias seem to stretch to infinity.

The extraordinary show of millions of flowers in almost every conceivable arrangement makes this garden one of the most popular in the world.

↓ A pink peacock of petunias—in the desert, less a bird of paradise than a bird of paradox.

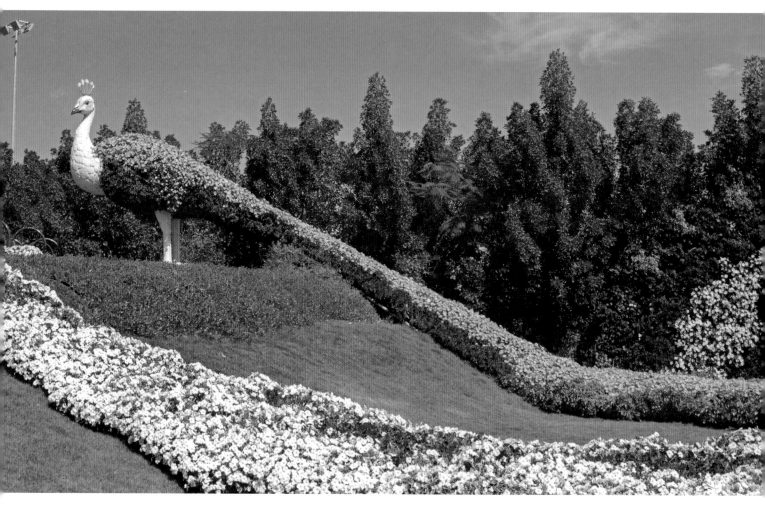

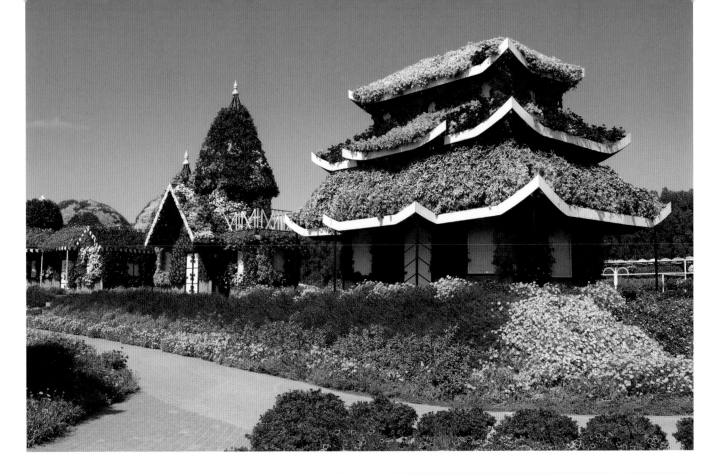

The garden is filled with replicas of Japanese, English, and Tyrolean villages, all laden with flowers on every available surface.

and pouring water. There is dried fruit too—thousands of lemons clothing what looks like a Tyrolean castle, and, in another piece, a model of the Burj Khalifa, the tallest building in the world, also made from lemons. For the romantic ornithologist there are pink swans and white peacocks. It is remarkable what can be done with petunias.

Sometimes we take ourselves too seriously. Garden designers talk about sustainability, whatever that actually means, and design intent, and invasive versus native plants, and so on. They question whether garden design is an art or a craft. Meanwhile, the overall population, oblivious to these back-room conversations, just wants to have fun, a place to take the kids, and an opportunity for selfies.

The Miracle Garden succeeds. It is for the enjoyment of beauty without the complications of intellect, and it doesn't pretend anything else. It's honest. With Dubai's children having such little access to truly green space, any time spent outdoors, even at this riotous and fantastic garden, is an appropriately laughing matter.

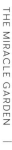

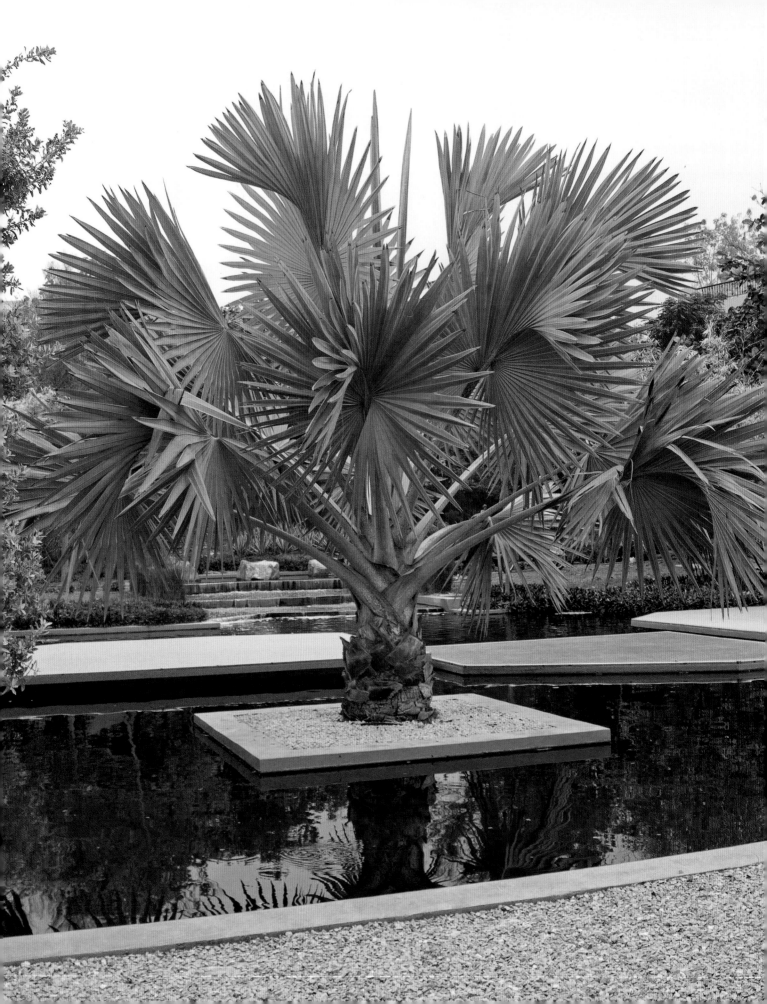

Al Barari

DUBAI, UNITED ARAB EMIRATES

Zaal Mohammed Zaal, Kamelia Zaal, Second Nature Landscape Design

321 acres (129 hectares) · 2009

"Some wine, a Houri (Houris if there be),
A green bank by a stream, with minstrelsy;
Toil not to find a better Paradise
If other Paradise indeed there be!"

—OMAR KHAYYAM

AL BARARI IS A SURPRISE. It is situated in a desert in suburban Dubai, and it's as lush as an English botanical garden: it holds thirty-four individual gardens and more than four million plants.

Kamelia Zaal is the garden designer and, with her father, Zaal Mohammed Zaal, she has created a garden overflowing with plants in what must be the greenest place in the United Arab Emirates. Perhaps this has something to do with a desire to imprint some of her own heritage on the relatively blank slate of the desert, because she is half Scottish and half Emirati.

Al Barari, which means "wilderness," is wild with layers of horticulture. These envelop a residential compound comprising 216 villas, a gourmet restaurant, a health club, and the region's largest privately owned plant nursery. New villas and gardens continue to be constructed.

It has been described as a botanical haven, and it is. What is remarkable is that all this is happening in a climate with an average summer temperature of 106°F (41°C) and an average annual rainfall of 6 inches (15 centimeters). But inside the compound, it is shaded and cooler,

Bismarckia nobilis's silvery-blue fronds look at home in a garden based on clear geometry.

For centuries, open pools of water in the desert, where water is a scarce resource, have been synonymous with luxury. This one, near the complex's main restaurant, contains cattails (*Typha latifolia*), papyrus (*Cyperus alternifolius*), and pencil grass (*Juncus effusus*).

on average 3 to 5°F cooler. How is this accomplished? There are lots of trees and shrubs, creating shaded tunnels, and the high density of the plantings as well as freshwater streams and 10 miles (16 kilometers) of landscaped lakes create an environment that differs greatly from the surrounding desert.

Where does all the water to support this design come from in the desert? Treated sewage effluent (TSE), in this case. It is better than it sounds. Black water from a nearby sewage treatment plant is filtered through a reverse-osmosis process, pumped to an on-site treatment plant, and used for irrigation. No potable water is used on plants. There are six open waterways in the development as well: lakes, streams, and waterfalls. The waterways also have a TSE source, but there is no smell except the perfume of flowers. Algae growth in the nitrogen-rich water is controlled using water recirculators, aerators, and ultrasonic devices

Cactus-like desert euphorbia and *Euphorbia tirucalli* 'Sticks on Fire', with the red-gold stems, planted among palms and more water-dependent trees and shrubs, reveal broad diversity in close quarters that is a testament to good garden management.

that use high-frequency sound to agitate the water, freeing it of pollutants. Gray water from the residences is also recycled, and also feeds the irrigation system. It is a complex and intelligent system; plants get the correct amount of water, and the streams and lakes are clean and appealing.

Al Barari is a sensitive development that focuses on ways to be as sustainable as possible. Aside from the water, all green waste is composted and returned to the planting beds. The gardens are designed to look naturalistic and are generally low-maintenance, and, although there are formal areas, they are designed to be consciously ecological in their relationships among water, plants, birds and animals, and residents and visitors. The endangered Arabian killifish (*Aphanius dispar*), one of three freshwater fishes found in the UAE, is thriving in the lakes and streams.

The high concentration of planting is practical, with its shade-giving qualities and humidifying effect, as well as aesthetically pleasing. Trees provide sheltered areas from the burning sun for an underlayer of shrubs, and they, in turn, create cooler, shaded environments for herbaceous plants.

The property is divided into a series of themed gardens—Balinese, Contemporary, Mediterranean, Renaissance, Showcase, Water, Woodland—with streamside pathways and avenues

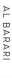

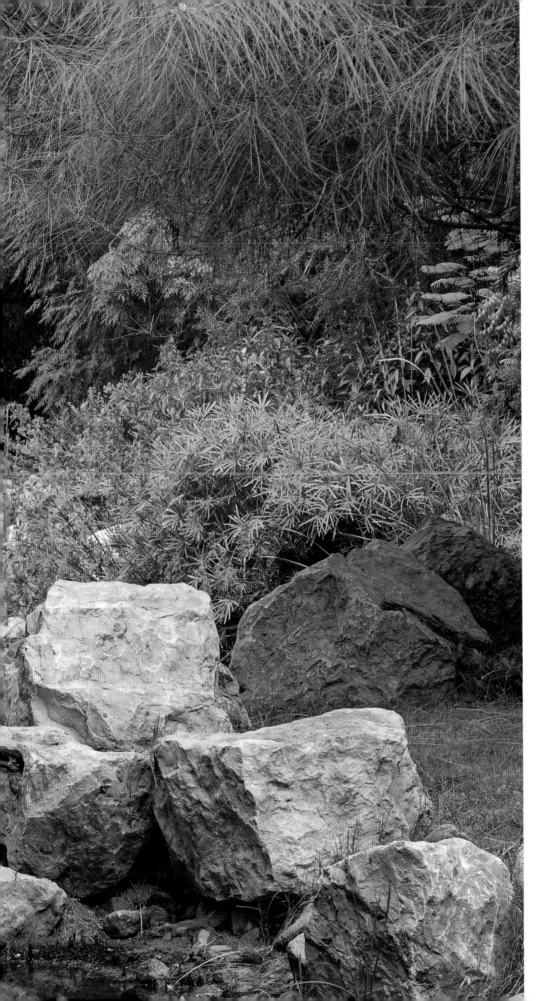

A recirculating water system with streams, pools, and ponds, lowers the ambient temperature in the garden, making it cooler and temperate enough for outdoor enjoyment.

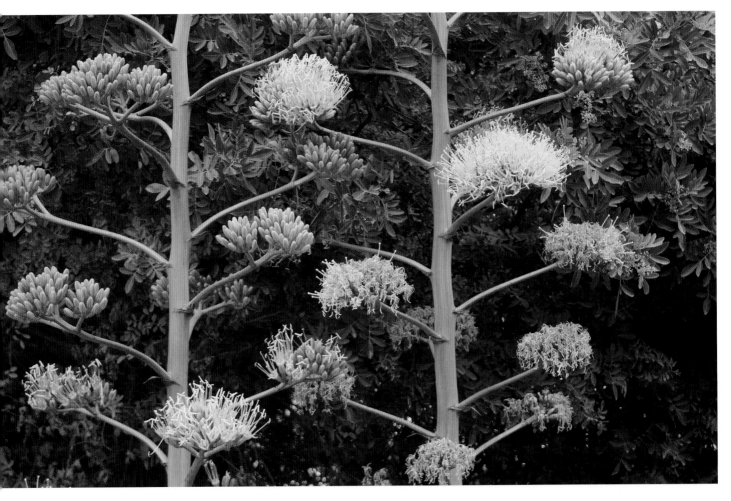

The fading flowers of *Agave americana* grow naturally in decorative espaliers.

→ There are many tropical hibiscus hybrids and cultivars represented at Al Barari, ranging in height from 2 to 16 feet (0.6 to 4.9 meters). This specimen may be a sport of *Hibiscus* 'Sylvia Goodman', which can grow to a height of 6 feet (1.8 meters).

of trees connecting them to one another. Bamboo pergolas with cushioned seats are strategically placed. It may be cooler in Al Barari, but it's still blisteringly hot at times.

The Contemporary Garden has, as its focal point, a large Bismarck palm (*Bismarckia nobilis*), with beautiful silver-blue fans. It is a large palm and its formal appearance, placed as it is in a square container in a geometrically sharp streambed, is a strong focal point for an angular garden. Pleached silver buttonwoods (*Conocarpus erectus* var. *sericeus*), a tree adapted to high heat, are trained to look like hedges on stilts, framing the waterway and extending the geometry upward. An entryway is framed by an avenue of fiddle-leaf fig (*Ficus lyrata*), offering softness with its large, round, leathery and veined leaves. It is the most formal of the gardens, all angles and steps, complementing the modern Mediterranean-Arabesque villas.

The most delicately designed of the gardens is one that surrounds the Farm, the high-end restaurant at the heart of Al Barari. The restaurant itself is stylishly modern with wooden decks, glass balustrades, large umbrellas, and topiary plants. The view from the restaurant could be of California, with small pools framed by palms and containing cattails (*Typha latifolia*), papyrus (*Cyperus alternifolius*), pencil grass (*Juncus effusus*), and the thick, egg-shaped leaves and lavender flowers of water hyacinth (*Eichhornia crassipes*). There are formal rows of topiary. *Clerodendrum inerme*, sorcerer's bush, flowers constantly with fragrant white flowers, and is attractive pruned into a globe, as is the golden curtain fig (*Ficus microcarpa* 'Golden') with waxy green and yellow leaves. The restaurant garden is beautifully lit at night with uplights illuminating date palms (*Phoenix dactylifera*), Mexican fan palms (*Washingtonia robusta*), California fan palm (*Washingtonia filifera*), and the magnificent traveler's palm (*Ravenala madagascariensis*). This could be Beverley Hills.

There is no question that a lot of time, design, and horticultural awareness, and, of course, financial investment, has been spent to make Al Barari an extremely pleasing and botanically diverse environment. The work done to make the development as environmentally sensitive and sustainable as possible is exemplary.

Walking under a bower filled with the delicious perfume of sweet acacia (*Acacia farnesiana*) and the ultramarine flowers of clustervine (*Jacquemontia violacea*) entwined around a robust bougainvillea with bright red flowers is a little bit of paradise. It is reminiscent of a Paradise Garden of Islam that we see at the Taj Mahal, the Shalimar Gardens in Pakistan, and, most famously, at the Alhambra in Spain. Al Barari is a meeting place of East and West, and while it may be precocious to state that it indicates a new achievement in the gardens of the Middle East, it certainly points the way toward a greening of the entire peninsula.

Oman Botanic Garden

AL KHOUD, OMAN

Centre for Middle Eastern Plants (CMEP), Atkins Global, Annette Patzelt and garden staff
1,045 acres (423 hectares) · 2004–2017

THE OMAN BOTANIC GARDEN is certainly one of the largest and arguably one of the most important new botanical enterprises being developed in the world today. It will be an impressive garden when it is completed, not because of the size of the site, but rather for the substantial and serious work in plant conservation, the sensitive display of plants endemic to Oman, the focus on the region's ethnobotany, and the traditional relationship between the Omani people and their native plants.

The Sultanate of Oman is bordered by the Arabian Sea and the Gulf of Oman to the east, Yemen to the south, and Saudi Arabia and the United Arab Emirates to the west. Being isolated from the floras of Africa and Asia, the region has developed a diversity of bioregions that those who might otherwise assume it to be a barren, harsh country would find surprising. These consist of desert and semi-desert, with mountain ranges and a subtropical region in the south, Dhofar, which is lush and green during the monsoon season. Oman is home to more than 1,200 species of plants, eighty of which are found nowhere else in the world. The Jebel Akhdar, or Green Mountain, part of the Hajar Mountain range that runs along the country's northern edge, gets enough precipitation to have sponsored the development of many native plants.

The garden is situated a few miles from the city of Muscat, in the northern gravel-desert region. This area is comprised of light-colored limestone basins and mountains and darker ophiolite, an igneous rock thrust up from the oceanic crust. Oman is, in fact, a geologist's dream.

The roots of *Arnebia hispidissima*, the Arabian primrose, are used to make a deep red dye.

This umbrella thorn tree (*Acacia tortilis*) is a dominant feature of the Omani landscape. It spreads up to 42 feet (13 meters) wide and 16 feet (5 meters) tall.

The vegetation of the country is dominated by the flat-topped, small tree *Acacia tortilis* and outcroppings of the light green evergreen shrub *Euphorbia larica*. Higher in the hills, the rare and threatened *Barleria aucheriana*, with its pink-blue flowers, adds a little color as does the atil (*Maerua crassifolia*) with its sweet-scented white flowers. Small villages frequently have groves of date palms (*Phoenix dactylifera*), persimmons (*Diospyros* sp.), and apricots (*Prunus armeniaca*), as well as small terraces of wheat, garlic, and lentils, all which help to pepper the arid landscape with green.

The botanic garden is the leading organization for plant conservation in the Arabian Peninsula, and as such has been at the forefront of protecting native species in a region that is fast undergoing change. The usual reasons why plants are disappearing everywhere also apply here: Habitat loss is a result of human expansion, pollution, and overgrazing—here by cattle, goats, and camels. Also, it has already been observed that climate change is making the country hotter and drier. This is not good news for a country that can experience sear-

ing summer temperatures reaching up to 120°F (48°C), and although plants have adapted over millennia to survive the climate, such fast-acting change is beginning to cause havoc in the more fragile plant communities. Small villages exist only thanks to perennial springs or by harnessing seasonal water running through *wadis* (ravines or dry creeks that turn into streams and oases in the rainy season). One moment they can be dry gravel beds, the next, when dark clouds bump up against the mountains, they can channel torrents.

The botanic garden uses the *wadi* running through it to divide the plant display. To one side, a large conservatory keeps cool plants native to the northern mountains. This is combined with a heritage village, a place to display and educate about Oman's long history and rich culture. On the other side lie thematic gardens representing a sand desert, a northern gravel desert, a central gravel desert, and a conservatory dedicated to plants from the southern mountains of Dhofar. In this case, the purpose of the conservatory is to keep the plants cool and wet. A large number of wetland-dependent plants, such as the rare eastern marsh helleborine (*Epipactis veratrifolia*), an orchid, are in danger of extinction and will be protected here.

Only 15 percent of the land will be developed as a cultivated garden; the rest will remain a vibrant nature preserve. Because of the environmental fragility and the work on plant conservation, the garden has attracted attention from other botanical gardens and organizations around the world, notably Botanic Gardens Conservation International (BGCI), based in Kew, London, and the Royal Botanic Gardens, Edinburgh. Both organizations have played an important role in providing support throughout the development of the garden.

The botanic garden is in the process of researching how the country's plants have been used for food and shelter, medicine and dyes, perfume and magic. Ethnobotany will be kept alive through educational offerings at the heritage village and will be accompanied by basketry and weaving, music, poetry, and rituals. It is part of the garden's mandate to capture as much of this ancient knowledge as possible before it disappears. The peoples of Oman still regularly use the dye of *Lawsonia inermis*, or henna, to decorate their skin, particularly on a bride's hands and feet. Frankincense, the resin from the olibanum tree (*Boswellia sacra*), is used as medicine as well as incense. Walnuts (*Juglans regia*), grown for their nutritious nut, are also used to treat scars and open wounds. *Aloe whitcombei*, a plant used to treat skin diseases, is now reduced to growing in a single site in the wild and would be threatened with extinction if it weren't for the garden's propagation program. *Dracaena serrulata*, a species of dragon tree still used to make rope and as camel fodder, is threatened by aridification brought on by climate change and road construction.

Garden staff have propagated over 100,000 plants in the nursery, making it the largest documented collection of Arabian plants in the world. In the *Oman Plant Red Data Book*, Annette Patzelt, the garden's director, writes: "Biodiversity loss is one of the world's most pressing crises. Species are declining to critical population levels, important habitats are being destroyed, fragmented and degraded, and ecosystems are being destabilized through climatic change, pollution, alien invasive species and direct human impact."

Used to feed camels, *Maerua crassifolia* is fast disappearing. It is also used as a medicinal plant for humans and is eaten as a cooked vegetable.

→ *Tecomella undulata* is a tough tree with vibrant blooms that produces high-quality timber; because of this, it is becoming increasingly endangered in the wild.

A member of the four o'clock family (Nyctaginaceae), *Boerhavia elegans* subsp. *stenophylla* is a desert plant with tiny red-pink flowers on numerous long stalks.

Euphorbia larica, a euphorbia that can be found clustered in crevasses, is notable for its green, pencil-like stems.

→ The flora of Oman is surprisingly varied. Fully 85 percent of the botanic garden is devoted to nature preserves like this one.

india and southeast asia

Prayer for Peace

The Garden of Five Senses

SAID-UL-AZAIB, DELHI, INDIA

Pradeep Sachdeva Design Associates · 20 acres (8 hectares) · 2003

THE GARDEN OF FIVE SENSES, one of the few places where residents of conservative and crowded New Delhi can experience some semblance of privacy, is infested with young lovers. Couples cuddle in corners, take endless selfies, and whisper sweet nothings. This is an unexpected social by-product for any public park, but especially one originally designed to focus on strong architecture and detailed horticulture. Perhaps it is a victim of its own success at stimulating the senses.

The garden is a project managed by Delhi Tourism and Transportation Development Corporation, a government organization that also maintains it. Delhi is, to put it mildly, a bustling city. With a population close to 19 million, it has one of the highest population densities in the world. It also has the dubious distinction of being the most polluted city on earth, recently surpassing Beijing. An average of half a million vehicles are added to Delhi's streets every year. This makes any green space a valuable and necessary resource for the overburdened people—and puts a heavy maintenance burden on the management as well. Fresh air being more of a concept than a reality, the garden, however, does bring some relief, a breath, and a respite.

It is much more than a passive green space. The eminent Indian architect Pradeep Sachdeva's work is the strongest element; it gives the garden its structure, character, and overall artistic value, distinguishing it from the other city parks. He insists that his design is utilitarian but he is being self-effacing. From the diversity of paving stone to the textures of walls, from the color of columns and mosaics to the layers of terraces, this is no ordinary functionality. It's also no ordinary appeal to the five senses as we think of them, but one that is more site- and soul-specific. As Sachdeva puts it, "Sitting at the site with its acacia trees

The garden features a number of sculptural works including *Children Praying* by Kamal Nayan.

and native shrubland, it felt, that being a bit away from the city, all of the body's senses were alive. The city's chaos had made one forget one's senses. This led to the naming of the garden and then the development of the various whimsical theme gardens and the language of the built form within it. All meant to stimulate the senses."

The entrance plaza boundary wall is made of Jodhpur pink sandstone, yellow Jaisalmer limestone, and pale blush Dholpur sandstone, and it references Mughal architecture, one of the best-known examples of which is nearby, Qutub Minar, the magnificent UNESCO-designated minaret. Inside the wall, five pink stone elephants carved by Rajasthani artists trumpet welcome. The garden path spirals from them to a formal Mughal-style garden, the Khas Bagh, with grids of clipped hedges and geometric waterways.

Stone also frames and paves other themed gardens. A sunken garden's most prominent feature is a series of pillars topped by fanciful contemporary finials. Reminiscent of ruins, a bamboo garden and a cactus garden, delightfully decadent in overgrowth, lead to the most dramatic architecture of all, a stone spiral staircase climbing the hill amid a paisley park of rare trees.

From the hilltop, the visitor is then returned to another spiral, whirling round a circular garden of clipped hedges and fishtail palms (*Caryota urens*) and a "wishing tree" or baobab (*Adansonia digitata*). At times, the deep sounds of chanting, *om*, can be heard as meditators sit in lotus position at the foot of the tree. Depending on the day, an astrologer, sitting on a mat, will tell you which days are most auspicious for garden writing.

As to plants, it is not without a certain contrarian intelligence that the first trees to be encountered are the silk floss (*Ceiba speciosa*), a dry-loving tree with pink hibiscus-like flowers—and fierce, sharp thorns along the length of the trunk. If this tree is meant to appeal to the sense of touch, it's as a challenge. Across from the silk floss is the more hospitable powder puff (*Calliandra haematocephala*), an upright shrub with masses of crimson brush-like flowers.

Widely planted throughout Asia, the false ashoka (*Polyalthia longifolia*), native to southern India and Sri Lanka, is a common tree in Delhi and in the garden. It is evergreen with slender, shining, green wavy leaves, and grows in tight columns. It is used as a street tree, as a barrier to noise and dust. There need to be more of them.

One of the most widely worshipped gods in India is Krishna. In the garden, he is represented by *Ficus benghalensis* var. *krishnae*, a fast-growing fig tree with cupped leaves. Mythology has it that Lord Krishna was fond of butter and would steal it. Once, when caught, he folded the butter in the ficus leaf to hide it, and the leaf of Krishna's butter cup has remained folded ever since.

Despite the thick air, there are many birds in Delhi, and the garden does its part to support them. The flowers of the Indian coral tree (*Erythrina indica*) are an important source of food for mynahs, parakeets, and other birds. The red blooms are striking among the leafless branches in the cool season. The garden not only has a good collection of trees, bamboos, palms, and herbaceous plants but is a repository for sculpture. Works by Indian artists—

Five Jodphur pink sandstone elephants welcome visitors to the garden.

← Powder puff (*Calliandra haematocephala*) features very fragrant, watermelon-pink flowers. A tough shrub, it can reach a height and spread of 15 feet (4.6 meters). Native to South America, it is commonly planted in warm regions of the world.

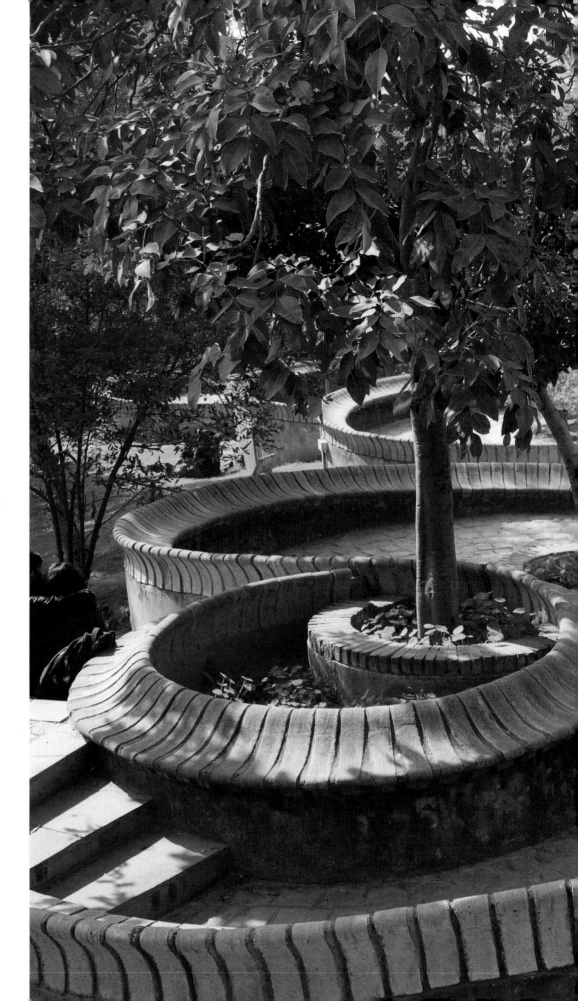

Rare trees are interplanted within a spiral staircase, the most arresting architectural element in the garden.

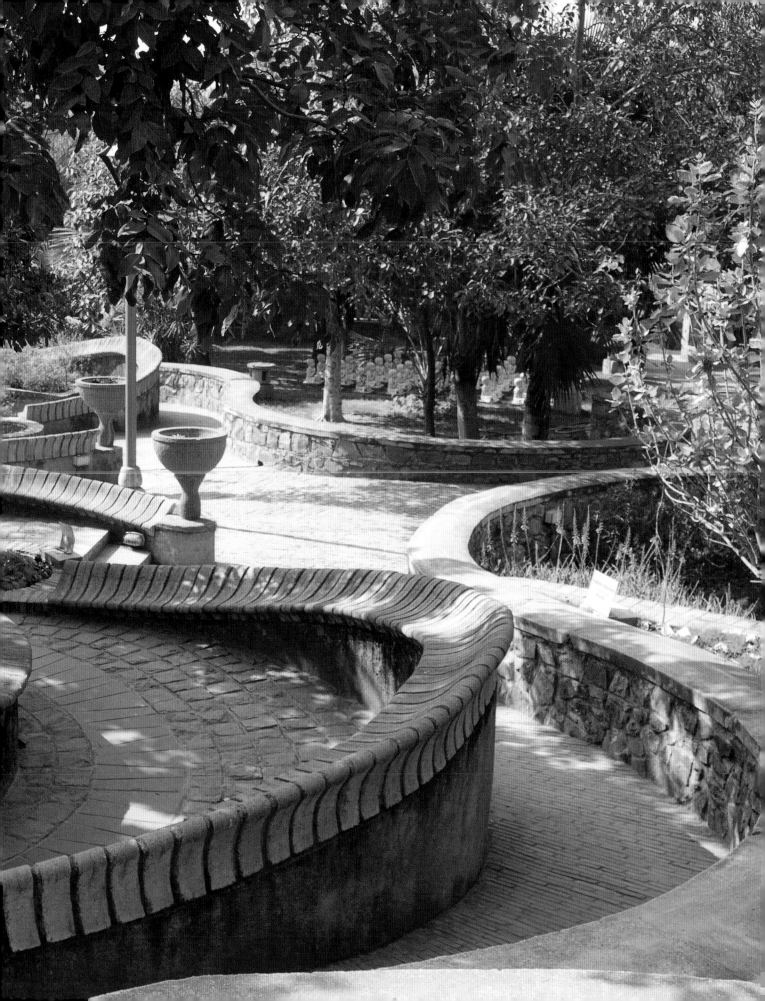

The Indian coral tree (*Erythrina indica*) produces bright-red flowers from January to March, before the leaves appear. It is common to see parakeets and mynahs in large groups feeding on its nectar.

→ *Polyalthia longifolia*, the false ashoka tree, is native to India. It is widely planted as a street tree throughout Delhi and other cities in the tropics, since it grows in a tight column and can be used as a living barrier, its lance-shaped leaves holding tight to the main stem.

Ceramic wind chimes on the Bell Tree clang in front of a replica of a Mughal arch.

Chanting the mantra "*Om mane padme hum*," groups of meditators take advantage of the peaceful space beneath a baobab tree.

↗ Decorative stone columns lead to a cactus garden and bamboo collection. The most ambitious—or foolhardy—young lovers seek out privacy in the cactus garden.

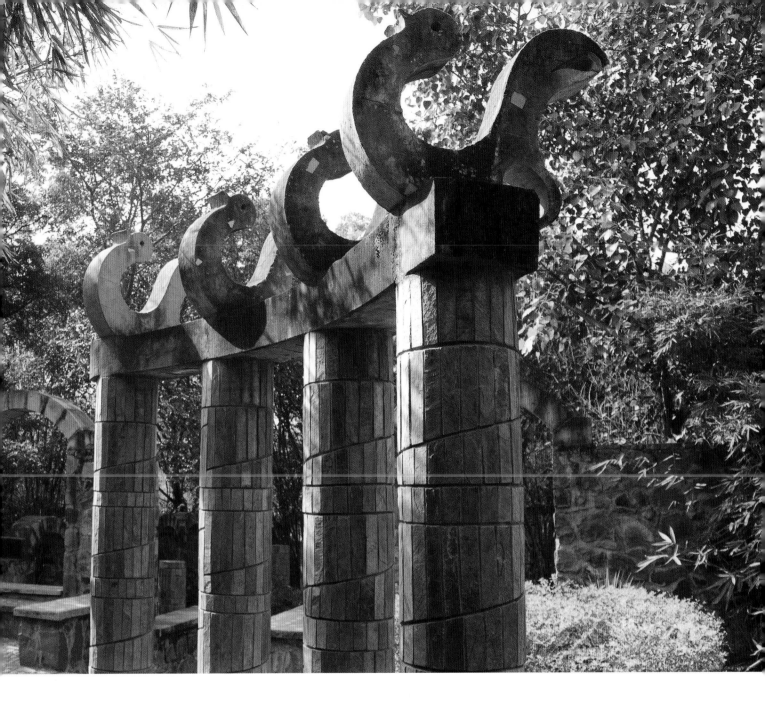

Subodh Kerkar, Giri Raj, M. J. Enaj, and others—are placed throughout the garden, adding to the architectural and spatial drama.

Other than the minimalist corporate landscapes of the new tech cities in Mumbai and Bangalore, contemporary gardens of any quality are hard to find in India. The remnants of faded British gardens may have inhibited new ideas, or maybe the sheer weight of population expansion intimidates innovators. This will change. The deep history and vibrancy of Indian culture has yet to fully express itself in modern landscape architecture. India has such cultural wealth, creative depth, and growing resources, there will be a green revolution. There has to be. The Garden of Five Senses is just the beginning.

137 Pillars House

CHIANG MAI, THAILAND

SilverNeedle Hospitality, P Landscape · 1 acre (0.4 hectare) · 2012

THE ENTRANCE TO 137 Pillars House starts off traditionally, with a Buddhist spirit house very like those seen outside almost every business establishment and on street corners and at most houses in Thailand. One of the spirit houses at this elegant hotel is dedicated to the guardians of the garden. The spirits protect the natural surroundings—the plants and animals. The visitor who moves deeper into the grounds suspects there must be one dedicated to the guests, too, if how well they are accommodated here is any indication, although the chains of tradition are quickly cast off in favor of new approaches to experiencing verdant delights.

Contemplating a garden's attributes while floating in a warm swimming pool sounds indulgent, but the design of this space practically begs someone to do it, and it is indeed one of the best ways to view one the most impressive features, an 82-by-130-foot (25-by-40-meter) wall of golden pothos (*Epipremnum aureum*). Over 1,500 plants fill the wall, providing a green and yellow living wallpaper for the property. The wall is balanced visually by two things—a line of seven turquoise-blue pool umbrellas that appear above a hedge and serve as complementary color, and across a courtyard the original house, built in 1889. The handsome teak structure, with tiled verandahs, rattan furniture, and ornately carved teak furniture, was the headquarters of the British-owned Borneo Company from 1896 until the Second World War. The house is deeply connected with Thai history and commerce. Anna Leonowens, best known from the novel *Anna and the King of Siam,* had a son, Louis, who became superintendent of the company; he was given a grant by the royal family to harvest teak from the northern forests. Later, the house was sold to a Scotsman, William Bain.

At the hotel's entrance, a small pool filled with tropical water lilies directs the gaze toward a traditional Buddhist spirit house.

A curtain of 1,500 golden pothos plants (*Epipremnum aureum*) provides a verdant, living backdrop for an elegant terrace.

The garden evokes the abundance of the surrounding Thai jungle, with orchids, ferns, heliconia, and the imposing foliage of *Philodendron* species.

↓ The bracts of the magenta flowers of ginger are poised to open fully.

Asplenium nidus, bird's nest fern, often grown as a houseplant, is at its best growing in the shade of trees in the tropics, where its spear-like, wide, glossy leaves grow up to 2 feet (0.6 meter) long.

The garden is finely balanced between serving the needs of the guests and adding a restrained beauty to the hotel. Care was taken during its renovation (which included moving the structure) to keep some of the oldest trees. A large royal poinciana (*Delonix regia*), a native of Madagascar, dominates one side of the garden. Its delicate, fern-like leaves shade the garden, and its bright-red flowers burst into flame from May to July. Araguaney (*Tabebuia chrysantha*), native to South America, blooms bright yellow in the dry season, and the fruit of the tamarind tree (*Tamarindus indica*), growing at the entrance, may well find its way into the delicious dishes served in the restaurant. In the hills above Chiang Mai and in the garden too, grows *Peltophorum pterocarpum*, the yellow flamboyant tree, its butter-yellow blossoms filling the landscape in October.

A giant fig (*Ficus* sp.) shades a seating area that is lit by paper lamps in the evenings, its muscular trunk reminding visitors of the elephants that hauled the massive teak tree trunks through the forest to build the original hotel.

Heliconias accompany native gingers to inject blooming hot spots of red and orange. Bird's nest ferns (*Asplenium nidus*) grow in the crotches of trees, their glossy leaves companionably showy alongside neighboring orchids and bromeliads.

The best way to describe this refined space, which is hidden within in the bustle of northern Thailand's largest city, is luxuriant luxury. May the guardians of the garden continue to watch over it for many years to come.

Seating is provided under the spreading giant fig tree that was preserved during renovation.

A corner of the teakwood main house is shaded by a royal poinciana tree (*Delonix regia*) at left.

Gardens by the Bay and Parkroyal Hotel

SINGAPORE

Grant Associates, Gustafson Porter, WilkinsonEyre Architects, WOHA

250 acres (101 hectares) · 2012

IN 1824, THE BRITISH took possession of Singapore under the leadership of Sir Thomas Stamford Raffles. They immediately set out to clear most of the native lowland tropical forest and mangroves to plant rubber trees. Fortunately for botany, a small but important remnant of the original tropical forest can still be seen at the Singapore Botanic Gardens. Founded in 1859, it is a very British maiden aunt of a garden, in English landscape style, with the more modern National Orchid Garden displaying thousands of species and hybrids in a rather prim but definitely beautiful setting. In 1963, Prime Minister Lee Kuan Yew, founder of modern Singapore, planted a pink-flowering native tree, mampat (*Cratoxylum formosum*), the first tree in a program to help Singapore become a garden city.

Today, almost 50 percent of the city is recognized as green space; about two million trees grace roadsides and parks, making it one of the most planted cities in the world. This is a remarkable place. Thoroughfares are divided by banks of bougainvillea and lined with enormous, durable naturalized street trees from similarly equatorial climates, such as the broad-leaved or Honduran mahogany (*Swietenia macrophylla*), with scaly bark and a dense evergreen crown. Singapore native tembusu (*Fagraea fragrans*) contributes, as its name suggests, fragrant, creamy white, night-blooming flowers. One particular avenue is so fragrant that locals come to sit under the trees in the hot and humid evenings. One of the largest trees, angsana (*Pterocarpus indicus*), grows to 130 feet (40 meters) high; its yellow flowers bloom for the one day nature has allotted them, and then Singapore's streets are carpeted.

The Cloud Forest dome is home to a massive artificial mountain of tropical plants; a walkway allows visitors to experience its unique microclimates from various vantage points.

The supertrees at Gardens by the Bay have become a world-famous phenomenon for their nighttime disco lighting displays.

↓ Three supertrees and the Cloud Forest dome announce the gardens as an unapologetically modern institution.

Two twenty-first century gardens contribute to the lushness. Gardens by the Bay is now one of the most visited public gardens in the world, having entertained its twenty millionth visitor in 2015—just three years after it opened. Built on reclaimed land, it consists of three public gardens. A series of themed gardens live within two spectacular conservatories, the Flower Dome and the Cloud Forest, both rising like lustrous, vitrified humpback whales at the water's edge. Outdoors, eighteen skyline-altering supertrees, ranging from 80 to 165 feet (24 to 50 meters) high, cluster in a grove of steel. Their latticed trunks host climbing plants, ferns, orchids, and other tropicals, but also function as solar power collectors, generating electricity for lighting and irrigation systems. Each night, the supertrees are brightened by a razzmatazzical light show, accompanied by Broadway show tunes and electronic dance music, much to the entertainment of thousands of visitors.

Gardens by the Bay attempts to educate and delight, and it succeeds exceedingly well. Purists may sniff at some of the televisual effects, but purists don't actually visit gardens in significant numbers. Regular people do. This isn't to say that the gardens aren't also sophisticated and highly educational. The plant collections are extensive and diverse, much more so than many "serious" botanic gardens.

The gardens display many rare and endangered plants. Plant conservation is a strong theme, and a powerful program on the devastating effects of climate change is broadcast in a theater as you exit the Cloud Forest, a 2-acre (0.8 hectare) conservatory of tropical plants found in the wet higher elevations of Southeast Asia and Central and South America. Within the conservatory, an elevated walkway skirts an impressive indoor mountain with a 115-feet-high (35-meter-high) waterfall, enabling the visitor to rather uniquely and very artificially experience what it would be like to fly up through different elevations and the associated flora. The mountain is fully planted with ferns, bromeliads, orchids, and species begonias as well as tree ferns, mosses, and flamingo lilies (*Anthurium* sp.). The reticulated structure and the swoop of the airborne walkway add a great deal of excitement to the experience.

The Flower Dome also impresses. This 3-acre (1.2-hectare) conservatory focuses on dry environments, featuring plants from the Mediterranean and semiarid tropical regions of the world. Plants in this conservatory have distinctly different needs and are displayed in seven biogeographical areas. A ground-level display rotates through seasonal plants with bright colors and slightly garish statuary. This last element is obviously a crowd pleaser.

A grove of baobab (*Adansonia digitata*) from Africa is truly impressive. The largest, from Senegal, weighs over 32 tons (29 metric tons). Another collection, of shaving brush trees (*Pseudobombax ellipticum*), also has weight. These feature fat, swollen trunks and flowers with green sepals that curl back and downward with brushes of white or pink stamens. The flowers last for one day. The tree is native to southern Mexico and Central America. There are date palms (*Phoenix dactylifera*) and olive trees (*Olea europaea*), Chilean wine palms (*Jubaea chilensis*) and proteas from South Africa. It's a little overwhelming to have so many plants from so many places together under one roof, but in a joyful, life-affirming way.

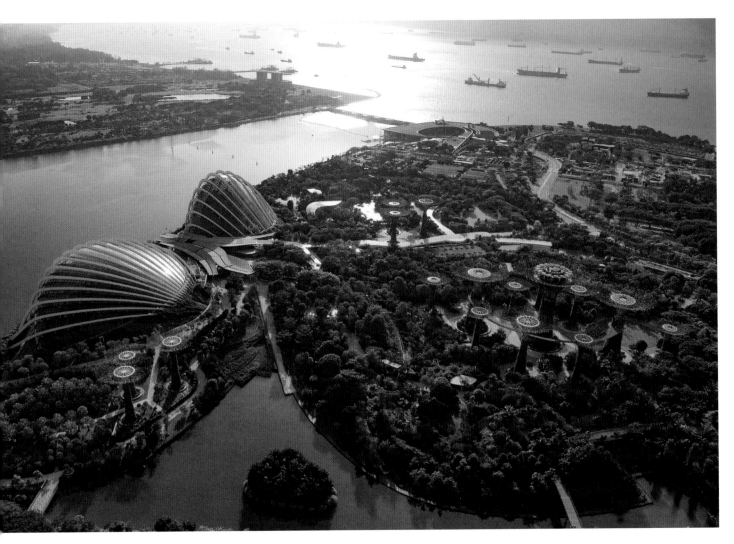

In one of the most wildly success-
ful applications of landfill ever,
Marina Bay now hosts two giant
glass conservatories as well as
expansive botanical gardens.

→ Baobab trees (*Adansonia
digitata*) are protected in the dry
Flower Dome.

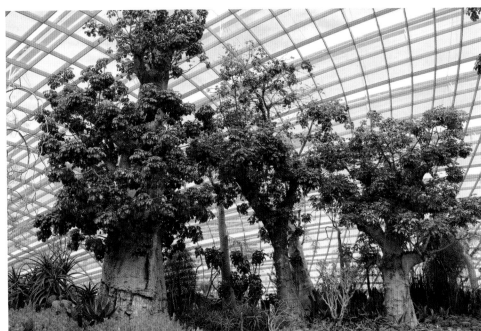

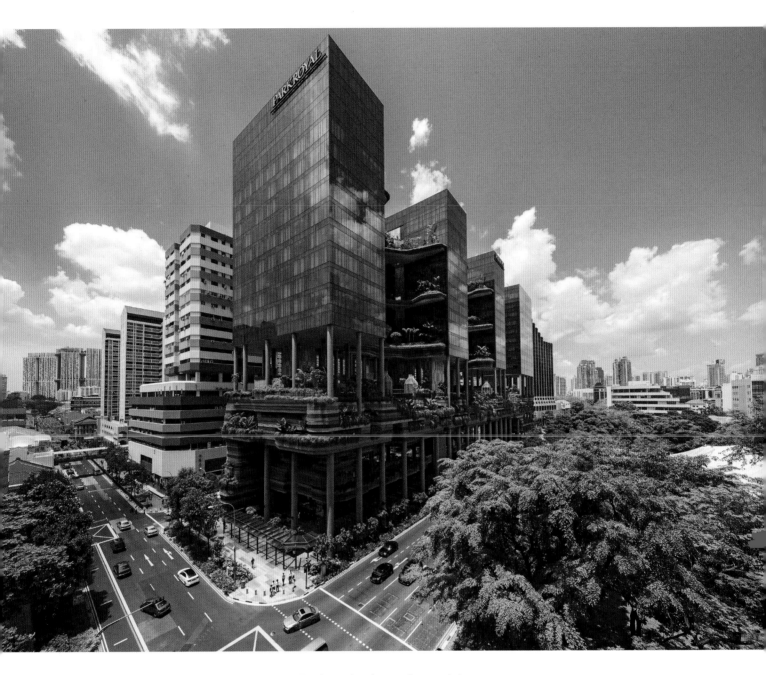

Every bay in the hotel's facade is filled with an abundance of tropical plants.

Terraces are dotted with outsize lounging pods as well as sophisticated plantings.

↓ The striated contours of the hotel facade add another layer of interest to the facade's terraces. Frangipani (*Plumeria* sp.) is planted on many of them.

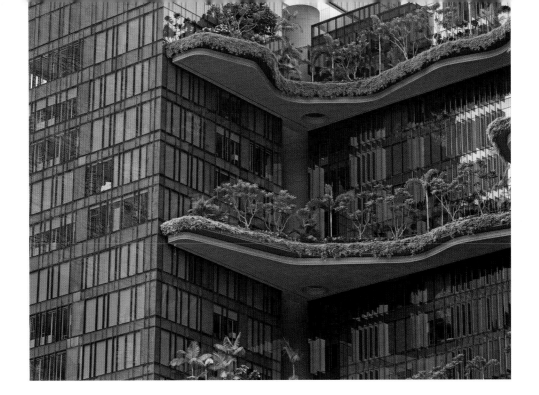

The long, contoured gardens at Parkroyal on Pickering are vertical horizontal gardens.

Outside, there are many themed gardens with encyclopedic ambitions. One is used for the biennial Singapore Garden Festival, fast becoming one of the most heavily visited flower shows in the world—it boasted 400,000 attendees in 2016. In contrast, the grande dame Chelsea Flower Show received 165,000 people the same year.

The Parkroyal Hotel on Pickering, near Chinatown, is a luxury hotel, but it also plays its part in greening the city. While not exactly a public garden, its extraordinary street-side facade and its intensive and innovative plantings make it one of the most fascinating and vibrant urban horticulture projects to be found anywhere. Designed by WOHA, a Singapore-based architectural practice founded by Wong Mun Summ and Richard Hassell, it is architecturally striking and horticulturally profound. The building accentuates its glazing with a series of striated, irregularly contoured terraces, plazas, gardens, valleys, and even waterfalls. These are slung in the courtyards between the building's four main towers as naturally as jungle vines would grow between supportive trees, and wrap the nearly 1,000-foot-long (300-meter-long) fifth-floor loggia to give guests a view of the plantings close up while enjoying a dip in an infinity pool or a lounge in a postmodern cabana, all just above the canopy of the city's street trees for a view of the entire metropolis.

Frangipani (*Plumeria* sp.) lean over high terraces, dark green clumps of lady palm (*Rhapis excelsa*) screen swimming pools, and the huge leaves of philodendrons clothe columns. The whole building is plausibly perceived as a garden first, a hotel second. Its presence, overlooking and drawing from an adjacent park, is immensely fertile and extraordinarily authoritative. It is breathing architecture.

Singapore is a model for greening the world's cities. If even half of the planet's metropolises paid as much attention to urban horticulture and urban planning as Singapore, the world would be a very different and healthier place.

Pha Tad Ke Botanical Garden

LUANG PRABANG, LAOS

Rik Gadella · 106 acres (43 hectares) · 2016

"Even in poetry and art does nature have its place, do flowers blossom in unexpected places, and do trees reach up to the sky. Not everything is pure science. What would garden design be without a palette of color, a sense of composition and structure, a playful line between nature and culture?"—RIK GADELLA, GENERAL MANAGER, PHA TAD KE BOTANICAL GARDEN.

THE ENTRANCE TO A GARDEN, the entrance to any space, establishes the tone of the experience that's meant to follow. It is the first note of the overture that lies beyond. If we are truly alive, truly listening and seeing, we are curious and full of expectation—a good mantra to bear in mind even when not standing in the middle of Laos, a Theravada Buddhist, animist, partly Hindu, socialist republic. It is rich in culture, and indeed the approach to Pha Tad Ke begins in the ancient city of Luang Prabang, a UNESCO World Heritage Site, known for its many Buddhist temples, French colonial architecture, and excellent cuisine.

A wooden longboat is moored to a jetty in the Mekong River. On the prow of the boat is a small tree in a pot. Traditionally, it is there to keep evil spirits away. Phaya Naga, mythical serpent creatures with supernatural powers, are said to inhabit the waters, bringing both blessings and misfortune. They are said to emit fireballs from their mouths in greeting the Buddha's return to earth. The potted tree placates the Nagas in some way. It seems to work, since the short journey from city to garden is one of serene beauty.

Few rivers are as inextricably linked to religion, geographically important, or economically vital as the Mekong. It starts in Tibet and ends, after 2,600 miles (4,184 kilometers),

The entrance to the garden is on a simple plateau above the Mekong River.

Every morning, fruit and flowers are placed as an offering at the spirit house of Pha Tad Ke.

in the South China Sea. On its way it brings life to 60 million people, who live close to it in parts of China, Myanmar, Thailand, Laos, Cambodia, and Vietnam.

The river is wide and smooth. On its banks are small plots of vegetables, fertile in the dry season when the river is low, washed away with the first big rain. People fish. People sit and watch. Buddhist monks in spice-colored robes sit meditating. A few boats glide by. Where it is not cleared for farming, the forest grows down from the sharp mountains to the water's edge.

Once you disembark and climb the steep steps upon the riverbank and have caught your breath, the garden presents itself. The sense of expectation, heightened by the river journey, becomes acute. Elegant reception and restaurant buildings, consciously and cleverly designed plantings of ornamental tropical plants give way to the opulent whisper of forest rising on a limestone karst—the mountain. Pha Ted Ka means "the mountain to untie and resolve." It is associated with the mantra to untie karmic knots, those actions that need to be resolved through chanting and prayer. Walking in the garden is, perhaps, a form of prayer.

Just 30 percent of the plants of Laos have been studied. Given that the country has one of the most diverse and profuse floras in the world, and slash-and-burn agriculture is devastating the countryside, there is much to do. The garden is an invaluable collection of diversity,

The restaurant near the entrance of the garden is adjacent to a pond that offers water lilies, lotus, and mangrove as scenery.

and a center of knowledge about the way the indigenous peoples have learned to harness plants for almost everything in their lives.

About 485 species of orchids are native to Laos. There may well be many more. The garden has collected 250 species, mostly of *Bulbophyllum* and *Dendrobium*, and they are on display in two shade houses. In time, more species will be added and the garden will be the central repository for the national collection. As with so many other plants, orchids around the world are in danger. About 10 percent of all plants on earth are orchids. It is hard to estimate the number of orchids lost to habitat destruction. Most orchids grow on trees, and logging is a profitable business in the short term. About 70 percent of Laos is forested, although only 9 percent of that is primary forest. Total forest loss since 1990 is about 7 percent, and is increasing. Without a strong conservation policy, Laotian forests and the orchids are destined to be severely diminished.

Habitat destruction, illegal wild collecting for sale, and climate change where previously suitable habitats are no longer tenable, are threatening Laotian plants. The garden's program of collection, propagation, and re-introduction is a core part of its botanical mission.

So, too, is its growing collection of gingers, palms, bamboos, and native trees. Gingers (Zingiberaceae) are used for food, medicine, ornament, and magical use. Possibly 300

species are native to Laos. The garden has a collection of over 200 with three-fourths identified. Some are highly ornamental, while galangal, ginger, and curcuma are used in cooking. Galanga (*Alpinia galanga*) has a sweet and spicy flavor; the flowers and buds are eaten with meat and salad. Turmeric (*Curcuma longa*) and wild ginger (*Zingiber officinale*) are mixed with chile and cardamom (*Elettaria cardamomum*) to make pungent and flavorful curry.

The garden is building an extensive collection of palms, 30 species so far, growing on a hill above the bamboos. *Arenga westerhoutii* grows along rocky streams and can reach a height of 40 feet (12 meters). The clustering fishtail palm, *Caryota mitis*, so-called because of the shape of the leaflets, can have many trunks and can reach a height of 25 feet (8 meters). *Areca catechu* is an Indonesian palm important for its fruit, the betel nut. The nut, combined with betel pepper leaf (*Piper betle*) and slaked lime, is a mild intoxicant causing saliva and excrement to turn bright red. It has been widely used in religious ceremonies and festivals in Southern Asia for centuries. It is now considered to be highly carcinogenic. Yum!

Clumping bamboos grow below the palms. They have been used for building, piping water, weaving, and cooking for over 5,000 years. Khene, an ancient Lao musical instrument, is a type of bamboo mouth organ that sounds a little like a violin. A little.

Bambusa tulda, a timber bamboo, can grow up to 80 feet (24 meters) and is used for paper, furniture, and building. And *B. arundinacea*, the spiny bamboo, can create a bamboo forest very quickly. It is used by the Hmong people to treat respiratory ailments as well as cirrhosis.

Back toward the river is the collection of native trees—many of them rare. *Goniothalamus laoticus* has strongly scented light yellow flowers that perfume the woodland. *Magnolia hodgsonii* is uncommon in Laos but it grows well at the garden, producing fragrant white flowers at the end of the dry season. Tree jasmine, *Radermachera ignea* (syn. *Mayodendron igneum*), is fragrant too. The bright orange flowers smell sweet. The tubular flowers are stuffed with meat and spices, and eaten.

The ethnobotanical garden is the biocultural center and is probably the most important part of the garden in that it directly connects people and plants. It is where we learn how important plants are to the indigenous population, and by doing so, how important they are to the rest of us. It is where food, medicine, magic, and ritual come together in the twenty-first century.

The ethnobotanical garden is comprised of ten separate gardens, designed within circular enclosures, in Lao village style. Each displays a use for the plants within it. For many Lao who have little access to Western medicine, medicinal plants for health and well-being and to treat illness are essential. Among the many plants used is *Clerodendrum indicum*, a semi-woody shrub with snow-white flowers and fruit turning from jade green to metallic blue. It is used to treat complications from child delivery as well as respiratory problems. Kalanchoe pinnata (*Bryophyllum pinnatum*), native to Madagascar, has become naturalized; it helps bones and bruises heal. Coleus (*Plectranthus scutellarioides*) is used for skin infections and healing wounds.

Branches of fishtail palm (*Caryota mitis*) make an intriguing pattern against the sky.

← *Bulbophyllum flabellum-veneris*, the Venus fan orchid.

The view out from the palm collection and toward Luang Prabang is one of the glories of the garden.

→ *Areca catechu*, the betel nut palm, can grow to 66 feet (20 meters), one of the tallest palm trees in the forest.

Eulophia andamanensis, a rare terrestrial orchid with long-lasting flowers in the spring and fall, is from the Andaman Islands.

→ *Habenaria rhodocheila* is one of the most attractive Laotian orchids. The species name means "red-lipped," although the flowers can come in orange and yellow as well as shades of pink and red..

Limestone rocks, tumbled from the mountain, are planted with cycads and palms.

← *Gastrochilus obliquus*, native to China as well as Laos, blooms from fall to winter with up to eight 1-inch-wide (2.5-centimeter-wide) flowers.

A path runs past an immense fig tree, leading visitors to steps through natural woodland and up to a large natural limestone cave. Deep in the cave, an old stone Buddha sits in the darkness.

Ceylon spinach (*Basella alba*) is eaten as a vegetable and used for dyeing cloth, while sugar cane (*Saccharum arundinaceum*), aside from giving sugar, provides stems used to roof houses and flowers to stuff pillows.

Magic and ritual are integral to Lao society. Every morning, offerings are placed in the ubiquitous spirit houses—traditional shrines—to placate the spirits. Coconut shells filled with oil and banana leaves full of marigolds and globe amaranth are sent floating down the river, prayers for a benevolent future. The sacred lotus (*Nelumbo nucifera*) is a symbol of the purity of the Buddha-nature and is placed on altars in temples or at home. The tight spiral buds of pinwheel (*Tabernaemontana divaricata*) and the waxy flowers of *Calotropis gigantea*, called the flower of love, are used to create floral offerings and decorations.

The garden will grow. A permaculture demonstration farm is coming. Figurative and fine art will arrive. Education programs will expand. Scientific research will prosper. And, to

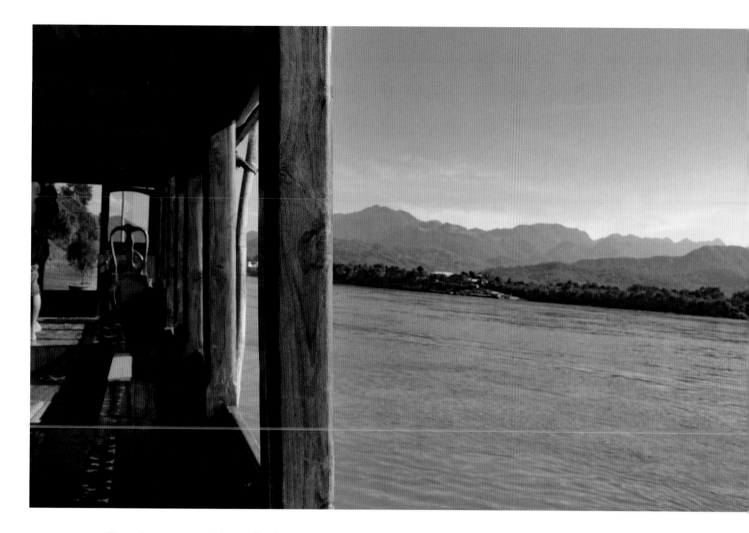

The only way to reach the garden from Luang Prabang is to embark on a longboat ride—truly one of the most satisfying ways of getting to a garden ever devised.

continue the spiritual tradition, every day votive offerings will be placed in the spirit house. Pha Tad Ke is one of the few botanical gardens in the world where science and culture hold equal weight and where art and horticulture are of equal pleasure.

As Gadella says, "When I first arrived in Laos, it was a holiday, just for a week. Then, Luang Prabang got under my skin and I decided to stay for three months to catch up on my reading. Whilst looking for a small bamboo hut where I could do so quietly, my friends took me for a walk at Pha Tad Ke. Full of weeds and magnificent old wild mango trees, spirits galore . . . I started to dream what I would like to do with the rest of my time and what made sense to me in these enchanting surroundings; the idea of a botanical garden grew rapidly and firmly, like most things do in this tropical region."

Made Wijaya's Gardens

BALI, INDONESIA

Made Wijaya · Various · 1979–2015

LANDSCAPE ARTIST MADE WIJAYA was known for creating Balinese-inspired landscapes. Combining architecture, both religious and secular, with artistically designed arrangements of tropical plants, his work both expanded the possibilities of the island's garden design traditions and exported them to the world.

His work at the Naples Botanical Garden in Florida is just one example. He designed over 600 gardens around the world—including in Singapore, India, Australia, Spain, Mexico, Morocco, and the United States. Some were for the rich and famous, many were for luxury hotels, and some were for private residences tucked away on his lush, adopted home island.

His life was full of personal and creative adventure. Born Michael White in Sydney, Australia, he sailed to Bali in 1973, but jumped ship in a storm and swam the last distance to shore. He became a tennis coach, writer of guidebooks, an expert on ritual dancing, an actor in the satirical play "Eat Pay Leave," an acerbic and witty newspaper columnist, and an embodiment of the island's flamboyance. Adopted by a Brahman family, he was named Made, meaning "second son," in a Hindu ritual. He started designing gardens in 1979 and continued until illness cut short his earthly life in September 2016.

His work is his memorial. He used his outstanding knowledge of Balinese culture and ritual to inform and constantly refine his vision for tropical gardens. Bali was his inspiration, and its architecture and landscape, derived from pre-Hindu and Hindu sources, particularly the island's red-brick Majapahit Empire temples, inhabited and defined his gardens.

Traditional Balinese domestic architecture often reflects the spatial arrangement depicted on the Surya Majapahit emblem, a star with eight cardinal directions—each guarded by one deity—and Shiva, one of the principal gods of Hinduism, at the center. Homes comprise a

Pink frangipani (*Plumeria* sp.), ubiquitous in Bali, grows vigorously in the tropical climate.

Rhaphidophora korthalsii, the shingle plant, grows up a wall of one of the rooms of a guesthouse at Taman Bebek.

series of pavilions made of teak beams and floors, bamboo rafters, and roofs thatched with nipa palm (*Nypa fruticans*). Tall drum towers (*bale kulkul*) with thatched roofs are placed at the entrance to the pavilions. All radiate in axial relationship from a central communal space. It is this communal space—so different from the Western mode of separate and private living—that distinguishes itself in Wijaya's designs. Within the elaborate set of Balinese spatial rules, plants can both frame and become the architecture.

In his work, Wijaya frequently creates ponds, pools, and water pots filled with water lilies and lotus, and surrounds them with the graceful teardrops of tropical maidenhair fern, *Adiantum raddianum*. The quiet of water, often in rectangular pools, is a counter-balance to rambunctious tropical flora.

Upward-thrusting flags of heliconias, the ringed trunks of swaying palms, the starry flowers of frangipani, and lurching tufts of bamboo are frequent favorites in his gardens.

Wijaya collected decorative Balinese stonework, some of it antique, some of it quite new. The exuberance of the stonework, and other decorative works in his studio in Sanur, is reflected in the fecund flamboyance of his plant combinations.

Less commonly, there is the wall-clinging vine *Rhaphidophora korthalsii*, the shingle plant, with its flat leaves cladding buildings, and the lovely symmetrically inclined shrub, the pinwheel, *Tabernaemontana divaricata*, with glossy evergreen leaves and waxy white, five-petalled flowers.

His early work can be seen at Taman Bebek, originally the home of Canadian composer and musicologist Colin McPhee, a boutique hotel overlooking the Ayung River near Ubud. Wonderfully overgrown, it is steeped in horticultural decadence, has a slightly postcolonial air, and is the perfect place to get a sense of Wijaya's eccentricity.

His studio in Sanur is a small village of eclecticism. A strikingly large pink frangipani (*Plumeria* sp.) grows almost as tall as a thatch-roofed ornamental tower. Antique Balinese doors are placed throughout the grounds, as are remnants of temple ruins and broken statues—a veritable pantheon of spirits—and modern artworks with erotic overtones. Among

From Taman Bebek the viewer looks across the Ayung River valley toward the mountains.

→ *Tabernaemontana divaricata*, an evergreen shrub, is beloved for its delicate pinwheel flowers.

Pieces of Balinese art from Wijaya's extensive collection are placed in his studio garden in Sanur.

← This French colonial Vietnamese house was recently transported to a garden in Bali and is part of a compound of buildings collected by Wijaya. His interest in and knowledge of architecture, combined with his skills in interior decoration, were more than matched by his brilliance as a garden designer.

these elements is a series of pools and ponds, mirrors for the art, and environments for pink lotus and water canna, *Thalia geniculata*.

In another part of the island, a garden in and around a deep ravine accompanies a series of pavilions: a Balinese baronial hall, a Malay colonial-style residence with a wraparound verandah, and two delightful French-colonial Vietnamese houses. The compound is owned by one family. Wijaya designed the gardens to decorate the houses and to provide space for social intercourse and relaxation. Along with adorning the interiors, he added exterior decoration, including a massive piece of hewn teak placed upright like a scholar's rock in a classical Chinese garden, and a delicately carved stone container of water hyacinth (*Eichhornia crassipes*), perfectly balanced on an uncut slab of marble.

Wijaya wrote, "Bali has a reputation as the cutting edge of tropical hotel design: the architecture of the tropical world's hospitality industry follows trends set on the island, trends set by a handful of talented international architects, bamboo house designers, and landscapers. Despite the filling-in of every vacant lot—and a few not so vacant ones (greenbelts, for example)—by architectural hacks, with cheesy modernist shtick, it is to the work of a handful of die-hard traditionalists and classicists that the design world looks." Given that modesty was not one of his most prominent characteristics, he may have been including himself with these ranks of good designers. Rightfully so.

His last big work in Bali, the Alaya Resort in Ubud, was completed in 2016. It is very different from his other gardens. It is understated, simple, and full of power. Bali is famous for the beauty of its rice paddies. Terrace upon terrace of sweet green. Wijaya designed a series of rice fields as the entrance to the restaurant. The rectangles of rice, bisected by a sharp-angled boardwalk and hung with wasp-like lamps, lead to a restaurant pavilion he also decorated, and then down to a pool and hotel complex. The rice continues, surrounding the pool but with the added touch of large, white-blooming frangipani. Green and white—so clever. This last garden illustrates Wijaya's ability to create mood in an extraordinary range of environments and temperaments.

Wijaya is remembered for his skill, his intelligence, and his embrace of life in all its color. He was a beauty warrior. He was cremated in Australia and his ashes transported to his beloved island for a Hindu purification and renewal ceremony known as *prelina*. The ceremony is a ritual meant to detach the five elements of life so that the spirit, *atman*, will find its way to heaven free from worldly life. May it be so.

Wijaya collected Balinese architectural elements such as these doors, many of which he incorporated in his gardens. He often used species of *Philodendron* and *Monstera* to frame the doors and windows.

The studio garden has several pools and ponds, each home to many water-loving plants including water canna, *Thalia geniculata*.

The entrance to the Alaya Resort in Ubud recalls the rice terraces that so define Bali's landscape. Wijaya also designed the wasp-like lanterns.

asia

Xi'an Expo Park

XI'AN, CHINA

Plasma Studio, BIAD, GroundLab, LAUR Studio, Beijing Forestry University,
John Martin and Associates, Arup. · 91 acres (37 hectares) · 2011

FAMOUS CLASSICAL CHINESE GARDENS, such as the Humble Administrator's Garden in Suzhou, established in 1509, and the Yuyuan garden in Shanghai, first established in 1368, have served as the best examples of garden design for centuries. Today, new attempts at honoring tradition are often displayed in tidy and nostalgic theme parks such as this, a horticultural amusement that benefits from proximity to the world-famous necropolis of the Qin Shi Huang Di Terra-Cotta Warriors and Horses Museum, a UNESCO World Heritage Site. It was designed for a 2011 landscape exposition, and is now a permanent public garden that promises a visual history of Chinese garden styles.

Modernization and its consequent by-product of leisure time have produced highly controlled environments for entertainment around the world. Many public gardens are in danger of becoming amusement parks with plants. But—and there is always a but—even in the most controlled display, a visitor with an open heart cannot escape the beauty of dancing willows, the fragrance of the Chinese fringe tree (*Chionanthus retusus*), the delicacy of the epaulette tree (*Pterostyrax corymbosus*), or the butter-yellow thickets of Japanese rose (*Kerria japonica*). Despite our most misled intentions, beauty shines through.

In Xi'an, vignettes from traditional gardens have been designed alongside modern courtyards and contemporary landscapes. Modern sculpture is bordered by traditional bamboo fencing, concrete replaces stone, and steel replaces the beam-and-bracket wooden construction of a pagoda.

A maple tree and a wall constructed of stacked clay roof tiles create a subtle and compelling vignette perhaps meant to reference classical gardens' prominent use of water.

The Chinese fringe tree (*Chionanthus retusus*) grows to a height of 20 feet (6 meters) and features sweetly fragrant flowers.

→ Traditional and modern Chinese garden design come together in often-dramatic dioramas.

Water Loong, by Jin Ren, can be seen from most areas of the garden by virtue of its size and eye-catching finish.

The Expo Park routinely offers many types of entertainment, including traditional music and dance.

By far the happiest example of a reinterpreted ancient feature is a towering sculpture of a water dragon, *Water Loong* by Jin Ren. Set so it can be viewed from many angles, in one corner of a large pond filled with lotus and edged with reeds and grasses, the silver-bright sculpture swoops and swirls over its own reflection and into the sky. Its massive form frames a more conventional and traditional statue of the Peony Fairy from one angle; from another, it towers over lines of Chinese weeping willow (*Salix babylonica* var. *pekinensis* 'Pendula').

Traditional gardens, each with a modern twist, line a central path. Customary architecture provides the framework for the Chinese white pine (*Pinus armandii*), wisteria (*Wisteria sinensis*), and the fluff of willow seed on a spring day. Outlying areas are designed in large, geometric blocks of red and yellow flowers. Trees are planted in perfectly arranged battalions like living green warriors. There is also a fun fair, a concert hall, and a number of noodle shops.

It is to be hoped that with President Xi Jinping's May 2017 announcement of China's trillion-dollar investment in the world's largest infrastructure project, some will be devoted to green and growing things. It may be a plaintive plea, but it could be the beginning of a green revolution. Meanwhile, the grass laughs, the birds make their nests, and brides are photographed under cherry blossoms.

Chenshan Botanical Garden

SHANGHAI, CHINA

Shanghai Municipal People's Government, Chinese Academy of Sciences,
State Forestry Administration, Valentien + Valentien Landschaftsarchitekten

509 acres (206 hectares) · 2010

"HEAD OF THE NINE PEAKS IN THE CLOUDS" is the poetic name for a rise of small hills in the Yangtze River delta near Shanghai, and the site of a botanical garden that combines traditional Chinese and contemporary European landscape architecture. German firm Valentien + Valentien won a worldwide competition to design the garden by creating a series of landscaped gardens, an institution devoted to scientific research, and a place of horticultural leisure. "Chinese garden design is the representation of landscapes, of ideal landscapes; in the end it is a form of landscape painting."

Creating a new, coherent botanical garden in the country that plant hunter E. H. Wilson (1876–1930) called the "Mother of Gardens" is no small assignment. With over 31,000 native plant species, China is the source of many of the home gardener's favorite ornamental plants. About half the species of the world's rhododendrons are native to China. As are 50 percent of peonies, 75 percent of maples, 75 percent of daylilies, 50 percent of dogwoods, and 45 percent of magnolias. It is where the parents of many of today's roses come from. It is where oranges, mandarins, and lemons originated. Modern-day plant explorers continue to find new species every year.

With a current population of almost 1.5 billion and one of the world's fastest growing economies, pressure on the endemic flora of China is great. The role of its botanic gardens to teach conservation, conduct research, and give people who live in megacities a place to simply enjoy nature is of the utmost importance. They recognize this, and accordingly botanic

Inside one glass house, elements of classical Chinese gardens such as a waterfall and rocks with intriguing shapes add interest to a display of flora from the tropics.

From Chenshan Hill the viewer looks down upon the former quarry and a series of lakes that refresh the garden.

gardens in China are springing up at a pace that almost matches development. In the past 100 years, 200 botanic gardens have been created, most since the founding of the People's Republic in 1949. Shanghai, with a population of 18 million, is in desperate need of green space. The Chenshan garden offers this even while its immediate surroundings continue to be developed for industry and housing. Creator Christoph Valentien says, "With the botanic garden, we are creating a sustainable park and a groundbreaking example of garden design that is orientated toward a policy of ecology, and is thus a new artificial landscape with integrative architecture. Our landscape as a reflection of the world should contribute to the knowledge about the world as an ecosystem, and to a sustainable way of dealing with it."

The Chinese symbol for garden 園 denotes an enclosed space containing mountains, water, and plants. Enclosed by thousands of ornamental cherries (*Prunus* spp.), ginkgo tree

The garden fulfills a dual mission of protecting a collection of botanically significant plants and drawing hundreds of thousands of visitors with displays that entertain.

(*Ginkgo biloba*), and scholar trees (*Styphnolobium japonicum*; syn. *Sophora japonica*), the Chenshan garden fulfills its namesake duty.

Everything about the scale and design of this garden is meant to impress. It is built on top of a granite hill that rises to about 330 feet (100 meters). A circular grade—a ring—surrounds the inner garden and the hill, introducing a use of geometry that makes the pure, almost austere shape of the entire property pleasing to navigate and easy to comprehend. At the center, a large lake with bisecting canals divides the garden into an astounding thirty-five individual theme gardens.

The theme gardens are raised above the poor, loose, sedimentary, salty, water-logged native soil to promote better plant growth and achieve a pronounced visual impact. Because the landscape architecture is so coherent, the different gardens connect in a graceful way.

Wisteria sinensis, one of the country's most famous exports, blooms below a scenic pagoda on nearby Chenshan Hill.

Bridges, curving walls, and flowing pathways guide the visitor smoothly even between areas with vastly different focuses.

Certainly the most dramatic topography in these gardens is a former quarry that plunges via a steep cliff with a 100-foot (30-meter) drop to a pool below. The geometric weave of the whole garden is visible from the pagoda hovering serenely above.

Three glass conservatories shaped like modernist silver carp lie to the northeast of the main garden. Jungles, deserts, and subtropical tenderness are exhibited under their lattice of protective aluminum. Unburdened by any latent cultural bias objecting to the teaching of evolution, a large section in one is devoted entirely to the topic—complete with tree ferns guarded by an animatronic dinosaur. It's kitsch, but children flock to it.

For the true plant connoisseur, there is plenty. In the arid house, there's a tall crested form of saguaro cactus (*Carnegiea gigantea* f. *cristata*)—a wonderful fan-shaped monstrosity. In another house, tall palms. And in another, carnivorous plants and some of the 1,000 species of orchids native to China.

Lakes bordered by broad, curving paths and bisected by undulating bridges provide contemplative green space just outside the city of nearly 18 million inhabitants. This photo, taken early in the morning before the garden opened, reveals the grounds in a rare, empty state.

Paeonia suffruticosa 'Fangi' is one of the many varieties of tree peonies in the garden.

← The Buddha's light tree (*Neolitsea sericea*) features remarkable foliage; these young leaves of soft pinkish red will gradually mature to match their green relatives below while the immature green berries eventually ripen over the course of a full year into a vibrant red.

The peony, the national flower, is duly represented by hundreds of herbaceous and tree varieties that flower in April and May. The garden-maze trope, usually created in boxwood or yew, is hedged here with *Paeonia lactiflora*.

In the northwest corner of the park, a research building is surrounded by a research garden, a "lively mediator between the world of science and the depiction of the plant world in the botanic garden."

The best of the garden is, however, not the themed gardens, the glass houses, or the science center, but the long pathways bordered by trees and shrubs from around the world. Since the trees are still young, there is plenty of light. It is also quiet. Both make the garden a much sought-after venue in crowded Shanghai. To soothe the soul there are willows in water, eucalyptus on a hill, redwoods in a grove, and even one small stand of the rare Buddha's light tree (*Neolitsea sericea*) that is native to Japan, Korea, and China's eastern coasts. In spring, its young leaves are golden brown, covered with soft, silky hairs that literally seem to glow in the light of the morning sun. The oils and wax in the leaves and berries have been used to make candles. This may be the reason for its common name.

The Chenshan Botanic Garden is one small part of China's movement toward a greener world. It is a counterpoint and an accompaniment to the country's rapacious urbanization. As goes China, in this case, we can hope, so goes the world.

Ichigaya Forest

TOKYO, JAPAN

Dar Nippon Printing Company, SWA Group, Kume Sekkei, Sumitomo Forestry, Taisei Corporation

8 acres (3.2 hectares) · 2012

JAPAN IS UNDERGOING an inspiring horticultural and cultural revolution. This project, called a forest but really more of an urban woodland, is making a considerable impression in a country with an allegiance to formal and traditional ornament, and is meant to influence the way people think about the use of urban space.

The greater Tokyo metropolitan area has a population estimated to hover near 36 million. The city itself contains almost 14 million. Sometimes it seems the entire population rides the same subway train. Tokyo has the second-largest urban sprawl in the world, recently overtaken by China's Pearl River Delta. It is a competition where no one wins.

Tokyo is not a city lush with parks, despite the famous Shinjuku Gyoen National Garden and Mizumoto Park. Just over 3 percent of land is considered green space—compare that to London, which comes in at almost 40 percent. Yet the Japanese have an almost sacred appreciation of nature. In a city of such confined space, this is not readily apparent, although street trees are squeezed in between the tower blocks, the black noodles of electrical lines, and the swoop of elevated highways.

Shinto, the state religion until the end of the Second World War, continues to be influential, and its reverence for the animism of trees, rocks, and springs is a deeply entrenched part of the culture. It is not just nature that receives the blessing of a *kami* (god). Near the Tokyo Stock Exchange, a small shrine, Kabuto, is the place of the god Ukano-mitamano-mikoto, the guardian of the securities industry. One religion meets another.

Tokyo is one of the most densely populated cities in the world, so even a small piece of green open space immediately stands out.

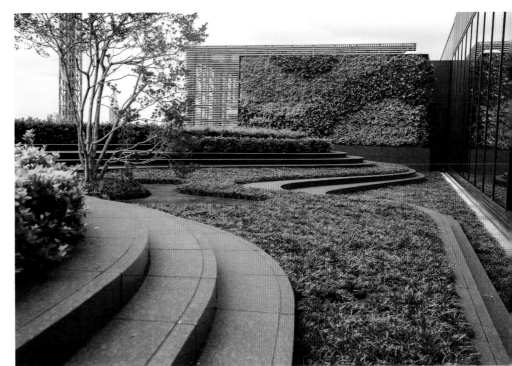

The contemporary rooftop garden features sinuous, low terraces that are immediately prominent both in color and form against the Tokyo skyline.

Lucky office workers pass through a native woodland on their way to and from work.

Despite the large population and the density of buildings, there is an order to city life that is distinctly Japanese. Littering is accidental, personal space is respected, and the cacophony of life has a formality about it unknown in other bustling conurbations. *Bushido*, the disciplined way of the warrior, seems to have permeated the code of the office worker and the sales assistant.

In the midst of this, we have the Ichigaya Forest, which surrounds the corporate headquarters of Dai Nippon Printing Company. It is being implemented in three phases: phase 1 was designed in 2007, and construction and planting began in 2012. Planting of phase 2 was completed in 2015. It is scheduled to be complete by 2020. Over half the area is planted with native trees, shrubs, and ground covers. And phase 3 will require removal of old buildings; adding "native" soil, Kanto loam; stormwater management that keeps all rainfall on site; and, finally, establishing the remainder of the forest.

Currently, there are two principal features on the property: the woodland, accessible to the public and DNP's 10,000 employees, and a curvaceous rooftop garden for executives and clients. The forest feels radically rural, the rooftop garden, highly stylized.

Tokyo's temperature has risen considerably in the past fifty years. Dangerous man-made climate change is having a profound effect on the city, because of atmospheric pollution, lack of greenery to absorb sunlight and mitigate the heat island effect, and reduced air movement caused by the mass of so many tall buildings in close quarters. Plans are under way to create more urban forests, carefully placing them at strategic points throughout. Other quasi-extreme plans are also being discussed, notably the removal of some buildings to create airways that will enable cooling breezes from Tokyo Bay to aid in reducing the temperature. With adjacent office space built skyward as well as underground, the Ichigaya Forest is an experimental environmental model for cities around the world.

What is immediately striking about this metropolitan forest is that it is not manicured. There are no white-gloved gardeners plucking leaves from the moss as soon as they fall. It is messily alive with the energy of wild growing things. Indeed, the forest moniker communicates the intent to create a wildness, a barely controlled natural environment. It could not be farther from a Zen garden in the traditional or modern sense. There is no minimalism here. Leaf litter is allowed to accumulate, adding to the richness and moisture-retention capabilities of the soil. Rustic wattle is used to retain the new berms and to help create a microtopography that will control water flow and provide diverse habitats for plants. Gangly pyramids of stakes hold the trees until they are established. It is so un-Japanese.

Out of 7,000 species of plants known to be growing currently in Japan, about 40 percent are native. This new forest showcases key specimens of some of Japan's finest plants. The woodland, as in nature, is planted in layers. *Castanopsis sieboldii*, the Itajii chinkapin, is a large, evergreen, subtropical tree dominant in the hilly areas of western Japan and is one of the tallest trees in the forest. A number of oak species, both evergreen and deciduous, add to the top layer. The blue oak, *Quercus glauca*, native to southern Japan, is glorious in spring, with its deep crimson new leaves.

Smaller trees, such as the Himalayan spindle tree, *Euonymus hamiltonianus*, and the Japanese maple, *Acer palmatum*, both with bright fall foliage, provide the next layer. Below that, there are many shrubs, notably tea of heaven, *Hydrangea serrata*, its blue and pink flowers lasting from summer into fall, and *Fatsia japonica*, the paper plant, with spirals of glossy, eight-lobed, fat-fingered, evergreen leaves.

A forest floor is never bare, and that is true of Ichigaya as well. Lilyturf, *Liriope spicata*, a grassy understory plant, is widely used in ornamental horticulture. It covers this forest floor. *Pollia japonica* is not as common in gardens, but it's a fine spreading shade plant with white flowers in summer and blue berries in fall. No woodland is complete without ferns, and Japan is home to a number of handsome species. One of the toughest yet most alluring is the upside-down fern, *Arachnoides standishii*, with evergreen, lacy, arching fronds that prefer to display their veins and spore structures (sori) on the upper side of the frond, hence the name.

The relief of these trees, a quiet grove tucked into a corporate canyon, reaches out to everyone who passes, softening the walls of concrete that separate. Nature has not been defeated, but has returned.

The woodland grows unfettered, emphasizing the plants' health and vitality. The design and maintenance are in stark contrast to many Japanese garden traditions.

Tokachi Millennium Forest

HOKKAIDO, JAPAN

Fumiaki Takano, Dan Pearson · 988 acres (400 hectares) · 2002–present

IT'S DIFFICULT TO OVERSTATE how different the northernmost Japanese landmass, Hokkaido, is from the swelter of Tokyo. In November, wind and snow come through a gap in the Hidaka Mountains near Mount Tokachi, dropping the temperature to an occasional negative 13°F (–10°C). It may stay cold and snow-covered until early April. The Hokkaido brown bear, *higuma*, hibernating in the mountains, doesn't wake until spring is established. Then, *Trillium camschatcense* and the rare *Trillium tschonoskii* bloom, and they and woodland anemones fill the forest floor. Spreading bamboo grass, *Sasa veitchii*, begins to cover the ground and, unless managed, will shade out many of the spring and summer flowering ephemerals. The trees, the robust Mongolian oak, *Quercus mongolica* subsp. *crispula*, enormous specimens of Japanese beech, *Fagus crenata*, and the smaller, white-flowered Kobushi magnolia, *Magnolia kobus* var. *borealis*, come into leaf.

All but remnants of this original forest were sadly cut down long ago. Land was cleared and crops planted. On the hillsides, straight lines of larch, *Larix kaempferi*, planted for telephone poles and lumber, stripe their way across the landscape in waves contrary to the topography of the mountains.

Summer is warm, with long days. Grasses flower with languid grace. The 6-foot-tall (1.8-meter-tall) lily *Cardiocrinum cordatum* var. *glehnii*, with tubular, light green flowers, and the 4-foot-wide (1.2-meter-wide) umbrellas of the giant butterbur, *Petasites japonicus* var. *giganteus*, shade the sweet streams and sparkling bogs. Autumn brings red and gold maples, while the 10-foot-high (3-meter-high) white umbels of *Ezo nyuu*, bear's angelica (*Angelica ursina*), turn to seed. Within a month, there is likely to be snow again.

Sculpted mounds in the Earth Garden frame the foreground in a view to the Hidaka Mountains.

Sasa veitchii, a robust bamboo grass, grows 3 to 5 feet (0.9 to 1.5 meters). It can be kept shorter by cutting it to the ground in early spring.

The Tokachi Millennium Forest is the dream of one person, Mitsushige Hayashi, who acquired the land to protect it against development and to mitigate the carbon footprint created by his own newspaper business, Tokachi Mainichi. His vision is one of a thousand-year sustainability, hence the name. Planning for such a timespan might sound overly ambitious, but put in the context of the life of an old-growth forest, it is of course brief. Hayashi purchased the land with a view to keeping it safe and restoring and expanding the forest. Achieving that goal requires educating visitors about the flora and fauna of Hokkaido, and from that was born the idea of making it a public garden. Dan Pearson, the famous London-based garden designer, worked with local landscape designer Fumiaki Takano to develop a masterplan that encompasses two main areas, an Earth Garden and a Meadow Garden.

In the autumn sun, the Japanese native *Sanguisorba hakusanensis* glows hot pink while the formerly green stalks of feather reed grass, *Calamagrostis ×acutiflora* 'Karl Foerster', begin to fade to brown.

Artificially constructed landscapes—that is, gardens—often serve as a bridge between us and what we think of as truly untamed nature. Our world has become so urbanized that even the level of "wild" still present on this highly cultivated island now alarms us. To brace ourselves to experience it, we require, like a child on the first day of school, a gentle introduction. The Earth Garden fulfills this purpose. It is a series of rolling green waves that echo the shape of the foothills and the mountains beyond. Pearson's work is often subtle, and this is no exception. In the midday light, the ground swells can be hard to discern, flattened by the bright sunlight as they are. But with the late afternoon comes long shadows, and the contours begin to emerge more distinctly from the mown grass. It is then, at the dimming of the day, that the landform is pronounced.

The larch boardwalk divides the haze of flowers in the Meadow Garden and leads to the restaurant and farm buildings.

→ *Persicaria amplexicaulis* 'Atrosanguinea', although native to inland Asia, is used here in a way that recalls an English border.

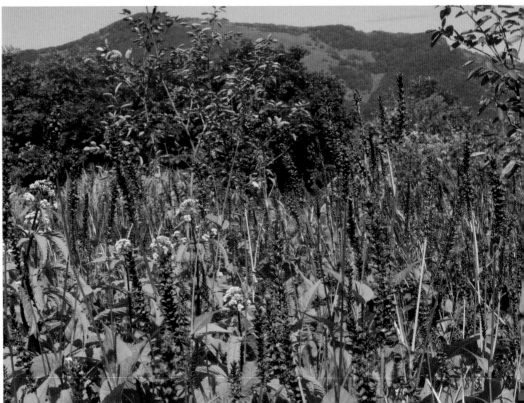

By ironic contrast, the Meadow Garden, which sounds wilder by name, actually feels even more constructed than the Earth Garden. It leads to a cafe, a farmyard complete with goats, an orchard and, somewhat surprisingly, a rose garden. The phenomenon of formal rose gardens in contemporary landscapes is one best not discussed in polite company—it's assumed to be a draw for more traditionally minded visitors, and yet so often disappoints.

The Meadow Garden might better be described as a vast perennial garden since its aim appears as much to introduce visitors to that style of herbaceous plant gardening rather than re-create the look of a native meadow. Divided into two large borders by a wide, curving path made of larch planks, one side is loud with color while the other is cooler and quieter. It is clear that the basis of design comes from the traditional English herbaceous border, with a twist from the Dutch and American prairie-garden movements. To Western eyes, the style is familiar. To the Japanese, it is a novelty.

Ornamental grasses provide the fabric that binds the plantings together. Columns of feather reed grass, *Calamagrostis ×acutiflora* 'Karl Foerster', weave through the border and provide a vertical foil for fluffy pink droops of *Sanguisorba hakusanensis*, a Japanese native, and the dark red spikes of *Persicaria amplexicaulis* 'Atrosanguinea'.

On the other side of the path, Japanese forest grass, *Hakonechloa macra*, shows off its inherent grace and elegance when used in mass plantings reminiscent of waves in the ocean. Growing well in sun and shade, the rich green color is perfect against the native lily, *Lilium auratum*, with large, gold-banded white flowers. It is a simple and successful arrangement. There are many more, each combination interlocking in a way that animates the space and points to the desire to create a grand scheme. It performs well as a garden-cum-public-space even if its focus is not on creating a strong sense of place.

Midori Shintani, the head gardener, continues to adjust the combinations, ensuring that balance is maintained and that adventurous plants stay within their boundaries. That is part of her and her staff's responsibility; the other is to educate, to explain, and to translate the language of foreign plant combinations for the Japanese gardening public.

The design generates an uncomfortable association between East and West—the question is whether this is, in the end, intentional. The Meadow Garden feels as though a piece of Sussex, England, has been plopped, fully grown, on the landscape to attract horticultural tourism. The other part, the Earth Garden, has an almost intangibly sublime quality about it that relates well to Zen traditions. In an increasingly international and homogenous world, what exactly constitutes a proper or authentic sense of place?

australia and new zealand

Geelong Botanic Gardens

GEELONG, VICTORIA, AUSTRALIA

John Arnott and garden staff · 9 acres (3.6 hectares) · 2002

GARDENS THAT ENDURE should be seen as living testaments to remarkable men and women as much as spaces for plants. The Geelong Botanic Gardens owes its present-day fame to Daniel Bunce, who was born in Hertfordshire, England, in 1813. Trained as a gardener and botanist, he emigrated to Hobart in Tasmania. He explored much of Australia, studying Aboriginal languages, geology, and botany. In 1858 he became director of the gardens, which he redesigned and planted. Before his death in 1872, he published an account of his adventures, *Twenty-Three Years' Wanderings in the Australias and Tasmania*.

The garden has played a crucial role for local residents for nearly three centuries—no small feat. In the 1800s and 1900s, its mission was to trial and acclimatize plants discovered throughout Australia and elsewhere in the Southern Hemisphere. In the twentieth century, it became more of a pleasure garden as its staff responded to community demand for decoration and leisure. Filled with stately trees and pretty roses, it was always attractive, but it became a little worn and began to lack cultural relevance.

To address the needs of twenty-first-century patrons, the garden has shifted focus to education, conservation, and sustainability. Australia has recently been subject to the longest and driest period of low rainfall since records began. The Millennium Drought, as it is called, began in 1997 and officially ended in 2009. Climate scientists predict that Victoria will experience a significant increase in very hot days and decreased rainfall in the coming years. Many of Victoria's plants and animals are already endangered, and additional species will suffer as the climate gets hotter and drier. Staff at Geelong now see part of their new

Bottle trees (*Brachychiton rupestris*), native to Queensland, are remarkable for their ground-level girth.

This ancient specimen of dragon tree (*Dracaena draco*) has grown so large it requires a substantial armature for support.

cultural mission as teaching people how to grow drought-tolerant plants; in a nod to increasing multiculturalism, they've included species from around the world that might plausibly grow in their corner of the continent.

Horticulturally attractive plants from the five Mediterranean-climate areas of the world now grow around a central, sunken court. Plants are grouped by region and by timing of evolutionary appearance. Examples are the monkey puzzle tree and the bunya bunya tree (*Araucaria araucana* and *Araucaria bidwillii*) and cycads, ancient species with fossil records dating back to 250 million years ago. The borders surround the sand court, which features a small pool, a billabong, at one end. This is home to native rushes and grasses as well as a chorus of frogs. At the opposite end of the billabong is an immense dragon tree (*Dracaena draco*), native to the Canary Islands. It is held upright with a large metal collar that can best

The highly stylized Sand Garden offers a display of cactus, aloe, and agave in the background.

be described as imposing. Next to it is a fat ponytail palm (*Nolina recurvata*) from Mexico. Many Australian grass trees (*Xanthorrhoea* spp.) are planted as are *Echium* sp. from the Canary Islands. The echium's tall blue spikes of flowers penetrate the dense green of the garden, as do the yellow daisy flowers of the rare tree daisy (*Sonchus arboreus*) from the mountains of Madeira, a large ornamental plant with serrated leaves and masses of yellow flowers in spring and summer.

Native plants growing within a fifty-mile radius of Geelong now contribute in a significant way to the garden's character. Plants from central Australia were also imported to test their hardiness in a cooler climate.

Drought-tolerant plants, however, are the core of the display. Aloes from South Africa and agaves from Mexico, cactuses from the Americas, puyas from Chile, and banksias from

Australia are grown in a variety of combinations to show off their forms and flowers. Without doubt, the most arresting plants are the Queensland bottle trees (*Brachychiton rupestris*). Like a group of expectant mothers, their bulbous shapes draw attention. They are planted effectively in two groups, both inside and outside the garden's perimeter fence.

Geelong's gardeners report that visitors often bypass the marvels of the modern garden on their way to the traditional garden, however. Their theory is that visitors are sometimes uncomfortable with the less-than-traditional design. Perhaps this is a failure of storytelling. Staff are making efforts to find ways of informing the public about what the newest sections offer as useful takeaways, and this seems to be helping. Perhaps the fact that gardeners will increasingly need to grow drought-tolerant plants in a more sustainable way also disturbs people, in the way that the facts of climate change are themselves disturbing. Teaching people about plants goes beyond horticulture and landscape design: plants react very quickly to changes in the environment, and so as living metaphors, they are perfect educational tools for teaching people about what may be coming.

Public gardens have many roles, two of which are to comfort and to educate. Sometimes the two are not necessarily harmonious. How do we tell the story of extinction, habitat loss, and the damage we have done to this planet and at the same time provide an environment that comforts our worries and gives us a quiet place to soothe our troubled minds? The Geelong Botanic Gardens addresses this conundrum with some success. Science and beauty go hand in hand, under the shade of the tall trees and the squawking of cockatoos and galahs.

↖ The tree daisy (*Sonchus arboreus*), native to Tenerife, grows up to 10 feet (3 meters) in height, with large sprays of 1-inch (2.5-centimeter) flowers that emerge in spring and early summer.

← Pride of Madeira (*Echium candicans*) adds a strong blue color to a foliage border.

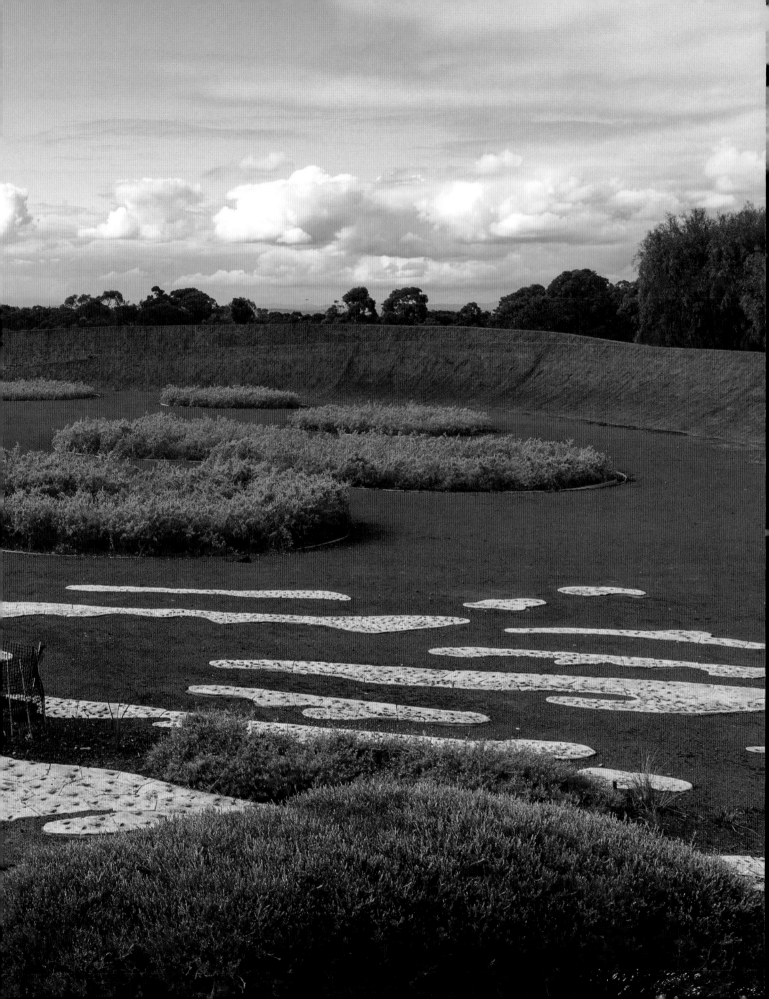

The Australian Garden, Royal Botanic Gardens

CRANBOURNE, VICTORIA, AUSTRALIA

Taylor Cullity Lethlean, Paul Thompson · 37 acres (15 hectares) · 2006

THE AUSTRALIAN GARDEN, a part of the Royal Botanic Garden situated southeast of Melbourne, has a mission of displaying as many of Australia's native plants in as creative a way as possible. Given the size of the country and the range of climates and soil types, it is an ambitious objective. Its designers and staff have managed to grow about 170,000 indigenous plants, and are successful at displaying them in an appealing, fresh, and attractive way via a series of seemingly abstract landforms—swirling masses of color and shape—that tell visitors stories, and make the garden immediately notable among large public gardens. Contrary to the way so many public gardens seek to regenerate nearby virgin landscapes in situ, this garden takes the opposite approach; by creating highly distilled, highly artificial references to the continent's unique attributes, it compels visitors to see them in a new way and ostensibly with a new appreciation for them.

Australia is home to an extraordinary and multifarious flora. About 24,000 species are native to the country, with over 700 species of gum trees (*Eucalyptus*), 170 species of honeymyrtle (*Melaleuca*), 214 species of emu bushes (*Eremophila*), over 900 species of wattles (*Acacia*), and many species and cultivars of the family Proteaceae.

A view from a lookout platform, Trig Point, above the garden puts the setting in context. The surrounding remnants of bushland, dotted with gum trees and shrubby tea trees (*Leptospermum*), enclose the Australian garden. Beyond the bush is farmland, now being encroached upon by expanding suburbs.

In the red desert sand garden, light-colored ceramic plates shaped like liquid wash up along one edge like a mirage of waves breaking ashore.

Australia is the driest country in the world, and so it is appropriate that the thematic garden devoted to it begins with a desert. The Red Sand Garden is a sculpted, sinuous crater of that very material, punctuated by carefully placed and shaped mounds of gray-leaved hedge saltbush (*Rhagodia spinescens*). It appears to be spare and sparse at first glance, and yet is thick with tint and texture.

Paradoxically, water is the key to the garden; it connects the diverse areas. It is, in a sense, the main storyline. Follow the water, and the chronicle of Australia's flora unfolds. Radiating outward from the sand garden is a series of individually themed gardens, the most inventive and artful of which is the Melaleuca Spits. Designed to mimic sand spits created by tidal mouths of rivers, it is highly evocative of the Australian coast, consisting as it does of a series of undulant shapes gently protruding into water. The primary plant featured, the flax-leaved paperbark (*Melaleuca linariiflolia*), is a small tree with spongy white bark and a profusion of creamy, fragrant flowers in summer. It grows in estuarine environments in nature and is planted in the meanders of this garden along with prickly speargrass (*Austrostipa stipoides*). The soft forms and white color of the spits juxtapose effectively with the strong stalks of grass and the rough, peeling bark of the trees.

Spoilt for choice, there are other gardens that stand out. The Eucalyptus Walk, divided into a series of five subgardens throughout the property, contains a collection of scribbly gum trees, a name given to a number of eucalyptus species, notably *Eucalyptus haemastoma*. They are so named because of a moth larva that burrows through the bark of a number of species, leaving squiggling patterns. A modulating walk designed to mimic that same meandering path doodles between the trees. All of the paths in the garden are multifaceted or multipurpose. They are practical wayfinders, of course, but they also have a stimulating quality, adding depth to the garden's stories by their form or material. The paths set tone and mood in an often subliminal way while enhancing didactic value.

The Gondwana Garden details the paleobotanical history of Australia and is named after the southern supercontinent that split 180 million years ago into what is now Australia, Antarctica, New Zealand, New Guinea, Africa, India, and South America. It is the garden's least successful horticultural site presently, simply because the trees meant to provide shade and shelter are not sufficiently mature to do so. It is difficult to grow rain forest plants in a setting that is either cooler or warmer than they need. This will change with time as the trees begin to provide the right microclimates. Time is what this garden is about, however, so in a way this is also fitting.

Plants recognizable as Australian evolved into existence as the continent drifted—and continues to drift—northward. The evergreen antarctic beech (*Nothofagus moorei*; syn. *Lophozonia moorei*) is a distinctive tree with new leaves that start as a brilliant orange and fade to dark green. Fossil records show it grew in Antarctica, once a forested and warmer continent. Now it is native to the eastern hills of Australia. Another tree, the Wollemi pine (*Wollemia nobilis*), was thought to have gone extinct two million years ago, but was discovered in 1994 growing happily in the Blue Mountains west of Sydney. A close relative of

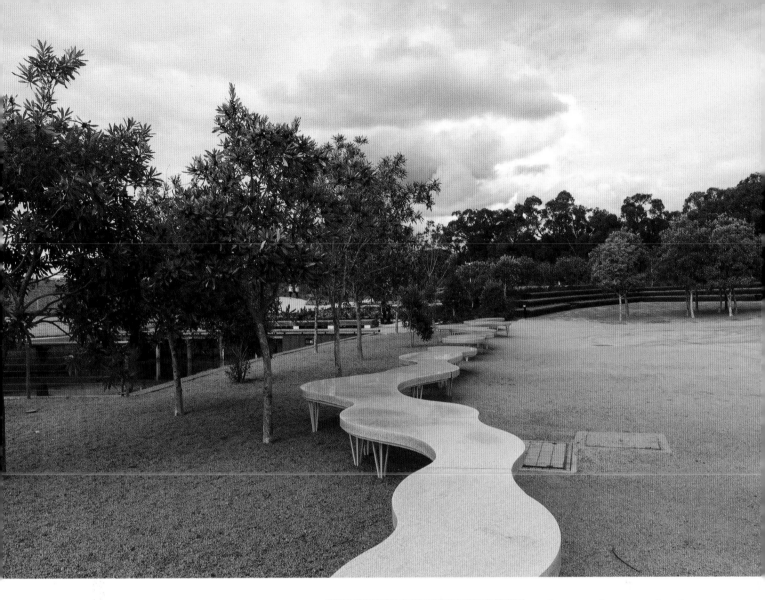

Sinuous pale concrete benches contribute to the garden's well-thought-out overall design.

← Inspired by Australia's red sandstone cliffs, the *Escarpment Wall* by Greg Clark begins the garden's didactic story about how water moves across the continent.

Stone terraces lead to one of the garden's most unexpectedly pleasing features: upturned boulders in the Box Garden.

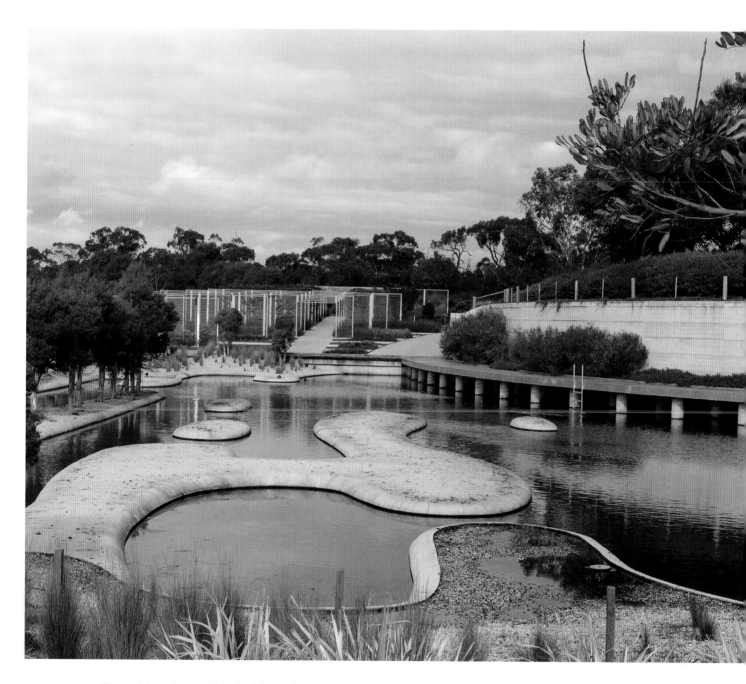

The undulant shapes of the Melaleuca Spits are a representation of the Australian coastline writ small.

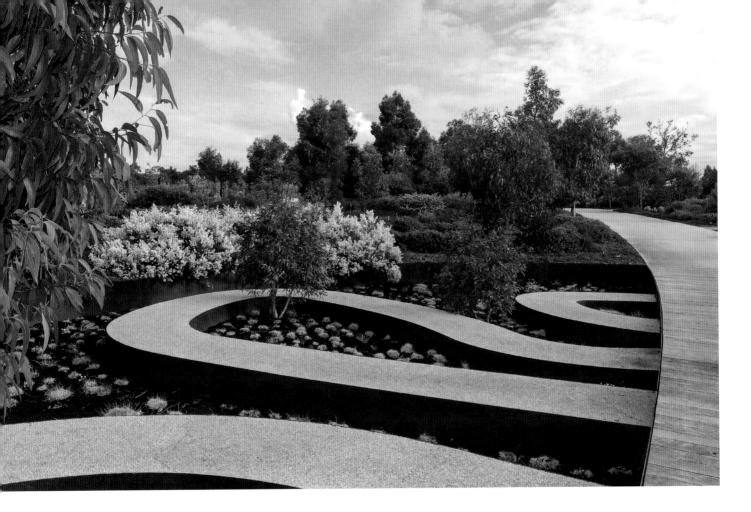

A twisting path evokes the bark of scribbly gum trees.

————————————

→ The grass tree (*Xanthorrhoea australis*) is perhaps the most iconic of Australian plants.

the monkey puzzle tree (*Araucaria araucana*), it is now propagated and distributed where it will grow worldwide. Large basalt blocks, echoes of the past volcanic upthrusts, create striking columns that enhance the feeling that this section of the garden is indeed a temple to evolution.

The Box Garden derives its name from the box tree, a name for various species of eucalyptus. The genus has a delightful assortment of common names: ghostgum, bloodwood, stringybark, ironbark, mallee, Paddy's River box, and the yellow box (*Eucalyptus melliodora*). *Eucalyptus polyanthemos*, red box, is grown for its reddish bark and "silver-dollar," round gray-white leaves and is the key tree for this garden. The garden also illustrates the story of Australia's geology. It is a rock garden, and, in landscape design, there are few things as satisfying as a great society of rocks. Faint hearts shy away from using large stones in landscapes—not because of their weight as much as for their power. Here, large slabs are laid horizontally, making a series of steps descending to a gently sloping terrace. The steps are punctuated with areas for plants, not so subtly deterring the visitor from walking hurriedly in a straight line. The terrace, made of blue and tan slate, is interrupted by large volcanic plugs thrust boldly and vertically into the ground. They suggest mountain ranges and seismic upheaval. The plantings are profuse, but so magnificent is the stone work that the plants are somehow secondary to the geology. Along with the box trees, a couple of Queensland bottle trees (*Brachychiton rupestris*), the botanical equivalent of sumo wrestlers, frame the view. Among the trunks of the trees and the walls of stone are understory plants: cycads, grasses, orchids, and small shrubs. A particular beauty is the rock orchid (*Thelychiton speciosus*). Formerly known as a *Dendrobium*, it is gorgeous when its abundant racemes of showy cream flowers, often with up to as many as 120 per stem, bloom in early summer.

There are many other gardens within the garden, such as a Lifestyle Garden; an Arid Garden; the Bloodwood Garden, devoted to the beauty of tree trunks; and the Weird and Wonderful Garden. They continue to be developed.

The earliest Western explorers often found the native plants ugly, unfamiliar, and primeval, but today the Australian flora is recognized as one of the most beautiful and important in the world. Breeders have created numerous cultivated varieties of plants once dismissed as scrub or bush, and Australian plants are much sought after for waterwise gardens.

The landscape architects and gardeners have successfully brought the wild to the people here, convincingly arguing that nature is not "out there" but here, and now. In doing so they have created a profound and insightful work of art and horticulture. They have demonstrated that contemporary design and gardens are not in conflict, but indeed an essential blend for today's audience. They have created an aesthetic expression of sustainability, harmony, intelligence, and beauty.

One Central Park

SYDNEY, AUSTRALIA

Jean Nouvel, Patrick Blanc · 0.3 acre (1,000 square meters) · 2013

NATURE HAS BEEN THE inspiration for many of our world's most prominent artificial structures—buildings. Antoni Gaudí's observations of the adjacent forest and nearby mountains led to his designing the branching columns and spires of Barcelona's La Sagrada Família. Frank Lloyd Wright's Fallingwater, in eastern Pennsylvania, appears to grow organically out of the site and float above the 30-foot (9-meter) waterfall below.

Patrick Blanc, a French botanist and designer, also takes inspiration from nature by making his mark as one of the first to design vertical gardens, which have now become so popular around the world. One of his most notable successes was wrapping 8,600 square feet (2,621 square meters) of the facade of Jean Nouvel's Musée du Quai Branly in Paris with 15,000 plants of more than 150 species. Working again with the same architect, he has recently created the world's tallest vertical garden in Sydney, Australia.

One Central Park consists of two buildings, sixteen and thirty-three stories high, both draped, as it were, with vertical hydroponic gardens built upon an armature of twenty-one individual panels of multilayered matting and nonbiodegradable felt. The gardens comprise 35,000 plants, many of them native to Australia. Those species requiring dry conditions, such as grasses and wattles (*Acacia* sp.), are planted at the top of the buildings, while those requiring a wet environment, such as violets, *Tradescantia*, and *Goodenia*, are planted at the bottom to take advantage of gravity drawing water down. Over 2,700 planter boxes contain bougainvillea, dwarf bottlebrushes, and many vines. The gardens are maintained as if they were horizontal in that they are maintained regularly—but with a considerable degree of caution.

Sea Mirror, an installation by artist Yann Kersalé, a platform of mirrors suspended from the highest floors of the tallest building, reflects sunlight onto the shaded side of the apartment buildings to keep plants healthy.

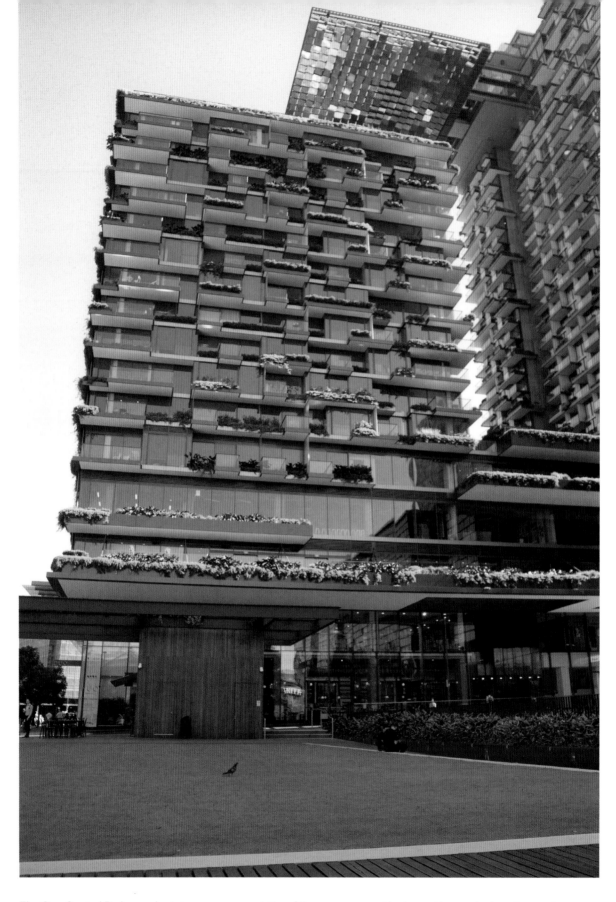

The One Central Park complex is in some ways a victim of its own success—the innovative vertical gardens and art installation draw so many visitors that the management was compelled to install, ironically, an artificial lawn.

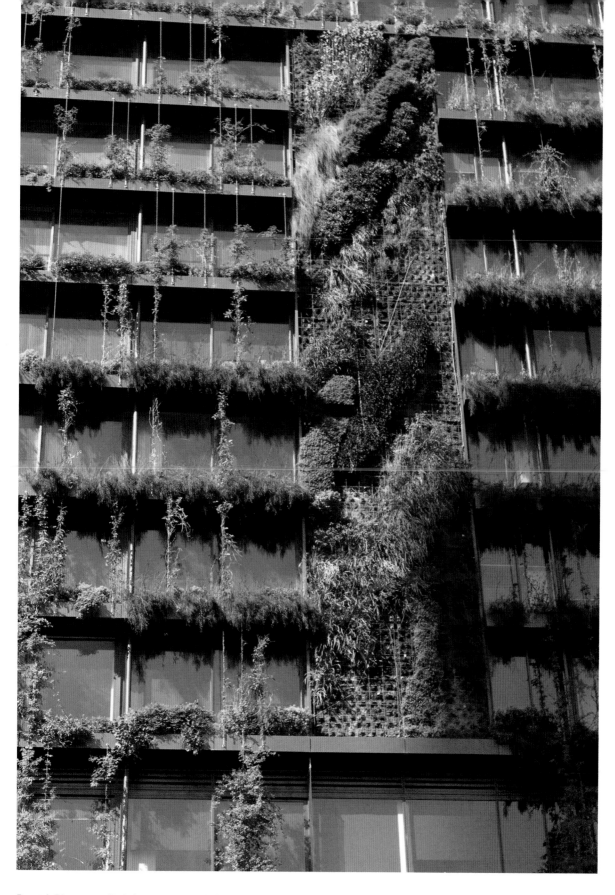

Patrick Blanc installed plants on every balcony, as well as large mosaic panels of more complicated arrangements at rhythmic intervals on the buildings' surface.

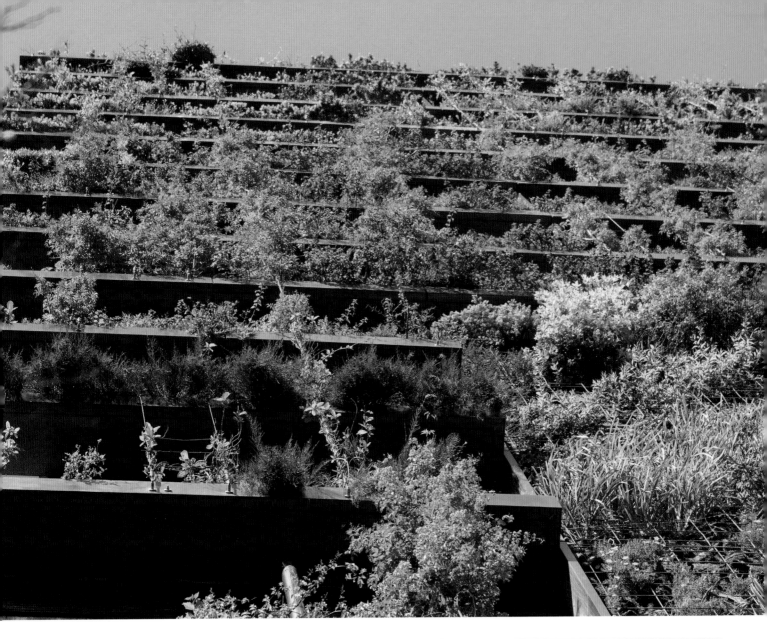

A pedestrian's-eye view of the complex vertical gardens is a passive but at the same time curiosity-creating experience.

→ Even the descent into the parking garage is decorated with plants.

One of the buildings is crowned with a cantilevered heliostat that is an astounding work of art. *Sea Mirror*, designed by artist Yann Kersalé, is a work of 320 mirrored plates that, in daytime, bounce light to the shaded parts of the building and adjoining parkland and, at night, light up with brilliant colors thanks to 2,880 LED bulbs. It is a permanent artwork, meant to be an allegory of the city's relationship with the nearby harbor in the way its lights reinterpret the way the sun's rays reflect off the surface of the water.

One Central Park has been called a "place for living in harmony with the natural world." If living in a skyscraper in the center of Sydney is considered an instance of that, we may have a lot to worry about. Can showy biomimicry really make residents and passersby reflect on and appreciate nature? Have we become adept enough at incorporating nature into our dwellings that it can make a tangible difference to us when experienced even on only a small patio? Or is this yet another form of twenty-first century greenwashing for the benefit of real estate developers?

The building's very concept can only elicit contradictory feelings—with a bent toward the philosophical. While there is brilliance in its decorative execution, there is also something a little sad about trumpeting the containment of nature, particularly when the plaza at the base of the buildings is carpeted in plastic grass.

To feel even the faintest connection with nature, we need to have some active form of relationship with it. Nature notably cannot exist in the abstract. We need not just to see it, but to touch, smell, hear, and connect to it using some or preferably all of our senses—which inform our intellectual and emotional selves. When an environment makes us feel something, we craft an inner discourse about what surrounds us, and this can only be achieved by actually experiencing the soil in our hands or the fragrance of plants as we weed amongst them.

The towering, plant-covered walls, while they certainly dazzle, cannot be directly experienced except by observation, and so all persons nearby are relegated to the status of passive onlookers. We regard the technical achievement with interest, even awe, but we are unable to interact, separated as we are from the garden by its height and by the busy road in front of the buildings. It is sophisticated and clever living wallpaper, but it is not a garden. It challenges our cultural beliefs about gardens and requires us to think critically about the world we are creating. That is its greatest value.

Patrick Blanc spent time at Wentworth Falls on the edge of the Blue Mountains about 62 miles (100 kilometers) to the west of Sydney, and calls his vertical gardens "a natural cliff" and his desire for this project to "cut a giant slice out of the Blue Mountains and put it in the middle of the city." This poetic thought is pleasant, but ultimately difficult to achieve even for a renowned designer like himself.

The creation of vertical gardens is a modern movement, a new aesthetic, perhaps one of the first horticultural fads of the twenty-first century. The developers have no compunctions about labeling it a luxury adornment, an artwork in a world where nature is in retreat, although at least here the gift is that those who look upon the building from the public sphere are able to discern more of the green than the wealthy residents looking from the inside out. It will be interesting to see how biologists and marketing firms vie over the term "nature" as the century progresses.

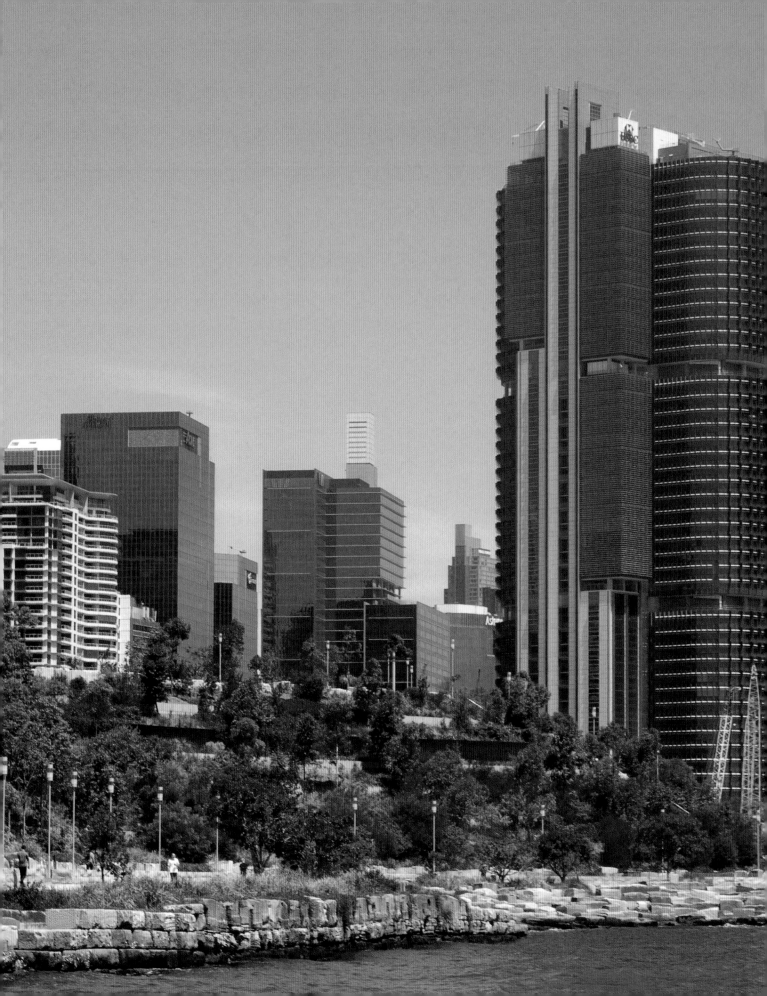

Barangaroo Headland Park

SYDNEY, AUSTRALIA

Peter Walker and Partners, Stuart Pittendrigh, Ron Powell, Johnson Pilton Walker

14.8 acres (6 hectares) · 2015

FOLLOWING THE ORIGINAL 1836 shoreline, the park lies between Walsh Bay and Darling Harbor, opening an area that was closed to the public until recently. It adds to an 8.6-mile (14-kilometer) walk along the foreshore from Wolloomooloo through the Botanical Garden, past the Opera House, around the Rocks and Walsh Bay, to Darling Harbor and the Anzac Bridge. It is named after an aboriginal woman of the Cammeraygal tribe who was influential in the interaction between the indigenous people and the British colonists and was known for having "a fierce and unsubmissive character." The resulting promenade alongside the water is a Giant's Causeway of hundreds of large Hawkesbury sandstone blocks fashioned to make tidal pools, benches to sit on, and cascading terrace walls and steps. Sandstone, found in abundance in the area and up to 600 feet (182 meters) thick in some parts of the region, is the bedrock of Sydney and was used to build many of the colonial buildings as well as breakwaters, and pier and wharf foundations. It is a golden stone with swirls of darker colors running through it. These attractive patterns of yellow, red, and brown are caused by ancient river currents that flowed through the sand as it consolidated into rock, and by plant, pollen, and animal fossils from the Triassic Period (251 to 199 million years ago). Not only was it used for buildings, but it defined the plants of the region. Because of the sandstone, the soil of the region is shallow and infertile. Water drains rapidly and salt-laden winds and strong sunshine add to the exacting conditions.

Charles Darwin, writing of his visit in 1836, described the flora as ". . . thin scrubby trees, bespeaking the curse of sterility." The great man was describing *Eucalyptus*. Our appreciation

Barangaroo's foreshore, with its accessible pathway, reads as a refreshingly green line in a growing, silver city.

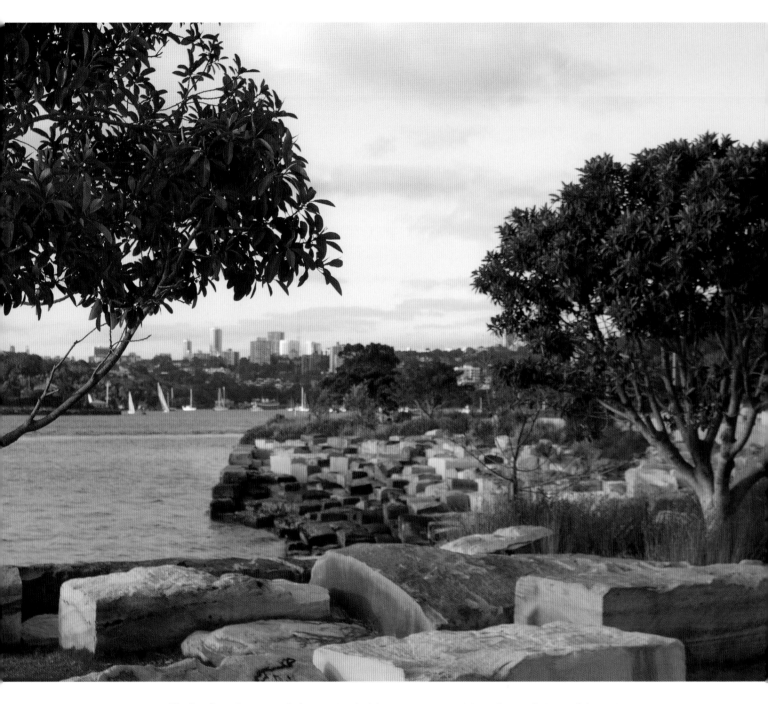

Blocks of sandstone settled at varying heights create seats with unobscured views of the activity in Darling Harbor.

Corten steel, echoing Australia's ubiquitous red soil, is a strong material for a retaining wall, and adds a postindustrial aesthetic to the planting of cabbage-tree palms (*Livistona australis*).

← Hawkesbury stone steps cut through the dense native plantings provide circulation to each level of the paths that ring the park's hillside.

A range of naturally occurring colors gives the Hawkesbury sandstone blocks that form the park's most visible feature a pleasing visual rhythm.

→ Swamp banksia (*Banksia robur*) grows naturally in wet places, but it also does well on dry banks, reaching a height of 6 feet (1.8 meters) or more with a spread of 6 to 8 feet (1.8 to 2.4 meters). It also provides roosting places for many birds, including the noisy miner (*Manorina melanocephala*).

of Australian flora has improved considerably. The beautiful Sydney blue gum (*Eucalyptus saligna*) is now a much admired tree as is the old man banksia (*Banksia serrata*), which was one of the first plants collected by Joseph Banks in 1770 at Botany Bay, now a suburb of Sydney. *Banksia serrata* is widespread in the region. With its cream-colored flower spikes and seeds looking like small shellfish, it is one of the more characterful plants in the native Australian plant collection.

More than 76,000 native plants have been established at the garden, most of them local to the Sydney region. Emblematic plants such as the spotted gum (*Corymbia maculata*) and the swamp banksia (*Banksia robur*) have been planted, as have a number of Moreton Bay fig (*Ficus macrophylla*), an evergreen tree with leathery leaves. The fig can reach a height of 200 feet (61 meters), a measure that will impact the park in twenty years or so.

Tree ferns (*Cyathea* spp.) as well as cycads (*Macrozamia communis*) and the paperbark tea tree (*Leptospermum trinervium*) are the understory. Beneath the shrubs are masses of basket grass (*Lomandra longifolia*), the blue flax lily (*Dianella caerulea*), and other herbaceous and ground-covering plants. The plantings are impressive in their numbers and variety. The landscape architects and gardeners have created a precolonial wild bush-land close to the center of a glistening, modern city.

There has been some controversy around the development, little of it associated with the park and most of it concentrated on a nearby casino and hotel. However, the selection of Peter Walker and Partners, an American company of landscape architects whose other marquis project of late is the design of the National September 11 Memorial in New York, ruffled some feathers. But it is their work, in creating a strong semblance of native bush in a busy and noisy city that makes the headland so important. The use of so much stone, to retain the slope, to enclose paths and to provide breakwaters, is bold and is the most dramatic architectural component of the park. The mass of native plants is profuse and, while not entirely historically or botanically accurate, the planting creates a pleasing counter-balance to the weight of the descending slope and the large sandstone rocks that surround it. The many layers of horticultural and human history are combined with contemporary needs to make a space that has a rare vibrancy and is a perfect place for a growing and increasingly multiethnic population. .

Rose Bay

SYDNEY, AUSTRALIA

Secret Gardens · 946 square yards (791 square meters) · 2014

LESS IS MORE, as the saying goes, but only when it's done well. Minimalist gardens have been popping up around the world for almost seventy years now—particularly in large urban spaces such as city plazas, government buildings, and corporate headquarters. A simple garden design truly based on geometry and proportion can be extraordinarily beautiful, but many that are billed as such turn out to be very banal. There seems to be no middle ground. Too often, the task of reducing a space to its simplest and most dramatic elements is used as an excuse to skimp on design, and by association too many people now construe minimalism with empty laziness.

Rose Bay, a private house and garden situated east of Sydney, could well be called a minimalist garden, but it relies on refined details to succeed. The primary view is to the Sydney Harbor Bridge, with the shells of the Sydney Opera House visible on occasion. The iconic focal point of the Opera House is the centerpiece of the garden, even though it is some miles away. To let the view dominate as a work of art, the garden is deliberately kept simple, with clean lines and what at first glance appear to be modest plantings.

The garden is a union of three spaces. One, a domestic environment with a backdrop of a 16-by 16-feet (5-by-5-meter) green wall, an outdoor sitting room, and an area for cooking and dining. Two, a small lawn with the expected border of plants to one side, though in an unexpected rooftop location. Last, a straightforward stage with potted plants and a small infinity pool focused to draw the eye out to the waters of the Bay. This is peak urban chic—cool and affluent.

The area farthest away from the house is one that directs the eye to the view of the bridge and opera house. The walls of the garden are either white concrete or panes of glass fencing

A vertical garden functions as a clever mosaic. The deep blue of the upholstery accentuates various shades and textures of green.

The clean lines of the weathered wooden decking, the simplicity of the pots, and the understated elegance of the furniture emphasize the sculptural quality of the sanseveiria, agave, and spear lily's dark foliage.

↓ Low and neutral-toned garden elements keep the view unobstructed out to Sydney Harbour Bridge and the Opera House. Rounded forms balance out sharply rectangular features to create a pleasing visual rhythm.

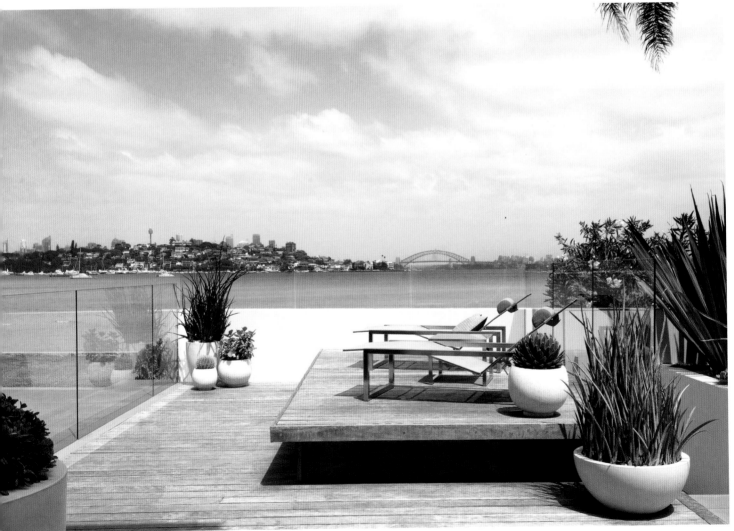

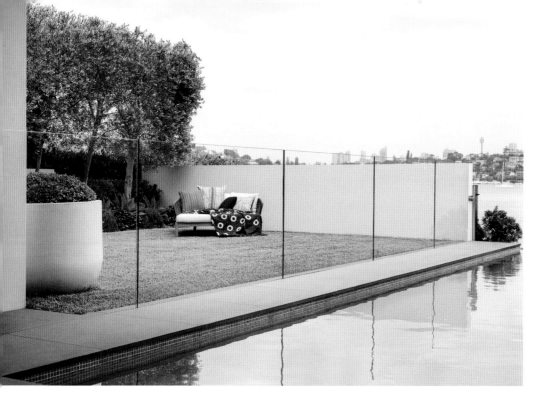

delicately held in place by thin steel posts. The furniture, sitting upon a recessed, gray teak wood deck, is white. The pots are white. The swimming pool, however, is a very tempting hue of the most perfect aqua. In the pots are various sun- and heat-loving plants. The mottled green and yellow *Sansevieria trifasciata* 'Uganda', mother-in-law's tongue, is appropriately sharp and upright. A dark green agave, set in round bowls, softens the hardscape, as do the symmetrically placed jade plants (*Crassula ovata*). To one side is a narrow planting of giant spear lily (*Doryanthes palmeri*), an Australian native with massive rosettes of foliage and a flower stalk that can reach 16 feet (5 meters).

Close to the house, when the visitor will have turned his or her gaze away from the splendor of the horizon and will naturally search for something else to delight the eye in equal measure, the landscape architect has the interplay of simplicity and complexity exert a more intriguing tension. A vertical green wall adds pattern as well as a refreshingly lush injection of thirst-quenching greenery, a sensation heightened by crisp blue yacht-like upholstery on wraparound banquettes beckoning just below. The glossy green leaves of Australian native *Philodendron xanadu* adds opulence, as does the big bromeliad *Alacantera imperialis*. The gray-green foliage of *Westringia fruticosa* 'Grey Box' adds a drier and crisper element—a brave move for a form otherwise clothed in tropical foliage. The wall reads as a clever mosaic of contrasting textures or a large abstract painting of plants but without the monumental sterility of One Central Park. It is highly decorative and intimate, and complements rather than conflicts with the leaner elements of the other spaces. With the wall and as a whole, the garden is urbane and sophisticated with strong geometry and adroit planting. It is the contrast, even conflict, between the simple and the complex—the less and the more—that creates an accomplished and satisfying garden such as this one. The art to this garden is based on restraint and ebullience, abundance and paucity.

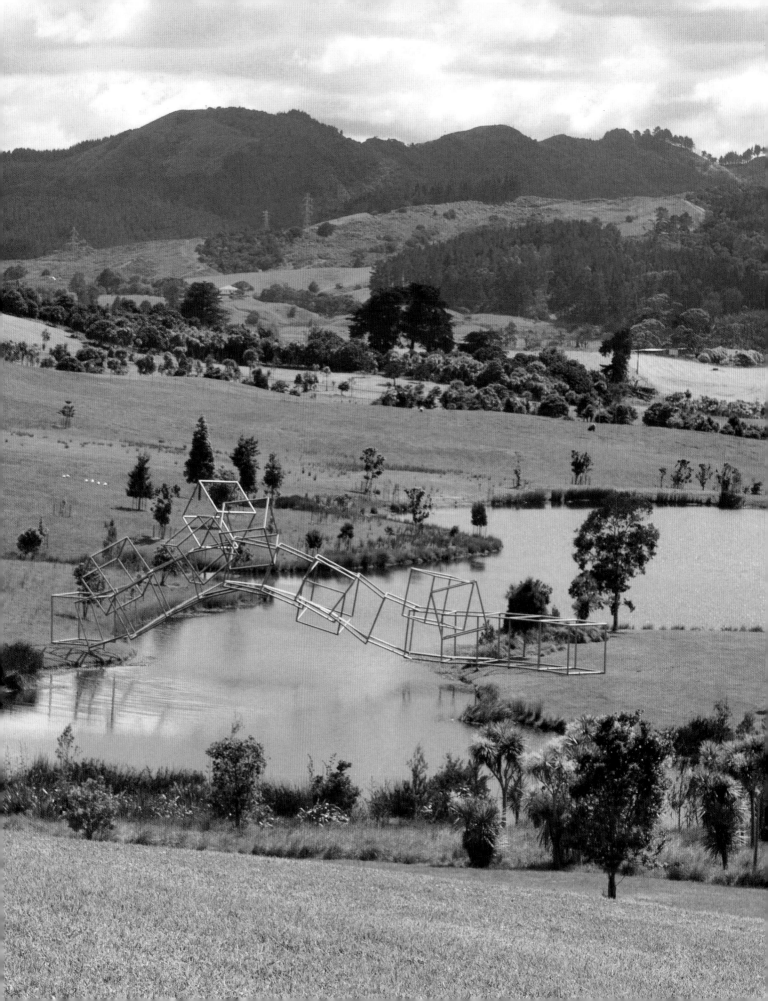

Gibbs Farm

MAKARAU, NORTH ISLAND, NEW ZEALAND

Alan Gibbs, Noel Lane · 990 acres (400 hectares) · 1991 to present

"I consider space to be a material. The articulation of space has come to take precedence over other concerns. I attempt to use sculptural form to make space distinct." —RICHARD SERRA

ALAN GIBBS IS AN entrepreneur, philanthropist, inventor of amphibious vehicles, adventurer, and art collector. All five come to literal play at Gibbs Farm, an impressively scaled tract of land that he's shaped in a way to help him have "serious fun," his personal mantra. He bought a farm overlooking Kaipara Harbour, the largest harbor in the southern hemisphere, in 1991, and over the past few years he has first sculpted the land himself and then invited sculptors to create custom pieces for it.

When he purchased the property, it was overgrazed sheep meadow and pine and eucalyptus scrub. He cleaned up the meadow and removed the scrub, planting native cabbage tree (*Cordyline australis*) and New Zealand flax (*Phormium tenax*) among other things. His approach to sculpting the land was androgenic, very male. Aside from large bulldozers and other grading equipment, he created wide paths by using an unusual landscape tool, an M41 tank. On occasion, he would blow things up, partly to remove them and partly for the fun of it. He built lakes, created islands at the edge of the bay, and built homes for himself and his family.

As a prolific art collector, his manipulation of the landscape led him to think about adding sculpture on an appropriate scale for the vast property. He met with some of the world's most famous sculptors, invited them to visit, and commissioned them to create in the undulating pastures.

Marijke de Goey's *The Mermaid* (1999), a sculpture of welded and painted tubular steel cubes, bridges a lake.

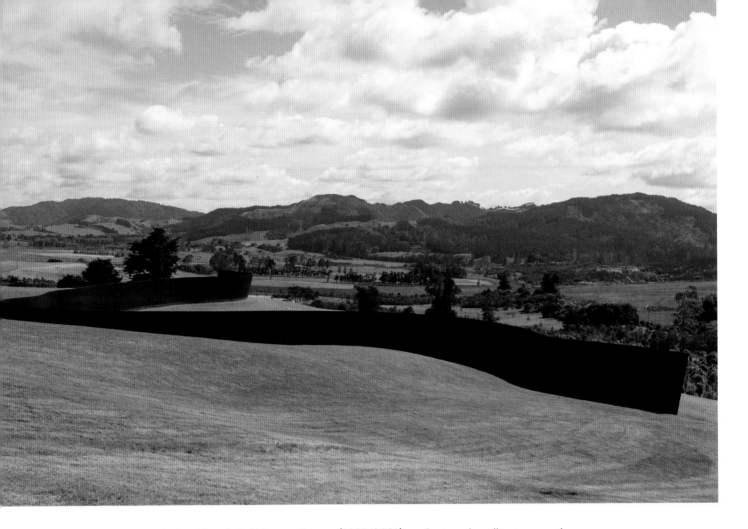

Richard Serra's *Te Tuhirangi Contour* (1999/2001) emphasizes the rolling topography.

Andy Goldsworthy, Marijke de Goey, Anish Kapoor, Sol LeWitt, Maya Lin, Richard Serra, Bernar Venet, Zhan Wang, and native Neil Dawson, among others, have created major works. Their pieces now stand on the tops of hills, float on lakes, and nestle in the park's rolling land. It is a profound collection of art, serious and transcendentally stimulating.

Bernar Venet's *88.5° ARC × 8* (2012), curved columns of corten steel, over 80 feet (24 meters) high, captures the extraordinary light of sunset and sunrise and seems to be blowing in the wind from the adjacent harbor. It is sometimes surrounded by a small herd of yaks, which seem unconcerned with the striking silhouette the individual components make against the sky as they munch on pasture below. Emus also stroll the grounds with an apparent haughty indifference to their aesthetically privileged surroundings.

Richard Serra's massive *Te Tuhirangi Contour* (1999/2001), consisting of fifty-six steel plates, traces the contour of the land, calling the visitor's attention to its sinuous turns and twists, rises and depressions in ways traditional plantings would likely only have obscured. Its intensely industrial material, paradoxically, invites you to caress it, to run your hands over its curves, to experience what matter of such obvious strength feels like for yourself.

Neil Dawson's *Horizons* (1994), at 49 by 33 by 118 feet (15 by 10 by 36 meters), looks like a giant sheet just blown in by a passing gale.

← *Floating Island of Immortals* (2006), by Zhan Wang, uses stainless steel to update the tradition of scholars' rocks in classical Chinese gardens.

Anish Kapoor's massive funnel, *Dismemberment, Site 1* (2009), rests between carefully sculpted land-form thighs.

Stone quarried in Scotland near where Gibbs's family originated is arranged by Andy Goldsworthy into *Arches* (2005), positioned as if migrating out of the bay and onto the land.

Neil Dawson's *Horizons* (1994) is a swooping, trompe l'oeil outline of what appears to be a sheet of fabric, really made from painted metal, that appears to have just blown in from elsewhere and settled precariously on top of a hill and next to a perfectly conical Norfolk Island pine (*Araucaria heterophylla*). Juxtaposing the two draws more attention to the pine than it might otherwise receive. Andy Goldsworty's nine *Arches* (2005), quarried from pink limestone deposits in Gibbs's ancestral Scotland, marches gradually from land into the silver-black mud of the tidal flats like a shy serpent. Anish Kapoor's *Dismemberment, Site 1* (2009), a red trumpet of PVC, stretched taut over 80 feet (24 meters) between two giant steel ellipses turned at ninety degrees to each other and set into a fold between hills, is a plastic suggestion of female genitalia, or as Gibbs declared it, the biggest vagina in New Zealand. Zhan Wang's *Floating Island of Immortals* (2006) brings a mythic spirituality to a small lake, injecting an element of classical Chinese gardens here, into a most modern landscape in a most modern way. A floating scholar's rock made of fiberglass coated with chrome, it turns in the wind, beaming reflected sunlight.

There are many more sculptures, placed in balanced distance with each other. Like its owner, Gibbs Farm pushes at the boundaries of traditional definitions of what is possible; it upends the idea of art as a mere accessory for the garden and turns the garden into a supporting mechanism for art. The wide natural vistas punctuated with moments that celebrate human ingenuity open our hearts and minds in the way all the best gardens do. That is, in the end, what they are all for.

"We often forget that **we are nature**. Nature is not something separate from us. So when we say that we have lost our connection to nature, we've lost our connection to ourselves." —ANDY GOLDSWORTHY.

← Bernar Venet's *88.5° ARC × 8* (2012), a group of massive corten steel beams, attracts another type of grouping—of yaks.

Paripuma

BLENHEIM, SOUTH ISLAND, NEW ZEALAND

Rosa Davison · 10 acres (4 hectares) · 2001 to present

NATIVE PLANTS HAVE BEEN gaining increasing respect in twenty-first-century garden design. Not only have we "rediscovered" the beauty of native flora; it feels good to imagine we are somehow, even if only in the abstract, taking action that is also ecologically sound. This is interpreted almost exclusively by designs that tend toward the wild, the untamed. It's unclear exactly why native must equate with informal, but the concept clearly appeals. It is exceedingly rare to come across a garden that uses native plants in formal design. It is a brave thing to do—but why shouldn't natives be used, as many other plants are, in varying styles?

At Paripuma, a private residence on the South Island of New Zealand, Rosa Davison excels at crossing these established boundaries. "I wanted to make a formal garden that dissolves into the wild," she says. "I was enamored with European gardens, particularly Sissinghurst and Great Dixter. Who didn't grow up as a gardener reading Vita Sackville-West and Christopher Lloyd?" But this is New Zealand, not restrained England, and the coast is rough.

Davison's land is just a few feet above sea level, on soil that is half gravel and half clay. It looks north, toward the warm sun. It is frost-free. This is the Southern Hemisphere, though, and when cold comes, it comes from the Antarctic. With the Pacific Ocean on one side and high sand bluffs on the other, the garden receives peculiar amounts of rainfall. "One year we had four inches of rain," she says, "the next year, twenty-two." She had a lot to learn about what could grow in such a place.

She chose plants native to the region, ready-adapted to unpredictable swings in conditions. Her next smart move was to borrow faraway scenery by laying out the garden along a

The garden features *Myoporum laetum*, the native ngaio plant. Its softly rounded crowns can reach a height of 30 feet (9 meters) and spread of 10 feet (3 meters).

The Marlborough lilac (*Heliohebe hulkeana*), actually a relative of *Veronica*, was misnamed upon discovery because of its color rather than its physiology.

→ The renga lily flower's loose panicles attract pollinators. An excellent summer-flowering plant for dry shade, it grows 3 feet (0.9 meters) high and wide.

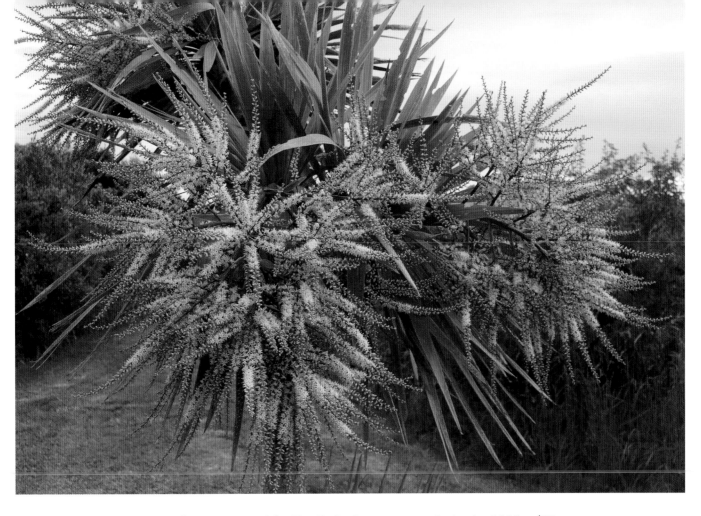

The cabbage tree (*Cordyline australis*), a New Zealand native, can reach a height of 66 feet (20 meters). It flowers in spring. The common name is odd because it does not resemble a cabbage and it is not particularly tasty, although it was used by indigenous peoples for food. "Cabbage tree" is a common name for a number of species.

main central axis that, in effect, extends her narrow acreage all the way across the bay and to the peak of a distant mountain, Mount Rahatia.

She chose one plant, ngaio (*Myoporum laetum*), as the primary architectural plant. Pronounced n-ay-oh, it is a fast-growing, evergreen shrub or small tree with small purple-dotted white flowers. She lined the main view with ngaio and then spread it out along a cross-axis until it disappeared into the gravelly beach. Its dome-shaped canopies lend graceful billows along the central path, creating the desired formality yet tempering it with soft waves.

In the center, nicely placed as a focal point, is an old iron whaling pot that now serves the gentler purpose of an antique, rust-hued foil to the Poor Knights lily (*Xeronema callistemon*), a species named after its homeland, a group of nearby islands to the north. It takes up to fifteen years to flower, but when it does, it produces striking red bottlebrush-like flowers. It is sensitive to frost but is otherwise a tough plant. Davison relates that a bucket of seawater dumped on occasionally actually seems to please it.

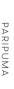

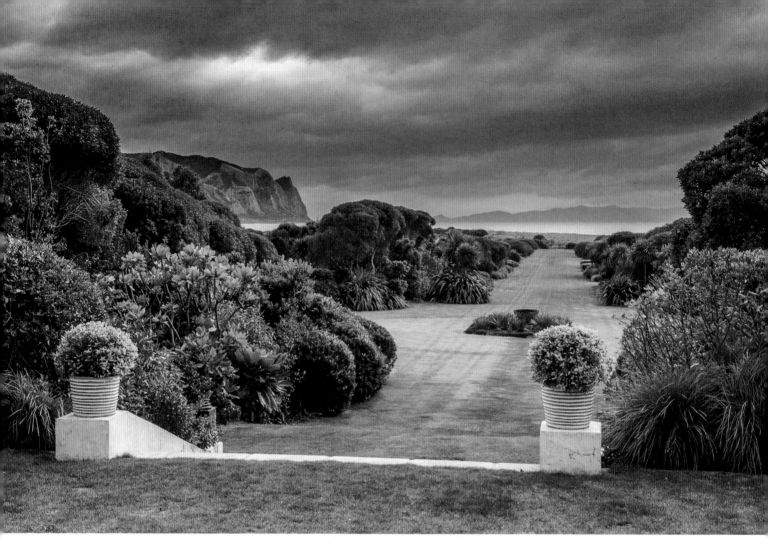

A broad, straight avenue draws the eye through the length of the garden and out to the distant Mount Rahatia, shaping a magnificent view.

→ Poor Knights lily (*Xeronema callistemon*) is endemic to the tiny group of eponymous islands off the coast of northern New Zealand.

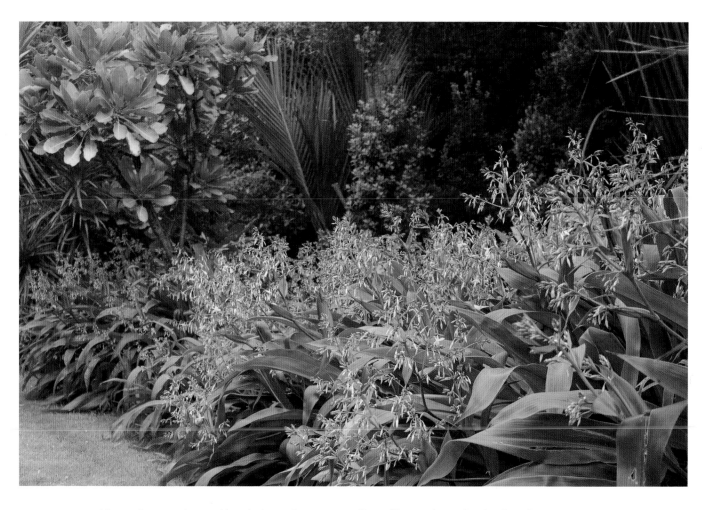

A large planting of renga lily—*Arthropodium cirratum* 'Parnell', is a cultivar that has broader and longer leaves and taller flower heads than the species. Behind it is *Rhopalostylis sapida*, nīkau palm, the most southerly growing palm in the world and, with the big leaves, *Meryta sinclairii*, the puka tree.

A small border of Marlborough lilac (*Heliohebe hulkeana*) softens the approach to the house. This plant is an interesting one from an etymological/horticultural point of view, because it's not a lilac at all but a relative of *Veronica*. It features long sprays of light lavender flowers in spring. Davison finds color distracting and only uses it, as in the case of the *Heliohebe* and *Xeronema,* as occasional accents within the calm repetition of evergreens.

To walk down the garden's central avenue to the rough beach beyond and then to look back up the length of it all is to realize that Mrs. Davison, in choosing plants that have as much right to be there as the rough waves and jagged cliffs, has created the perfect balance between the intended and the untamed.

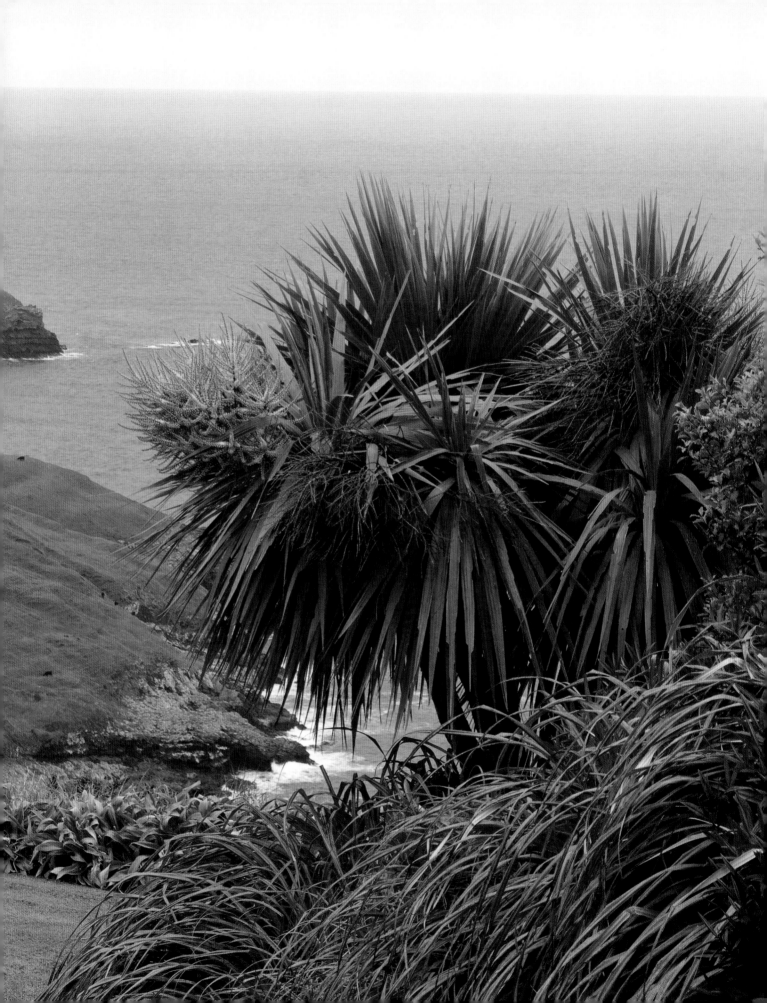

Fishermans Bay Garden

LONG BAY, SOUTH ISLAND, NEW ZEALAND

Jill and Richard Simpson · 4 acres (1.6 hectares) · 2000 to present

MANY GARDENERS ARE INTERESTED in attracting birds, but few get the option of inviting yellow-eyed penguins, or *hoiho*, to their property. And seals are a different consideration altogether. Jill and Richard Simpson bought a rather rundown house on 790 acres (320 hectares) of farmland in the late 1990s. It wasn't their intention to create a garden; they just wanted "something nice around the house." Today, it's a fully-fledged plantswoman's garden with thousands of plants, stone steps, walls, and terraces. Protected from the grazing cattle, the area is lush with native plants—podocarps and tea trees, cabbage trees, ferns, and mosses. The hoihos nest in the scrub close to the waters of Red Bay.

For a real gardener like Jill, modest intentions disguise grand plans. Richard, a retired farmer, is proud of the garden and provides great support both practical and emotional. He wants his wife to be happy. "Designing a garden isn't a cerebral thing." says Jill, "It's about feeling your way through, constantly adjusting, stepping back and seeing how it feels. That's why I don't like most landscape architects' work. Too much thinking and not enough feeling."

Jill, also a landscape painter, took the good fortune of the coast's great light into account while developing the planting schemes to account for what would appear prominent at different times of day. The garden faces east-northeast, and the rising sun creates an explosive burst of scattered light and color, intensifying the already red flowers of tea tree, *Leptospermum* 'Red Ensign', the dense clusters of crimson rātā (*Metrosideros carminea*), the oranges of azaleas, the bronze of New Zealand sedge (*Carex testacea*), and the stripes in several varieties of New Zealand flax (*Phormium tenax*).

A view through a planting of cabbage trees (*Cordyline australis*) goes down to the shore where penguins like to nest.

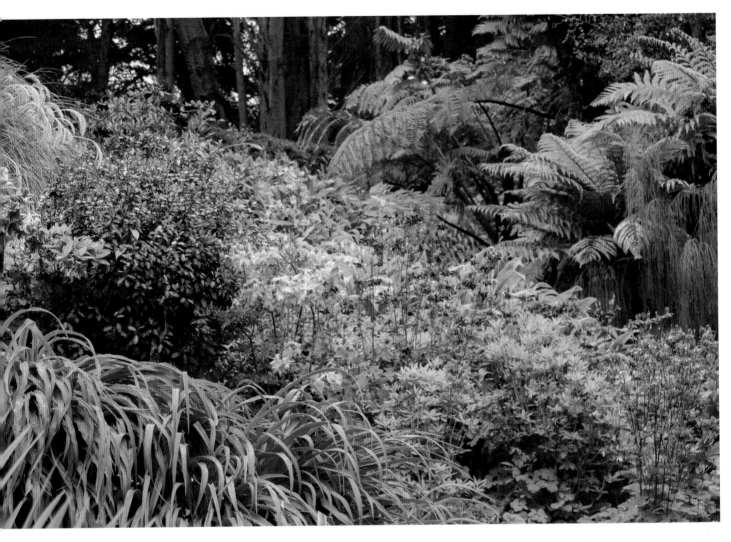

Deciduous azaleas, blue columbines, and tree ferns create a fetching color combination that stands up to the intense midday sun.

→ The soft green plumes of one of the most graceful grasses, *Chionochloa flavicans*, glow chartreuse in early-morning or late-afternoon sun.

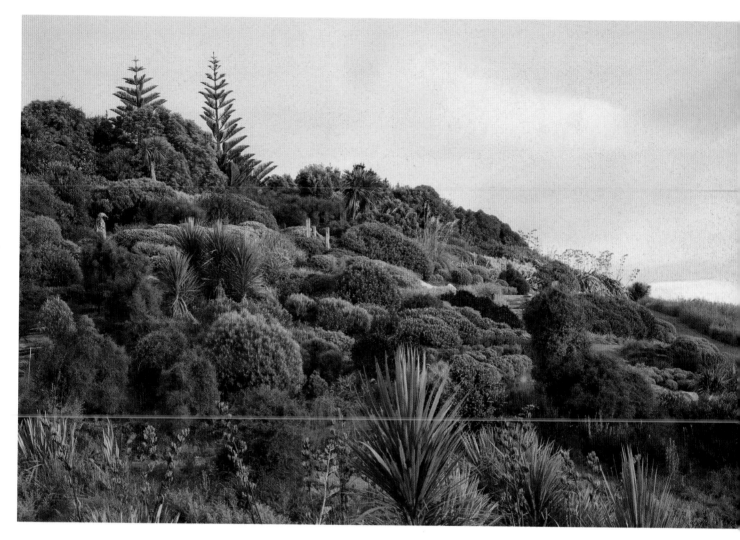

At sunrise, the light turns this bayside garden to gold.

← *Acacia cognata* 'Limelight', a dwarf plant that always grabs attention for its almost fur-like tufts of foliage, anchors one end of a long border.

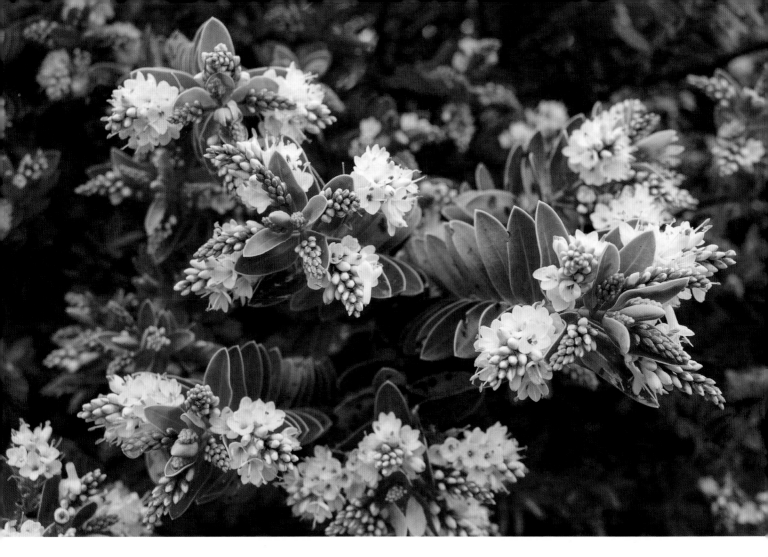

The genus *Hebe* is one of New Zealand's proudest exports. This cultivar, 'Wiri Mist', boasts pretty sprays of white flowers in spring.

→ The already vibrant flowers of *Leptospermum* 'Red Ensign' take on a particularly intense color at sunrise and sunset.

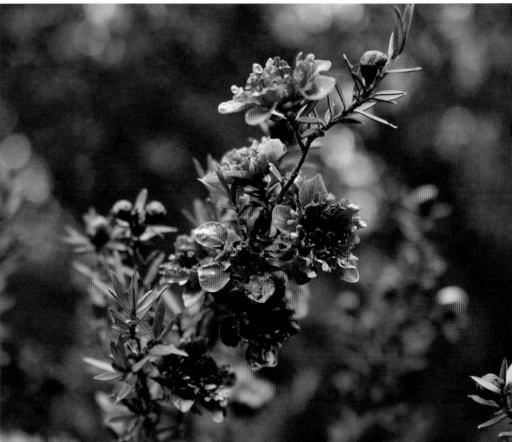

As the sun rises and the path of its light shortens, red light is reflected and green and blue appear stronger to our eyes. At early morning, certain plants come forward, presenting themselves: towers of blue *Echium pininana*, a biennial that can reach 13 feet (4 meters) tall; the exquisite soft green of toi toi (*Chionochloa flavicans*), a native grass; and the soft mounds of Australian dwarf *Acacia cognata* 'Limelight' with its filigree of lime green leaves.

At midday, only the strongest of combinations stand out. In early summer, the combination of white wisteria and yellow-orange monkey flower (*Diplacus aurantiacus*) sparkles. As the sun sets, the garden begins to glow again, only this time with a softer orange. Soft plantings vibrate. The large undulating hedges of light green hebes with white flowers, *Hebe* 'Wiri Mist' and *H. subalpina*, seem to take on substance and catch the last of the light in the angular shadows. Hebes are the quintessential New Zealand plant, with about 100 species and many cultivars. They are evergreen. Some look like conifers and others have oval leaves that are opposite and at 90 degrees to each other, making them fine textural plants. Taxonomists, bless their hearts, keep moving the genus name from *Hebe* to *Veronica* and back again.

A garden on a cliff, like this one, is made with a decent sized tractor and a great deal of care. One of the first features the Simpsons built was The Great Wall, a stone retaining wall that helped create a terrace around the house and a lawn surrounded by hedges. It leads to a zigzag path and plantings of daylilies and deciduous azaleas in warm colors. The expressive smokebush, *Cotinus* 'Grace', a cross of *Cotinus coggygria* and *Cotinus obovatus*, flings around her purple arms in the coastal breezes while small towers of red-purple leaf barberry (*Berberis thunbergii* f. *atropurpurea* 'Helmond Pillar') push their way upward.

The native *Podocarpus totara* is one of five species of New Zealand podocarps. It is a dominant tree in the garden, its seedlings popping up here and there and its peeling bark and gray-green leaves making the mature specimens conspicuous. Its tough wood has traditionally been used in agricultural construction as well as for Maori carvings.

Parts of the garden are also devoted to a traditional mixture of roses, shrubs, and perennials, reflecting the British heritage of the inhabitants. But New Zealand's gardeners are evolving away from the horticultural stereotype and moving toward a style of their own, Fishermans Bay among them. Its natural, free-flowing style feels proper for the setting, and is a style that fits easily and very happily along the landscape of a rugged coast.

Cotinus 'Grace' and *Berberis thunbergii* f. *atropurpurea* 'Helmond Pillar' add deep, almost mahogany, tones to the garden.

Echium pininana, a native of the Canary Islands, produces towers of flowers up to 13 feet (4 meters) tall.

← A pairing of white wisteria and yellow-orange monkey flower (*Diplacus aurantiacus*) creates a stunning vignette.

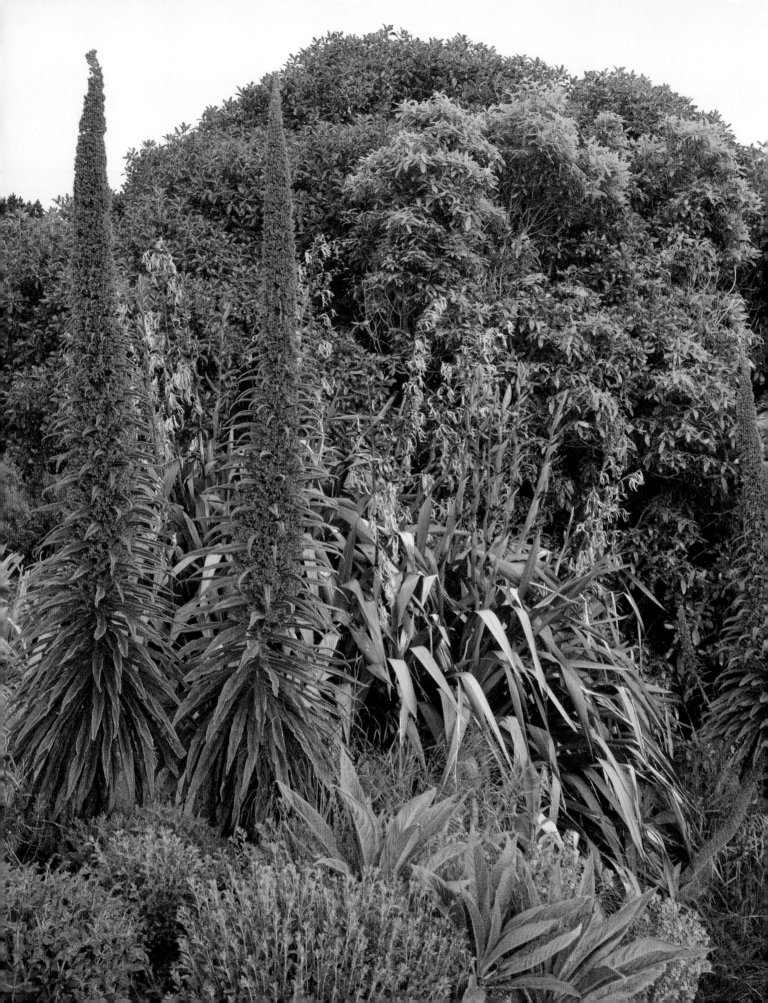

When propagated from a cutting of an adult plant, crimson rātā (*Metrosideros carminea*) will spread like a shrub rather than climb.

← The prominent spikes of *Echium pininana* and New Zealand flax (*Phormium tenax*) are revealed to full effect against a background of rounded ngaio trees (*Myoporum laetum*).

SOURCE NOTES

INTRODUCTION

p. 10 "This is my house . . . ": from a personal interview with a Dutch homeowner, May 2017.

p. 13 "What I like about my garden . . .": from a personal interview with Carrie Preston; she repeated it in a Facebook comment, May 2017.

p. 13 "Even in poetry and art does nature have its place . . . ": Rik Gadella, Pha Tad Ke newletter, February 2014.

NORTH AMERICA

The Garden of Flowing Fragrance, Huntington Botanical Garden, San Marino, California

p. 25 "You ask me why I dwell in the green mountain;" epigraph, Li Bai, Tang Dynasty poet. In Li Bai and Du Fu, *Facing the Moon: The Poetry of Li Bai and Du Fu*, transl. by Keith Holyoak. Durham, New Hampshire: Oyster River Press, 2007.

p. 26 "By detours, access the secrets": Chinese proverb, unknown origin, illustrating the zigzag bridge in the Humble Administrator's Garden, Suzhou, China.

Chihuly Gardens and Glass, Seattle, Washington

p. 43 "If you take a thousand hand-blown pieces of a color . . ." and "I want people to be overwhelmed with light and color . . . ": www.chihuly.com/learn, accessed January 2017.

Mordecai Children's Garden, Denver Botanical Garden, Colorado

p. 51 "nature deficit disorder": Richard Louv, *The Nature Principle*, New York: Algonquin, 2011.

p. 52 "You have to reach the parents . . .": Cindy Tyler, Terra Design Studios, telephone and email interviews, June 2015.

p. 53 "We created a journey . . .": Tina Bishop, Mundus Bishop, telephone interview, June 2015.

p. 53 "We know that children explore visually . . .": personal interview with Julie Casault, June 2015.

Federal Twist, Stockton, New Jersey

p. 57 Quotes and impressions from James Golden are from a personal interview, March 2015, and from his blog, View from Federal Twist, federaltwist.blogspot.com.

p. 61 "The still point of the turning world . . . " T. S. Eliot, *Four Quartets*. London, UK: Folio Society, 1968.

Naples Botanical Garden, Naples, Florida

p. 71 "He said, 'I have a hundred and seventy acres . . .' ": personal interview with Brian Holley, January 2016.

p. 76 "Naples Botanical Garden sits at the epicenter of . . . ": email from Chad Washburn, March 2016.

Vallarta Botanical Garden, Puerto Vallarta, Mexico

p. 81 "Why isn't there a botanical garden here?": Robert Price, personal interview, December 2015.

CENTRAL AMERICA AND THE CARIBBEAN

Golden Rock Inn, Nevis, West Indies

p. 99 "Brice concentrates on the rocks . . . ": personal interview with Brice and Helen Marden at Golden Rock, April 2016.

SOUTH AMERICA

Jardín de Salvias, Mar del Plata, Argentina

p. 113 Personal interview with Rolando Uría and Francisco Javier Lozano, January 2017.

Juan Grimm Gardens: Chile, Uruguay, and Argentina

p. 121 Personal interview with Juan Grimm, January 2017.

EUROPE

Iúri Chagas Gardens, The Algarve, Portugal

p. 139 Personal interview with Iúri Chagas, March 2017.

Quinta da Granja, Miranda do Corvo, Portugal

p. 143 Personal interview with Kevin Scales, March 2017.

Camel Quarry House, Cornwall, United Kingdom

p. 169 "The world is full of magic things . . . ": "Land of Heart's Desire, The Countess Cathleen," by W. B. Yeats, London: T. F. Unwin Ltd., 1925.

p. 169 "We are losing what few wild places . . . ": Mary Reynolds, *The Garden Awakening*, New York: Green Books, 2016.

p. 171 "An old pathway, overgrown and forgotten . . .": Mary Reynolds, *The Garden Awakening*.

The Alnwick Garden, Northumberland, United Kingdom

p. 189 "The garden stimulates change . . . ": personal interview with the duchess of Northumberland and numerous email exchanges, 2015.

p. 192 "We've hosted cage fights . . .": email correspondence with the duchess, July 2015.

p. 192 "The British disease of worshipping the past . . . ": quote by Sir Tim Smit in *The Making of the Alnwick Garden*, by Ian August, London: Pavilion Books, 2006.

p. 192 "For this garden to work . . . ": quote by Sir Tim Smit, from *The Making of the Alnwick Garden*.

p. 195 "If your values behind a project are solid . . . ": email from the duchess of Northumberland, July 2015.

Carrie Preston's Gardens, The Netherlands

p. 197 Personal interview with Carrie Preston during four-day visit; follow-up email, May 2017.

The Tree Museum, Rapperswil, Switzerland

p. 207 "The most important qualities . . . ": Michael Jakob, *Enea: Private Gardens*, Switzerland: Schmerikon, 2011.

p. 207 Together, they "grew the best peaches . . . ": personal interview with Enzo Enea, May 2016.

p. 207 "I am not looking for minimalism . . . ": personal interview with Enzo Enea, May 2016

p. 209 "Gardens are very special places . . . ": Michael Jakob, *Enea Private Gardens*.

Landschaftspark, Duisburg-Nord, Germany

p. 213 "A generation without history . . . ": Simon Schama, *Landscape and Memory*, New York: Penguin Books, 1996.

Peter Korn's Garden, Eskilsby, Sweden

p. 219 Quotes from a personal interview with Peter Korn, May 2016, and from his book, *Peter Korns [sic] Garden*, Eskilby, Sweden: Peter Korn, 2013.

AFRICA AND THE ARABIAN PENINSULA

The Aloe Farm, Hartbeespoort, South Africa

p. 235 "Plant breeding has great possibilities . . . ": email correspondence with Andy De Wet, February 2017.

Al Barari, Dubai, United Arab Emirates

p. 245 "Some wine, a Houri . . . ": Omar Khayyam, *Rubāiyāt of Omar Khayyām*, translated by Edward Fitzgerald, Franklin Center, PA: Franklin Library, 1979.

Oman Botanic Garden, Al Khoud, Oman

p. 255 "Biodiversity loss is one of the . . . ": Anna Patzelt, *Oman Plant Red Data Book*, published by Diwan of the Royal Court, Sultanata of Oman, 2015.

INDIA AND SOUTHEAST ASIA

The Garden of Five Senses, Said-ul-Azaib, Delhi, India

p. 263 "Sitting at the site . . . ": personal interview and follow-up emails with Pradeep Sachdeva, February 2017.

Made Wijaya's Gardens, Bali, Indonesia

p. 307 "Bali has a reputation as . . . ": Made Wijaya, *Now! Bali/Life on the Island*. July 20, 2016.

ASIA

Chenshan Botanical Garden, Shanghai, China

p. 319 Christopher Valentien quotes from emails to me, April 2017.

AUSTRALIA AND NEW ZEALAND

One Central Park, Sydney, Australia

p. 361 One Central Park has been called a "place for living in harmony . . . ": from promotional material selling the luxury apartments.

Barangaroo Headland Park, Sydney, Australia

p. 363 "thin scrubby trees . . . " Charles Darwin, *The Voyage of* The Beagle (Harvard Classics edition), New York: P. F. Collier, 1909.

Gibbs Farm, Makarau, North Island, New Zealand

p. 373 "I consider space to be a material . . . ": Richard Serra, from the website I Require Art. http://ireqireart.com/artists/richard_serra/the_matter_of_time-634.html.

p. 379 ". . . the biggest vagina in New Zealand": from Alan Gibbs, in a raucous and amusing personal interview, November 2016.

p. 379 "We often forget . . . ": Andy Goldsworthy, *The Influence of Nature in Art*. https://landartists.weebly.com/andy-goldsworthy.html.

Paripuma, Blenheim, South Island, New Zealand

p. 381 Quotes from Rosa Davison from a personal interview four hours before the Kaikoura earthquake, magnitude 7.8, on November 14, 2016. We survived and had a cup of tea.

Fishermans Bay Garden, Long Bay, South Island, New Zealand

p. 387 "something nice around the house . . . " and "Designing a garden isn't a cerebral thing": from a personal interview with Jill and Richard Simpson, November 2016.

ACKNOWLEDGMENTS

I am grateful to the following people, who helped with this book.

Stacee Gravelle Lawrence edited this book. She did so with grace, humor, and a laptop. She turned my tangential and meandering writing into something approaching coherence. She's good with apostrophes too.

To the staff at Timber, especially Sarah Milhollin, who helped so immensely with the images and guided me on how to point and shoot. Ellen Wheat, who gave the text a polish—it gleams. And to the graphic designers Laura Shaw and Adrianna Sutton.

Thank you to the gardeners who allowed me to interrogate them and who hosted me. They fed me with stories, good food, and no small amount of alcohol. They opened their hearts and told me of the intimate beginnings of their love of gardens. They talked about plants—a lot. You are sweet, crazy people and I love every one of you. Your names are listed below and, if I have missed anyone, please accept my profound apologies. I blame my editor.

I am also grateful to the world of people who transported me around the planet several times. The taxi-drivers, airplane staff, hotel and restaurant staff and all the people we describe as "behind the scenes" who really aren't. They make international travel so easy, if a little hard on the back.

Also special thanks to: Abdulrahman Al Hinai, John Arnott, Kamelia Bin Zaal, Erin Bird, Dan Bishop, Karina Blakey, Conseulo Bravo, Naomi Brooks, Ray Careme, Julie Casault, Iúri Chagas, Ken Chavez, Alasdair Currie, Rosa Davison, Michael Davison, Andy deWet, Marcia Donahue, Tyler Drosdeck, Julie Eakin, Steve Eldred, Enzo Enea, Robert Finnie, Jim Folsom, Cevan Forristt, Rik Gadella, Neil Gerlowski, Alan Gibbs, Luciano Giubbilei, Ryan Guillou, Ellin Goetz, James Golden, Juan Grimm, Richard Hartlage, Brian Holley, Paz Hormazabal, Andrea Jones, Panayoti Kelaidis, Peter Korn, Tess Kruss, Una Lavery, Claire Leadbitter, Mary Linde, Bill Manning, Brice Marden, Helen Marden, Andrew Mills, Kirsten Mills, Paul Mills, Ximena Nazal, Scott Nickerson, Jane Northumberland, Ben Noyes, Ralph Osborne, Judy Osburn, Maggie Oster, Annette Patzelt, Dan Pearson, Winnie Poon, Carrie Preston, Bob Price, Rob Proctor, Inanna Reistad, Mary Reynolds, Stephen Richards, Maria Rigoli, Yadiel Rivera-Diaz, Fabrice Rolando, Caroline Rosenthal, Pradeep Sachdeva, Sunita Sachdeva, Sue Savage, Kevin Scales, Dennis Schrader, Midori Shintani, Jill Simpson, Richard Simpson, Siv Stagman, Lee Sutton, John Tan, Cindy Tyler, Rolando Uría, Christoph Valentien, Chad Washburn, Kim Wilkie, Sheila Wilson, Shuntaro Yahiro, Nona Yehia, and Annette Zealley.

PHOTOGRAPHY CREDITS

All photos are by the authors, except for the following:

Annenberg Foundation Trust at Sunnylands, pages 16, 18, 19, 20, 23

Boughton House, Euan Myles, pages 182, 184, 186

Boughton House, Kim Wilke, page 187

Andy De Wet, pages 232, 234, 236, 237

Denver Botanic Gardens, page 54

Richard Felber, pages 66, 69

Roger Foley, page 72

Scott Frances, page 68

Rik Gadella, page 296

James Golden, pages 56, 58, 60, 62, 63, 64, 65

Juan Grimm, pages 4, 120, 122, 123, 124, 125, 126, 127

Richard Hartlage, pages 40, 44, 43, 45, 46, 47, 49

Emma Cooper Key, pages 168, 170

Peter Korn, pages, 218, 220

David Lloyd/SWA Group, pages 326, 328, 329, 330, 332

MESURA, www.mesura.eu, pages 158, 160, 161

Ximena Nazal, page 130

Annette Patzelt, pages 252, 256, 257, 258

Kevin Scales, pages 142, 144, 146, 148, 149, 150

Secret Gardens, pages 368, 370, 371

Darren Soh, page 285

Steven Brooke Studios, page 70

Rolando Uria, pages 112, 115, 116, 118, 119

Paul Wager, page 297

Michal Wells, page 384

Wikimedia Commons, used under the Creative Commons Attribution-Share Alike 3.0

Unported license, Badlydrawnboy22, page 297

INDEX

Copyright © 2018 by Christopher Woods. All rights reserved.
Photo and illustration credits appear on page 400.

Published in 2018 by Timber Press, Inc.

The Haseltine Building
133 S.W. Second Avenue, Suite 450
Portland, Oregon 97204-3527
timberpress.com

Printed in China

Text design by Laura Shaw Design
Jacket design by Adrianna Sutton

ISBN 978-1-60469-797-1

Library of Congress Cataloging-in-Publication Data

Names: Woods, Christopher, 1953– author.
Title: Gardenlust: a botanical tour of the world's best new gardens / Christopher Woods.
Description: Portland, Oregon: Timber Press, 2018. | Includes bibliographical references and index. |
Identifiers: LCCN 2018019654 (print) | LCCN 2018023037 (ebook) | ISBN 9781604698909 | ISBN
 9781604697971 (hardcover)
Subjects: LCSH: Gardens—Pictorial works.
Classification: LCC SB450.98 (ebook) | LCC SB450.98 .W66 2018 (print) | DDC 635.022/2—dc23
LC record available at https://lccn.loc.gov/2018019654